NOTES AND RECIPES FROM A

SOUTHERN ODYSSEY

BARBECUE
CROSSROADS

ROBB WALSH

PHOTOGRAPHS BY

O. RUFUS LOVETT

UNIVERSITY OF TEXAS PRESS ⚐ AUSTIN

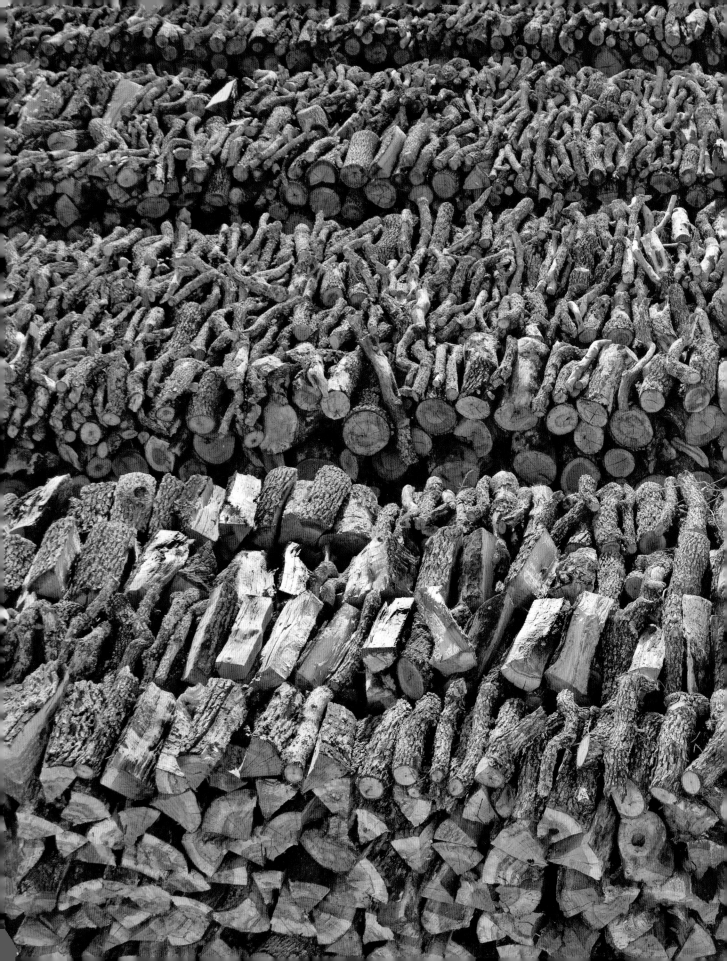

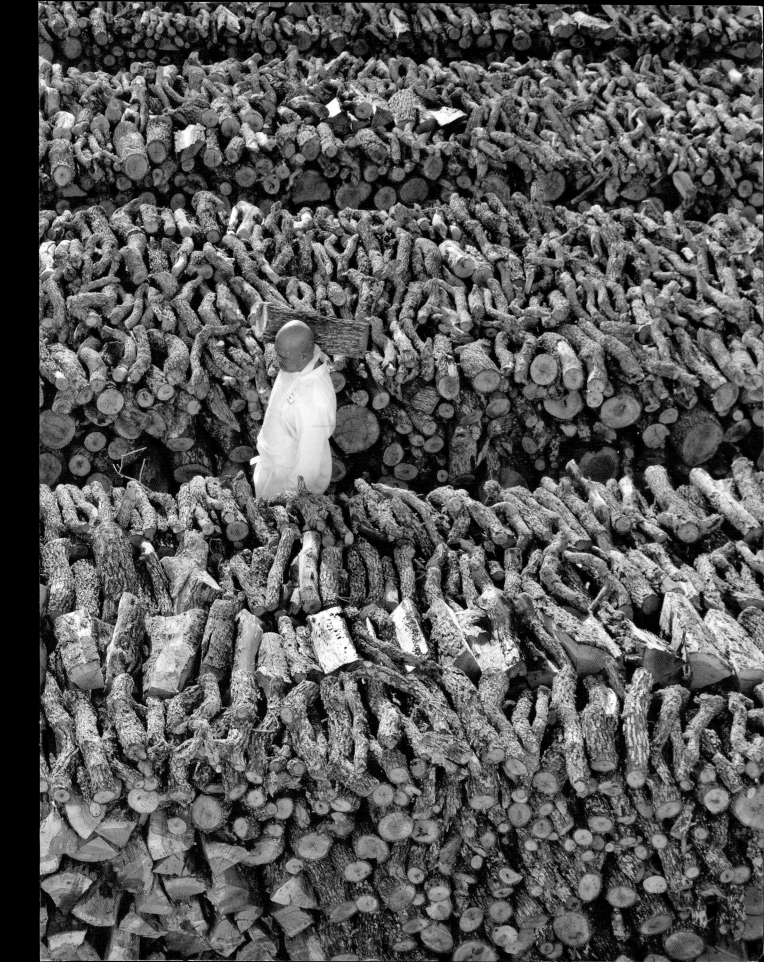

Publication of this book was aided by the generous support of
Michele and Brad Moore
Ellen and Edward Randall
Richard and Martha Rorschach

Requests for permission to reproduce material
from this work should be sent to:
Permissions
University of Texas Press
P.O. Box 7819
Austin, TX 78713–7819
http://utpress.utexas.edu/about/book-permissions

The paper used in this book meets the minimum requirements of
ANSI/NISO Z39.48-1992 (R1997) (Permanence of Paper). ∞

Design by Lindsay Starr

LIBRARY OF CONGRESS CATALOGING-IN-PUBLICATION DATA
Walsh, Robb, 1952–
Barbecue crossroads : notes and recipes from a southern odyssey / By Robb Walsh ;
Photographs by O. Rufus Lovett. — First edition.
p. cm.
Includes bibliographical references and index.
ISBN 978-0-292-73932-1 (cloth : alk. paper)
1. Barbecuing—Southern States. I. Lovett, O. Rufus, 1952– photographer. II. Title.
TX840.B3W35 2012
641.7'60975—dc23
2012035824

doi:10.7560/739321

*Frontis: Community barbecue crew member Bubba Roese at
the Sons of Hermann Lodge in Washington, Texas*

*Pages iv–v: The woodpile at Smitty's Market in Lockhart, Texas.
Post oak is seasoned for two years before it's burned.*

Dedicated to Richard Walsh and
Opal Rufus Lovett

CONTENTS

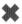

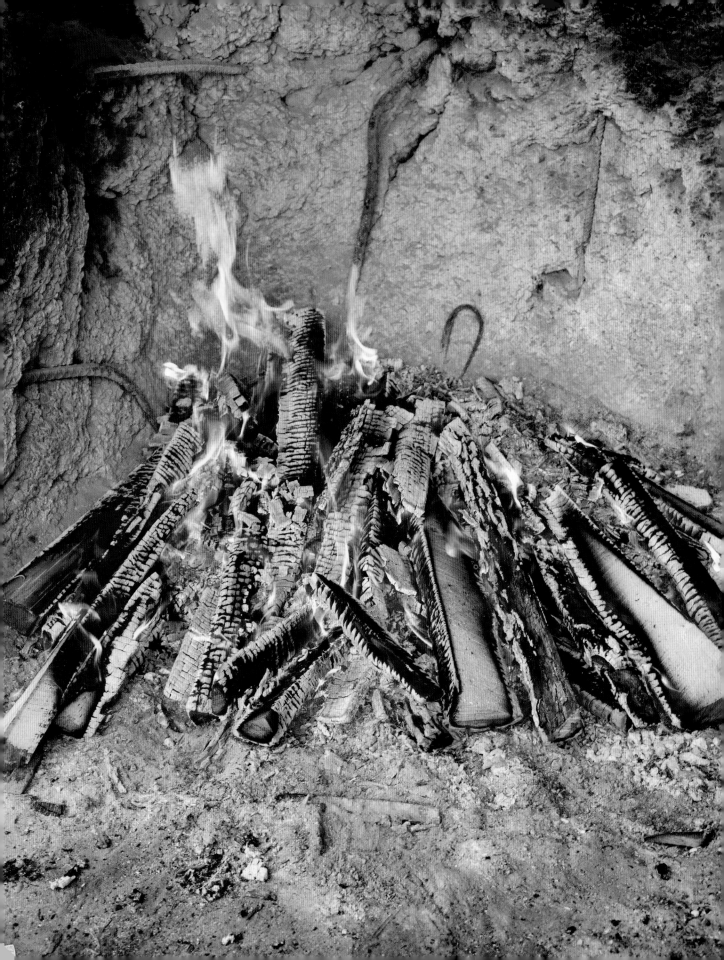

PREFACE

SAYING GRACE

EVENING OF OUR FIRST DAY on the road found Rufus and me at Doe's Eat Place in Little Rock, Arkansas. We each had a whiskey on the rocks and a soggy iceberg salad for an appetizer. We probably should have said grace before we dug into our shared medium-rare two-and-a-half-pound T-bone, because if there was one thing we learned on the first day of our barbecue trip, it was that much depends on divine providence.

Doe's serves a tasty steak, but it was a consolation prize—we were on a barbecue trip, after all, not a steak pilgrimage. Although we had stopped at two famous barbecue joints on our trip north, by some strange collection of circumstances, we failed to get any barbecue. Nealy's in Marshall, Texas, home of the famous "Brown Pig" sandwich, closed at three in the afternoon—twenty minutes before we got there. And although we spent several hours at Baby J's Bar B Que and Fish in Palestine, we didn't get any meat.

We were looking for the keepers of the flame—the last of the old-fashioned Southern barbecue pits.

We would return to both establishments in the months to come. Meanwhile, we would pass by a dozen other barbecue joints as we drove north up the Eastex Freeway through the Piney Woods, and we would ignore plenty more barbecue establishments on the road to Little Rock—none of them met our standards. We weren't looking for just any barbecue restaurants. We had no interest in places that used electric or gas-fired barbecue ovens. We were looking for the keepers of the flame—the last of the old-fashioned Southern barbecue pits.

This quest started when I left my job at the *Houston Press* after ten years of restaurant reviewing. I found myself enjoying barbecue more than I had in decades.

Scott's-Parker's fireplace, Lexington, Tennessee. Old-time Southern barbecue joints burn hardwood logs down to coals and then shovel the coals into the pit.

Liberated from my role as critic and otherwise unemployed, I had the luxury to just sit back and take it all in. And without the strictures of anonymity, or anything better to do, I could banter to my heart's content with the folks who tended the pits.

And I could see the folly of much of what I had written. Barbecue Top 10 lists, ratings, and all the rest of it are, as the Buddhists would say, illusion. Bloggers, journalists, and magazine editors put scores on barbecue joints in order to convince the public (and ourselves) that we are the masters of the barbecue universe. But it's all a lot of smoke.

When you get caught up in arguing about who serves the best barbecue, you lose sight of the larger picture. Some days the sausage at Smitty's in the Central Texas town of Lockhart is so wet it squirts when you cut it, and sometimes in the late afternoon it gets dry. So what? You want to give the sausage a score? Go ahead if it makes you happy. The sausage has been smoked the same way for over a hundred years. It will still be here after we are gone.

There is no best barbecue, anymore than there is a best song or a best painting. In the part of the country where barbecue has long been part of everyday life, as soon as you forget about the scorekeeping, you become open to the wider experience of BBQ as an art form, a spiritual pursuit, and a culture. I realized that in twenty years

The author waits in line for some late-night Q in Houston's Sunnyside neighborhood.

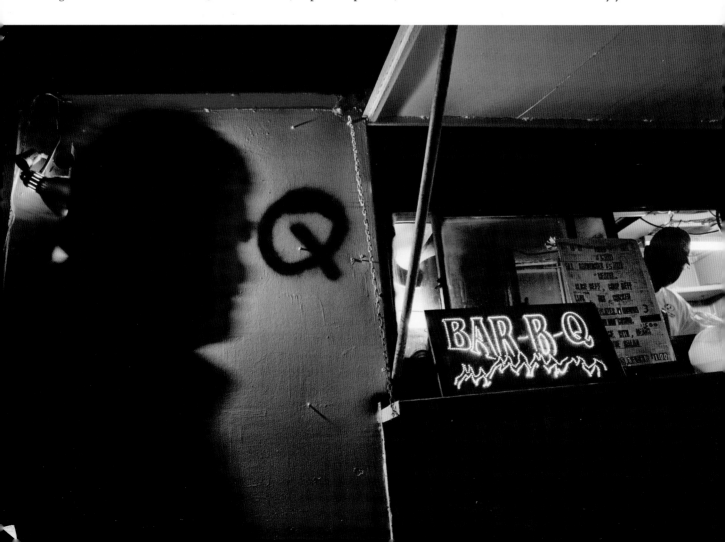

of food writing, I had never actually written what I wanted to say about barbecue. So I teamed up with the photographer O. Rufus Lovett for a magazine article. The idea was to take another approach to barbecue. We didn't go looking for the best barbecue—we went looking for the wellsprings of barbecue mythology.

After the article was done, Rufus and I were hooked. What we found was the routine of the pitmasters; the sharpening of knives, the cutting of meat, the chopping of hardwood, the tending of coals, and the opening and closing of black iron pit doors. In these daily rituals, we saw an older way of relating to food. The sliced brisket, pulled pork sandwiches, and tender ribs were delicious. But it was the ancient artisanal tradition itself and the culture and mythology that surrounds it that we were determined to document. We both wanted to keep going. So we decided to take a road trip. We had already covered most of the famous German meat markets in Central Texas and some obscure bars and former service stations that served barbecue too.

In East Texas, we found open pits and chopped pork sandwiches that were clearly the remnants of an earlier barbecue culture. Rufus kept talking about the great old barbecue pits in Alabama, where he grew up. His father, Opal Lovett, photographed agrarian life there in the 1950s, so Rufus had that Southern photographer thing in his genes. So we decided to try to trace the lineage of Southern barbecue backward through time from East Texas to the Arkansas Delta and Memphis, across the Piedmont region of Alabama, Georgia, and North Carolina, and down the coastal plains of the Carolinas to the shores of the Atlantic.

And then we would bring our impressions back home and try to make sense of it all.

Next page: Fire barrel at Scott's Variety in Hemingway, South Carolina

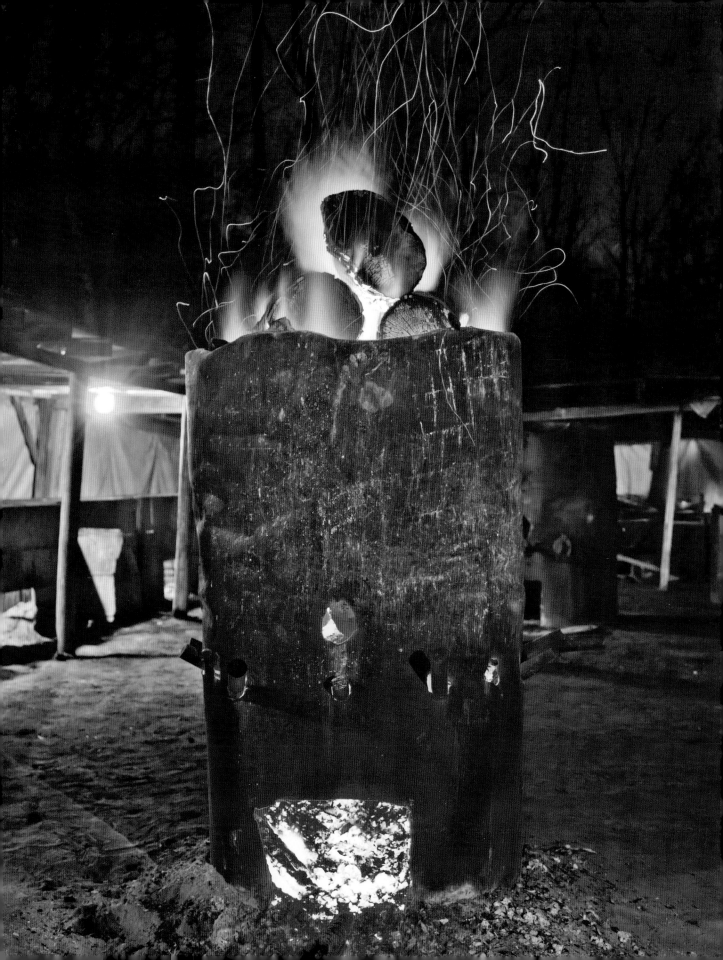

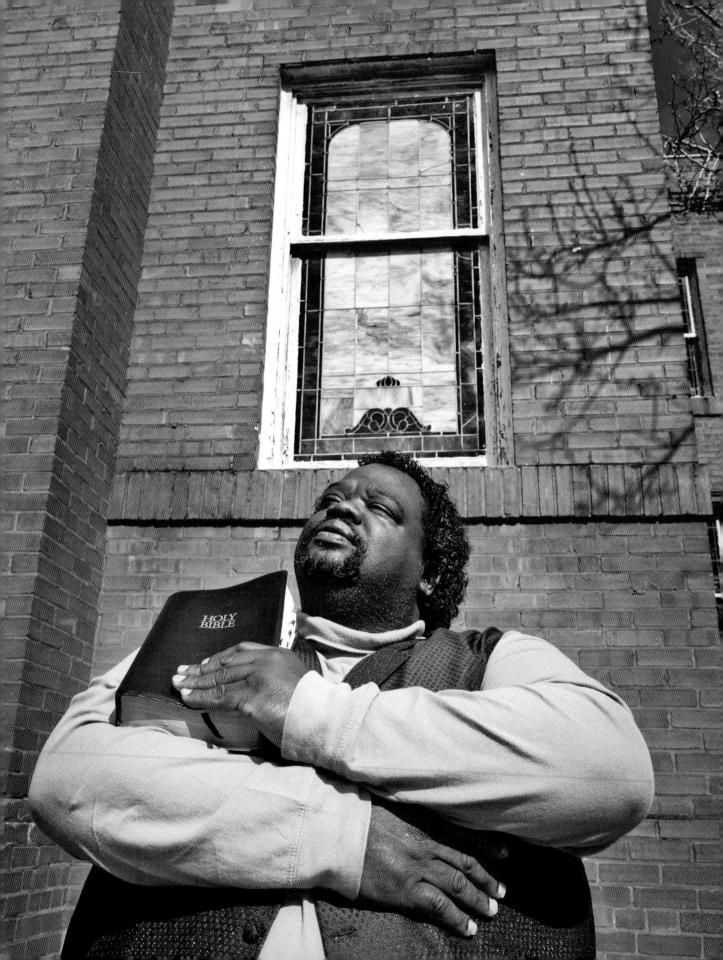

1

PITS AND

PULPITS

OUR SMOKY PILGRIMAGE BEGAN on a Tuesday morning in August. At our rendezvous point and first stop, my wife dropped me off and I loaded my luggage into Rufus's Honda Element. In anticipation of the mess I would make while eating barbecue in his car, Rufus had draped a beach towel over the passenger seat. The rear of the vehicle was packed with photo equipment and lighting apparatus. After squeezing in my suitcase and laptop, I kissed my wife good-bye and the work began.

Rufus and I introduced ourselves to Jeremiah "Baby J" McKenzie, the proprietor and pitmaster of Baby J's Bar B Que and Fish, in Palestine, Texas. But our trip got off to a strange start when he told us, "We're out of brisket, pork, and ribs. All we got is fried catfish."

Baby J's had been written up in a Dallas newspaper over the weekend, and the meat had sold out. When the restaurant reopened on Tuesday morning, all they had left to serve for lunch was crispy fried catfish. I rationalized that we were going to be eating plenty of meat on our travels, so a little catfish might be a pleasant prelude.

"Believe it or not, fried catfish is pretty common in African American barbecue joints," I told Rufus. We placed our order for fish and then went outside to visit with Baby J and look at his various cooking rigs. Baby J's started out at a small location in Elkhart and moved to its current site on the edge of Palestine a few years ago. The restaurant building is located on a vacant lot under a water tower on the unpopulated outskirts of town. Its only neighbor, besides the giant steel ball full of water, is a fireworks stand.

A large, baby-faced black man of thirty-nine, Baby J spoke quietly, and his words conveyed a sense of wonder. I was surprised to discover that Baby J recently celebrated his tenth year as pastor at the One Way Apostolic Church of Palestine.

Reverend Jeremiah "Baby J" McKenzie

"I started cooking for our church suppers. Everybody at the church loved my barbecue, and they kept saying, 'You should open a restaurant.' So I did. I started with those catering trailers," he said, pointing at several big barbecue trailers spread around the grass like wrecks in a junkyard. "That one caught fire, and I have to sand-blast it out and start over," he said, pointing at one giant rig with three steel doors cut into the vertical steel cylinder that constituted the pit.

He climbed the stairs to enter a larger, enclosed trailer and invited me to join him. Baby J opened the steel door of the rig and cut off a few slivers of the brisket that was cooking so I could taste his spicy seasoning. When we reemerged, a friend of his pointed out that the wooden deck on the front of the trailer was on fire. Baby J asked him to take care of it, so the man fetched a plastic bucket and nonchalantly poured water over the burning deck. The biggest smoker at Baby J's is a curiosity and local tourist attraction. It's a giant black steel box the size of a small building.

"This is Big Baby," the Reverend McKenzie said with pride. "It's a smoker with an electric carousel inside that rotates the meat. It came from a barbecue place in Spring, Texas, that had the smoker custom built. It originally cost forty thousand dollars. When the place went out of business, they gave it to me. They liked my barbecue, and they blessed me with a donation. I went down there with a pickup truck and a sixteen-foot trailer, and they laughed at me. They had to tear down one wall

Sausage, picnics, and briskets on the pit at Baby J's

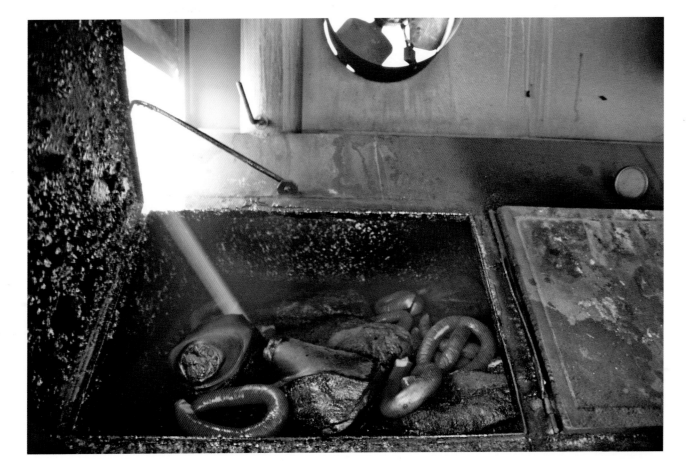

of the building to get the smoker out, then it had to be lifted with two forklifts. It was set on a tractor-trailer and delivered up here." It's not hard to figure out why the barbecue joint in Spring went out of business. Big Baby is a hell of a show rig, but a lousy barbecue pit.

"I use Big Baby for ribs and whole chickens and jerky and jalapeños, but it doesn't put out enough smoke for briskets and pork. I still do those in my old trailer rigs," Baby J said.

I asked him whether he was ever tempted to try one of the new stainless-steel push-button barbecue ovens. "The only other barbecue joint in Palestine boiled the meat and put it in an electric smoker," Baby J told me. He figured he was doing better than the competition because real pit-smoked barbecue tastes better than the other stuff.

"There are a lot of barbecue joints out there, and to be singled out like that is a blessing from God."

"A guy from Southern Pride came and installed one of those stainless-steel smokers and told me to try it for free. He just left it here for a couple of weeks, and then he called and asked me how I liked it. I told him to come by. I cooked a brisket in my old pit and one in the Southern Pride smoker. He ate some of each, and then he said, 'You won't be needing it, I'll take it back.'"

"People in town said I would never last because I made my meat too spicy," Reverend Baby J told me. "I guess they were wrong. My barbecue place started showing up in newspapers and magazines and my business took off." Baby J was convinced that the good ink flowed down from heaven. "There are a lot of barbecue joints out there, and to be singled out like that is a blessing from God," he said.

After our tour of Baby J's smokers, we sat down for lunch. I ordered some of Ms. Linda McKenzie's greens and ate them with cornbread before the catfish arrived. The greens were mixed with boiled turnips and trimmings from the pulled pork. The lard left a lovely sheen on my lips. But there was a sweetness to the greens that I wasn't accustomed to. I dunked my cornbread in the juice left in the bottom of the bowl as I ate it.

"What is that sweet flavor in the pot liquor?" I asked Ms. McKenzie when she walked by. She giggled at my stupid question.

"It's sugar," she said.

"It sure tastes good with cornbread," I told her.

"It's even better with hot-water cornbread—that's the best," she said. Hot-water cornbread is made by mixing boiling water with cornmeal and then forming the paste into patties that are fried on the stove. You eat it hot out of the skillet with syrup for breakfast, or with beans or greens.

When our catfish arrived, we dug into the paper boats and ate it with our hands. The thin fillets were coated with cornmeal and very crispy.

THE REVEREND BABY J isn't the only pitmaster in East Texas who divides his time between preaching and barbecuing. The Reverend Leroy Hodge has also dedicated his life and his barbecue to Jesus. The New Hope Missionary Baptist Church Building Fund Barbecue sets up in front of McCoy's Building Supply on Avenue H in Rosenberg, Texas, on some Sundays after services. Look for the folding tables and chairs under a blue-plastic-roofed tent with a sign in front that reads: "Barbecue Sale." The group has been selling barbecue for the last five years. Leroy Hodge has been smoking meat since he was a child in the nearby hamlet of Crabb. So to raise money for the church building fund, he proposed that the congregation sell barbecue.

The Sunday I went by to sample the Reverend Hodge's barbecue, I got a three-meat plate of falling-apart-tender sliced brisket, crunchy rib chunks, and thin lengthwise slices of sausage. The barbecue is cooked on a big double trailer parked alongside the tent. The meat comes piled high in a square polystyrene to-go box. Pickles, onion, jalapeños, and white bread are all available as options for those inclined to make sandwiches. The side orders are homemade baked beans and mashed-potato salad with yellow mustard dished up out of plastic containers the church ladies bring from home. There were also some tea cakes and other bake-sale items.

Reverend Leroy Hodge, pitmaster at the New Hope Missionary Baptist Church

Charity barbecue stands are unlicensed and can't ask for money; donations are at your discretion. I handed over twenty dollars—ten dollars for the barbecue plate and ten for two bags of tea cakes. The church used to sell barbecue one Sunday a month, and then other area Missionary Baptist churches began selling barbecue. But local authorities now restrict barbecue sales there to four a year per church.

When Rufus and I attended services at the New Hope Missionary Baptist Church one Sunday, we met a guest preacher, the Reverend Jimmie Cobbin. Cobbin works with challenged youth at a state school, he told us. When I asked him whether he ever cooked barbecue, he smiled and said, "Funny you should ask." Cobbin said that he was a former barbecue professional. For several years, he operated a barbecue stand called Jimmie's Ribs. He gave us his phone number and said that anytime we wanted to place an order or hire a caterer, he would be delighted to show us his stuff.

The Reverend Hodge got the idea for his barbecue stand from the famous New Zion Missionary Baptist Church Barbecue in Huntsville, Texas. That barbecue stand began in 1969 when Deacon Ward and a crew of volunteers gathered to paint the church. Deacon Ward's wife, Annie Mae, said that, "When [she] and the other wives began to prepare their husbands' dinner, cooking barbecue on a makeshift grill, they couldn't hardly cook for all the people stopping by who wanted to buy it." So the congregation voted to start a proper business, and pretty soon it became a regular thing every Wednesday through Saturday. Today the pitmaster-preacher is the Reverend Clinton Edison, a former Criminal Investigator with the Chambers County Sheriff's Department in Alabama. Reverend Edison has added an Ole Hickory automatic barbecue smoker to the original wood-fired smoker on wheels out in front of the church hall. But the down-home side dishes and good-hearted volunteers make New Zion Missionary Baptist Church Barbecue a wonderful scene.

New Zion's brisket is coated with dry rub for twenty-four hours and smoked until tender. Then it's held in a covered roasting pan in the oven, where it continues to slow-cook. A spicy barbecue sauce adds a tangy touch. And if the homemade mashed-potato salad, creamy coleslaw, and soft-as-butter beans taste as though they came from a church hall supper, it's because they did.

New Zion Missionary Baptist Barbecue in Huntsville, Texas

RELIGION & BARBECUE

THE CONNECTION BETWEEN barbecue and religion has a long history. Barbecue was an important component of the outdoor revival movement of the 1800s. The first giant revival was held in Kentucky in 1799. Lacking churches and preachers, frontier folk would travel to large campsites and stay for several days or even weeks to hear sermons, sing hymns, and enjoy the rare opportunity to socialize. By the 1820s, revival meetings were drawing crowds of as many as 10,000.

The people had to be fed, and the most practical way to cook for so many was to dig massive barbecue pits. And in those days, when subsistence farmers lived on corn pone and bacon for months on end, the promise of good barbecue drew large crowds out of the wilderness.

In September, 1836, the following notice might have been seen upon the doors of every public house and grocery, attached to the largest trees near the cross-roads and principal trails, and even in the remote dells of the mountains of Texas, miles away from a human habitation: "Harbeczie Camp-meeting" "There will be a camp-meeting, to commence the last Monday of this month, at the Double-spring Grove, near Peter Brinton's, in the county of Shelby. The exercises will open with a splendid barbecue. (Signed) Paul Denton, Missionary, M.E.C."
One Thousand Temperance Anecdotes, edited by John William Kirton, 1867

One of the most famous Texas barbecue men of all time, C. B "Stubbs" Stubble-field, was born in 1931 in Navasota, Texas, to a Baptist preacher, and learned how to barbecue at camp meetings. Stubblefield recalled that his father's East Texas revivals were equally famous for preaching and barbecue. The gatherings could last for weeks, and the meats included barbecued beef, pork, raccoon, and possum. Combining the Good Book and good meat was common all across Texas:

Why, we used to have camp meetings that lasted three or four weeks. Everybody would come and camp and listen to every sermon that preacher preached, for no telling when the preacher would get back this way. I remember one big camp meeting they had there one time. They sent for a preacher from back in East Texas somewhere, and they got up money enough to carry the meeting for three weeks. They barbecued beef and goats and had plenty of other stuff to last for three weeks, but at the end of that time, the joiners were still coming in. My wife's father wanted to keep it going another week. He used his own money and killed his own meat for the barbecue.
William "Uncle Billy" Biggs, *Frontier Times Magazine,* August 1948

EATING CATFISH in an African American barbecue joint reminded me of Thelma Williams, the first barbecue pitmaster to serve me fried fish. During our Texas wanderings, Rufus and I visited Thelma's Restaurant on Southmore at the corner of Scott Street in Houston's Third Ward—the original on Live Oak near downtown Houston burned down a few years ago. Thelma had just come from church, and she was decked out in a purple dress with a matching hat.

Reverend Clinton Edison, pitmaster at New Zion Missionary Baptist Barbecue, studies the scriptures while the meat smokes.

Thelma grew up speaking Creole French in rural Louisiana, where her father catered parties for a living. "I learned how to barbecue from my daddy," she explained. Before Thelma opened her restaurant, she had never even worked in one. Like the Reverend Baby J, she got her start by cooking church suppers on Sundays—in her case, at Good Shepherd Baptist on North Wayside in Houston—then opened a restaurant at the urging of friends and went on to become a barbecue legend.

I guess they both just brought the whole menu of barbecue, fried fish, Southern sides, and desserts along with them from the church suppers when they opened their restaurants. It may seem odd that the best place to eat catfish is in a barbecue joint, but you get used to it. It's not like catfish is threatening the brisket business.

Baby J's catfish wasn't quite as sweet and greaseless as Thelma's. Rufus nearly fell out of his chair when he tasted Thelma's cornmeal-battered catfish. Thelma's

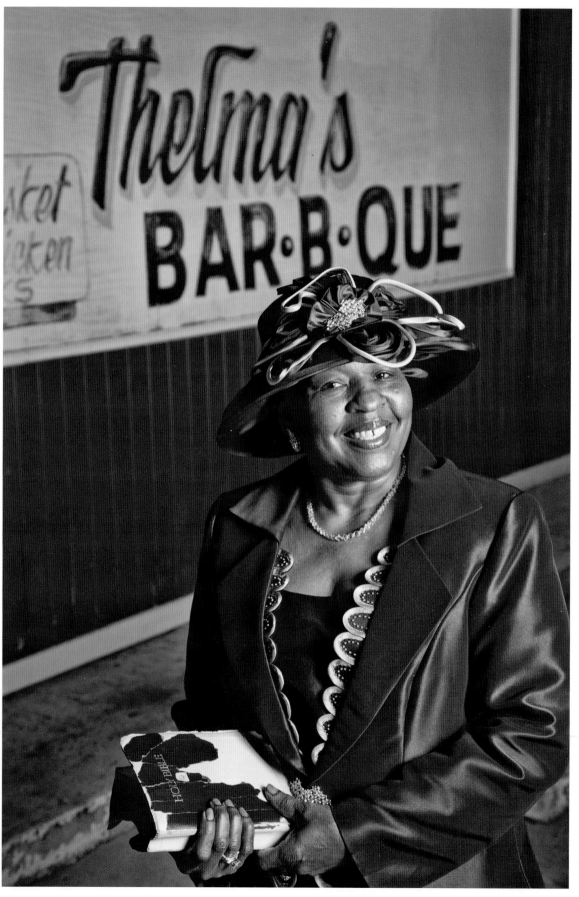

Thelma Williams went from serving church suppers at Good Shepherd Baptist in Houston to opening her own barbecue restaurant.

catfish is heavenly. Fried to order, it is served cornmealed and crispy on the outside and piping hot and mild inside. No fork is required: the fillets are so rigid you can pick them up and eat them like candy bars. "It's so fresh tasting, it's almost sweet," Rufus marveled.

Thelma's brisket has a tasty black char on the outside, but the inside is slick with juice and as tender as the Wonder bread it comes with. How Thelma gets it so soft is a head-scratcher. She swears she never wraps it in foil. She told me she just starts an oak-log fire around 5 p.m. and then lets the meat smoke all night. The buttery brisket comes pre-anointed with dark brown sauce. Thelma doesn't like to serve her brisket without her sauce. And to demonstrate her displeasure, if you order the barbecue sauce on the side, Thelma charges you two dollars extra. It's just one of her many quirks. Don't even think about using your cell phone while waiting in line. But if you stay on her good side and order "in and out" brisket, you get plenty of black outside pieces along with the juicy inside cuts.

There's a big difference between African American barbecue in East Texas and meat-market barbecue in Central Texas. East Texas brisket is not a fanned array of picture-perfect slices. It's a falling-apart mess of hot and greasy meat, aggressively seasoned with peppery barbecue sauce. In East Texas, cheap and plentiful beef was substituted for pork, but the "chopped sandwich" barbecue style remained the same. In Central Texas, German butchers adapted Southern barbecue to their traditions of sausage making and Old World enclosed smokers.

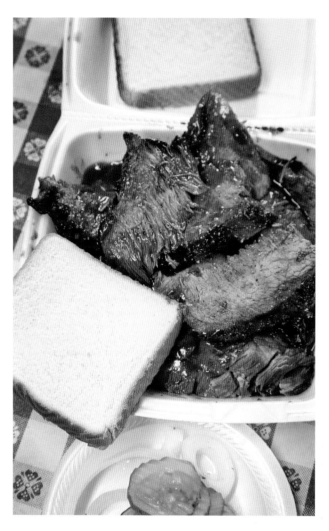

An order of brisket at Thelma's comes with barbecue sauce, pickles, onions, and white bread.

THE DIFFERENCE IN barbecuing styles can sometimes lead to serious misunderstandings. Central Texas was the locale of the Southern Foodways Alliance's' "Taste of Texas Barbecue Trip," but the event ran into problems in the planning stage. (The alliance is an affiliate of the Center for the Study of Southern Culture at the University of Mississippi.) The idea was to bring food writers, scholars, and barbecue lovers from across the country to the Lone Star State for a barbecue tour in June 2002. But SFA officials were dismayed to discover that all the barbecue spots selected by a committee of Texas SFA members were white owned.

The SFA asked for a list with more diversity. The Texas barbecue experts insisted that the state's most typical barbecue was produced by Czech and German meat markets. When officials insisted that any SFA program about barbecue in the American South had to be multiracial, one Texan accused the SFA of "inserting a racial agenda" where one didn't belong. As a compromise, a few black- and Hispanic-owned barbecue joints were eventually added to the tour.

I offered to take the participants around Houston to sample African American barbecue before the tour began, but the only taker was Jeffrey Steingarten, the famous author of *The Man Who Ate Everything*. Steingarten served as a judge at the Memphis in May World Championship Barbecue Cooking Contest, so he knew his barbecue.

I took him to Thelma's original restaurant, which was in a little red house just east of the Houston convention center in a Third Ward neighborhood occupied primarily by littered vacant lots and giant windowless warehouses. The cozy little dining room had twelve mismatched tables, a jukebox loaded with blues, Motown, and zydeco, and a television that was perpetually tuned to a soap opera. The lunchtime clientele included policemen in uniform, truck drivers taking a break, some folks from Thelma's church, and the occasional barbecue fanatic.

Steingarten asked to see the pit and quizzed Thelma about her methods and cooking times. Thelma fielded all questions graciously and took us around back to see her fabulous little cinder-block smoker. It had a firebox outside and a weighted door that opened into the kitchen. The building was empty when Thelma took it over. In its last incarnation, it had been a bar with a couple of pool tables. But obviously the place had started out as a barbecue joint.

Judging by the design of the pit, which is nearly identical to the one I had seen at a Houston barbecue restaurant called Green's on Almeda, I'd guess it was built in the 1950s, probably by Joe Burney, a Beaumont barbecue entrepreneur, or his disciple Harry Green. Those two barbecue legends built most of the cinder-block pits in Houston's Third Ward.

Back at our table, Thelma whipped out her pad and we put in our orders. Steingarten attempted to skip the two sides that normally come with a two-meat plate, but Thelma would have none of that nonsense. He settled on potato salad and coleslaw with his brisket and ribs.

"Take off your jacket, honey, make yourself comfortable," Thelma chided the New Yorker. On a steamy June afternoon in Houston, Steingarten had arrived from the airport wearing a blue blazer and jeans. The Harvard Law School graduate and onetime Manhattan legal consultant is known for bringing a rigorous, scientific skepticism to food writing. The ultimate in tough customers, he bases his research more on verifiable data than on anecdotal opinions. The purpose of his trip was to study Texas barbecue. And as a barbecue judge, he wasn't as clueless about "Q" as your average New Yorker.

Before our barbecue arrived, Thelma brought us a stack of fried catfish fillets. Steingarten was mystified that I had ordered fish for lunch. But I was acting as tour guide on one of the buses ferrying SFA members around the next day, and since we were scheduled to visit five barbecue joints in a few hours, I figured I'd get enough meat tomorrow.

Thelma returned and set some barbecue down in front of the hard-to-please gastronome. After a few bites, it was obvious from the movement of his eyebrows that he was having some sort of epiphany. I tried to steal a piece of beef off his plate to see what sort of jubilee was taking place in his mouth, but he nearly stabbed me with the plastic fork. Finally, he passed me a little bite. Thelma was having a good day.

The ribs on the two-meat plate were also excellent. But Steingarten had eaten lots of great ribs in Memphis. Thelma's wet and winsome, extra smoky brisket was something else altogether.

"This gives me a new perspective on brisket," said Steingarten judiciously, still clad in his blue blazer and regarding the shrinking pile of beef with a reverence approaching awe. "Now I see what people in Texas have been talking about for all these years. I've had only forty or fifty briskets in my entire lifetime. But Thelma's is on an entirely different level." He was also quite impressed with the crisp, greaseless catfish and took an instant liking to the African American style mashed-potato salad, which he had never eaten before.

After a few bites, it was obvious from the movement of his eyebrows that he was having some sort of epiphany.

After a quick sampling of Thelma's fare, I figured we would visit several other Houston barbecue joints. But as much as I tried to hurry Steingarten up, he wouldn't budge. He was intent on finishing the entire pile of brisket. I was happy that somebody from the barbecue tour got a chance to see more than one style of Texas barbecue. I love Central Texas meat-market barbecue as much as the next fanatic, but Thelma is a gem.

AFTER OUR CATFISH LUNCH at Baby J's, Rufus and I got out the map and talked about where we were heading. Rufus worried that not getting any barbecue at our first stop was a bad omen. I figured it was more a reality check. Although we had made only one stop, I could already see that it was going to be impossible to squeeze the complicated story of barbecue into the chronological account of a single road trip. There were going to be some return trips. And the narrative would require a lot of detours and flashbacks. We would follow the route traced on the map, but our explorations of barbecue culture and mythology would end up being part road trip and part mind trip.

We got back in the car in Baby J's parking lot at around three in the afternoon. I tried to bring some leftover catfish along in a to-go container, but Rufus said, "No way." He didn't want the Honda Element smelling like fish.

Fried Catfish

- -

It somehow seems fitting that the first recipe in this Southern barbecue book is for fried catfish rather than smoked meat. Thelma and the Reverend Baby J would approve.

FLOUR MIXTURE:
- 1 cup all-purpose flour
- 1 cup cornmeal
- 1 tablespoon baking powder
- 1 tablespoon salt
- ½ teaspoon cayenne

SPICE MIX:
- 1 tablespoon salt
- ½ teaspoon cayenne
- ½ teaspoon Lawry's lemon pepper
- ½ teaspoon onion powder
- ½ teaspoon garlic powder

- 1 cup buttermilk
- 6 American catfish fillets, 6–8 ounces each

Preheat oil in a frying pan or deep fryer to 350°F.

In a large bowl, combine the flour, cornmeal, baking powder, salt, and cayenne.

Cut the catfish fillets in half lengthwise to make 2 strips. In a small bowl, combine the spice mix ingredients.

Season each strip on both sides with the spice mix. Dip in the buttermilk to coat each side and then dip in the flour mixture, making sure the flour sticks to the fish. Place the coated fish pieces on a rack for 5 minutes to allow the coating to dry. (This will help it stick to the fish.) Add the fish pieces to the fryer a few at a time, moving them around so they don't stick. Fry until brown and crispy, about 5 minutes or until the catfish floats. Remove from the fryer and drain on absorbent paper before arranging on a heated serving platter. Serve with a mess of greens (p. 16) and hot-water cornbread (p. 15) or french fries and hush puppies (p. 179). *Makes 12 fish strips.*

*Thelma's cornmeal-coated deep-fried
catfish is sweet as a candy bar.*

Corn Pone (Hot-Water Cornbread)

- -

Baking cornbread means heating up a 400°F oven. It's a great way to warm the kitchen in the winter. But in the middle of a sweltering Southern summer, it makes more sense to fry up some hot-water cornbread on top of the stove. It's not only easier on the air conditioner, it's a lot quicker. Eat these little patties hot while they're crispy on the outside and soft in the center. When they get cold, they turn into corn pucks.

- 2 cups cornmeal
- ½ teaspoon baking powder
- 1 teaspoon salt
- 1 teaspoon sugar
- 1 tablespoon lard or vegetable shortening
- ¾ to 1¼ cups boiling water
- Oil for frying

Combine cornmeal and dry ingredients in a bowl; stir in lard. Gradually add boiling water, stirring until batter is moist but stiff.

Pour oil in a large, heavy skillet to a depth of ½ inch and place over medium-high heat. Make 8 patties and fry them in small batches, dropping each into hot oil and turning after 3 minutes or until golden on both sides. Drain well on paper towels. Serve immediately for breakfast with butter and cane syrup, or as a side with greens or beans. *Makes 8 patties.*

BACON-CHEDDAR PONE

Stir in ½ cup of cooked and crumbled bacon and ½ cup shredded sharp cheddar cheese after adding boiling water to the cornbread mixture.

JALAPEÑO HOT-WATER PONE

Stir in 1 minced jalapeño pepper and 1 cup creamed corn after adding boiling water to the cornbread mixture.

A Mess of Greens

- -

After Baby J McKenzie removes the meat from barbecued pork shoulders, his wife, Linda McKenzie, uses the bones, trimmings, and fat to flavor her greens. Linda starts with frozen greens, and you can too. You can also substitute a ham bone, one smoked ham hock, bacon and bacon grease, or some salt pork if you want to make some greens and you aren't barbecuing pork.

- Bone, fat, and trimmings from a pork shoulder (one pound meat and fat, plus bones)
- 1 bunch kale or collard greens
- 1 large bunch mustard greens
- 1 large bunch turnip greens
- 1 large onion, chopped
- 3 medium turnips, peeled and cut into small dice
- 1 tablespoon sugar or to taste
- Salt and pepper to taste

Chop the pork fat and pieces into small dice. Trim tough stems and dead leaves off the greens. Stop up the sink and fill it halfway with water, or put water in a large basin. Submerge the leaves in the water and wash thoroughly. Drain off the water and do it again. Repeat several times until there is no more grit in the bottom of the sink or basin. Chop the leaves into fork-friendly pieces. In a large soup pot over medium heat, melt some of the fat and stir in the onions. Add the greens, turnips and meat, stirring to coat with the fat. Don't worry if all the greens don't fit in the pot to start; just reserve the rest of the leaves for a few minutes. Add 4 cups of water to the pot, cover, and bring to a boil. As the greens cook down, add more raw leaves. Add more water if needed to make a soupy consistency. Season with sugar, salt, and pepper. Simmer for 45 minutes or until very tender, adding water if necessary. *Serves 10.*

Jalapeño Potato Salad

- -

Here's a favorite Texas potato salad for those who like it spicy.

- 4 large potatoes, peeled and cut into ¾-inch cubes
- ¼ cup Dijon mustard
- ¼ cup white wine vinegar
- 2 cloves garlic, crushed
- ¼ teaspoon salt
- ¼ teaspoon ground black pepper
- ½ cup olive oil
- 1 can (3½ ounces) pitted black olives, drained
- ¼ cup thinly sliced scallions
- 6 ounces feta cheese, crumbled
- 4 jalapeños, seeded and chopped

Place the potatoes in a 3-quart saucepan or Dutch oven and pour in cold water to cover. Bring to a boil. Reduce the heat to low and simmer for 10 minutes, or until the potatoes are tender. Drain.

Meanwhile, combine the mustard, vinegar, garlic, salt, and pepper in a large bowl. Slowly whisk in the oil. Add the potatoes, olives, scallions, feta cheese, and jalapeños. Toss to mix well. Serve chilled or at room temperature. *Serves 6.*

Mashed-Potato Salad

This kind of potato salad is light and fluffy. It is served with an ice-cream scoop at New Zion Missionary Baptist Church Barbecue.

- 1½ pounds russet potatoes
- ½ cup mayonnaise
- 2 green onions, sliced
- 1 tablespoon pickle relish
- 4 teaspoons pickle juice
- 4 teaspoons hot-pepper sauce
- Salt

Peel the potatoes and cut them into 1-inch chunks. Place the potatoes and enough water to cover in a 4-quart saucepan. Bring to a boil over high heat. Cover and simmer 15 minutes, or until the potatoes are tender. Drain.

In a large bowl, coarsely mash the potatoes. Stir in the remaining ingredients, adding salt to taste. Serve at room temperature. *Serves 4.*

Church Supper Butter Beans

You'll find pinto beans served with barbecue all over the state, but New Zion Missionary Baptist Church Barbecue is the only place I've had Southern-style butter beans.

- 1 pound dried butter beans
- 1 onion, peeled and diced
- Barbecue pork bones and trimmings, or 1 ham hock
- Salt and pepper to taste

Sort the beans and rinse them well. Soak them overnight in water and discard the water. Combine the soaked beans with the onion and ham hock and cover with water in a slow cooker. Cook on high for 1 hour, and then turn the heat to low and simmer for 4–5 hours, or until meltingly tender. *Serves 6.*

Sausage, ribs, church supper beans, and mashed-potato salad at New Zion Barbecue

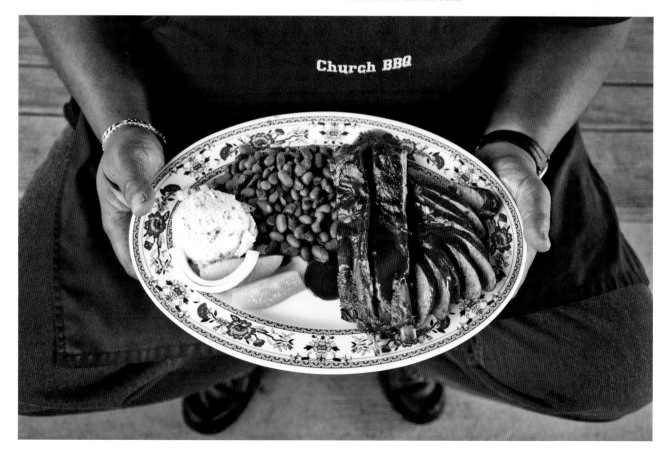

Navasota Rub

Here's an all-purpose East Texas barbecue rub from Ruthie's Bar-B-Que in Navasota. Louis Charles Henley, the pitmaster who created the recipe, says he stopped using MSG because of allergies. He also stopped making a separate rub with sugar for the pork because it made the meat black and gave it a burnt taste unless you cooked it at extremely low temperatures.

- ¼ cup Lawry's Seasoned Salt
- 1 tablespoon finely ground black pepper
- 2 teaspoons garlic powder
- 1 teaspoon chili powder

Combine all ingredients in a shaker bottle and sprinkle on the meat before cooking. *Makes 6 tablespoons.*

"Texas Crutch" Brisket

The easy way to smoke a brisket is to barbecue it for 5 or 6 hours until the internal temperature hits 170°F or so and then wrap it in foil, put it in a roasting pan, and either return it to the smoker or put it in a 250°F oven until the internal temperature reaches 195°–200°F. The foil-wrapped meat cooks fast at the higher temperatures, but the texture is looser and wetter.

- Packer's cut (untrimmed) USDA Select beef brisket, 8–10 pounds
- 1 cup Navasota Brisket Rub
- 6 cups Baby J's Monkey Juice (p. 21)
- Texas Barbecue Sauce (p. 21)

Rinse the brisket and pat dry. Sprinkle it on both sides with the dry rub. Wrap in plastic wrap and refrigerate overnight.

Set up your smoker for indirect heat. Use wood chips, chunks, or logs, and keep up a good level of smoke. Maintain a temperature between 250°F and 300°F. Place the brisket in the smoker as far from the heat source as possible. Mop every 2 hours, rotating the brisket to cook it evenly, keeping the fat side up at all times. Add charcoal or wood every 2 hours or so to keep the coals burning evenly.

After 6–8 hours, when the meat has reached an internal temperature of at least 170°F, place the brisket in a roasting pan with what's left of the mop sauce and seal with heavy-duty aluminum foil. Continue cooking over low coals for 3 more hours or until a thermometer reads 200°F at the thick end. If it gets dark, or the fire goes out, or you run out of fuel, you can finish cooking the brisket by putting the roasting pan in a 250°F oven.

Serve with your favorite barbecue sauce and condiments such as pickles and raw onion slices and sandwich bread. *Serves 10–12.*

A brisket sandwich with pickles and red onions on a custom-baked bun at Franklin Barbecue in Austin

Spicy Brisket Rub

- -

- 1 cup salt
- ¼ cup chili powder
- ¼ cup paprika
- ⅓ cup garlic powder
- ⅓ cup cayenne
- ½ cup ground black pepper

Combine all ingredients and store in a shaker. *Makes about 2⅔ cups.*

Baby J's Palestine Brisket

- -

Baby J uses a blend of post oak and red oak in his fire-box. His recipe is pretty elaborate: "I season my briskets heavy—it's a very spicy rub—then I cook them slow at 225°F for 10 or 11 hours. After that I foil them and pour on Baby J's Monkey Juice—it's my own secret recipe—basically a spicy oil-and-vinegar mop sauce—then I seal them up and cook them another 3 hours at 225°F—at the end I crank the fire up to 350°F for 30 minutes."

- Packer's cut (untrimmed) USDA Select beef brisket, 8–10 pounds
- 1 cup Spicy Brisket Rub
- 6 cups Baby J's Monkey Juice (p. 21)
- Red Barbecue Sauce (p. 55)

Rinse the brisket and pat dry. Sprinkle it on both sides with the dry rub. Wrap in plastic wrap and refrigerate overnight.

Set up your smoker for indirect heat. Use wood chips, chunks, or logs, and keep up a good level of smoke. Maintain a temperature around 225°F. Place the brisket in the smoker as far from the heat source as possible. Mop every 2 hours, rotating the brisket to cook it evenly, keeping the fat side up at all times. Add charcoal or wood every 2 hours or so to keep the coals burning evenly.

After 10 hours, place the brisket in a roasting pan with what's left of the mop sauce and seal with heavy-duty aluminum foil. Continue cooking over low coals for 3 more hours (or put the roasting pan in a 225°F oven). If a thermometer reads less than 200°F at the thick end, stoke up the fire for one last 30-minute blast. At this internal temperature, meat will tend to fall apart as you slice it.

Serve with your favorite barbecue sauce, condiments such as pickles and raw onion slices, sandwich bread, and Piney Woods side dishes such as beans, mashed-potato salad, and a mess of greens. *Serves 10–12.*

Baby J's Monkey Juice

Baby J wouldn't give me the secret recipe for his "Monkey Juice" mop sauce. So I guessed at the ingredients while he nodded yes or no. Here's a mop sauce that comes close. This sauce is intended for barbecued brisket.

- 1 gallon beef stock
- ¼ cup salt
- ¼ cup dry mustard
- ¼ cup garlic powder
- 5 bay leaves
- 2 tablespoons chili powder
- ¼ cup paprika
- 1 cup hot-pepper sauce or pepper vinegar (see p. 000)
- 2 cups Worcestershire sauce
- 2 cups cider vinegar
- 2 cups peanut oil

Combine all ingredients and let stand overnight before using to baste brisket. *Makes about 2 gallons.*

Texas Barbecue Sauce

You can use anchos, pasillas, New Mexican red chiles, or any other dried chile you like in this barbecue sauce—each has its own distinctive flavor. For the best flavor, try a blend of 2 or 3.

- 4 dried chiles, stemmed and seeded
- 1 tablespoon olive oil
- 2 cups diced onion
- 7 cloves garlic, minced
- 1 can (6 ounces) tomato paste
- ½ cup Worcestershire sauce
- 1 cup packed brown sugar
- ¼ cup cider vinegar
- ¼ cup lemon juice
- 1½ tablespoons prepared mustard
- 2 teaspoons salt, or to taste

Soak the chiles in hot water for 30 minutes or until soft. In a large, heavy saucepan, heat the oil over medium heat and add the onion and garlic. Sauté for 3 minutes, or until they begin to wilt. Add the tomato paste and anchos and sauté for 4 minutes. Add all the remaining ingredients and simmer gently for 30 to 40 minutes, stirring frequently. Remove the mixture from the heat and allow to cool. Place in a blender or food processor and purée. Serve immediately, or store in the refrigerator in a sealed container for up to 3 weeks. Reheat before serving. *Makes about 4 cups.*

2

EAT DESSERT
FIRST

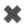

THE ARKANSAS DELTA is the mirror image of the Mississippi Delta on the other side of the river; together, the two are known simply as "the Delta." The area is defined by a deposit of black alluvial soil formed over thousands of years in the shared floodplain of the Yazoo and Mississippi Rivers and encompasses some of the nation's most fertile farmland. With its history of cotton plantations, blues music, barbecue, and largely African American population, the Delta has been called "the most Southern place on earth."

In the small town of Marianna, population 5,000, we pulled over at one of the most revered barbecue joints in the South. Jones Barbecue Diner won a James Beard America's Classic Award in 2012. It is located in a small house that looks just like all the others in the neighborhood. The Jones family has been in the barbecue business for more than a hundred years. James Jones's father, Hubert Jones, told an interviewer in 1986 that the family barbecue business began in the early 1900s with a barbecue pit that was a hole in the ground, a grate made from some iron pipes and a piece of fence wire, and two pieces of tin for a cover. Pork barbecued in the earthen pit was sold at a stand called "The Hole in the Wall," where barbecue was dished up from a washtub and passed through a window to waiting customers.

John T. Edge, director of the Southern Foodways Alliance, once wrote that James Jones's pulled pork was "as soft and creamy as rillettes." I figured any barbecue that made a Georgia boy like Edge start speaking French had to be spectacular. But once we were inside the tiny dining room, Jones told Rufus and me that we were out of luck. He didn't have anything ready to eat.

*Eating Mary Thomas's coconut pie on
the tailgate of the Honda Element*

James Jones didn't want to grant us an interview or allow any photos either. He had had enough of journalists and photographers. A writer from a national magazine had wasted forty-five minutes of his time just the other day, he complained. Jones escorted us out the front entrance of the restaurant, where we stood, mouths agape, while he turned the Open sign around to Closed. We got in the car and headed for another famous Arkansas Delta barbecue joint.

DEVALLS BLUFF IS IN THE White River Valley section of the Arkansas Delta. During the Civil War, DeValls Bluff, with good stores, several saloons, and more than 2,000 residents, was a major stop on the Memphis and Little Rock Railroad. The Union army held the town throughout the war because its port on the White River was more dependable than the port of Little Rock on the sometimes-impassable Arkansas River. The river port and the railroad allowed for easy transport of troops and supplies. Today, the rural hamlet of DeValls Bluff has a population of fewer than 800 and the air of a ghost town.

Rufus and I pulled into the parking lot of Craig Brothers Café (better known as Craig's). Lawrence Craig founded the place in 1947, and the Smithsonian Institution has honored him for his contributions to American cuisine. Lawrence Craig's life story was recounted onstage in 1998 at the first symposium of the Southern Foodways Alliance.

Craig's Bar-B-Q in the extremely quiet town of DeValls Bluff, Arkansas

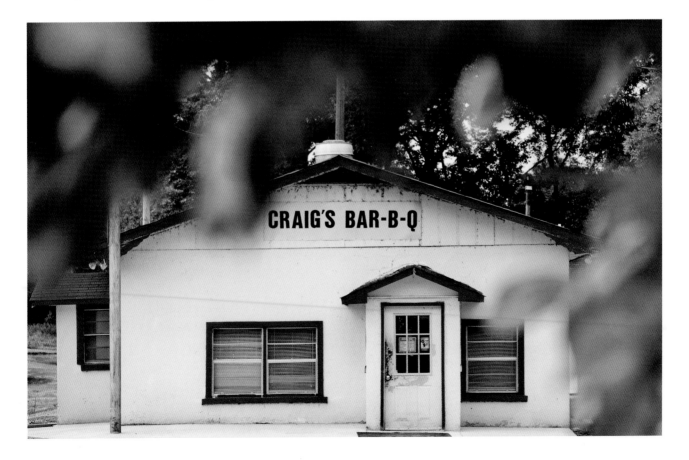

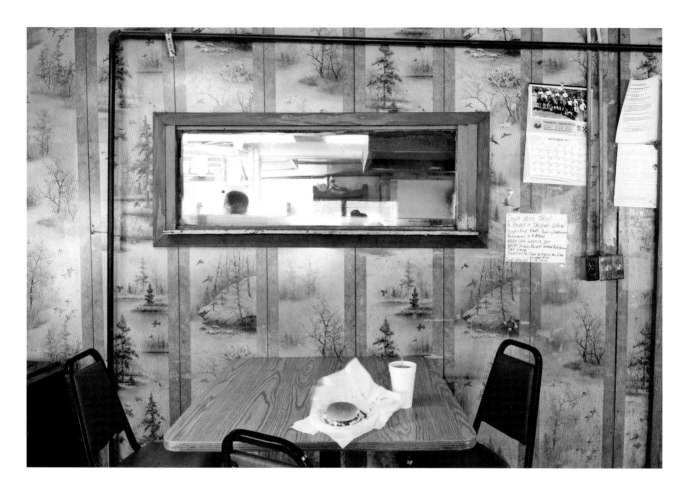

But sadly, Lawrence Craig isn't cooking anymore. Some of his distant cousins run the place now. Someone was tinkering in the building out behind the restaurant where the barbecue pit was housed, but the door was kept locked. I could tell from the woodpile and the ash pile that there was a big barbecue pit in there, but the pitmaster was adamant that we couldn't come in.

The dining room was a museum piece, looking as it did in the 1940s. Gas and electrical lines ran along the cinderblock walls. The interior walls were covered in vintage wallpaper with a wintery motif of snowy woods, ducks, and pheasants. Most of the customers got their sandwiches to go. We sat down at one of the ten or so faux-wood-grain Formica tables and ordered a little bit of everything. The ribs were very tender, the reheated beef and pork sandwiches were a little dry, and the ginger-inflected barbecue sauces were amazing.

Eleatha Lewis was managing the restaurant that day. In the kitchen, the cooks reheated slices of pork and beef with barbecue sauce in frying pans. There were three sauces available: mild, medium, and hot. There wasn't any fresh meat being sliced. I felt like we had arrived at a great barbecue place a few years too late.

Vintage wallpaper with snowy landscape scenes decorates the walls of Craig's Bar-B-Q.

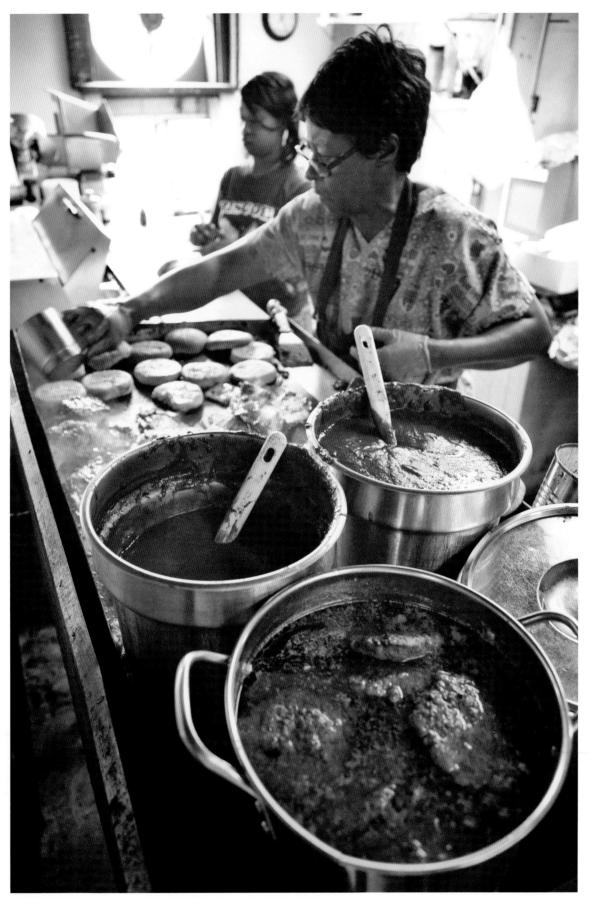

The usual quid pro quo of the food writer's game is the promise that the publicity will bring more business. And the unspoken fear of interviewees is that the writer will emphasize their failings and make them the object of public ridicule. In most of America, the public is so plugged into the mainstream media machine that people clamor to be in the spotlight. But the Delta isn't like the rest of America. It is the region with the nation's highest poverty rate and lowest literacy rate, an area whose residents have been systematically deprived of many governmental services. Much has been written about Craig's, and none of it has changed the place. Were the barbecue folk in this part of Arkansas sick of being gawked at by tourists, writers, photographers, and food bloggers? Or was it just us?

That brought up a nagging question: what was the real nature of our project? My wife, Kelly Klaasmeyer, is an art critic who grew up in Arkansas. She has been critiquing my reporting on the American South for quite some time. Every time I pull over to take a photo of a hand-lettered "watermelon for sale" sign or a rusted barbecue pit, she asks me whether this is really a legitimate story, or whether I am "exoticizing rural Southern poverty" for the amusement of the affluent.

Strangely enough, I realized after we had been hanging around at Craig's for a while that this very barbecue joint had been the subject of one of Kelly's most withering tirades. In August 2004, in an article Jane and Michael Stern wrote for *Gourmet* magazine titled "Hog Wild in Arkansas," the authors wrote, "The best food in Arkansas is served in the worst-looking restaurants . . . you will eat majestically in derelict shacks." They described Craig's in particular as "a shack so unrepentantly dumpy that you've got to love it": "Dim fluorescent lights hang over a half dozen rickety tables . . . Diners' attire . . . includes an astounding number of giant-size overalls on great big farm folks." After reading that story, Kelly wrote this letter to the editor of *Gourmet*:

> Tour bus passengers pressing their noses against a window at 60 miles an hour could generate more insightful cultural commentary than Jane and Michael Stern did in "Hog Wild." They describe Arkansas with a blend of superiority and exoticism that calls to mind colonial commentaries detailing the bizarre and primitive habits and habitations of the natives. Their descriptions of "farm folk" and their attire ooze condescension.
>
> The Sterns' writing is intensely self-absorbed and ethnocentric, using whatever place they visit as a backdrop to highlight the authors. Your magazine should not provide them a platform.
>
> Sincerely,
> Kelly Klaasmeyer

Kelly never mailed the letter; writing it was enough for her to get over her anger. But while the Sterns may have escaped her wrath (up until now), I haven't. We have been married long enough for me to know exactly what she would say about Rufus's and my present situation: "Two middle-aged white guys with smart phones and expensive-looking photographic gear driving around in a geeky Honda Element in the poorest, blackest region of the United States asking a lot of personal questions—gee, I wonder why you aren't getting anywhere?"

In the excitement of launching our road trip, maybe Rufus and I were getting a little overeager. To get our project back on track, we had to recapture the spirit that had got the book started. We had to slow down, take in the landscape, and get to know the people and places we were visiting.

Craig's and Jones Barbecue Diner, the places that brought us to the Arkansas Delta, had been written about for a long time. Lawrence Craig had retired, and James Jones had gotten tired of all the attention—and there was nothing we could do about any of that. The family that owned Craig's was related to the owner of the

Pie Shop across the street, and we had been talking with the proprietor, Mary Thomas, all morning. We didn't intend to interview or photograph her. We were just passing the time until the barbecue joint opened.

While we were waiting for Craig's to open, I could smell something cooking inside the Pie Shop's kitchen, and I guessed it was peach pie. I was wrong. It was the barbecue sauce. It turns out Thomas makes Craig's barbecue sauce on her eight-burner stove. I think Thomas uses some of the same spices in the barbecue sauce that she uses in her peach pie. When I asked her about it, she chased us out of the kitchen and refused to speak to us.

We didn't go away. We stood in the tiny vestibule of the Pie Shop, waiting for Craig's to open, because we had nowhere else to go. We read her entire menu of whole pies and fried pies several times. Rufus took photos of the empty white pie boxes. We put our business cards on the bulletin boards with all the others. Rufus photographed the still life in front on a little table under a window decorated with some lace curtains. It was an arrangement of plastic roses in an ornate vase

and a very worn Bible sitting on top of a brand-new plastic flyswatter. The unstill part was the fly that kept circling and landing on the Bible.

A minivan parked in the driveway had the name of Thomas's church, Mount Olive Missionary Baptist, written on the side. When she walked by on her way to the Pie Shop, I asked her about the church suppers they served.

The driveway and the former garage that house the Pie Shop are shaded by pecan trees. On her way back, we talked about the lousy pecan harvest that year, 2011, and the horrible drought that was responsible for it. We talked about the wildfires back in Texas and we bought some pies.

After a while, Thomas stopped giving us the evil eye and loosened up. And since we didn't think we were working, we loosened up, too, and started absorbing the whole experience. We were eating pie and getting to know the lady who made it. A few weeks later, Rufus drove back to the Pie Shop from his home in Longview, Texas, and spent another day with Mary Thomas. On that trip she let Rufus take some photos in the kitchen while she made pies. And then she posed for a portrait out front in the doorway. I wish I could say she also gave me her secret piecrust recipe. She swears it doesn't include lard. I wonder if she uses suet? She wouldn't say.

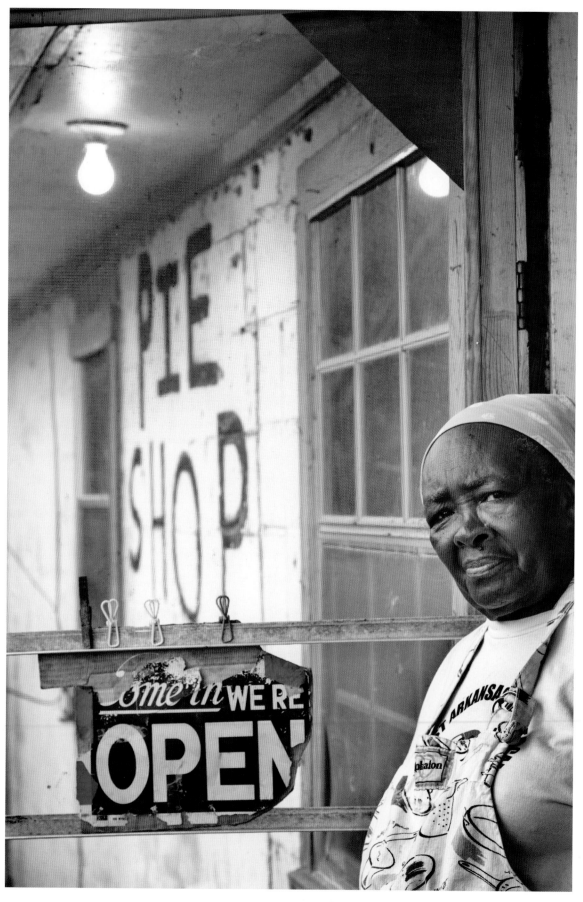

*Mary Thomas
in the doorway
of her Pie Shop
in DeValls Bluff,
Arkansas*

We shared a slice of coconut pie and a slice of chocolate pie and got a couple of apricot fried pies for the road. The chocolate pie was very good, and the coconut pie was terrific. We never did make any headway over at Craig's, but we seemed to cover the pie story pretty well.

Pie, and especially fried pie, has somehow become the official barbecue dessert. On our way up here, I saw billboards along I-30 advertising Big Jake's BBQ and Original Fried Pie Shop in Hope, Arkansas. There is also a restaurant called Walker's Fried Pies & Barbecue in Ellijay, Georgia. The Baker's Ribs chain in Texas and other barbecue joints sell fried pies at the front counter.

Fried pies aren't usually made with fresh fruit fillings like those used in peach pie or apple pie. Fresh fruit is too juicy—it would leak out of the pie while it was frying, and burn. Fried pies are made with reconstituted dried fruit. Dried fruit was a staple of Southern households during the winter. The dried peaches, apricots, and apples were simmered with sugar and spices and then appeared on the dinner table as a side dish or a light dessert. The concentrated texture and intense flavor also proved ideal for making small pies that could be baked or fried.

Fried pies are a Southern phenomenon; they are also known as pocket pies, lunchbox pies, and half-moon pies. Peach fried pies in particular are known also as "crab lanterns," though no one seems to know where that strange name came from.

One of Mary Thomas's apricot fried pies

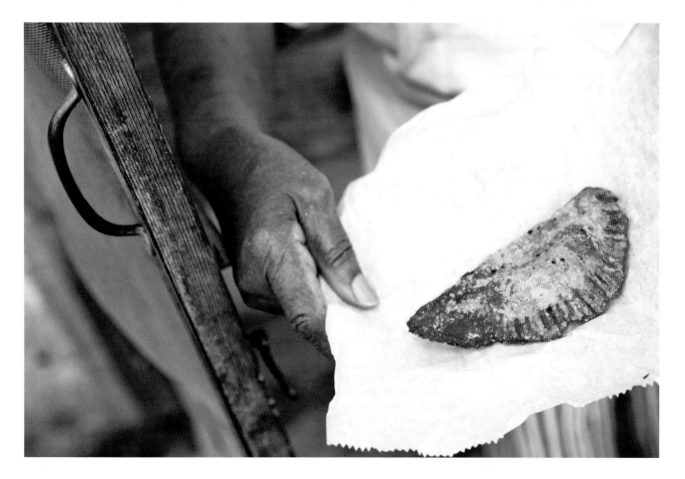

In Natchitoches, Louisiana, they make fried pies filled with savory meat. When I asked my daughter Katie Walsh to help me test fried pie recipes for this barbecue book, she assumed we were going to fill the pies with pulled pork. I have been intrigued by that idea ever since.

ON WEST MISSISSIPPI STREET in Marianna, we pulled over so Rufus could take a photo of the sign on the front wall of a barbecue bungalow called Ora Lee's Bar-B-Q Rib House. The hand-painted sheet of plywood included illustrations of menu items, including pork ribs, a turkey leg, a hamburger, and a whole chicken. When the owner saw us taking photos, he came out and talked to us. "The place is named after my mama, Ora Lee Farris, who passed away half a year ago," the owner, Edward Farris, told us. The former tenant, Nick's Wings & Things, had gone out of business, and the Farris family had taken the place over a few months ago.

Coleslaw mayo and barbecue sauce ooze from a chopped pork sandwich at Ora Lee's Bar-B-Q Rib House in Marianna, Arkansas.

Edward Farris told us he was related to James Jones at the Barbecue Diner, but unlike his relative, he was delighted to see folks with notebooks and cameras, and he insisted we try his barbecue. We ordered a rib sandwich and a pulled pork sandwich at the counter inside and took a seat in a pleasant booth by the window. It looked as if we were finally going to get some barbecue on this barbecue trip.

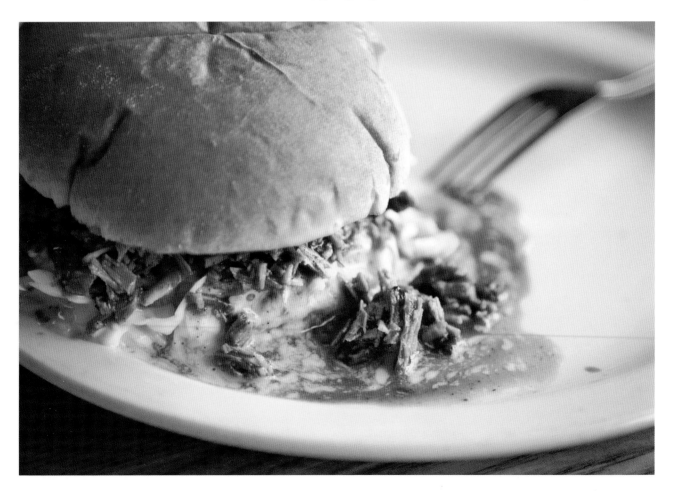

Farris was a little reluctant when we asked to see his pit while we waited for our order, but we were patient, and eventually he took us around back. The pitmaster was embarrassed by his humble equipment. He cooked his barbecue on a pair of rusty backyard charcoal grills.

In one grill he burned hardwood logs down to coals. Then he shoveled the hot coals into the other grill and arranged his meat cuts above them. I was glad we got the tour of the pits. They weren't the sorts of monumental barbecue pits that we set out to document, but for a home barbecuer like me, they were nothing short of inspirational. Edward Farris was running a business with a pair of charcoal grills you could pick up at a garage sale for fifteen dollars each. It was the modern-day version of a hole in the ground, some iron pipes, fence wire, and two pieces of tin, I suppose.

The chopped pork sandwich at Ora Lee's came on a hamburger bun with a thin red sauce and a topping of coleslaw that oozed out of the sandwich as you ate it. But the real star of the table was a rib sandwich. The three bones in the rib section pulled out cleanly, leaving the tender rib meat intact on the hamburger bun. Like the chopped pork, the ribs were topped with mayonnaise-heavy coleslaw and doused with barbecue sauce. The outside of the ribs, with all the crispy bits and spicy crust, gave the sandwich a much more interesting texture than the chopped pork sandwich beside it.

There were a lot of lessons learned that day. We learned to take our time. We learned that famous barbecue joints aren't always what they used to be. We learned that the unknown little joint that you pass on the way to the famous place is probably your best bet. And by seeing ourselves reflected in the eyes of the people we were talking to, we learned that not everyone shared our assumptions.

As we headed for I-40, Rufus expressed some concern: "What are we going to put in this book if none of the barbecue folks will talk to us or allow us to take their photos?"

"It's not that bad. Nobody is shooting at us or anything," I joked.

"Yet," said Rufus with a nervous laugh.

We headed for Memphis with a couple of Ora Lee's sandwiches and some of Mary Thomas's apricot fried pies in a brown paper sack, and counted our blessings.

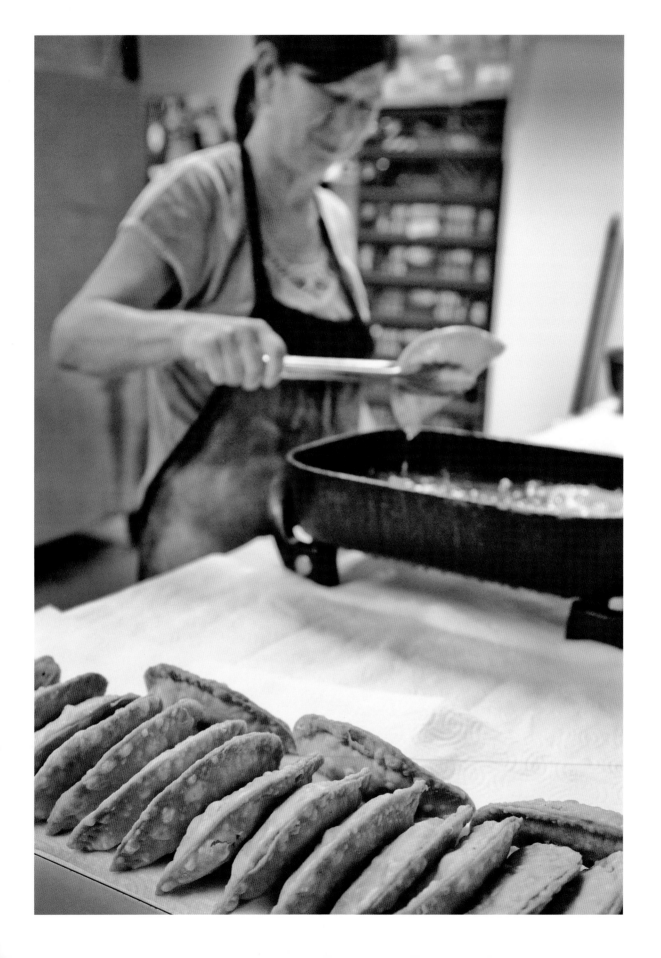

Fried Pies

The best temperature for frying pies is 360°F. At 350°, they take about a minute on each side and come out paler than we like. At 375°, they bubble fiercely and get dark brown fast. If you can keep your frying fat right around 360°, they take about 20–30 seconds per side and come out a nice golden brown.

Check your oil temperature before you begin, and adjust the heat as you go if it gets too hot or cold. We turned it back and forth from medium to medium low a few times as we fried.

Try to work quickly. If your pastry dough dries out too much between when you roll it out and when you fry, you're likely to get some cracks or a split seam in the pan, which you'll know right away—the oil will sizzle audibly when it comes in contact with the smallest drop of filling.

You will think that 1 heaping tablespoon of filling isn't enough. You will be tempted to use 2 tablespoons. If you can pull it off, hats off to you. But we found that any more than 1 heaping tablespoon resulted in filling leaking out of the pie.

Make sure your edges are sealed tight. If you don't moisten them enough or seal them completely, they'll curl up as the pie fries, allowing oil to seep into the middle and yielding a greasier pie.

Fried pies are best eaten hot out of the fryer. If you are planning on making them in advance and eating them cold, you might want to consider baking instead of frying them—baked pies taste better cold, and they aren't as greasy. If you have cold fried pies and want to serve them for dessert, consider heating them up in the microwave and serving them with vanilla ice cream.

- A doubled recipe of Pie Pastry (p. 37), or use 4 premade, unformed piecrusts
- One recipe for the fruit filling of your choice (see recipes on p. 36)

Prepare pastry dough and refrigerate. Or take premade, unformed pastry dough out of the refrigerator. Prepare filling.

Heat 1 inch of oil or lard in a cast-iron or other heavy-bottomed skillet. On a floured surface, roll pastry dough to ¼" thick. Cut into 5-inch squares.

TO ASSEMBLE PIES:

Lightly moisten the edges of a square of dough. Drop 1 tablespoon of filling into the center and use a spoon to shape it into a thick line across the middle, leaving space at the edges. Fold the top of the square over the filling and line it up with the bottom half. If any filling or juices seep out as you fold, push the filling back a bit and try again. Wipe the edges of the dough clean; any exposed filling will burn in the hot fat.

Press the seam closed all around the edges with your fingers, and then use a fork to crimp.

Use a cooking thermometer to test the oil; once it reaches 360°F, carefully drop pies in one at a time. Fry until the edges begin to turn golden brown (about 30 seconds), and then flip and fry another 20 seconds or so. Remove hot pies to a paper-towel-lined plate to drain.

Serve hot with a scoop of vanilla ice cream. *Makes 20–30 pies.*

VARIATION: BAKED PIES

Follow the method above, but rather than frying, bake the pies on an ungreased baking sheet at 350°F for 15 minutes.

Frying pies in an electric frying pan at the Top Hat in Alabama. The thermostat keeps the oil at the ideal temperature.

Dried Apple Filling

- -

- 6 ounces dried apples
- ¼ cup brown sugar
- ½ teaspoon cinnamon
- ⅛ teaspoon nutmeg
- ⅛ teaspoon allspice
- Dash ground cloves

Cover fruit with water in a small saucepan. Bring to a boil, cover, and simmer until apples are rehydrated, plump, and soft, about 30 minutes.

Mash the fruit well with a potato masher and stir in sugar and spices. Continue simmering, uncovered, until thick and stewy, another 15–20 minutes. Cooked apples will retain some liquid.

Use immediately or make ahead and store in the refrigerator up to 1 week. *Makes enough to fill about 30 rectangular or half-moon pies.*

Dried Apricot Filling

- -

- 6 ounces dried apricots
- ¼ cup brown sugar
- ½ teaspoon cinnamon
- ⅛ teaspoon nutmeg
- 4–5 drops almond extract
- 1 teaspoon vanilla extract

Cover fruit with water in a small saucepan. Bring to a boil, cover, and simmer until apricots are rehydrated, plump, and soft, about 30 minutes.

Mash the fruit well with a potato masher and stir in sugar, extracts, and spices. Continue simmering, uncovered, until thick and stewy, another 15–20 minutes.

Use immediately or make ahead and store in the refrigerator up to 1 week. *Makes enough to fill about 20 rectangular or half-moon pies.*

Pie Pastry

- -

You can use shortening or butter if you want, but lard makes the most flexible piecrust. See if you can find some fresh leaf lard for the ultimate in crusts.

- 2 cups all-purpose flour
- ½ teaspoon salt
- ½ cup lard, butter, or shortening
- ¼ cup ice water

In a medium mixing bowl, sift flour and salt together. Cut in lard or shortening with a fork or pastry cutter until flour clumps together. Add ice water 1 tablespoon at a time, mixing with your hands just until dough comes together in a ball.

Wrap with plastic and refrigerate 30–60 minutes before rolling out. *Makes enough for 1 9-inch double-crust pie.*

Blind-Baked Piecrust

- -

Blind baking a piecrust means baking the shell without a filling. To keep it flat, you will need to weigh it down with either pie weights or dried beans (throw the beans away when you are done). Or you can dock it by pricking the bottom with little holes. Pie weights work best.

- Pie Pastry

Place the piecrust in an 8- or 9-inch pie pan and fill it with pie weights (or uncooked beans) to keep it flat in the pan. Bake at 425°F for 18 minutes until it begins to brown. Remove the crust from the oven and gently remove the pie weights. Reduce the heat to 375°F and bake another few minutes to brown the bottom. Remove from the oven and cool before filling.

Chocolate Pie

- -

This chocolate pie is known as a "refrigerator pie" because the filling sets in the fridge.

- 1 8-inch Blind-Baked Piecrust
- 1 cup unsalted butter
- 1½ cups superfine granulated sugar
- 6 eggs
- 1½ tablespoons pure vanilla extract
- 2 teaspoons almond extract
- 1 cup sifted cocoa powder

Cream the butter and sugar until light in color and texture. Add the eggs one at a time, beating well after each addition. Blend in the extracts and sift the cocoa over the creamed mixture. Set mixer speed on medium low and beat for 30 minutes. Mixture will be light and fluffy in texture and an intense chocolate color. With a plastic spatula, scrape the chocolate pudding into the baked piecrust and refrigerate for 24 hours before serving. Don't cover it with plastic wrap, as this leaves marks in the top of the pie. Leave it uncovered or cover it with something that doesn't touch the surface. *Makes 8 servings.*

Coconut Pie

- -

Coconut custard is one of the easiest pie fillings around.

- 4 tablespoons (½ stick) butter, melted
- 2 eggs, beaten
- 1 tablespoon cake flour
- ¾ cup sugar
- 1 cup sweetened coconut shreds
- 1 cup milk
- 1 teaspoon vanilla extract
- 1 9-inch unbaked Pie Pastry

Preheat the oven to 350°F. In a large bowl, combine the melted butter, eggs, flour, sugar, coconut, milk, and vanilla. Mix well. Pour into the pie shell. Bake until firm, 45–60 minutes. *Makes 6 servings.*

THE SPIRITUAL HOME
OF BARBECUE

THE MEMPHIS SKYLINE LOOMED over us as we crossed the Mississippi on the Hernando de Soto Bridge and came into town. Luckily for me, Rufus was driving, and since he used to live in Memphis, there wasn't any panic over the highway interchanges. I sat back and took in the scenery. It's pretty easy to find good barbecue and a charismatic pitmaster in Memphis, so I figured our losing streak was about to come to an end.

We decided to have an early dinner before checking into a hotel. We settled on Payne's Bar-B-Que, an African American barbecue joint that first opened in 1972. Located in a former garage on Lamar, the restaurant is famous for its chopped pork sandwiches.

When we walked in, we found Flora Payne stirring something on the stove. At midafternoon the dining room looked a little deserted. There weren't enough tables to fill up the space. The plain brown plastic tablecloths and the beige walls made for a pretty drab decor. The plastic plants didn't do much to cheer things up.

As we peered into the kitchen from the ordering window, we got a different impression. The tiny range top looked like it came out of grandma's house—the burners had cute little floral covers. It could have been a home kitchen, except for the large flathead shovel sitting beside the built-in brick barbecue pit. When Flora Payne opened the pit door, I saw a shaft of afternoon sunlight shining straight down the chimney onto the glistening meat, as if the pork shoulder were being divinely spotlighted.

The well-worn pit door at Payne's
Bar-B-Que in Memphis

Payne's Bar-B-Que was founded in 1972 by Emily Payne and her son, Horton Payne. In 1976, they moved to the present location, a converted three-bay garage building on Lamar. When Horton Payne died in 1984, his widow, Flora, joined his mother in the barbecue business. Today Flora Payne runs the place with two of her children, Ron Payne and Candice Parker.

A great many of the old-fashioned barbecue pits still in use across the South are found in multigenerational businesses. Which makes sense when you think about it. The old pits have been grandfathered by health department inspectors and building-code enforcement authorities. If the business is sold, the new owners aren't allowed to continue using the old pits. The only way to keep them in operation is to keep them in the family.

What a relief—it was the first well-known barbecue joint on our trip that was open and serving great-looking food. I ordered a pork shoulder sandwich and a barbecued bologna sandwich. The pork included soft meat mixed in with lots of crispy end pieces, all finely chopped together and drizzled with a light, runny barbecue sauce. The meat was piled high on a hamburger bun, topped with mustardy yellow slaw, and secured with a dainty toothpick. The red barbecue sauce and the mustard and mayo blend from the slaw combined in an orange pool on my plate as I squeezed the sublime sandwich on its way into my mouth.

Third-generation pitmaster Ron Payne

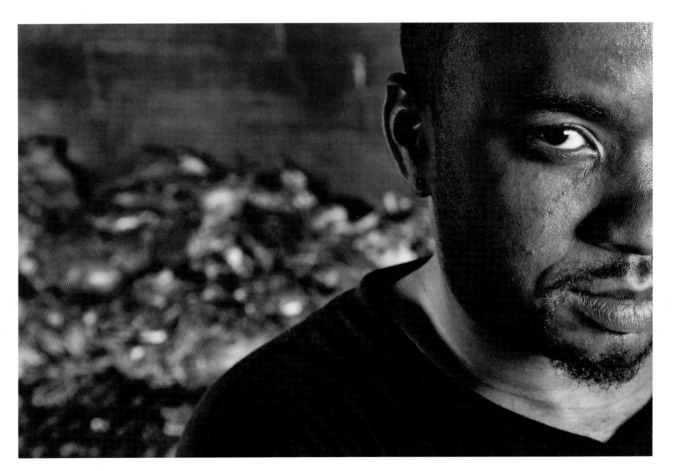

Candice Parker (left) and Flora Payne in the dining room of Payne's Bar-B-Que

But good as the chopped pork sandwich was, it was the barbecued bologna that stole the show. I have eaten barbecued bologna before at the Railhead Smokehouse Barbecue in Fort Worth and at home. But the version I make tastes like smoky hot-dog meat on a bun with barbecue sauce. Payne's bologna, which was barbecued over hickory coals inside the casing, separated into layers as the fatty, emulsified ham came apart. It was served on white bread with barbecue sauce and slaw. The slaw juice and barbecue sauce permeated the fissures in the bologna, giving the humble lunch meat a rich, juicy texture that I had never tasted before. The menu also included sliced pork, hot dogs, and ribs by the slab or sandwich. I promised Flora Payne and Candice Parker I would return to Memphis to try the rest of the menu.

RUFUS AND I HIT BEALE STREET at around eight in the evening. It was nothing like the dark and gritty scene I remembered from my first visit, four decades ago. There was a lot more neon, for one thing. And it was a Wednesday night, which is "Bike Night on Beale." So there were several hundred Harley-Davidsons parked down both sides of the street, gleaming under the bright lights of giant signs advertising B. B. King's nightclub and other blues bars.

Next page: Sign in the window of Blues City Cafe on Beale Street, Memphis

Some
h in
Mouth!

s City Cafe Blues City C

I ATE

At the Blues City Cafe we watched the hilarious act of a "World Championship Elvis Impersonator" named Robert Washington, better known as "Black Elvis." A few doors down, we drank whiskey while watching a mediocre black electric-guitar player in an empty restaurant. Then we squeezed into a packed house to watch a multiracial group called the Plantation Allstars. My favorite song in their repertoire was a medley that started with Beethoven's "Für Elise," segued into Bill Withers's "Ain't No Sunshine," and ended with a New Orleans–style brass band march. We ended up at the Blues Hall Juke Joint listening to Brandon Santini & His Band, a bunch of white hipsters in porkpie hats playing excellent renditions of traditional blues tunes.

It wasn't like being in an old Delta juke joint, but I wasn't disappointed. I had come to pay my respects to Beale Street, the birthplace of the Delta blues and the "spiritual home of barbecue," and Rufus and I enjoyed ourselves immensely. Now it was time for some Beale Street barbecue. There were lots of places to choose from, but we picked Pig, a place that had a bunch of barbecue competition trophies in the front window.

Robert Washington, the Black Elvis, performs at the Blues City Cafe.

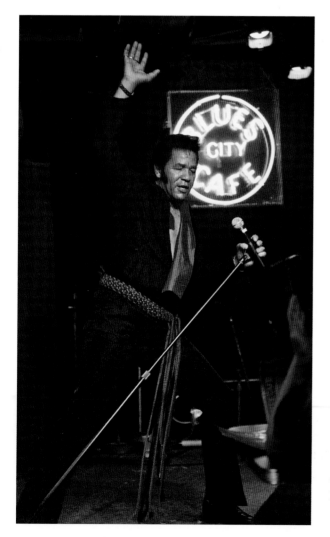

The waiter told us that the trophies belonged to a cook-off team called Ten Bones BBQ and that the cook-off team had helped the restaurant's owners, River City Management, with recipes and cooking techniques. The restaurant opened in 2002 and received an "Editor's Pick" from the *Memphis Flyer* in 2003 in the category "Best BBQ Ribs in Memphis."

The ribs at Pig were meaty with a nice smoky flavor. The barbecue sauce was too sweet, but we weren't paying much attention to such details. It was late, and Rufus and I were hungry and slightly inebriated after a night of barhopping. Like typical tourists, we had spent the better part of Saturday night wandering up and down Beale Street.

Somewhere that night, I spotted the Memphis slogan: "Home of the Blues, Birthplace of Rock 'n' Roll, Spiritual Home of Barbecue." Clearly, rock 'n' roll was born at Sun Studio in Memphis. And though some might argue that the blues came from deep in the Delta, not the big city, that's splitting hairs. As for the "spiritual home of barbecue," well, finding that is what this road trip was all about. But even if you take the hometown boosterism with a grain of salt, there is no denying that Memphis played a special role in the history of barbecue.

Memphis is the capital of the Delta. It was the home of rich planters and the cultural center of the region during the plantation era. The upheaval following the fall of the Confederacy began a social reordering. Since Memphis was the center of commerce for the region, freed slaves headed for the city in search of jobs. Between 1865 and 1900, the African American population of Memphis went from less than four thousand to fifty thousand—half the city's population.

By the early 1900s, Beale Street had become the African American business district by day, and the entertainment center at night. Historical markers commemorate the first African American photo studio and other early businesses. Ragtime and jazz musicians performed in the streets, taverns, and nightclubs.

The rural Delta traditions of barbecue and African American folk music were adapted to urban surroundings in Memphis. African American musicians gravitated away from rural folk music played on banjos and the reed flutes called quills, and toward urban dance music played on the piano and the guitar. At the turn of the century in Memphis, Atlanta, and other Southern cities, urban barbecue joints and the new music called the blues began to emerge, and they went hand in hand.

In 1909, an accomplished musician and composer named W. C. Handy introduced his distinctive Delta blues sound to Beale Street. Handy's sheet music for "Memphis Blues" established the twelve-bar blues format. The music was published in 1912 and became a popular recording in 1914. In his book *The Father of the Blues*, Handy explained his use of flatted thirds and sevenths, known forever after as "blues notes," to imitate the slurring between major and minor keys that he had heard in the folk music of the Mississippi Delta. Handy also followed the example of black musicians when he set the three-chord structure of the blues song.

At the same time on Beale Street, barbecue was making its own big-city transition. When *The Jungle*, Upton Sinclair's novel that doubled as a meat industry exposé, was published in 1907, it set off a firestorm of outrage about sanitary standards in the food industry. Within a year of the book's publication, the Pure Food and Drug Act was enacted and federal, state, and local health departments were formed. New regulations regarding food service changed the face of barbecue.

Cooking barbecue in earthen pits out in the countryside continued for religious revivals and other civic gatherings that didn't charge money for the food. But commercial barbecue in the city began to be regulated by restaurant inspectors in order to protect the public health. Pits made out of bricks and cinder block passed the new sanitary standards; holes in the ground did not.

In the 1920s, black barbecue man Johnny Mills served ribs to late-night revelers at his restaurant on Fourth Street between Beale and Gayoso. His pit was located in the alley behind the restaurant. The late 1920s were the heyday of the marriage between barbecue and the blues. As urban barbecue joints replaced the old-fashioned open pits of the rural South, they became impromptu African American culture centers.

A CD compilation from Old Hat Records titled *Barbecue Any Old Time: Blues from the Pit, 1927–1942* offers an assortment of blues songs about barbecue recorded in that era. At least one of the blues musicians was also a barbecue man. Robert Hicks, who recorded under the name "Barbecue Bob," was the pitmaster at Tidwell's Barbecue Place, in Atlanta. He was famous for taking off his apron and playing the blues on a twelve-string guitar for restaurant patrons. He recorded his first song, "Barbecue Blues," in 1927. A record company executive suggested the stage name. Barbecue Bob wore a chef's jacket and toque in his publicity photos. The singing barbecue man made sixty-two recordings before his death at age twenty-nine.

The enthusiasm for barbecue in African American culture comes through in the music. And the double entendres make the tunes extra spicy.

The enthusiasm for barbecue in African American culture comes through in the music. And the double entendres make the tunes extra spicy. On the song "Barbecue Bess," Bessie Jackson has tender barbecue for sale behind the jail. Savannah Churchill wants you to know that "fat meat is good meat." Vance Dixon and His Pencils sing "Meat Man Pete (Pete, the Dealer in Meat)." And if those lyrics are too subtle, Charlie Campbell croons, "Pepper Sauce Mama, you make my meat red hot."

WHAT I KNEW ABOUT THE BLUES, I had learned at Antone's nightclub in Austin. The late Clifford Antone dedicated his career to giving legendary blues musicians a place to play and a decent income. At Antone's I heard bluesmen like Lightnin' Hopkins, Albert Collins, Johnny "Guitar" Watson, and James Cotton. They were in the twilight of their careers by the time I heard them, but it was quite a show anyway.

My nights at Antone's frequently ended with barbecue—either from Ruby's Barbecue, conveniently located next door to the Antone's location on Guadalupe, or at Stevie Ray Vaughn's favorite barbecue joint, Sam's, on the east side of Austin. One night, I met the late C. B. Stubblefield, better known as Stubbs, cooking barbecue as a "guest chef" on a couple of barrel grills outside Antone's. The barbecue legend from Lubbock went on to open his own barbecue and blues venue in Austin. Mr. Stubblefield passed away, but Stubb's Bar-B-Q on Red River Street is still open, and Stubb's Barbecue Sauce is still one of the most popular in the state.

THE NORTH CAROLINA barbecue scholar John Shelton Reed once wrote an essay comparing barbecue to jazz. Jazz is a product of New Orleans creolization, a sort of musical gumbo. Barbecue comes from the same plantation culture that gave us the blues. But if you had to create a musical metaphor, I'd be more inclined to compare modern barbecue to rock 'n' roll.

Elvis Presley and other Memphis performers created rock 'n' roll by repackaging African American blues tunes for a white audience. "The colored folks been singing it and playing it just like I'm doin' now, man, for more years than I know," Elvis once said. "They played it like that in their shanties and in their juke joints and nobody paid it no mind 'til I goosed it up. I got it from them." Though he took their music,

most black bluesmen bore Elvis no ill will. "Elvis was a blessing," Little Richard once said. Thanks to Elvis, the whole country became interested in the blues.

Likewise in Memphis, white people took the African American barbecue style of the Delta and repackaged it for the mainstream. In the documentary *Smokestack Lightning: A Day in the Life of Barbecue*, the writer Lolis Eric Elie asked Charlie Vergos, the owner of the Rendezvous, perhaps the most famous barbecue joint in Memphis, about the origins of the Memphis barbecue tradition. "Brother, to be honest with you, it don't belong to the white folks, it belongs to the black folks," Vergos said. "It's their way of life, it was their way of cooking. They created it. They put it together. They made it. And we took it and we made more money out of it than they did. I hate to say it, but that's a true story."

At Memphis in May, a monthlong festival, the humble slow-cooked pig meat that poor folks once ate in the Delta gets dressed up in sequins for a cook-off where major corporations spend thousands of dollars on competitors' booths. Just as Elvis created a larger market for the music of Little Richard and B. B. King, television shows about barbecue and barbecue cook-offs have done wonders for the fortunes of traditional African American barbecue joints like Payne's on Lamar Street in Memphis and Jones Barbecue Diner in Marianna, Arkansas.

Gregory Carter sells late-night barbecue from his Bar-B-Que Done Right trailer in front of a nightclub in Houston's Fifth Ward.

Mainstream enthusiasm for barbecue and the blues came along at a time when the African American community was losing interest in both. When I moved to Houston in 2000, there were still a few juke joints where you could eat barbecue and catch a local blues act. C. Davis Bar-B-Q, a barbecue joint in the Sunnyside neighborhood, had blues night on Sunday nights. If you got there early enough, you could get a plate of brisket and ribs as the kitchen closed for the night and just before the blues show started.

On Mondays, there was a blues open-mike night at a juke joint called Miss Ann's Playpen in the Third Ward. The club's proprietor, an amateur blues singer and barbecue caterer named Bobby Lewis, cooked ribs on a barrel smoker outside the front door and sold barbecue plates to the crowd for eight dollars each.

C. Davis Bar-B-Q went out of business ten years ago, and Bobby Lewis closed Miss Ann's Playpen after he was diagnosed with cancer. There isn't much left of the old juke-joint scene in Houston. None of the once-famous barbecue joints in Houston's once-famous Fifth Ward are thriving anymore either. Bert Long, a seventy-something African American artist who lives in the "The Nickel," as the Fifth Ward is known, told me that the African American culture of the Old South is dying in the black community because young people associate that stuff with their grandparents. In the 'hood, barbecue and the blues were long ago replaced by Micky D's and hip-hop, he said.

BARBECUED PORK RIBS

✖ PORK RIBS come in several sizes, so be sure to pick a cooking method that works with the ribs you are cooking.

Baby back ribs. Taken from the loin, these are the leanest and meatiest ribs. They are also the most expensive. Depending on how much of the loin meat the butcher leaves on the ribs, these range from one and a half to two pounds per slab, about half of which is bone. Baby backs are the fastest and easiest ribs to cook.

3.8 and down spareribs. Spareribs under 3.8 pounds are the best for barbecue. You can find ribs of this size, free of chemicals or salt-solution injections, at discount clubs like Sam's and Costco or at a custom butcher.

Big ribs. The huge five- and six-pound racks of spareribs sold at most grocery stores are difficult to barbecue. You need to use a recipe for these ribs that includes some braising time.

Ribs come in several styles as well as different sizes.

Country-style ribs. These aren't really ribs, and they don't have any bones. They are fingers of meat from the loin and shoulder. They cook like thick pork chops.

St. Louis ribs. To trim a rack of ribs St. Louis style, cut off the breastbone and trim off the rib tips at each end to produce a squared-up rack that fits nicely on the grill. The breastbone is connected to the top few ribs—it runs north and south while the ribs run east and west. Removing it also makes carving at the table much easier. Cook the rib tips and breastbone meat for a cook's treat.

Kansas City ribs. Follow the directions for St. Louis ribs, then also cut off the flap on the bone side of the ribs, chop this diaphragm muscle (or "skirt steak") into strips, and cook it along with the rib tips and breastbone.

And there is a common rib-preparation technique to be aware of if you cook ribs at home.

Skinning ribs. There is a membrane on the bone side of a rack of ribs that many barbecuers like to remove. Some argue that this process speeds cooking time; some say it makes the ribs more tender. When cooking 4 and ups with a braising liquid, it's definitely a good idea to remove the skin, because it allows the steam to penetrate the meat. To remove it, work a few inches free by scraping along the bone with a butter knife and then grip the skin with a paper towel and rip it off.

Stubb's Spicy Pork Rub

Stubb has passed away, but Stubb's Bar-B-Q on Red River Street in Austin tries to keep his spirit alive. This is the restaurant's recipe for hot pork rub.

- 1 cup salt
- ¼ cup chili powder
- ¼ cup paprika
- ⅓ cup garlic powder
- ⅓ cup cayenne
- ½ cup ground dry rosemary
- ½ cup ground black pepper

Combine all ingredients and store in a shaker. *Makes about 3 cups.*

Brown Sugar Rub

This rub works best with ribs that are cooked in a pan on the smoker, such as Smoke-Braised Ribs (p. 53). The ribs don't come in direct contact with the flame in these recipes, so the sugar doesn't burn.

- 1 cup dark brown sugar, packed
- ¼ cup garlic powder
- 2 tablespoons chipotle powder or chili powder
- 1 tablespoon cayenne
- 4 tablespoons kosher salt
- 1 teaspoon powdered thyme

Combine all ingredients and store in an airtight container. *Makes 1½ cups.*

Arkie Rub

If you use a rub that contains sugar and then cook your ribs directly on the grill, you might end up with a burned taste. Here's a simple rub without any sugar.

- 3 tablespoons kosher salt
- 3 tablespoons Hungarian mild paprika
- 1 tablespoon finely ground black pepper

Combine all ingredients and store in a shaker bottle. *Makes about a half cup.*

RUBS ➤

✖ WHEN USING A RUB, sprinkle it generously over the surface of the meat, but don't overdo it. Just as you wouldn't want to completely coat a good steak in salt and pepper, you don't want to cover the meat with a barbecue rub. If you rub the meat a day in advance and marinate it in the refrigerator overnight, you allow the meat to absorb the flavors.

If you want to buy a commercial barbecue rub, go ahead. Just be sure to check the ingredient list for liquid smoke, MSG, chemicals, and preservatives if you don't like those things in your food. It's a lot cheaper to make your own rubs at home.

Ora Lee's Wet Ribs

Many people love "falling off the bone" tender pork ribs, and they are great for rib sandwiches. The ribs that win barbecue cook-offs are firmer: after you take a bite, your teeth marks should be visible in the tender meat, but it should remain on the bone. Some barbecue joints cook ribs on the smoker for 3 or 4 hours (until a fork slides through easily), and then spread them with sauce and hold the hot ribs a dozen racks at a time in a large ice chest. The ice chest keeps the ribs hot and traps the steam, so they keep getting more tender.

You can accomplish the same thing by dousing the ribs with barbecue sauce and wrapping them in aluminum foil or by putting them in a pan with some sauce and covering the pan with foil. Put the foil-wrapped ribs back on the grill or in the oven until they are as tender as you like them.

- 1 rack 3.8 and down pork spareribs
- Arkie Rub (p. 50)
- Hog Mop (p. 53)
- Barbecue sauce of your choice

Rinse the ribs to remove any blood. Trim as desired (see Barbecued Pork Ribs, p. 49). Season both sides with the rub, wrap them in plastic wrap, and put them in the refrigerator overnight.

Set up your barbecue for indirect heat with a water pan. Start a fire with charcoal briquettes or hardwood lump charcoal, or burn hardwood down to coals. Maintain a temperature between 250° and 300°F. Place the ribs on the grate, bone side down, as far away from the fire as possible. Cook for 3½–4 hours, mopping with a cotton mop dipped in Rib Mop and turning the ribs every half hour.

When a knife tip or toothpick passes easily between the ribs, place the rack on a sheet of aluminum foil or in a pan big enough to hold them. Brush the ribs with heated barbecue sauce. (Do not use cold sauce!) Seal the aluminum foil or pan. Return the ribs to the smoker for 30 minutes, turning once. Before serving, allow the ribs to sit for at least another 30 minutes, or until they're falling-apart tender. *Serves 2–3.*

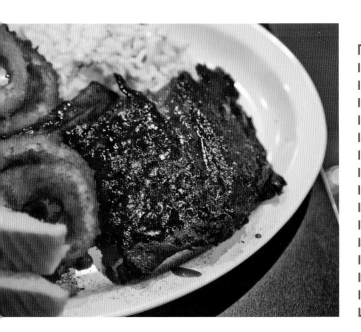

BARBECUE PANS

IF YOU USE YOUR FAVORITE roasting pan in the barbecue pit, it will be coated with smoke stains that are nearly impossible to scrub off. Unless you have a roasting pan you are willing to dedicate to your barbecue pit, the most convenient way to barbecue in a pan is to buy the largest size of aluminum foil roasting pans sold at the grocery store or restaurant supply center. A full-size aluminum steam table pan measures 20¾ inches × 12¹³⁄₁₆ inches across the top and will accommodate the largest rib racks easily.

Ora Lee's Rib Sandwiches

You need falling-apart-tender ribs to make these rib sandwiches. You should be able to easily pull the bone out of the meat.

- 1 rack well-cooked Ora Lee's Wet Ribs (p. 51)
- 4 or 5 hamburger buns or Kaiser rolls
- 1 cup barbecue sauce of your choice
- Onion slices
- Pickle slices
- Memphis Mustard Slaw (p. 54)

Carve the ribs into 2 or 3 bone sections to fit the buns. Dip the inside of the bottom half of the buns in the barbecue sauce. Place the ribs on the buns and top with onion slices and pickles. Add additional sauce to the top halves of the buns. Top with slaw if desired. Serve immediately.

Diners can eat the sandwich open-faced or pull the bones out of the ribs before picking up and eating the sandwich. *Makes 4 or 5 sandwiches.*

Memphis Dry Ribs

- 1 rack 3.8 and down pork spareribs
- 3 tablespoons Arkie Rub or Stubb's Spicy Pork Rub (p. 50)
- Red Barbecue Sauce (p. 55)
- Hog Mop (p. 53)

Set up your smoker for direct heat. Burn hardwood or hardwood charcoal down until the coals are gray, spread them out, and place the ribs on the grate at least 18 inches above the coals. Cook for 20 minutes, moisten with the Rib Mop, and then flip the ribs over and cook the other side. Light more coals in a chimney starter and replenish the fire after 1 hour. Continue flipping and mopping for 3½–4 hours, or until a knife tip or toothpick passes easily between the ribs. Serve with barbecue sauce of your choice. *Serves 2–4.*

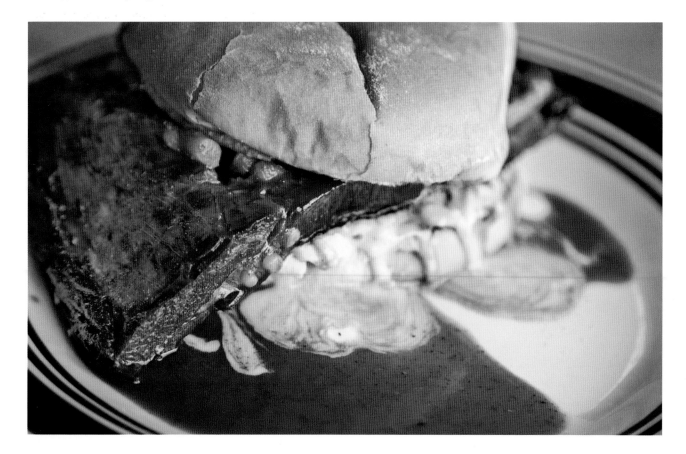

4

CONVENIENCE
STORES

IT WAS A SHORT DRIVE from the Day's Inn east of Memphis to Summer Avenue, where we stopped at the famous Bryant's Breakfast, formerly Bryant's BBQ & Breakfast. I jogged into the diner while Rufus waited in the car. I had visions of a pulled pork omelet or maybe pulled pork over biscuits, but a quick scan of Bryant's menu revealed that it no longer featured barbecue of any sort. This Summer Avenue spot used to be a barbecue joint, then started serving a big country breakfast that became so popular that they decided to drop barbecue from the name and the menu.

The menu did make my mouth water: homemade biscuits, grits, country gravy, country ham, country sausage, grilled pork tenderloin, grilled bologna, city ham, smoked sausage, country-fried steak. It was just what the doctor ordered for a road trip breakfast on a hung-over morning, but it wasn't barbecue. Rufus groaned when I told him we had to keep driving.

The smoked brisket and egg tacos I ate at the Plantation BBQ trailer in Richmond, Texas, had long ago convinced me that barbecue was a brilliant idea for the morning meal. At Hawkin's Breakfast and Bar-B-Que back in West Memphis Arkansas, eggs and ribs were reportedly on the menu. I was willing to backtrack, but the phone had been disconnected. The restaurant evidently went out of business in its first year. So maybe the rest of the world had not yet woken up to the beauty of barbecue for breakfast.

Rufus was pained to learn that our next destination, and something to eat, was an hour away. We headed for a tiny grocery store in Eads, Tennessee, a hamlet on the outskirts of Memphis. The proprietor, a black barbecue man named Laddie Morris, chopped his own barbecue wood out of hickory stumps.

Brisket, sausage, and ribs at
Martin's, in Bryan, Texas

The scenery on our morning drive was a study in sprawl. Eads was on the very edge of the newest Memphis suburbs. The as-yet-undisturbed portions of the landscape were wooded and shrouded in kudzu. Old farmhouses and barns poked out of the foliage here and there. The rest of the acreage had been clear-cut and covered with brand-new shopping centers and condominium complexes.

Our destination was an old convenience store with a dirt parking lot. "Morris Grocery, Bar-B-Q, Deli" read the sign outside. Across the street stood a brand-new convenience store with gas pumps. It looked like Morris Grocery's owners had given up on competing for convenience store customers and decided to concentrate on the sandwiches.

Classic Southern barbecue is sold by a wide variety of businesses. In the beginning, when barbecue was cooked in a hole in the ground, it was sold commercially at roadside stands in the country and from wagons that carried it to town. When new sanitary laws sent barbecue indoors, it became a common offering at a dizzying array of outlets, including general stores, meat markets, saloons, juke joints, barbecue stands, and, later, drive-ins, gas stations, and roadhouses, along with cafes, restaurants, food trucks, and trailers. Each has its own style of presentation, and on our journey I hoped to experience Southern barbecue in as many venues as possible.

Behind the "Kudzu Curtain" at Morris Grocery, Bar-B-Q, and Deli in Eads, Tennessee

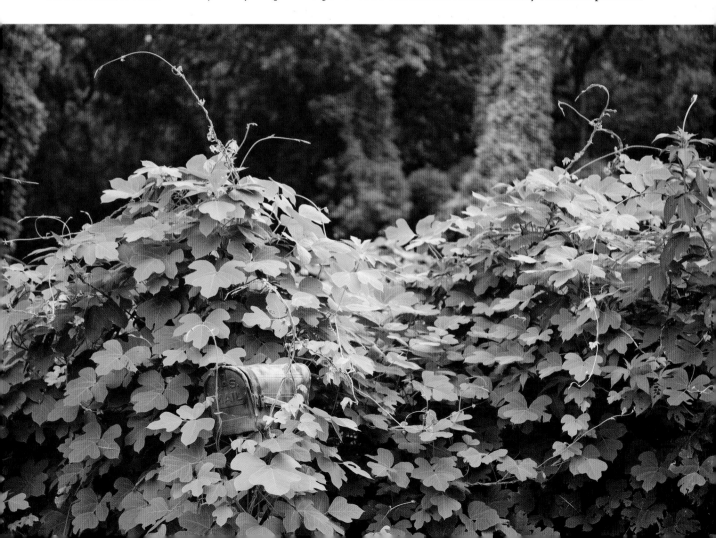

We were ready for breakfast, but Morris Grocery wasn't open yet. So we killed some time. Rufus waded into the kudzu to shoot some photos. I made a list in my black-and-white marbled 100-page composition book of all the convenience stores, markets, and filling stations where I had eaten barbecue. I've been using these college composition books since I started writing about food more than twenty years ago, and I have quite a stack of them.

Finally, the little store opened for business and we passed through the screen doors. Inside we found worn wire shelves along the walls and very little in the way of inventory. We also encountered Laddie Morris, who wasn't in a very good mood. A short and powerful man with salt-and-pepper hair, he considered our request to conduct an interview and photograph him at work for barely a millisecond before he said no. When we followed him back into the screened enclosure where he cooked, he turned around and asked, "Why would you want to take photographs of this?" The cooking area looked like a screened porch, and the barbecue pit was a simple sawed-in-half steel barrel.

. . . here and there you'll find amazing barbecue at a place with a name like Git It N' Go, Wag a Bag, or Pay and Takit.

"I have a barbecue pit just like that," I said with a broad and not entirely genuine smile. I do indeed have a steel-barrel pit in my backyard—we call them Texas hibachis back home. But given my hunger, the throbbing headache of a hangover from too many beers on Beale Street, and the prospect of another aborted interview, I didn't really feel like smiling. It didn't look like we had any hope of changing Laddie's mind either. To keep us out of the barbecue enclosure, he barricaded himself behind a wall of cardboard boxes.

DISCERNING DINERS who aren't from the South are generally contemptuous of the food served in convenience stores. There's plenty of bad food available in convenience stores, of course, but here and there you'll find amazing barbecue at a place with a name like Git It N' Go, Wag a Bag, or Pay and Takit. Sometimes these places are barbecue stands that started selling convenience-store items to make more money, and sometimes they are convenience stores that added barbecue as a sideline.

The Southern tradition of eating at stores and markets came from the migrant farmworkers. For a hundred years, from the end of the Civil War to the mid-1960s, cotton was picked by hired hands. Hundreds of thousands of pickers were required. They moved from south to north, following the ripening of the cotton. There were often more cotton pickers than local residents for the several weeks it took to bring in a crop. Regardless of whether they were African Americans, Mexican nationals, or poor whites, cotton pickers were at the bottom of the social scale. They weren't welcome in restaurants or cafes where townspeople ate.

Cotton pickers bought their food in gas stations, convenience stores, and meat markets. In Lockhart, Texas, cotton pickers were dropped off after work in the parking lot of a meat market now named Smitty's, and formerly known as Kreuz Market.

Knives once hung from chains at regular intervals along the stand-up counters at Smitty's in Lockhart. The old wood still shows the wear of decades of enthusiastic meat carvers.

The front door of the retail meat market is on the town's main square. The parking lot and back door are located across the street from the cotton gins and railroad tracks. Migrant workers came in the back door and either got their smoked meats to go or ate them at picnic tables in the back of the market. The same scenario was repeated in other meat markets run by European immigrants.

In the days before refrigeration, butchers followed the traditions of eastern Europe, grinding their scraps into sausage and smoking them along with unsold meats. They probably had no idea what the cotton pickers were talking about when they called the smoked sausage and pork "barbecue." But the butchers knew that when the cotton pickers were in town, they sold a lot of it. Soon enough, the eastern European immigrants were calling it barbecue, too.

The meat market on the Lockhart town square has been selling smoked meats since 1900. If you eat your sausage at the dark wooden counter along the wall outside the meat market, you can feel the grooves and hollows where generations of barbecue lovers cut their meat and see the metal stubs where the knives once hung on chains. Some say the knives were kept on chains to prevent them from being stolen, and others say they were chained up to prevent knife fights.

Sometimes the cotton pickers collected their pay at the plantation equivalent of the company store. I visited one such place ten years ago in Egypt, Texas, just north of Wharton. It was called John's Country Store, and it had been turned into a weekend-only barbecue joint.

There were antique 7Up signs on the walls, patent medicines on the shelves, and a few tables with red-and-white-checked tablecloths up front, where I sat down to try the place out. A man named Bubba Hodges came by to take my order. The choice was pretty easy. All they had was brisket and sausage. There were no sides. I ordered a brisket sandwich.

While my order was being prepared, I wandered around. There was a very old saloon adjoining the store; in it, I noticed a safe with the inscription "Northington Land and Cattle Company, 1867." Evidently, the combination cotton plantation and cattle ranch went into business immediately following the Civil War.

The barbecue pits were in a middle room, and in the back of the store there was another room with a pool table and a jukebox. That room has no glass or screens on the windows, just big wooden shutters hinged at the top and propped open with two-by-fours. Outside, a brown horse with a black mane was grazing in the bright summer sun. Flies buzzed around the crude, homemade wooden booths.

John's Country Store was called the G. H. Northington Sr. Mercantile Store when it first opened, in 1900. Over the years, a feed store, meat market, and saloon were added to the original structure, creating the little commercial strip that became "downtown" Egypt. The store was where the cotton pickers and laborers collected their pay.

Usually, after the migrant farmworkers were paid their daily or weekly wages, they would head for the nearest market looking for food and cold drinks. Wily cotton growers like Northington paid the pickers at the company store, which, on payday, was freshly stocked with cold sodas and where the meat man was slicing hot barbecue. Faced with the choice of spending their money there or walking for miles to find another store, a great many cotton pickers ended up giving part of their wages back. At Northington's adjoining saloon, the pickers could spend what they had left on cold beer.

Smitty's in Lockhart started out as a German meat market in 1900.

In 1978 the store came into the ownership of a G. H. Northington descendant, John Northington, who sought to preserve some of its history. He changed the name to John's Country Store and opened on weekends when the weather was nice. But mostly he rented the place out to oil companies and large groups for company barbecues.

Displayed in the center of the store was an antique desk at which sat a dummy of a woman wearing a period costume. John Northington told me it was the likeness of the paymaster, a woman named Miss Ivory. "That's where all the wages were given out on this plantation for over a hundred years," he said.

John's Country Store isn't open much anymore, but I am glad I got to see it. The combination of Northington's saloon, the convenience store that served barbecue, and Miss Ivory's paymaster desk explains a lot about barbecue and the plantation culture.

MARTIN'S IN BRYAN, TEXAS, is another barbecue joint that's frozen in time. The pits at Martin's are tended by a third-generation owner, Steve Kapchinskie. His grandfather Martin Kapchinskie bought the site in 1924 and built a combination gas station, barbecue stand, convenience store, and domino parlor. Martin's son Albin, who spent World War II as a butcher in the U.S. Navy, joined the business

The kitchen at Martin's

after the war and added a meat market. Albin made his own Polish sausage. Albin's son Steve worked in the family business from the time he was a boy; Albin handed him the keys in 1976.

Martin's doesn't sell gas or groceries anymore, just barbecue. But the social part of the business lingers on. There is always someone hanging out with Steve in the pit room. To get there, you walk through the kitchen on a path worn through several layers of vinyl flooring to the bare concrete underneath. The kitchen stove is an antique.

"We would love to get a new stove, but we can't," Steve explains. "If we got a new stove, we would have to have a vent hood. And to get a vent hood, we would need a building permit. And if we got a building permit, we would have to bring the whole building up to code." Unsuited to modern regulatory requirements, the barbecue joint is preserved in smoky amber.

Unsuited to modern regulatory requirements, the barbecue joint is preserved in smoky amber.

Martin's doesn't turn up much on "Best BBQ" lists. The barbecue gets rated "average" by barbecue websites. Of course, average is pretty damn good in that neck of the woods. The brisket is moist and smoky, and the ribs are crispy on the outside and tender at the bone.

When I brought Rufus there to take took photos, I pointed out my favorite table at Martin's, which has an intriguing pattern on the top. The original Formica was ersatz wood grain, but decades of tile-dragging domino players wore a brown and ivory double oval in the middle. When we put our smoked meat, pickles, and onions down on the table, it looked like a barbecue mandala.

MORRIS GROCERY WAS GOING TO SERVE US some barbecue sooner or later, I figured. "You better give up. He's not going to talk to you," Laddie's daughter Yolanda Morris said as she worked at the cooktop in the front of the store. She was flipping corn fritters in a little frying pan and turning them out into a case with biscuits and sweet rolls.

Although my brain function was less than optimal, a couple of things became clear. If Laddie Morris was just now starting a fire in his pit and he was preparing to cook some Boston butts, it would be a minimum of five or six hours before he had any barbecue ready. Which meant he wasn't cooking for today—he was cooking a day or more in advance. The barbecued pork he was going to serve for lunch in an hour or so had already been cooked and chopped and was sitting in the refrigerator or freezer waiting to be heated up.

"Yolanda, we are on an assignment, and we have to stay here until we sample some barbecue. Why don't you make us a sandwich out of the barbecue in the fridge, and we'll go away."

"Okay," Yolanda agreed, eager to get rid of us. She took some chopped pork out of a white plastic half-gallon container that was sitting in the refrigerator and got out another container of barbecue sauce, mixed them together and heated them up on her cooktop.

Next page: An order of brisket and ribs in the middle of a fifty-year-old domino table at Martin's forms a barbecue mandala.

The picnic grove at Morris Grocery in Eads consists of two stumps and a barrel with a piece of plywood and a square of carpet on top.

"I have one other favor to ask," I told her when the meat was hot. "Could you make our sandwich on two of those corn fritters?" Corn fritters are cornbread batter poured into a hot greased skillet and fried into the shape of thick pancakes. Hot out of the frying pan, they make an awesome substitute for hamburger buns on a pulled pork sandwich.

"That's going to cost extra," she said. I assured her the extra charge was okay. When the sandwich was done, she wrapped it in aluminum foil and put it in a bag. We got a couple of Cokes to go with the sandwich, paid up, and left. We were delighted to get something to eat at long last.

We took the convenience-store sandwich behind the building to a bizarre tree-stump picnic table covered with a carpet scrap. The barbecue sauce was dark brown and tasted like molasses with a dash of cider vinegar and salt. Sitting there in the aluminum-foil wrapper was a stack of two cornbread pancakes oozing molasses and stuffed with barbecued pork. It was messy but satisfying. The pork was tender with a nice hickory flavor, and I loved the sweet, thick barbecue sauce with the corn fritters—not a bad barbecue breakfast after all.

Cornbread Fritters

Cornbread fritters can be made with any cornbread batter. What makes them fritters is the way they are cooked. You pour the batter into a hot skillet and flip the flat round of cornbread like a pancake.

- 1 tablespoon lard or bacon drippings
- 1 cup yellow cornmeal
- 1 teaspoon salt
- 1 cup buttermilk
- ¾ cup all-purpose flour
- 1 teaspoon baking soda
- ¼–½ cup water

Heat the lard in a cast iron skillet over medium-high heat. Mix the remaining ingredients with water as needed to make a smooth batter. Drop the cornbread mixture by spoonfuls into the skillet and allow to cook for 3–5 minutes or until golden brown. Turn to brown on the other side. *Makes about 6 fritters.*

Morris Grocery's chopped pork sandwich on corn fritters

Fried Green Tomatoes

Instead of fritters, you can also eat your chopped pork sandwiches on fried green tomatoes. You put a layer of pork and barbecue sauce between two slices of fried green tomato. Pick it up like a sandwich or eat it with a fork and knife.

- 2 cups peanut oil
- 1 cup finely ground cornmeal
- Salt and ground white pepper to taste
- 2 eggs, beaten with 2 tablespoons of water
- 4 green tomatoes, thickly sliced

In a heavy-bottomed pot, heat the peanut oil to 350°F. Sprinkle the cornmeal on a plate and season with salt and white pepper. Place the beaten-egg mixture in a shallow dish, such as a pie plate. Drop the green tomato slices in the egg mixture and then pat them in the corn meal to coat. Place the tomato slices in the hot oil in batches and fry for 2–3 minutes, turning over once during the frying. Remove the slices from the fryer and allow to cool slightly on a wire mesh rack. Serve immediately. *Makes about 12 tomato slices.*

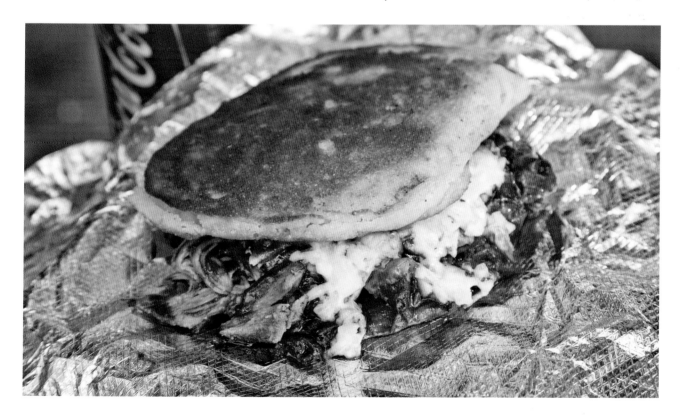

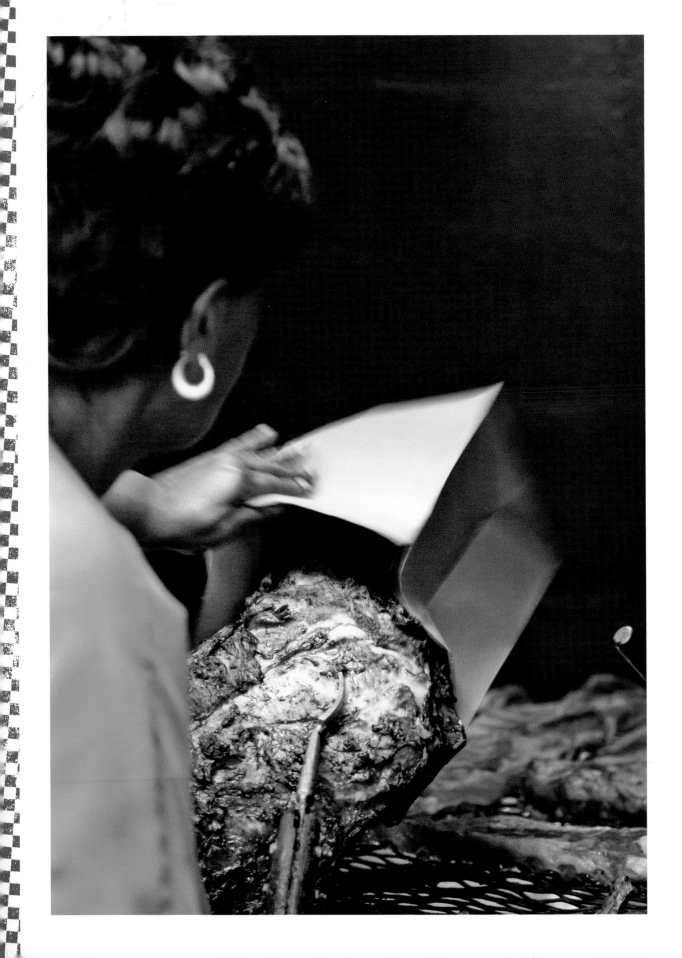

Barbecued Boston Butt

A butt is a kind of wooden cask used for meatpacking. Meat packers in Boston began filling wooden butts with preserved upper pork shoulders (a cut known in England as "pork hand") before the American Revolution. The cut, which usually contains the Y-shaped blade bone, has been known as Boston butt ever since.

- 1 Boston butt, 4–5 pounds
- 6 tablespoons Tennessee Hog Rub
- 2 onions, peeled
- 2½ cups Hog Mop (p. 53)
- 2 cups Eads Molasses BBQ Sauce
- 10 sandwich rolls, toasted
- Shaved slaw (p. 87)

Rinse the pork roast and pat dry with paper towels. Rub the roast with the spice mixture, pressing it into the meat, and refrigerate it overnight.

Cut the onions in half and put them in the water pan to flavor the steam. Add water to fill the pan.

Set up your smoker for indirect heat with a water pan. Use wood chunks or logs and keep up a good level of smoke. Place the roast in the smoker. Maintain a temperature of around 250°F. Replenish the water pan as needed. Cook the roast, turning occasionally so it browns evenly. Mop the meat with the Hog Mop every half hour. Be patient: the longer you cook the meat, the better it will taste, but if you attempt to speed things up by using a higher temperature, your pork will come out dry. For chopped pork, the roast is ready at 190°F, which may take 6–8 hours. For pulled pork, the internal temperature needs to exceed 200°F, which could take 8–10 hours. When it reaches the desired temperature, put the pork in a brown paper bag, seal the bag, put it in a pan, and set it in a cool place on the grill or in a warm oven to hold it.

When ready to serve, season the chopped or pulled pork with barbecue sauce and pile ⅓ of a pound of seasoned pork on a toasted sandwich roll and top with slaw. Or drizzle with barbecue sauce and serve on a plate with coleslaw and potato salad on the side. *Serves 8–10.*

Tennessee Hog Rub

- ¼ cup salt
- 2 tablespoons brown sugar
- ¼ cup paprika
- 2 tablespoons garlic powder
- 2 tablespoons onion powder
- 1 teaspoon cayenne
- 2 tablespoons ground black pepper

Combine all the ingredients in a bowl and mix well, then pour into a shaker jar. This rub will keep for a couple of months in an airtight bottle. *Makes about 1¼ cups.*

Eads Molasses BBQ Sauce

For a stunning barbecue breakfast, heat up some chopped Barbecued Boston Butt in this dark, sweet sauce and serve it between two Cornbread Fritters.

- ¼ cup (½ stick) butter
- 1 cup chopped onion
- 1 clove garlic, minced
- 1 teaspoon lemon zest
- 1 cup ketchup
- ½ cup molasses
- ¼ cup cider vinegar
- 1 tablespoon Worcestershire sauce
- 1 teaspoon Dijon mustard
- 1 teaspoon sea salt
- ½ teaspoon finely ground black pepper

In a large saucepan over medium heat, melt the butter. Add the onions and cook, stirring often, for 5 minutes or until translucent. Add the garlic and continue cooking another 2 minutes or until the garlic is soft. Add the other ingredients and stir to combine. Bring to a boil, then reduce heat and simmer, uncovered, for 10 minutes. Use immediately or store in the refrigerator in a sealed container for up to 1 month. *Yields 2 cups.*

5

BIG PIGS AND LITTLE PIGS

WE LEFT MORRIS GROCERY in Eads a little after 10 a.m. and drove 110 miles east on I-40 to Scott's-Parker's Barbecue in Lexington, Tennessee. We pulled in right around lunchtime. Scott's-Parker's is one of the most famous barbecue restaurants in the country and one of the few in Tennessee that still barbecues whole hogs. I didn't meet Parker that day, but I interviewed him over the phone and gleaned more of his life story from an oral history recorded by the Southern Foodways Alliance. Rufus stopped by some months later to get some photos of Ricky Parker cooking whole hogs.

Scott's-Parker's Barbecue was originally named Scott's Barbecue after the restaurant's founder, Early Scott, who opened the place in 1976. Ricky Parker grew up in a family of migrant farmworkers and spent his childhood picking oranges in Florida and apples in Michigan. At the age of thirteen, Parker's abusive father threw him out of their house in Tennessee. Early Scott and his wife met Parker at a gas station where the teenager was working. They gave him a job at the barbecue joint and ended up informally adopting him. For more than a decade, Parker studied Early Scott's barbecue technique. Ricky Parker bought the place when Scott retired in 1989, and changed the name to Scott's-Parker's Barbecue.

Ricky Parker and his sons Zach and Matt expanded the capacity of the business. They erected a building that houses a large walk-in refrigerator where a week's supply of hogs hang by their feet. Behind the restaurant, they built the big, screened pit house where the hogs are cooked. The whole hogs are splayed and laid out on the pits and then cooked over slow coals. The Parkers cook with split hickory logs

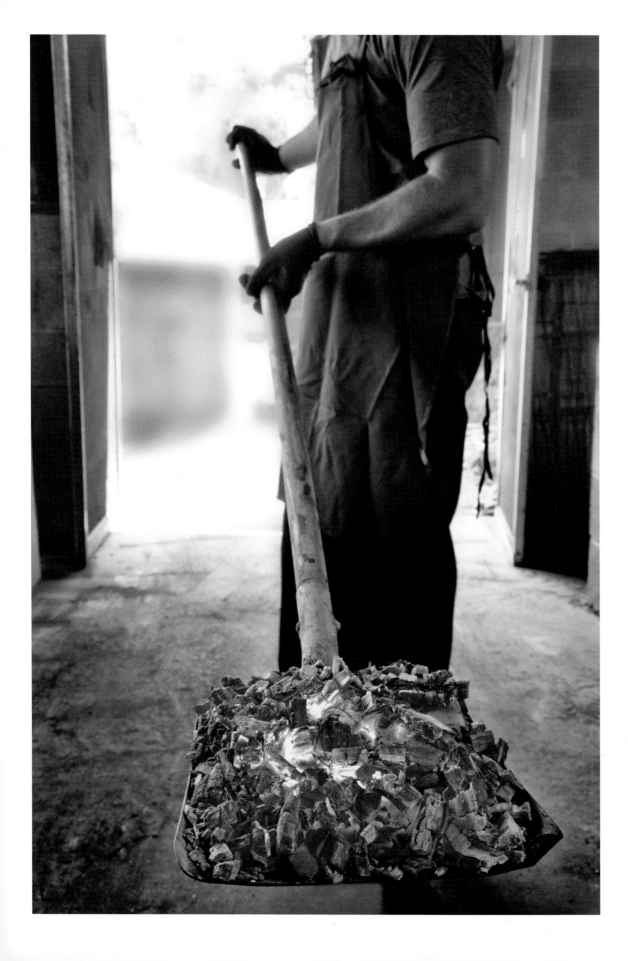

that they burn down in a concrete furnace. Then they carry the coals to the pits in long-handled square shovels.

"It's all common sense," said Ricky Parker. The heat is controlled with vent doors along the bottom of the pit that regulate the draft and by the amount of ash left on top of the coals. Open the vents and knock off the ashes to crank the heat up—close the vents and shovel ashes over the top to slow it down. Parker chuckles about an aspiring barbecue restaurant owner who came to him for help after attempting to use steel pits to cook hogs. "Barbecue looks easy," Parker said. "A lot of people think you can learn it out of a book, but you can't. There's no way."

"We cook the hogs with cardboard over the top to retain the heat," Ricky Parker told us. "Early Scott got the idea for using cardboard for insulation after watching somebody wrapping their pipes with newspaper before a freeze. We go through twelve hundred dollars worth of cardboard sheets every year."

Scott's-Parker's Barbecue is nationally acclaimed because it's the oldest whole-hog barbecue in the area. Tennessee newspapers and magazines can't write enough about the last bastion of old-time pig tradition. We sat down at a table with an enthusiastic customer named Bill Elliot and asked him to tell us a little about what makes Scott's-Parker's special. Elliot, an antiques dealer, obviously regarded the old barbecue joint with the same affection he held for the relics he sold—it was the last of a dying breed, he said. You don't see whole-hog barbecue joints opening anymore.

But how does whole hog taste different from pork shoulder, I wondered. First of all, when you order a sandwich at Scott's-Parker's, you can request meat from specific parts of the hog, Elliot told us. The white meat from the shoulder is the most popular, but some like the dark meat from the ham. There is never enough of the juicy "catfish," as the loin is known. I sampled some of the connoisseurs' choice—the moist and stringy meat from under the ribs called the "middlins." This is pork belly—the cut used to make bacon.

Rufus and I also got two of the definitive Scott's-Parker's shoulder meat sandwiches with slaw and spicy sauce. We ate the sandwiches over a spread-out newspaper, and when we were done, it looked as though we had drained a rasher of bacon and then knocked over a bottle of barbecue sauce.

Ricky Parker said he has modified Early Scott's methods a little. He cooks slower and with less fuel now. That's not because the old method didn't produce great barbecue; it's because hickory wood is a lot more expensive now than it was in the 1970s. But at least Parker hasn't started cooking with gas. Tennessee barbecue is moving away from whole hogs slow-smoked over hickory coals by artisan pitmasters toward smaller cuts of pork cooked in automatic gas and electric ovens—and the change is sending shock waves through the culture.

Next page: Ricky Parker shoveling coals under the whole hogs at Scott's-Parker's in Lexington, Tennessee

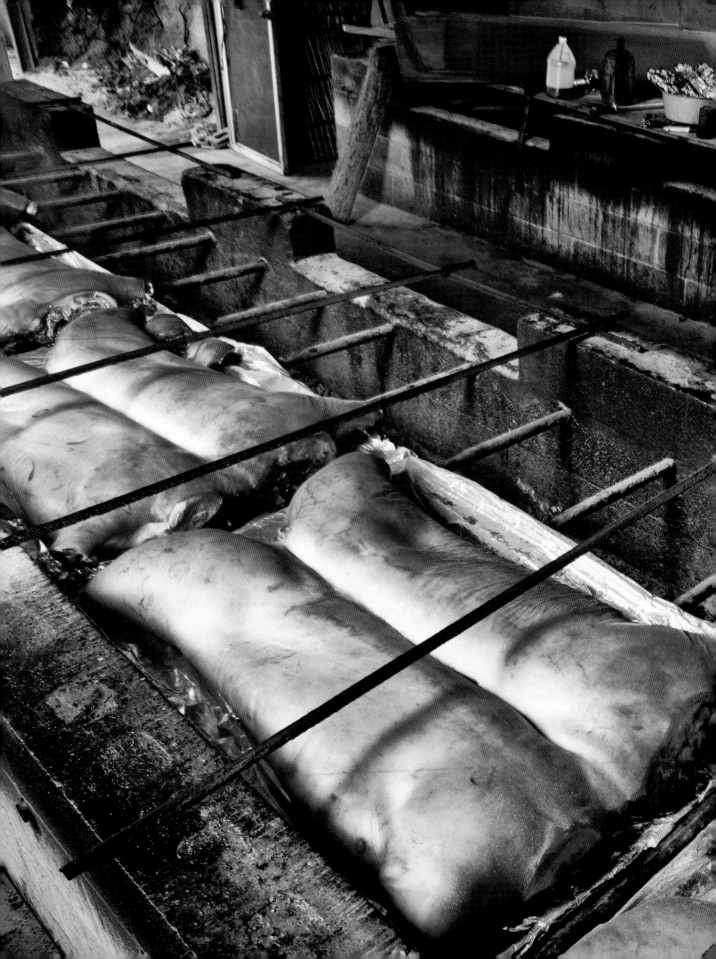

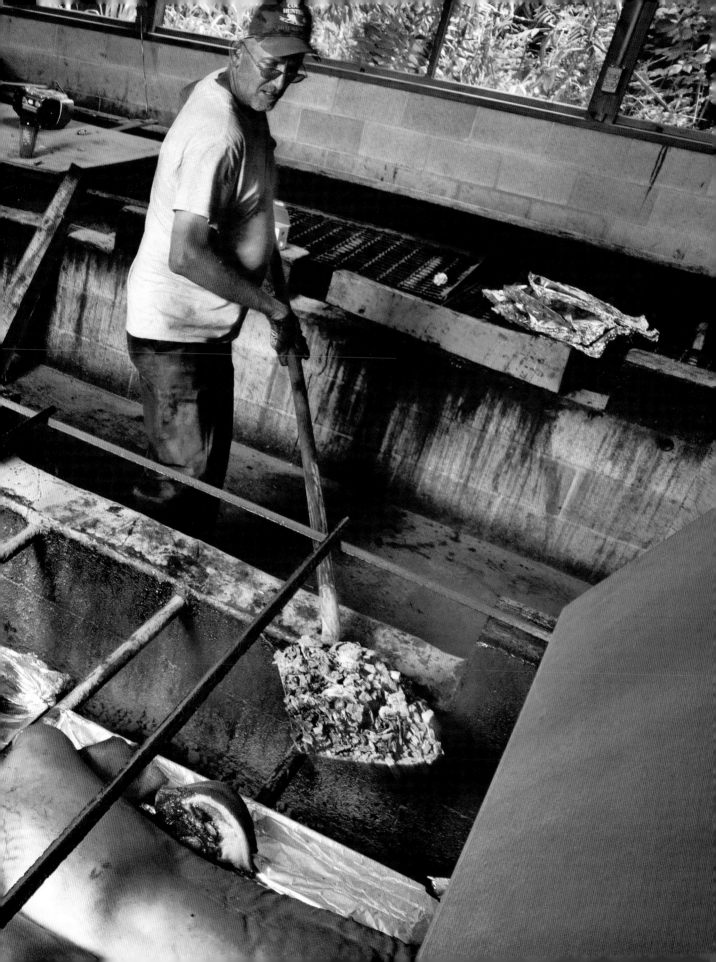

While we ate, Elliot chatted about western Tennessee barbecue. You couldn't beat the whole hog at Scott's-Parker's, he said, but the history of Tennessee barbecue went much deeper. Scott's-Parker's was practically a newcomer compared to some of the ancient barbecue spots down in Chester County, he said. Rufus and I set off down the road to see what we could find.

"When you travel the county, and smell the whole-hog barbecue being roasted over an open pit, you understand why Chester County is the self-proclaimed 'barbecue capitol of the world,'" reads an article on the Chester County Chamber of Commerce website. Community whole-hog barbecues in Chester County can be traced back to the early 1800s, according to the site. In the late 1970s, Chester County started an annual barbecue festival in Henderson to commemorate the region's barbecue history. Twenty-eight whole hogs were cooked at the event in 2011.

Jacks Creek Bar-B-Q, at the crossroads of Highway 100 and 22A in the town of Jacks Creek, has been around for some sixty years. It has a huge screened-in pit house out back behind the restaurant. It looked very impressive from the road. But on closer inspection, we found broken tables and chairs and other junk piled on top of a busted pit that hadn't been used in quite some time. Inside the restaurant, an electric barbecue cooker was in operation. Two high-school-age kids were gabbing behind the counter. There wasn't a single customer in the place. We walked out without ordering anything.

. . . we realized that we were documenting the end of the Southern barbecue culture that we once knew and loved.

As it turned out, there weren't any restaurants cooking whole hogs in Chester County, "the barbecue capitol of the world," anymore. This journey was supposed to be about documenting the wellsprings of Southern barbecue culture. Standing there at that rural crossroads in Tennessee, looking at the ruins of a brick pit behind a sixty-year-old barbecue joint that now roasted pork in an electric appliance, we realized that we were documenting the end of the Southern barbecue culture that we once knew and loved.

IN THE PREFACE of the paperback edition of *Southern Food: At Home, on the Road, in History*, Southern food historian John Egerton identified two opposing forces at work in Southern food culture. The reverence of folk foodways and the profusion of literature, recipes, and lore underscores the qualities of permanence. And the disappearance of old-fashioned techniques and landmark Southern restaurants reminds us how fast these things are fading into oblivion.

"Where else but the South could two such ambiguous and contradictory notions be harnessed to the same wagon, like a team of stubborn and independent mules pulling a load of corn?" Egerton asks.

In 1991, Egerton told a reporter that the barbecue pitmaster "represents the kind of pride in craft that is disappearing from all of American life." He went on to

say: "The fall of that art is synonymous for me with the fall of Western Civilization." Why is the artisan pitmaster that Egerton so admires disappearing? The practical explanation is supplied by an earlier work by Egerton, *The Americanization of Dixie*.

The South isn't rural anymore, Egerton explained in a chapter about agriculture. The statistics he cited when the book was written in 1974 are even more dramatic today. Twenty percent of Southerners lived on a farm in 1940—in 2008 it was something like 2 percent. With the drastic decrease in the number of farmers, the size of the average farm has increased. Agriculture has been taken over by giant corporations.

Barbecue has been cut off from its roots. The most ardent barbecue artisans complain to anyone who will listen that it just isn't possible to be a purist anymore. The rising price of hardwood and the industrialization of the pork industry have stymied any attempt to keep a barbecue joint (and by extension, Western civilization) running smoothly.

In the era of the family farm, hickory wood was taken for granted. Now it is a precious commodity in Tennessee, where it is made into ax handles, mallets, drumsticks, and all sorts of finished wood products. As the price of wood goes up, the number of barbecue joints that cook with nothing but wood goes down. The stainless-steel barbecue unit that uses a little bit of hickory wood and the assistance of a gas burner is a hell of a lot cheaper in the long run.

Pigs aren't as easy to come by as they once were, either—and they aren't as easy to lift. Ricky Parker can keep barbecuing whole hogs because he has established a relationship with a local pig farmer. Because he buys hundreds of pigs, Parker can afford to have the animals raised to his specifications, feeding them a special diet and killing them at a precise size and weight. His competitors have to rely on what the purveyors can supply.

It's hard to buy good barbecuing hogs at an auction barn anymore, Ricky Parker observed. In a region where pigs were once raised on every farm, hundred-pound shoats (young hogs) have become all but impossible to find. The pork industry has done a good job of satisfying the national demand for lean, inexpensive pork chops and loin roasts. But as the family farm and the local butcher were replaced by giant factory farms and centralized slaughterhouses, the animals got bigger. Pig-raising operations produce 280-pound behemoths that are too lean for slow-cooking and too big to fit on the pit.

The rest of the American livestock business went through the same sorts of changes. "Nobody cooked briskets in the old days," a retired Houston barbecue man named Harry Green told me. "I used to go down to the packinghouse and buy a front quarter of steer. I'd cut it up myself. It was a hell of a job." An average forequarter weighs more than a hundred pounds. A dressed shoulder clod alone weighs around thirty pounds. Lifting and dressing those cuts took brute strength.

In the 1960s, beef cutting was moved to centralized packinghouses, and Texas barbecue men didn't have to cut up the forequarters anymore. And for the first time, they had the opportunity to order the specific cuts they wanted to cook. Kreuz Market in Lockhart continued to cook whole shoulder clods. But most Texas barbecue joints began cooking briskets.

Walter Jetton, who put on more than a hundred barbecues for president Lyndon Johnson, advised amateurs who wanted to cook Texas style that brisket was the easiest piece of beef to barbecue. The large fat cap made it what Jetton called "a self-basting cut." Cooking shoulder roasts meant staying up all night and mopping the beef to keep it moist. Cooking briskets was easy; they mopped themselves as the fat cap melted and the pitmaster snoozed. The changes in the meatpacking business made it easier for artisans to barbecue beef.

Truth be told, using shoulders and Boston butts instead of whole hogs made things easier for those who barbecued pork, too. The difference was in the public perception. There was no tradition of barbecuing whole steers in Texas; the beef was generally cut into eight- to twelve-pound chunks before it was put on the pit. But the whole hog was emblematic of Tennessee barbecue culture, and the public remains skeptical of barbecue made of smaller parts.

THERE WASN'T MUCH REAL ESTATE development around the busy intersection of Highway 22 and State Route 100 in Reagan, Tennessee, but the owners of JD's Barbecue Barn figured it was an ideal place to sell takeout barbecue to hungry motorists. The red metal building looked like one of those prefab storage units people often put in their backyards.

Inside the front door of the tiny building there were three plastic tables, some racks filled with white bread and potato chips, and an opening where you ordered barbecue. It was a new take on the old tradition of roadside barbecue stands.

Alan Smith, the pitmaster that day, offered to give us a tour. He was a striking sixty-something guy, around six-three, who sported a full white beard. He said he came in only now and then, when the owner, Jeff Dill, wanted to take the day off. Smith confided that while he loved barbecue, his real passion was raising heritage Southern draft horses. He showed us a photo of himself standing in a logging sled and holding the reins of a team of huge Suffolk horses. In the photo, he is dressed in an old-fashioned teamster outfit. "The beard makes it look authentic, doesn't it?" he asked with a wink, stroking his facial hair.

Behind the storage-shed dining room was a much larger space enclosed by screens and housing two big metal barbecue pits. Outside the back door of the screened enclosure were fireplaces where hickory wood was burned down to coals. Alan Smith demonstrated how the coals were then transported in enormous shovels to the barbecue pits inside.

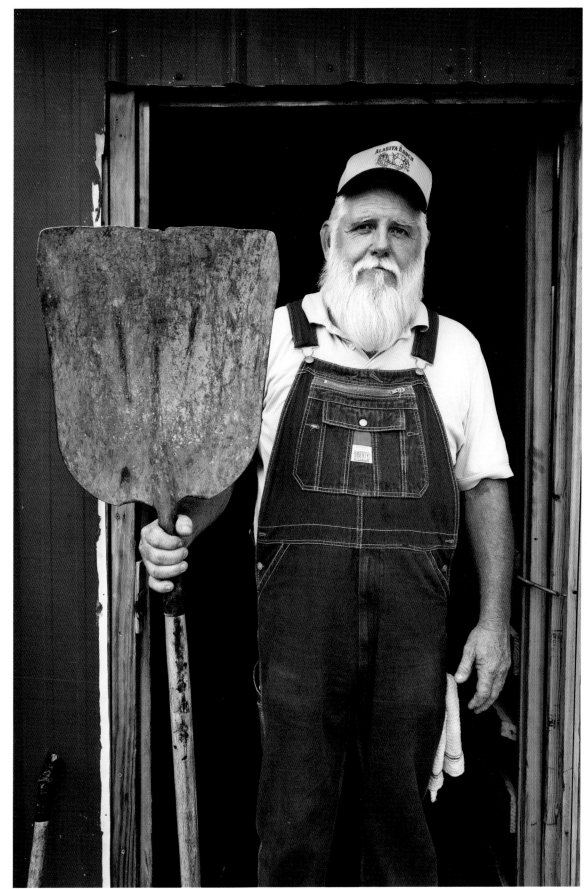

*Guest pitmaster
Alan Smith at
JD's Barbecue
Barn in Reagan,
Tennessee*

A local factory cuts hickory squares for drumsticks; rejected squares are sold to barbecue joints.

We were puzzled by the small, evenly cut hickory sticks in the woodpile near JD's fireplace. Smith explained that a factory nearby produced hickory squares for drumsticks. The company, Tennessee Hickory Drum Squares and Dowels, in nearby Adamsville, cuts seasoned hickory wood to specified lengths and sells the unfinished wood to woodworking shops, where it is made into drumsticks, mallets, and pepper mills. But many of the unfinished hickory squares are discarded because they contain knots or imperfections. JD's Barbecue, and several other local barbecue operations, stop by the factory and load up a trailer with the rejects. Because the wood is seasoned and cut into small pieces, it is very easy to burn.

From the road, JD's Barbecue Barn is one of the least impressive-looking establishments you can imagine. But the barbecue pits and fireplaces out back were beautifully designed and expertly tended. Inside the screened porch, Smith pulled some pork shoulder from the smoldering smoker and parked it on a big butcher block. There was a well in the middle of the wood from the constant use. Smith chopped the meat with a big meat cleaver.

Texas barbecue men are proud of their meat-slicing knives. In Tennessee, and most of the rest of the South, barbecue men are never far from a cleaver. And many practiced hands at the art of chopped pork wield their cleavers two at a time.

Below: Pork shoulders and hams are finely chopped, then the meats are mixed together and moistened with barbecue sauce for sandwiches.

Next page: Alan Smith wields a meat cleaver at JD's Barbecue Barn.

Smith cut off some ham and some shoulder, and then he chopped the meats together. When I asked him why, he explained that people around this part of Tennessee were used to eating whole hog. By mixing some of the white meat from the shoulder with the dark meat from the ham and then adding some spicy bark and crispy skin, you get a blend with flavors and textures that recall whole-hog barbecue, he said.

. . . the whole pit could be taken apart, like a kid's construction set.

The sandwich Smith made for us was excellent. At the cash register, I saw little plastic bags of fried pork skin for sale. "We cut up the leftover pork skin and fry it up," the cashier explained. I bought a bag of crispy pork skins to eat later. Rufus was horrified that I was going to get pork fat crumbs all over his car.

IT WAS LATE AFTERNOON when Rufus and I pulled up to Old Time BBQ in Henderson. The owner, Chris Siler, gave us a tour of the remarkable pit house out behind the main building. The barbecue pits lined both sides of a barnlike structure. They were constructed out of cinder blocks with no mortar—the whole pit could be taken apart, like a kid's construction set.

Chris Siler, owner of the Old Time BBQ in Henderson, Tennessee

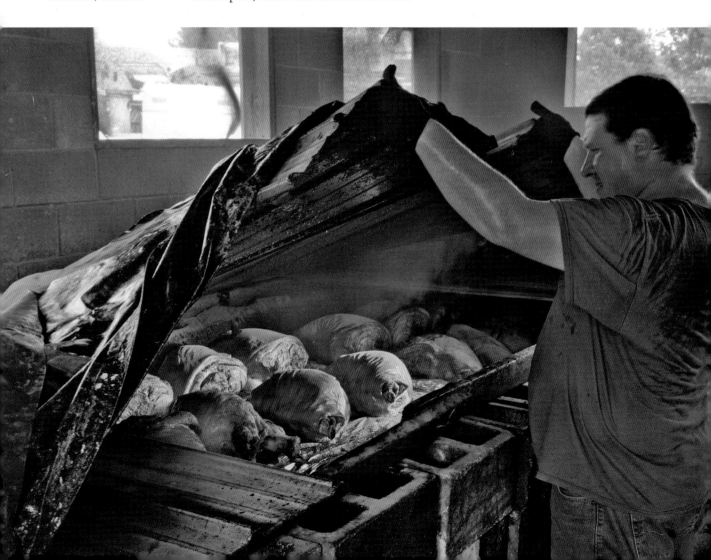

To add more coals to the meat that was cooking, Siler and his assistant started a fire and burned down some hickory wood. Then they took several of the cinder blocks out of the pit structure and set them aside. With long-handled shovels, they carried the coals from the fire to the opening in the cinder block pit and poured them in. Then they replaced the cinder blocks and moved down the line and took some blocks away at another spot. When they were finished shoveling coals, Siler moved the canvas covering from the top of the pit to let us see the pork shoulders and hams that were cooking.

When Siler took over Old Time BBQ, the sign in the front window read: "Whole Hog Pit BBQ." The restaurant's hours were "Open when the hog is on, Closed when the hog is gone." But the barbecue joint doesn't cook whole hogs anymore.

Siler had been working at Old Time BBQ for five years when the owner, a minister named Chad Sellers, was called away to do missionary work in Asia. Siler kept everything the same for the first few years, but by his own admission, he wasn't an experienced cook. A veteran pitmaster named Ronnie Hampton, who had been working at the place for decades, supervised the barbecuing of the hogs.

When Hampton retired, Siler took over, but he had trouble buying and cooking whole hogs. His decision to switch to shoulders and ham was difficult because of the history of the place, he told us.

Old Time BBQ is built on the site of a barbecue grove where hogs were cooked in earthen pits before the Civil War. Pits were dug and fired the night before, and the hogs were cooked through the night. Barbecue sauce was prepared in fifty-gallon cast-iron laundry pots.

Farmers from all over the area used the grove for their barbecue celebrations. Siler recalls hearing that a barbecue held for the annual reunion of the Trice family began around a hundred and fifty years ago. At times, the Trice reunion was attended by more than a thousand family members. A barbecue pavilion was erected in the grove, and later a restaurant was built.

May and Ruby Brewer currently own the Old Time BBQ building. "There has always been a barbecue place on this spot," the octogenarian Ruby Brewer told us when she stopped by. "And there will always be a barbecue business in this building while we own it."

The business was called Noble Barbecue when it was owned by a family of that name in the 1960s through the 1980s. During that period, the restaurant was used as a location in the movie *Walking Tall*, a biopic based on the life of a Tennessee sheriff named Buford Pusser. Siler recalls that the movie crew gave the place a fake name for the film. In its heyday, Noble Barbecue went through sixty to eighty whole hogs a week, Chris Siler said. The restaurant doesn't do nearly that much business now, and there aren't any whole hogs.

We went inside and sat down to sample the food. The dining room of Old Time BBQ was a depressingly modern expanse of fluorescent-lit Formica tables. Christian

music was piped through the sound system. We paid for a meal and sandwich at the cash register. Siler handed Rufus and me our plates. I got barbecued pork and chicken. The cook was proud of the fact that the meat was not seasoned in any way except by smoke. It was served with barbecue sauce and a side of red coleslaw made with the same sauce. It was my first experience with red slaw, and I winced when I tried it.

"It doesn't taste very good unless you eat it with the barbecue," Siler instructed. The bland pork and chicken were both undercooked. When Siler was called outside for a minute, Rufus and I dumped the contents of our plates into the trash can to avoid insulting the owner.

It's odd that a recently opened prefab storage unit in a gas-station parking lot is carrying on some semblance of the Tennessee barbecue tradition while the hundred-year-old barbecue joint has lost its way, I said to Rufus as we got in the car and headed for Alabama. In the rearview mirror, I thought I caught a glimpse of Egerton's twin mules pulling a corn wagon down the road.

Shaved Slaw

Because most barbecue joints make a lot of slaw, they grate the cabbage in a food processor. But at home, I like thinly sliced cabbage in my coleslaw. Shave the cabbage on a mandoline or the fine blade of a food processor if you like.

- ½ cup olive oil
- ¼ cup white vinegar
- ½ cup yellow prepared mustard
- 1 teaspoon salt
- 1 teaspoon ground black pepper
- 1 teaspoon celery seed
- 1 teaspoon celery salt
- 1 teaspoon sugar
- 1 medium head green cabbage, shaved

Combine the oil, vinegar, mustard, salt, pepper, celery seed, celery salt, and sugar. Toss with the cabbage until well mixed. Slaw wilts and loses volume, so the yield will be less than the amount of raw ingredients. Allow to mellow in the refrigerator overnight. *Makes about 8 cups.*

Red Slaw

- 8 cups finely chopped green cabbage
- 1½ cups Red Barbecue Sauce (p. 55)

You can chop the cabbage by hand if you like, but its much easier to chop it in batches in the food processor, pulsing eight or ten times until the shreds are the size of confetti. Then combine the cabbage and sauce in a medium mixing bowl and mix well with a wooden spoon or your hands. Refrigerate before serving in order to meld the flavors. Slaw wilts and loses volume, so the yield will be less than the amount of raw ingredients. Will keep in the refrigerator in a sealed container for up to 1 week. *Yields 6 cups.*

Country Potato Salad

Leave the eggs in big pieces if you like an old-fashioned-looking potato salad. You can also reserve one of the eggs and slice it thin to garnish the top.

- 8 russet potatoes
- 8 hard-boiled eggs, chopped
- 1 cup chopped onion
- 1 cup chopped celery
- 3 tablespoons chopped parsley
- 2 teaspoons celery seed
- 2 tablespoons mustard
- 2½ cups mayonnaise
- Salt and ground black pepper
- Paprika to garnish

Place the unpeeled potatoes in a large pot and pour in cold water to cover. Bring to a boil. Reduce the heat to low and simmer for 20 minutes, or until the potatoes are tender. Drain.

Peel the potatoes while still slightly hot and cut into chunks. Place the chunks in a large bowl and add the chopped eggs, onion, celery, parsley, celery seed, mustard, and mayonnaise, plus salt and pepper to taste. Mix well, then turn with a spatula into a decorative bowl. Garnish with a few dashes of paprika.

Serve chilled or at room temperature. *Serves 12.*

Barbecued Pork Picnics

- -

Boston butts, the bottom part of the pork shoulder, are easy to find at the grocery store. You will also sometimes find the top part of the shoulder, a cut known in the meat-cutting business as a "picnic." The picnic has a big piece of pig skin still attached and two large bones with the shoulder joint inside. The skin on the picnic keeps the meat very moist, but the large shoulder bones drastically reduce the yield. In other words, you get a lot more meat on a Boston butt than on a picnic, but picnic meat is juicier.

Some pitmasters cook picnics instead of Boston butts because they are so much moister. You can also cook picnics, butts, and hams at the same time and chop the meats together to approximate the texture of a whole hog.

- 1 pork picnic, about 8 pounds
- 6 tablespoons Pork Rub (p. 50)
- 2 onions, peeled
- 1 quart Hog Mop (p. 53)
- 2 cups Red Barbecue Sauce
- Salt and pepper to taste

Season the meat with the dry rub, pressing the spice mix into the meat, and refrigerate it overnight. Cut the onions in half and put them in the water pan. (If your barbecue didn't come with a water pan, use a fireproof steel bowl.) Add water to fill the pan.

Set up your pit for indirect heat with a water pan. Use hardwood lump charcoal or charcoal briquettes. Maintain a temperature between 225° and 275°F. Place the meat in the smoker skin side down. The skin will shrink and harden, serving as a bowl to contain the fat and juice. You might rotate the roast from end to end to achieve more even cooking, but don't turn it over; keep it skin side down or all the juices will run out.

Replenish the charcoal and the water in the water pan as needed. Mop the meat whenever you open the lid. Expect a cooking time of eight hours—more if you raise the lid often or the fire goes out. For chopped pork you need to reach an internal temperature of 190°F. For pulled pork an internal temperature of 200°F is best.

When the meat is done, allow it to rest for at least fifteen minutes. Then remove the skin and bones. For chopped pork, put the meat and fat on a chopping block and mince with a pair of meat cleavers. For pulled pork, pull the meat away from the bone and shred it into little pieces, massaging the big chunks of fat into the shredded meat. Chop any pieces that don't come apart easily. Season the meat with salt and pepper and your favorite barbecue sauce.

Serve the minced or shredded meat on sandwiches (see Barbecued Pork Sandwiches, below). *Serves 8 to 10.*

Barbecued Pork Sandwiches

- -

Most barbecue joints serve their chopped pork sandwiches on a hamburger bun. Since hamburger buns range in size from 3½ to 5 inches in diameter, the amount of meat varies. Figure a quarter pound of meat for a small bun and a third of a pound for a large bun.

You can use chopped or pulled pork from the Barbecued Pork Picnic recipe (p. 88) or any of the other barbecued pork recipes in the book.

- 3–4 hamburger buns
- 1 pound pulled or chopped pork
- 1 cup Red Barbecue Sauce
- Shaved Slaw or Memphis Mustard Slaw

Toast the buns. Mix the pork with half the sauce. Divide the meat among the hamburger buns. Add additional sauce to the pork. Top with slaw. Serve immediately.

Makes 4 quarter-pound sandwiches or 3 third-pound sandwiches.

Sandwiches at Scott's-Parker's Barbecue in Lexington, Tennessee

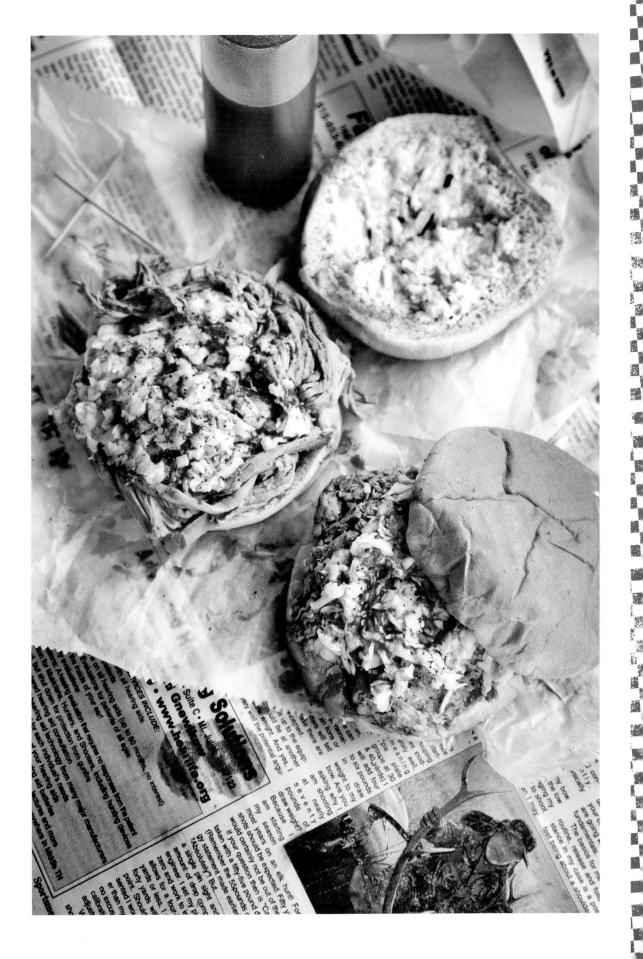

6

FAST FOOD AND
SLOW FOOD

TENNESSEE WAS IN THE REARVIEW MIRROR and Rufus's home state was before us. We had scouted the small towns of southeastern Tennessee en route to Alabama, but all we found was another famous barbecue joint that had abandoned its old-fashioned hickory pits for stainless-steel barbecue ovens. We decided to spend the night in Muscle Shoals, and we congratulated ourselves on getting to Brooks Barbecue on Union Avenue for a late dinner before it closed.

At the front counter, the manager of the barbecue joint was none too friendly. Rufus asked whether he could take a photo of the brick chimney behind the restaurant. The chimney was badly damaged, and part of it was falling down. The manager said, "No photos."

So we got a couple of sandwiches and some sweet potato pie to go. When we got back to the car, I tore the paper bags and then set out a picnic on the hood of the Element. As a longtime food blogger and taco truck scout, I had always considered a car hood the perfect combination of picnic table and photo studio. But by the look on Rufus's face, I could see that he wasn't on the same page.

There was grease all over his car hood, he pointed out. Then I remembered the towel draped over my seat, and I realized that Rufus's relationship with his vehicle wasn't like my relationship with mine. I pictured Rufus in his driveway on a sunny Saturday afternoon, lovingly waxing his Honda Element. Oh well, it was too late to worry about staining the car hood now, so I suggested to Rufus that he might as well take some photos.

Sweet potato pie on the hood
of the Honda Element

I was thinking he would just grab a camera and bang out a couple of snapshots in the fading light. Which goes to show how little I know about serious photography. Rufus got out a tripod, a light with an umbrella shade, and a battery pack and set about lighting the smushed barbecue sandwiches and torn-paper-bag pie plate on the car hood. I thought about that Carl's Jr. commercial with Paris Hilton seductively eating burgers while draped on a car hood. Too bad Paris Hilton wasn't handy, because Rufus would have been all set. As the equipment was getting set up, curious residents from the neighborhood began to congregate to see what we were up to.

When Rufus started shooting, a patron of the restaurant approached us as an emissary to reiterate the establishment's prohibition on photography. I assured him that we were taking photos only of food we had purchased and the hood of our own car. Rufus showed him the shots on the camera's video display to prove that our subject matter didn't include the restaurant itself.

When Rufus was done, we ate the food. The sandwich was all right, but the sweet potato pie was spectacular. Sweet potato pie looks a lot like pumpkin pie and is often seasoned with the same cinnamon, nutmeg, and ground clove "pumpkin pie spice" mix. But while pumpkin pie is almost always made with canned pumpkin, sweet potato pie is most often made with freshly cooked sweet potatoes—and that makes the chunky filling a lot more satisfying.

Marvin Brooks, owner of Brooks Barbecue in Muscle Shoals, Alabama

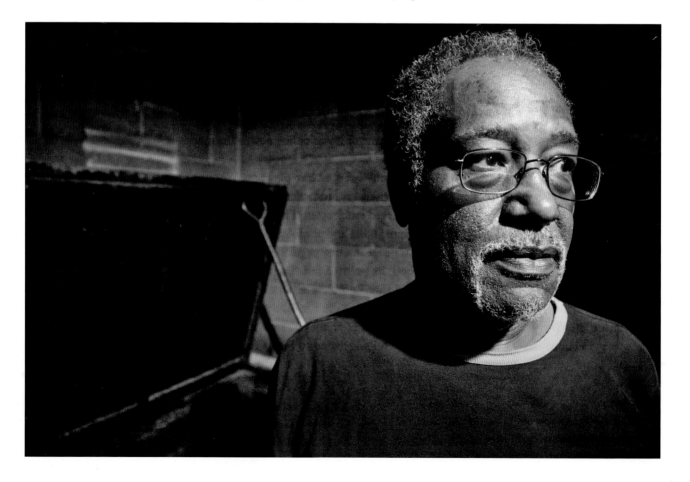

While we were shooting, the restaurant's owner, Marvin Brooks, arrived. Mr. Brooks was a soft-spoken, kindly man. He and the restaurant's manager were worried that we were with some governmental agency that had come to document the disrepair of the building's chimney. We assured him that we weren't with the health department or the building inspector's office and that we would leave the chimney out of our photos.

While he was there, Rufus suggested that Marvin Brooks should pose for a portrait.

Given the angry reception we had received thus far, I was surprised when the barbecue man agreed. When we discussed a spot to take the photo, Mr. Brooks led us through the dining room to a door that led to the pit room in the back of the restaurant. The pits where the meat cooked were long, low-slung cinder-block enclosures about waist high with metal lids. The brick chimney was built over a fireplace where hardwood was burned down to coals.

The restaurant had a tall A-frame design; the fireplace had been added on later. Brooks said it was a former fast-food restaurant that had been turned into a barbecue joint in the 1960s. He bought the place in 1985 and wasn't sure who had owned it before or what kind of fast food was once sold there.

THE ORIGINAL MCDONALD'S on Route 66 in San Bernardino, California, was a barbecue joint when it opened in 1940. Had brothers Dick and Maurice "Mac" McDonald been a little better at making chopped pork sandwiches, they might never have switched over to burgers. The evolution of this California barbecue joint into the mother of all fast-food franchises explains a lot about what happened to American food culture over the last fifty years.

Barbecue was king at roadside restaurants in the 1940s. But competition was fierce. The McDonald brothers were barely breaking even. And the tastes of suburban teens in affluent Southern California were changing. The kids made burgers, fries, and shakes emblematic of the 1950s *Happy Days* youth culture while they ignored the rest of the original McDonald's menu, which included tamales, chili, and ham sandwiches, along with barbecue.

The McDonald brothers concluded that the extensive inventory and the higher labor costs associated with slow-smoking barbecue and employing carhops were driving their costs up. So they decided to try a radical experiment. They closed the restaurant down for three months in the fall of 1948 and started over.

Henry Ford's invention of the assembly line was an inspiration to businessmen in the early days of the automotive era. Entrepreneurs were looking for artisan products that could be made more lucrative by applying the mass-production model. The McDonald brothers were among the first to attempt an assembly-line approach to food service. They called their process the "Speedee Service System."

The McDonalds pared their menu down to burgers, shakes, and fries. They standardized the application of condiments so that each burger came out exactly the same. They premade the hamburgers and sold them for fifteen cents, around half of what a burger or barbecue sandwich cost at most other drive-ins at the time. The carhops were replaced by a walk-up window to cut labor costs. The china plates were replaced by inexpensive paper wrappers.

The fast, cheap hamburgers were a sensation. By the early 1950s, the brothers had sold eight franchises.

A salesman named Ray Kroc called on McDonald's in 1954. He worked for Prince Castle, a company that sold a milkshake blender that could make five shakes at once. He went to McDonald's to try to figure out why the restaurant chain was buying so many of his blenders.

When he got there, he was so fascinated by the potential of the assembly-line approach to food service that he quit his job and built a McDonald's franchise in the suburbs of Chicago—the first franchise outside California. Kroc bought out the McDonald brothers and quickly turned the company into the leading prototype of a fast-food franchise operation. The chain had sold its 100 millionth burger by 1958 and had 100 restaurants by 1959.

The switchover from slow-cooked barbecue to mass-produced burgers also figured in the creation of the Wendy's chain. Like the McDonald brothers, Dave Thomas, the founder of Wendy's, once sold barbecue at his Hobby House restaurant in Evansville, Indiana. And like the McDonald brothers, Thomas realized that he was trying to please too many people with too many different items on his wide-ranging menu. After a stint with the Kentucky Fried Chicken chain, he went on to found his own fast-food empire in 1969.

To achieve consistency across locations, the fast-food franchise model relied on a centralized supply of standardized ingredients and partially precooked products. The meat patties were machine formed, precisely weighed, and frozen. The potatoes were grown to McDonald's specifications, then cut and frozen at the McDonald's plant.

As fast-food sales skyrocketed, the American agriculture and meat-processing industries were transformed. McDonald's is the nation's largest beef buyer. In its early years, the chain bought beef from a variety of processing plants around the country. Last year, the nation's largest beef purchaser bought meat from only four plants. Those four plants, which produced around 20 percent of the nation's beef in 1970, now produce 85 percent of all the beef sold in America.

Assembly lines and mass production made automobiles, radios, television sets, and countless other products affordable for average Americans. No one saw any problem with applying the same manufacturing know-how to food service; in fact, it seemed downright patriotic. The lower prices were irresistible. The novelty of

eating in the car became part of the new automotive culture. It seemed especially fitting to grab a bag of burgers on the way to the drive-in theater or before an excursion in the country.

The interstate highway system, which was authorized in 1956 and completed in 1985, diverted traffic away from the barbecue joints that had been built on popular motorways in the early days of the automotive era. Now motorists exited the highway right into the parking lots of fast-food franchises.

During the same period, cattlemen took advantage of the highway system and cheap grain prices to create a national system of feedlots and slaughterhouses. By 1963, 66 percent of the steers slaughtered in the United States were fattened with grain. Pork consumption declined from eighty-one pounds a person in 1944 to forty-three pounds a person in 1975 as American tastes shifted toward beef.

Although barbecue never disappeared, over the last thirty years it evolved into a specialized food that only a few people sought out and enjoyed.

Some believe the fast-food restaurant industry has passed its peak. Currently, the more than 200,000 fast-food restaurants in the United States generate some $160 billion in income, around 30 percent of total restaurant-industry sales. But the steamroller seems to be slowing down. Market saturation, rising commodity prices, and negative press about the health consequences of fast food—generated by books like Eric Schlosser's *Fast Food Nation* and the movie *Super Size Me*—are resulting in stagnating or falling profits for some chains.

Although barbecue never disappeared, over the last thirty years it evolved into a specialized food that only a few people sought out and enjoyed. Writers like Calvin Trillin kept the spark of barbecue culture alive by writing about American folk foods during the 1970s. Trillin has often reiterated the claim that the best restaurant in America was Arthur Bryant's Barbecue in the author's hometown, Kansas City.

Sometime in the 1980s, a barbecue revival began to take shape. It started with newspaper and magazine articles about old barbecue joints. And it gathered steam at barbecue festivals and cook-offs in the mid-1980s. By the 1990s, new barbecue restaurants were opening all across the South. While barbecue will never dominate the culinary landscape as it did in the days before the interstate and McDonald's came along, it has pulled out of its long slump.

Unfortunately, America's oldest artisan food tradition had to make some sacrifices to compete with fast food. Most new-generation barbecue restaurants cook with automated stainless-steel barbecue ovens—not wood-fired pits.

WE SPENT THREE DAYS AND NIGHTS driving around Alabama while based at the Lovett family home in Jacksonville with Rufus's dad, Opal Lovett, better known as the "Big O." Friends, neighbors, and members of the Lovett family had fond memories of old barbecue joints, which we dutifully called on the phone. Most of them

The barbecue pit building at the Glencoe Masonic Lodge in Gasden, Alabama

had converted to gas or electric cookers over the years. No doubt many of them still carried on old family traditions. But it was the remaining wood-fired pits we wanted to document.

North Carolina and Texas make a big deal about their old-fashioned barbecue pits, and those places get a lot of national attention. But the treasure trove of barbecue joints in Alabama came as a shock to me, and so did the variety of shapes and sizes they came in. As a native of Alabama, Rufus adopted a bemused, "I told you so" attitude about the state's unsung barbecue glory.

One morning we headed for Tuscaloosa, but ended up making two unexpected stops. I made Rufus turn around when I saw a massive barbecue pit at the Glencoe Masonic Lodge in Gadsden. We pulled open the wooden shutters and looked inside at one of the finest pit houses we had ever seen. There was a massive fireplace fed from an opening on the outside. Inside there were two long pits. Above, a series of crisscrossed wooden rafters left big spaces in the roof for the smoke to escape. I looked unsuccessfully for information about when the Masonic Lodge held their barbecues, but the encounter with a community barbecue hall that dwarfed any restaurant would prove prophetic.

The other stop was at another converted fast-food joint called Liz's Homestyle Bar-B-Que. We were driving down a street in Gadsden when we saw a cloud of smoke. We dropped our plans and followed our noses. The scent of pork and hickory led us to the corner of Broad Street and Stroud Avenue. There we found Carolyn Shealy and her husband, Charles Dobbins, cooking Boston butts on a portable pit set up behind the restaurant. After poking my head inside, I wondered why they were using a small metal barbecue unit out in the parking lot when they had a big brick pit with a chimney built into the kitchen. "Come back around this afternoon and you'll see why," Dobbins said.

Rufus and I stopped back by Liz's that afternoon to sample the food. It was a particularly hot summer, and in the one-hundred-degree heat of the August afternoon we didn't spend long looking around the kitchen. Dobbins was doing the heavy cooking outside and using the indoor pit as a holding oven to keep from heating the place up any more than necessary. As long as the health department didn't come by, the system made sense.

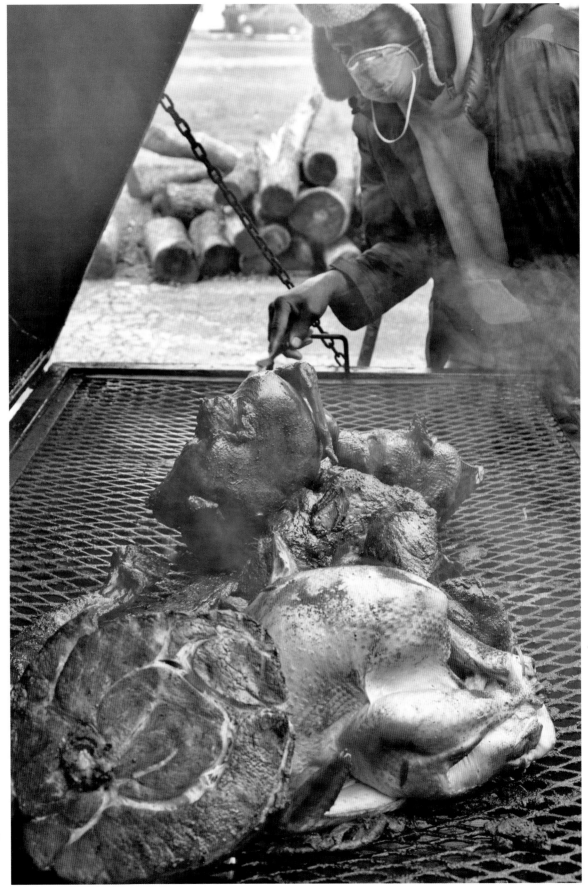

Charles Dobbins at the grill at Liz's Homestyle Bar-B-Que

Liz's Homestyle Bar-B-Que was another former fast-food restaurant with a stout brick chimney pit built into the side of it. Like Brooks Barbecue, the current owners took it over after it had already been converted.

"The business has been open for twenty-five years, sixteen at this location," Carolyn Shealy said. "The building was a Dairy Queen in the 1950s. Someone added the pit and turned it into a barbecue restaurant in the 1970s. My mom, Liz Leach, bought the place and ran it for years." Shealy's daughter Angelicia Leach helped her run the kitchen, and her granddaughter Kendra Leach covered the cash register. When I remarked that it was wonderful to see three generations working together, Carolyn said, "It was four generations until a couple of months ago when mom died."

I ordered a sandwich and sat down at one of the two tables in the front—it was more a place to wait for to-go orders than a dining room. A display case full of baseball and other sports trophies took up most of the space. There were also two gumball machines and a very old television. A miniature galvanized tin bucket with the slogan "It's a Barbecue Thing" sat on top of the counter.

Liz's sliced pork sandwich was served on a hamburger bun with a thick, sweet barbecue sauce. Instead of slaw, the sandwich was topped with dill pickle chips and a big leaf of iceberg lettuce. It was a delicious change of pace. The crunch of the

Carolyn Shealy (foreground), granddaughter Kendra Leach (left), and daughter Angelicia Leach (right) run fourth-generation Liz's Homestyle Bar-B-Que in Gadsden Alabama. Founder Liz Leach passed away a few months earlier.

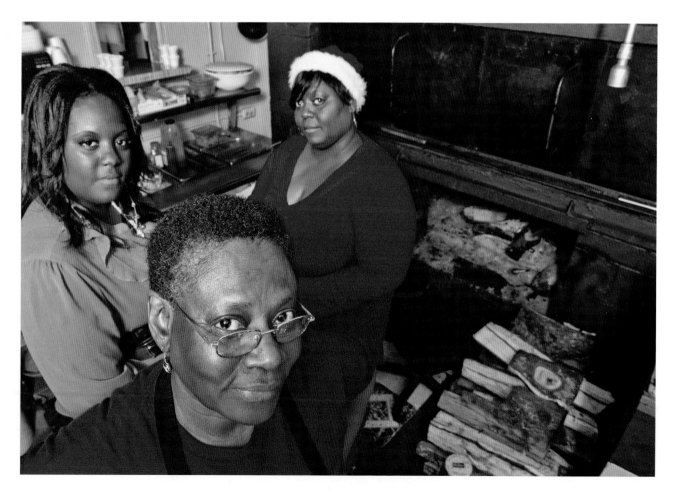

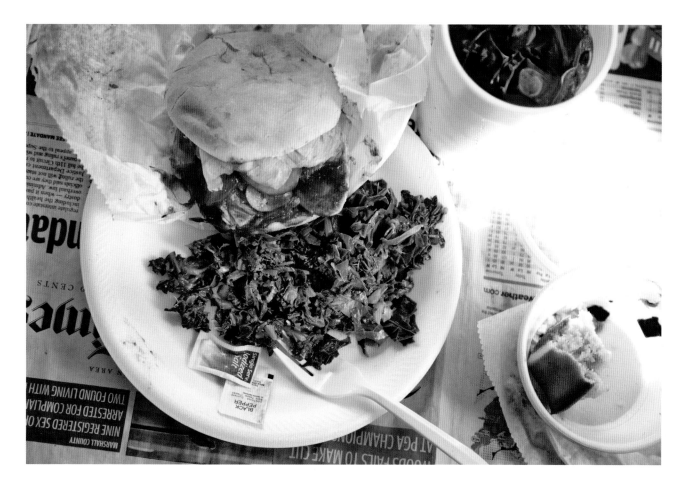

Chopped pork sandwich topped with lettuce and pickles and served with mustard greens and cornbread on the side at Liz's Homestyle Bar-B-Que

iceberg was a wonderful contrast to the creamy chopped pork. I wish more barbecue joints offered iceberg instead of slaw. I got chopped and stewed mustard greens with cornbread on the side, which was another pleasant departure. The greens were sweetened with sugar, just like the ones I had at Baby J's. The other available sides included beans and okra.

Another morning we pulled into the parking lot of Big Bob Gibson's, in Decatur, to watch the legendary "white chicken" being made. We were just in time. The chickens served at lunch have to be on the smoker early in the morning. The butterflied chickens cook over hickory coals for an hour and a half, bone side down, then, when the skin is golden brown, they get turned over to cook another hour and a half until they pass the leg-wiggle test (a little resistance, but not too loose). Finally, the chickens get dipped in Big Bob Gibson's famous white barbecue sauce and cut into quarters.

Chris Lily is the author of the bestseller, *Big Bob Gibson's BBQ Book: Recipes and Secrets from a Legendary Barbecue Joint*. I bought a copy and asked Lily to autograph it. The book starts with a biography of Robert Gibson and a history of the business, including lots of old black-and-white photos of Gibson. The northern Alabama

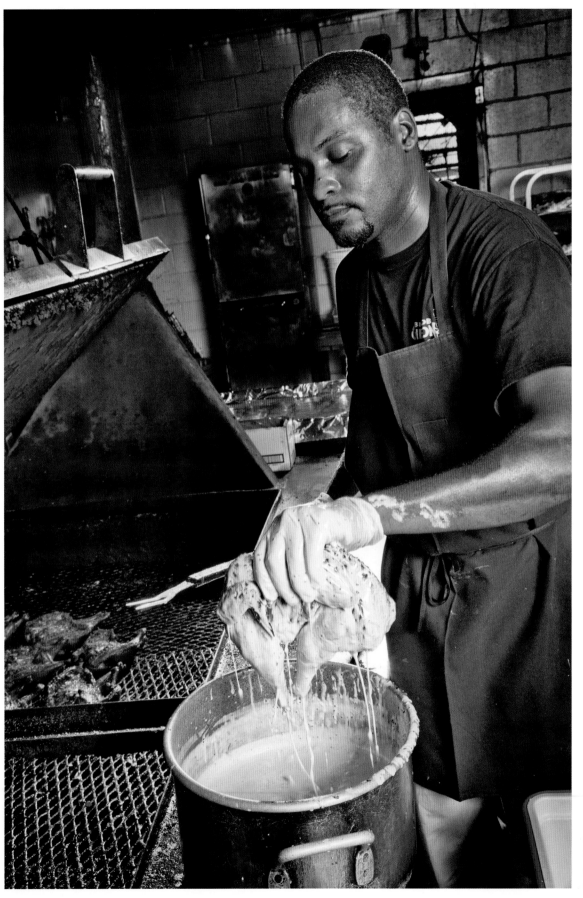

Dipping chickens in white barbecue sauce at Big Bob Gibson's in Decatur, Alabama

railroad worker stood six-three and weighed more than 300 pounds, so it's not hard to figure out where he got his nickname.

Outside Decatur, the Gibson family tended a small farm where Bob Gibson often cooked barbecue in an earthen pit. He had a knack for it, and became locally famous. Gibson and a partner named Sam Woodall opened Gib-All's barbecue stand on Moulton Road in Decatur in 1925. The first restaurant pit was a low, coffin-style enclosure with double-brick walls, a red clay floor, and corrugated metal sheets for a lid. Every week two feet of clay, along with all the grease and ashes, was shoveled out of the pit and replaced with fresh clay.

The menu at Gibson's first restaurant included barbecued pork, chicken, Brunswick stew (a thick concoction of vegetables, meats, and offal), Golden Flake potato chips, and coleslaw. Big Bob seasoned his pork shoulders with a generous amount of salt and nothing else. The chicken was seasoned with salt and pepper. It was the cooking method, not the spices, that produced the distinctive flavor of his barbecue. "The greatness of a pitmaster is directly proportional to the size of his ashpile" reads one quote in Chris Lily's cookbook.

When Woodall went off to work with his brother, Big Bob took over on his own, opening and closing several different locations. In 1952 he opened his famous 6th Avenue location in Decatur. The restaurant burned down in 1988; the current location is right next door. The original neon sign was saved and still stands out front.

In the early 1960s, Big Bob Gibson was the caterer of choice for company picnics in Decatur. For big companies like Monsanto, he would cook for 2,000–3,000 people. Such giant community barbecues were common throughout the South at the time. As Big Bob Gibson's grew, his children and grandchildren came to work at the restaurant.

Gibson's grandson Don McLemore started working at the restaurant in 1972, a year before Bob Gibson died. McLemore is a notorious barbecue hound. The first time I met him, he had just returned from a tour of Texas barbecue joints. Big Bob added beef to the menu of his barbecue joint in the 1940s. After his first tour of Texas, McLemore switched from the beef round that Big Bob Gibson used to beef brisket. McLemore and his son-in-law Chris Lily perfected their beef brisket technique while competing in barbecue cook-offs.

The front door to the dining room of Big Bob Gibson's on 6th Avenue in Decatur is an obstacle course of enormous barbecue trophies. Big Bob Gibson's cook-off team was the 2011 winner of the Grand Champion trophy at the Memphis in May barbecue cook-off; they have also won the shoulder competition more than half a dozen times.

When the restaurant opened at eleven, Rufus and I sat down to a large lunch. We shared "Big Bob's Colossal Bar-B-Q Stuffed Potato," a jumbo russet fully dressed with butter, sour cream, smoked bacon, chives, and cheddar cheese, topped with a pile of barbecued pork shoulder and barbecue sauce; we also sampled the famous barbecued chicken.

There was a bottle of Big Bob Gibson's "Original" white barbecue sauce on the table. After taking a few bites of the remarkable chicken, I poured out a pool of the white sauce and used it for a dip. Mayonnaise, horseradish, and vinegar make a wonderful sauce; I thought about what a terrific chicken salad you could make with the leftovers. We also sampled the restaurant's famous coconut pie.

Touring the pit room in back of the restaurant, I was shocked to discover a stainless-steel barbecue oven sitting beside the long low pits where the chicken is cooked. "It's a Southern Pride," Chris Lily said when I asked him about it. I suppose I shouldn't have been so surprised. Kreuz Market, the iconic German meat-market barbecue in Lockhart, Texas, installed an electric-heated smoker for sausage production when it moved to its new location. City Market in Luling, the Salt Lick in Driftwood, and countless other iconic barbecue restaurants around the country have added stainless-steel barbecue ovens, too.

In the old days, restaurant owners hung a Sold Out sign on the door and went home when they ran out of barbecue.

A barbecue restaurant can cook only so much meat on an old-fashioned pit before reaching full capacity. In the old days, restaurant owners hung a Sold Out sign on the door and went home when they ran out of barbecue. Today, even the most traditional barbecue restaurants are installing automated barbecue ovens in order to increase their capacity. Southern Pride and Ole Hickory Pits are the two most popular brands.

Big Bob Gibson's has entered the franchising business, which is no doubt a big reason for the addition of the Southern Pride barbecue unit. It would be hard to sell franchisees on the need for automated ovens if the original didn't operate one too.

HIGH TECHNOLOGY AND BARBECUE got hooked up at a gambling den in the East Side neighborhood of Houston in the late 1940s when a machinist named Leonard D. McNeill won a small barbecue joint called the Lenox Cafe in a game of craps. McNeill, who worked at Hughes Tools Company, had never run a restaurant before, but he had some big ideas.

It was the era of the giant Texas barbecue, and McNeill was soon competing with the biggest. By the 1960s, McNeill was catering barbecues for thousands of guests at a time. Along with Walter Jetton of Fort Worth, he was one of the state's top two barbecue caterers. In 1967 Ann Valentine, the food editor of the *Houston Post*, wrote an article titled "Barbecue Barons" about those two mega-caterers. At the time, Jetton held the record for the biggest barbecue, having fed 12,000 people at one event.

McNeill could cook mountains of barbecue in open pits, just like his contemporaries, but unlike them, he could also see there wasn't any future in it. The outdoor pits were running into problems with sanitary standards. Sooner or later, a more modern method of barbecuing would have to be found. With one giant step, McNeill took barbecue straight from a hole in the ground into the era of mechanization.

McNeill bought an enormous bread-rising oven from Rainbo Bread. The oven had a rotating mechanism inside that moved the loaves through a timed cycle. McNeill converted the machinery into a wood-smoke rotisserie that could cook 3,000 pounds of meat at one time.

Today the old Lenox Bar-B-Q restaurant where McNeill got his start uses three rotisserie ovens of a type patented in 1967 by Herbert Oyler, of Mesquite. Oyler, another Texas barbecue restaurant owner, tinkered with a smoker-rotisserie made from a bread-rising oven, too. Whether he was working independently or in cooperation with McNeill is unknown.

Oyler's invention is a steel barbecue pit with a rotisserie inside. It has an electric carousel, but no heating elements. It is fueled exclusively with wood, which burns in a remote firebox. The advantage of the rotisserie is that while the meat is getting basted with dripping fat, it is cooked with pure wood smoke. It wasn't exactly an old-fashioned barbecue pit, but the results still depended on time, temperature, and the talents of the pit boss.

In the 1970s, the patent to Herbert Oyler's barbecue pit was acquired by J&R Manufacturing in Dallas. The company still produces the original Oyler wood-fired smokers, along with an automated pit with electrical heating elements, convection fans, and computerized humidity control. A. N. Bewley Fabricators in Dallas makes a similar wood-burning pit.

Next page: Chicken on the wood-burning pit at Big Bob Gibson's in Decatur, Alabama. As in Texas, Alabama barbecue is often cooked with hardwood logs rather than burned-down coals.

Southern Pride began selling barbecue ovens in 1976. The company was founded by Mike Robertson, a Decatur, Illinois, restaurant owner, and his father, B. B. Robertson. Headquartered in Marion, Illinois, the company eventually built a factory in Alamo, Tennessee, thereby substantiating its claim to be "Southern." Southern Pride automated barbecue ovens are used in thirteen of the fourteen top-grossing barbecue restaurants in America, according to the company's website.

There are many models of Southern Pride barbecue units, which come in electric, gas, and portable designs. The biggest units are stainless-steel boxes with a gas-fired heat source and a gas-ignition firebox that holds a couple of logs, an electric rotisserie to rotate the meat, a convection fan, and a "Subterthermic flue" that retards smoke emissions. The flue reduces wood use to the point that an entire day's barbecue can be cooked with only two fireplace-sized logs, the website brags.

Ole Hickory Pits is located in Cape Girardeau, Missouri. The company operates the Port Cape Girardeau Restaurant, a restaurant overlooking the Mississippi River that specializes in pork ribs. The original wood-fired pit at the restaurant was built in 1974. After it caught fire several times, the owners designed an automated barbecue oven. David B. Knight, the company founder, is active on the barbecue cook-off circuit. Ole Hickory Pits can be operated with a combination of gas and wood, with gas only, or with wood only.

Very few barbecue restaurants opening today opt to build wood-fired barbecue pits. Given the cheaper operating and labor costs of the automated ovens, and the obstacles that government bureaucracies have put in the way of building wood-fired pits, it's easy to understand why. I met one restaurant owner who got around health department regulations by installing a small Southern Pride unit in his kitchen to pass inspection, and then secretly added a wood-fired pit in a fenced-off enclosure out back. But the subterfuge is usually the other way around.

Don't assume that a large woodpile means pit-fired barbecue. Some barbecue franchises stack cords of wood beside brick chimneys on the outside and operate fireplaces to create the smell of hickory smoke. Meanwhile, the restaurant is cooking meat in a stainless-steel oven inside. Other stainless-steel barbecue restaurants run a token wood-fired pit for appearance' sake and so they can say: "Yes, we barbecue on a real wood-fired pit."

The public wants wood-fired pit barbecue, but environmental, health, zoning, and building-code regulations make it nearly impossible to build new wood-fired pits. And so the stainless-steel barbecue ovens have taken over. And they have made barbecue easy. It takes years, even decades, to teach a pitmaster the craft of barbecue. But any high school kid can load a Southern Pride and push the button. The automated stainless-steel ovens provide barbecue restaurants with the same sort of mass-production capability that made the fast-food industry possible.

Labor costs, training costs, and wood costs were dramatically reduced by automated ovens—which made the franchising of barbecue restaurants possible.

Barbecue chains like Sonny's Real Pit BBQ in Florida, which currently has ninety-seven locations, began franchising in 1977, shortly after the first automated ovens were introduced.

These high-tech gas-fired ovens are designed to replicate the flavor of old-fashioned barbecue pits, and in some cases they do an adequate job. Ribs and sausage have a high enough ratio of surface area to weight for these ovens to give them a smoky flavor. But the virtual barbecue pits just don't put out enough smoke for heavier cuts like brisket or pork shoulder. And even the quality of the ribs and sausage pales in comparison to the taste of artisan barbecue.

When I talk about the disappearance of "artisan barbecue," I am referring to the loss of the pitmasters' craft . . .

No doubt old-time pitmasters find this talk of "artisan food" strange. And it's hard to blame them. The food term "artisanal" first appeared in 1983 in a *New York Times* story about an "earthy, artisanal, sourdough baguette, made according to old-fashioned rules and standards." Thirty years later, Domino's and Wendy's were using "artisan" to describe their fast food. When I talk about the disappearance of "artisan barbecue," I am referring to the loss of the pitmasters' craft that Egerton described.

The word "artisan" is easily understood by my generation, the kids who grew up on Wonder bread, Swanson frozen dinners, and Chef Boyardee canned spaghetti. This highly processed and packaged food was the stuff in our pantry and our refrigerator, the stuff we saw advertised on television. When the "artisan food" trend emerged in the 1980s, processed food was so ubiquitous that handmade farm cheeses, crusty irregular breads, charcuterie, and homemade pickles seemed exotic and wonderful.

My mother, who is now a great-grandmother, has watched the entire cycle go around. When she started school, just after World War II, she wanted Heinz pickles, not the kind the family kept in Mason jars down in the basement. My mother begged my grandmother, who was an immigrant from Eastern Europe, to stop baking homemade bread and buy packaged white bread. All the cool kids had sandwiches made on store-bought bread. And it was assumed that families who sent their kids to school with sandwiches made on homemade bread couldn't afford to buy bread at the store.

Today, food writers praise chefs who make pickles, ketchup, mayonnaise, and mustard in their own kitchens instead of buying prepared products. Canning and preserving local produce is considered cutting edge by the locavore ("eat local") movement. And families who send their kids to school with sandwiches made on packaged white bread are assumed to be too poor to afford artisanal bread.

Perhaps the same cycle has gone around for the roadside restaurant. Cheap hamburgers replaced barbecue when the drive-in restaurant defined youth culture. Now growth in the fast-food industry has begun stagnating, and barbecue chains and franchises are among the fastest-growing segments in the restaurant industry.

That two African American families in Alabama have converted failed fast-food restaurants into old-fashioned barbecue joints with wood-fired brick pits is a wonderful irony. I wish I could say that Brook's Barbecue in Muscle Shoals and Liz's BBQ in Gadsden were part of a new trend.

But most of the new franchises in the resurgent barbecue segment use stainless-steel ovens while replicating the look of old-fashioned barbecue joints. Jim 'N Nick's and Dickey's are popular franchises, and both are opening new locations across the country. Rudy's Country Store and BBQ franchises are designed to look like country convenience stores, complete with convenience-store items and working gas pumps out front.

Just as the old country store was replaced by Wal-Mart, the old-fashioned barbecue pit was replaced by the high-tech barbecue oven. And somehow, fake country stores selling fake barbecue now seems completely normal.

As Marshall McLuhan famously observed, we never appreciate what we have until it is replaced by something new. "Because we are benumbed by any new technology—which in turn creates a totally new environment—we tend to make the old environment more visible; we do so by turning it into an art form and by attaching ourselves to the objects and atmosphere that characterized it."

Like all obsolete technologies, wood-fired pit barbecue has become an art form.

Barbecued Chicken with Alabama White Barbecue Sauce

- -

Barbecue the chicken first and then coat it in the white sauce. Then you slather on lots more white sauce at the table—or give each diner a cup of sauce so they can dip each bite in white sauce as they eat it.

- 1 whole fryer, about 3½ pounds
- Salt to taste
- Freshly ground pepper to taste
- 4 cups Wish-Bone Italian dressing
- Alabama White Barbecue Sauce (p. 110)

Remove the giblets and, with a sharp knife or poultry shears, cut the chicken along the backbone and flatten it open to "butterfly" it. Rinse the insides. Place the chicken in a freezer bag with Italian dressing and marinate in the refrigerator overnight. Remove the chicken from the refrigerator and discard the marinade. Sprinkle the chicken inside and out with salt and pepper.

Set up your pit for indirect heat with a water pan. Use charcoal or a combination of wood and charcoal. Maintain a temperature between 275°F and 325°F.

Spread the butterflied chicken on the grill, bone side down. Cook with indirect heat for 2 hours, then turn over and cook skin side down for 1 hour or to an internal temperature of 165°F. Transfer the chicken to a platter and coat with about ½ cup of the barbecue sauce. Serve with additional sauce at the table. *Serves 2.*

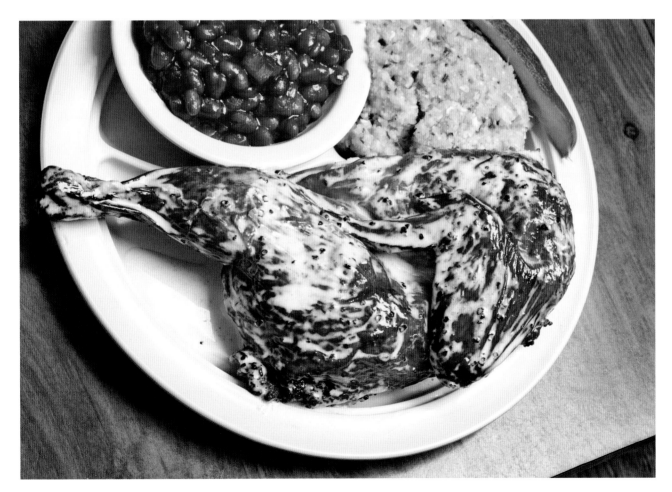

Barbecued chicken in white barbecue sauce at Big Bob Gibson's.

Alabama White Barbecue Sauce

- -

Here's a variation on Big Bob Gibson's white barbecue sauce. It tastes great on chicken, and it also makes a great chicken salad dressing.

- 1 cup Duke's Mayonnaise
- ½ cup apple cider vinegar
- ¼ cup apple juice
- 1 teaspoon garlic powder
- 1 tablespoon prepared horseradish
- 1 teaspoon freshly ground black pepper
- ¼ cup lemon juice
- ½ teaspoon salt
- ½ teaspoon white pepper
- Dash of cayenne or to taste

Combine all ingredients in a mixing bowl and stir well. Use immediately or keep in a covered container in the refrigerator for up to 2 weeks. *Makes about 2 cups.*

Barbecue Baked Potatoes

- -

Barbecue restaurants typically use "colossal"-size Idaho baking potatoes that weigh around 1 pound each for their barbecue stuffed baked potatoes. It makes an impressive presentation, but that's an awful lot of starch. You don't see colossal potatoes in most grocery stores, either. Try this recipe with russet potatoes of between ½ and ¾ pound.

- 8 russet potatoes, 8–12 ounces each
- 1 teaspoon olive oil
- 4 tablespoons butter
- 3 tablespoons finely chopped green onions
- 1 clove garlic, minced
- 2 cups grated sharp cheddar cheese
- ½ cup sour cream
- 1 teaspoon sea salt
- ½ teaspoon freshly ground black pepper
- 3 pounds (48 ounces) chopped barbecued pork, hot
- Red Barbecue Sauce (p. 55)

Wash and dry the potatoes, rub them with olive oil, and prick the skins. In a 400°F oven, bake for 1 hour or until just soft to the touch. Over medium heat, melt the butter in a sauté pan and add the green onions and garlic. Cook until tender and set aside.

Cut a thin slice off the top of each baked potato and scoop out the meat, leaving the skin intact and with about ¼ inch of meat on the skin. Mash the potato meat and add the sautéed butter, onion, and garlic mixture, then combine the cheese, sour cream, and seasonings. Beat the mixture until smooth and restuff the potatoes. You can hold the stuffed potatoes until ready to serve.

Before serving, place the potatoes under a broiler to brown. Place each potato on a serving plate and top with 6 ounces of chopped barbecued pork. Drizzle with barbecue sauce and serve with more barbecue sauce on the side. *Serves 8.*

Chess Pie

- -

Legend has it that this famous Southern pie got its name when the husband of the inventor asked what kind of pie it was. His wife responded, "It's jus' pie."

- 1 9-inch Pie Pastry (p. 37)
- 3 eggs
- 1½ cups sugar
- 3 tablespoons melted butter
- 1 tablespoon plain white cornmeal
- ⅓ cup buttermilk
- ½ teaspoon salt
- 1½ teaspoons vanilla extract

Preheat oven to 375°F and position a rack in the bottom slot. Beat eggs with a wire whisk. Stir in remaining ingredients and mix well. Pour into an unbaked 9-inch pie shell.

Bake pie on the bottom rack for 15 minutes, then reduce heat to 350°F and bake another 20 minutes. *Makes 8 servings.*

Lemon Meringue Pie

- -

- 1 can Eagle Brand sweetened condensed milk
- Juice from 3 lemons, seeds removed
- 1 teaspoon lemon zest
- 3 eggs, separated (save whites for meringue)
- 1 9-inch Blind-Baked Piecrust (p. 37)
- Pinch cream of tartar
- 2 tablespoons granulated sugar, or to taste

In a mixing bowl, beat the egg yolks until creamy. Add the condensed milk and slowly stir in the lemon juice a little at a time to prevent curdling. Add the lemon zest and mix well. Pour into the baked piecrust. To make the meringue, place the egg whites and cream of tartar in the bowl of a stand mixer fitted with the whisk attachment. Beat whites until soft peaks form and then gradually add sugar and continue beating until stiff peaks form, approximately 1–2 minutes. Top the pie with the meringue and place in a 375°F oven for a few minutes, just until the peaks brown. Allow to cool before serving. *Makes 8 servings.*

7

BARBECUE BARBARIANS

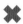

FROM THE ROAD, all you could see of Archibald's Bar-B-Q was a cloud of smoke emanating from a chimney. As the Honda Element climbed the hill to get to the parking lot, we could make out the rivulets of creosote that traced black lines down the white monolith of the pit chimney. Some ran all the way to the ground. There were picnic tables outside, but the abundance of flies made the outdoor dining areas unusable. So on an early Saturday morning in August, Rufus and I sat at the counter of Archibald's in Northport, Alabama, watching one of America's foremost barbecue artisans at work.

George Archibald, Jr., is the pitmaster and owner. He took the place over from his father, George Archibald, and his mother, Betty Archibald. For many years, George Sr. worked in a steel mill and Betty worked in a paper mill. In the mid-1950s, the couple bought the barbecue business from James Morrows, who built the place. It was their dream to get out of the mills and own a business of their own. Their son, George Jr., started working at Archibald's when he was twelve years old. When he and his sister Paulette took the place over, they started working opposite shifts, relieving each other over the course of the day.

The pit at Archibald's is different from the pits we had encountered in Tennessee. There, wood was burned down in a separate fireplace and coals were shoveled into an enclosure two feet or so below the meat; here, the wood fire burned directly under the grate, but at a greater distance from the meat. Every half hour or so, George went outside to throw a hickory log on the blaze. He opened the steel doors on the outside of the chimney and shoved the wood in, then closed it up. From the inside, he slid open the pit door to turn and check the meat.

Archibald's Bar-B-Q in Northpoint, Alabama, burns hardwood logs in a pit with the firebox door on the outside and a door inside that opens to the kitchen.

George Archibald, Jr.'s meat fork was five feet long. It looked like a regular barbecue fork that had been screwed onto the end of a mop handle. The long-handled fork made it easy to reach the meat in the back of the pit without leaning too far into the intense heat of the fire. Watching George work from a few feet away was an education.

George Archibald usually cooks low and slow—but when he is in a hurry, as he was this Saturday morning, he stokes the fire up high and cooks ribs in an hour and a half. His Boston butts were started early that morning to be ready for lunch—a cooking time of a mere four or five hours. This technique reminded me of Central Texas meat markets like Smitty's, where a shoulder clod gets cooked at temperatures over 400°F in little more than four or five hours. Later in the day, George would slow the fire down and let the meat coast on the coals until dinnertime.

George Archibald, Jr., is a friendly man who is willing to discuss the Crimson Tide's chances for a national championship or the tornado season, but don't try to engage him in a conversation about barbecue. When asked what he thought of barbecue joints in Tuscaloosa, just across the Black Warrior River, he freely admitted that he had never been to any other barbecue restaurant. "I get tired of barbecue," he said. After all, he has done little else since he was twelve.

George Archibald, Jr., takes some ribs out of the pit with his custom-made barbecue fork.

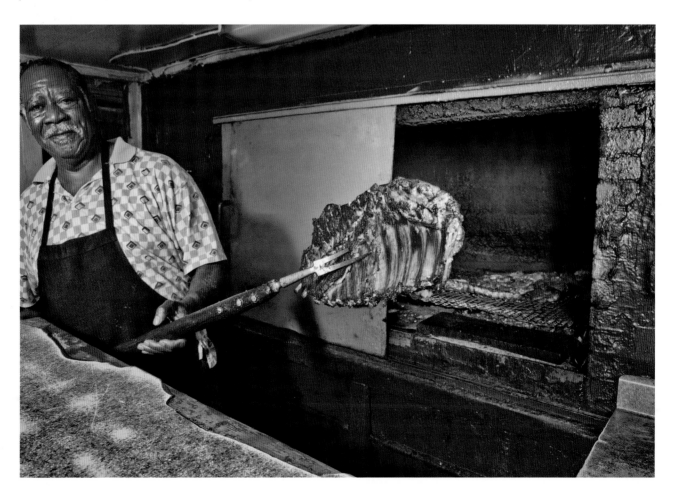

The stools that Rufus and I occupied for some three hours were directly in front of the steel door that opened onto the pit. We ate George's succulent ribs while we watched him work and waited for the Boston butts to be done. Every time the steel door slid back, you could feel the heat on your face. When George stabbed a piece of pork, smoke blew into the tiny dining room, and you could hear the meat sizzle and smell the aroma of hot pork and burning hickory. It was among the most visceral barbecue-joint experiences I can remember.

Sitting at the counter at Archibald's is a sort of a barbecue Rorschach test. My wife cringes and walks away with her hand over her face when I start to pull a barbecued pork shoulder apart. The ripping off of the skin, the sorting of fat and bones, and the shredding of the meat is a process she would rather not watch. For me, close encounters with barbecue trigger a primal response that bypasses my cognitive processing center and proceeds directly to the animal part of my brain, where it evokes wide-eyed focus and a mouth-watering appetite.

Listening to my stomach growl and thinking about these primal urges reminded me of the over-the-top premise of a book I have been trying to finish: *Savage Barbecue*, by Andrew Warnes, who equates barbecue with barbarians. The book includes some shocking passages about the coarse behavior at barbecue bacchanals in London as described by Ned Ward in *The Barbacue Feast* in 1707. Ward, who also wrote *Sot's Paradise* and *The Delights of the Bottle*, was a sort of Damon Runyon forerunner who delighted in describing bad behavior and capturing the suggestive vernacular of the denizens of outdoor fairs and public houses in old London.

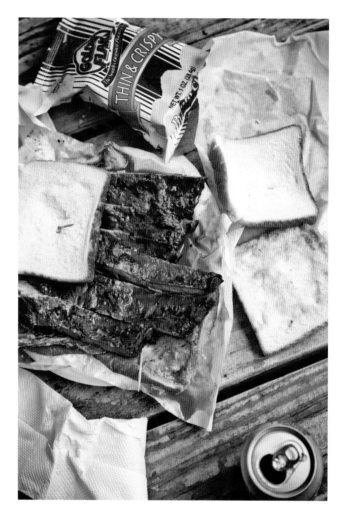

Archibald's ribs come with barbecue sauce and white bread. Golden Flake potato chips are also available.

Ward described a "savage feast" held in Peckham Rye in which three pigs were roasted in a re-creation of an exotic Jamaican barbecue. A properly done barbecued pig should be as brown "as the tawny belly of an Indian squaw," one of the gluttonous and inebriated participants declared as he ate his meal with one hand in his mouth and the other on the rim of his plate. In an argument over the cooking of the pig, every seaman at the table who had "crossed the Tropik of Cancer and taken a negro wench by the short wool" had an opinion, Ward tells us.

Iron Bowl tailgaters in Alabama cooking a whole hog on a rotisserie pit mounted on a trailer

We'll never know how accurately Ward described the behavior at London's early eighteenth-century barbecue re-creations. But the disturbing account supports Warnes's contention that for the English, barbecue conjured up images of sexual violence, savagery, racism, and cannibalism in the New World. But the book doesn't prove much of anything to modern American barbecue lovers.

Warnes's prejudices run deep. When he warns readers in the book's introduction that "those of more sophisticated tastes should now take a deep breath and hold their noses, or just look away as we delve into the history of this most American food," he draws a line between his upper-class audience and the low-class American food he is writing about. His contention that barbecue is not a recognized part of American cuisine because it is not enjoyed with silverware and fine wine further illustrates his cluelessness.

After I threw this maddening book across hotel rooms in several cities, I eventually returned to the dented text. And I had to grudgingly admit that some of what Warnes has to say is intriguing.

Old barbecue joints like Archibald's are repositories of Southern tradition, like rustic juke joints and country churches. But sitting a few miles away from the campus of the University of Alabama in Tuscaloosa, I found it impossible to deny that for many Southerners, barbecue culture bears at least a passing resemblance to the raucous feast of Ned Ward's London. I am thinking in particular of the tailgaters who barbecue in the parking lots of college football stadiums.

Old barbecue joints like Archibald's are repositories of Southern tradition, like rustic juke joints and country churches.

The tailgaters at my alma mater, the University of Texas, are no slouches in the barbecue department. In the parking lots surrounding Scholz Garten just south of Darrell K Royal–Texas Memorial Stadium, you will find some of the best-looking smoked brisket in the state. Texas A&M barbecuers around Kyle Field do a nice job, too. But I take off my hat to the tailgaters at the Iron Bowl, the annual Thanksgiving weekend game between the University of Alabama and Auburn University.

Alabama doesn't have any professional football teams, which makes the fortunes of the Alabama Crimson Tide and the Auburn Tigers the focus of the entire state. The two squads are not only perennial rivals, but also two of the finest college football teams in the country lately, having traded the national championship back and forth in the last few years (Alabama winning it in 2009 and 2011, Auburn in 2010). When they meet, the intense loyalty of their fans reaches a fever pitch, and the ferocious spirit spills over into the parking lot.

Alabama tailgaters cook whole hogs in wild contraptions they tow behind their pickup trucks. Some of them cook pigs upright and put them out on display so those who wish to partake can simply tear off a piece of flesh—a favored form of barbecue celebration known in these parts as a "pig pickin' party." While it's a lot of fun, the skeleton of the denuded pig is a shocking sight. Just the sort of barbaric display that might cause Andrew Warnes to say, "I told you so."

Next page: Alabama and Auburn football fans dance around a barbecue pit built into the front of a '60s Chevelle Malibu at an Iron Bowl tailgate party.

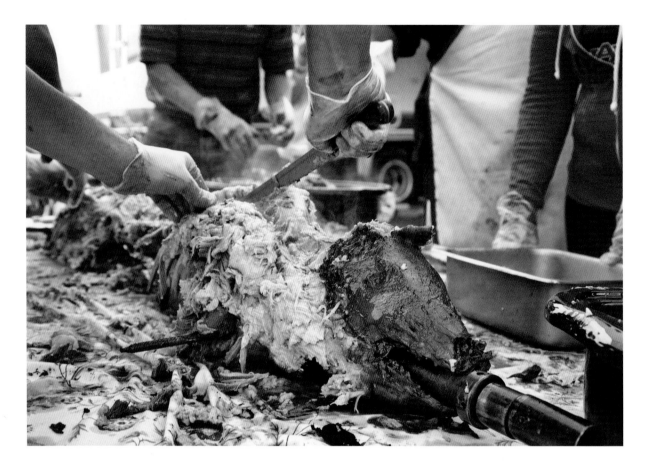

Warnes's most disputed points have to do with the etymology of the word. Most American barbecue experts accept that the English word "barbecue" and the Spanish word "*barbacoa*" are derived from the word used by the Amerindians of Hispaniola to describe a grate of green sticks, the term variously written as *barbecu*, *barbicue*, or *babracot*, among other spellings. This etymology has led to the conclusion that barbecue is a cooking method that began in the Caribbean and was transferred to the plantation culture of the American South by the English and their slaves, and to Latin America by the Spanish. Both the etymology and the history are questionable, according to Warnes.

Warnes suggests the word "barbecue" resonated with the English colonizers because of its similarity to the Greek word for those who lived outside civilization, "barbarians." The use by some tribes of the Amerindian cooking method to roast a torture victim on a grate above a slow fire created a link between barbecue and cannibalism that English chroniclers couldn't resist.

It wasn't just a philosophical discussion in those days. If the Amerindians were deemed barbaric, then the English had every right to round them up, imprison or kill them, and take their land. The motivation to exaggerate the savagery of those one sought to displace was compelling.

Warnes's most interesting thesis is that barbecue is an invented tradition. Invented traditions, such as Christmas, Thanksgiving, and the Fourth of July, were created by elites to influence public behavior. Warnes argues that the European colonists created American barbecue mythology out of their need to characterize native peoples as barbaric and violent. Ironically, he observes, the European colonists would later adopt the barbecue tradition and claim it as a connection to native culture.

I am not convinced that the similarity between the words "barbecue" and "barbaric" is anything more than a coincidence. But Warnes asks some perplexing questions in making his case. If barbecue was originally a Caribbean way of cooking, what happened to it? There are some very old accounts of barbecue in the literature of the Caribbean, including the 1698 description of a West Indian barbecue by Dominican missionary, Jean-Baptiste Labat. But there is very little mention of barbecue there after the 1800s. How is it that barbecue is so closely associated with the American South and with African Americans? Did American barbecue have African antecedents?

ARCHIBALD'S BAR-B-Q was a wonderful place to ponder philosophical conundrums. But by eleven in the morning, George Archibald, Jr., was tired of us hanging around. The Boston butts weren't done yet, but he found some that were pretty far along and carved some outside slices off so he could serve us a couple of sandwiches and get rid of us. The pork slices had a deep smoky flavor and the firm bite of a well-done pork chop rather than the soft, creamy texture typical of great Southern pulled pork.

I have no doubt that the barbecue at Archibald's got a lot more tender later that Saturday afternoon. Too bad we made such a nuisance of ourselves. We probably should have gone for a drive and come back later. But we were on the highway and headed to the next barbecue mecca.

NORTH OF BIRMINGHAM, Rufus turned off I-65 onto the Bee Line Highway, which was once the main route between Birmingham and Decatur. The road runs through a steep valley on an old rail bed in the foothills of the Appalachians. The route is marked by an abundance of natural beauty and few residences. Then we came around a bend and found ourselves in front of Top Hat Barbecue, a complex that looks like a row of three houses next to an enormous red-block wall. The monolithic wall, as wide as one of the houses and nearly twice as tall, contained several pits and chimneys.

The pits at Top Hat Barbecue were built fairly recently, but the oldest part of the building dates back to 1952, when the business first opened as the Top Hat Inn. From the beginning, the Top Hat was a family restaurant known for excellent barbecue. In 2006, Amy Evans, a historian at the Southern Foodways Alliance, recorded an oral history with the owner, Dale Pettit, who told her that he was considering switching over to a gas rotisserie.

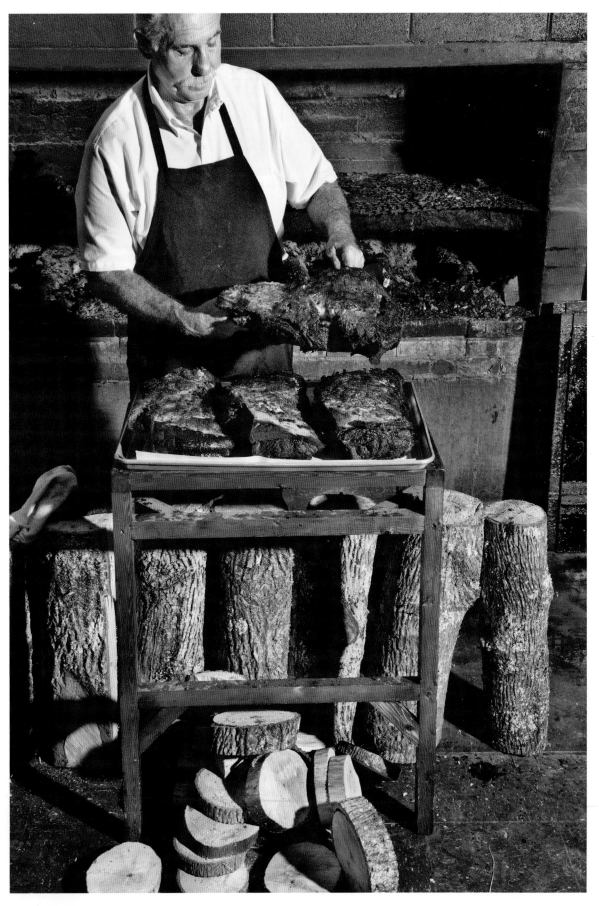

Pitmaster Dale Pettit carving shoulders at Top Hat Barbecue

"The last load of wood I got was $1,300, so the wood costs a lot more than the gas. It's very costly to cook it the way we do, but that's the only way to get the product," Pettit told Evans. "That's the only way to get the quality out—there is some pride in being one of the last few people who actually cook barbecue the old way. You know, really nobody does that anymore simply because it's too much work. When people like me stop barbecuing the old way, it will die. And people that don't try it while they have the opportunity will be sorry, because one day it won't be here anymore." Given Pettit's warning, we figured we had better put Top Hat on our list of places to stop.

. . . there is some pride in being one of the last few people who actually cook barbecue the old way.

Top Hat is located in Blount Springs, which was once one of the most popular resorts in the South. As many as 15,000 people would visit during the summer to bathe in the sulfurous springs and enjoy the dramatic scenery of steep cliffs, deep caves, and winding trails. In its heyday, Blount Springs bottled waters were sold all over the state. Some of the spring water contained lithium, which is prized for its mood-stabilizing effects. In 1915, a fire destroyed the two main resort hotels and many other nearby buildings, and the town was never rebuilt. When the railroad that once ran through the narrow valley was rerouted, the remaining population moved away.

We found the owner and pitmaster, Dale Pettit, in the pit house removing pork shoulders from the fire. The barbecue pit room was among the tidiest I have ever seen. Pettit had a huge mustache and wore a short-sleeve dress shirt under his apron. He looked like a colorful character who could spin a yarn, but he turned out to be a man of few words. Dale inherited the business from his father, Wilbur. His daughter Heather manages the restaurant and will someday take it over.

Wilbur Pettit fell into the barbecue business late in life. The son of sharecroppers, he spent most of his working life delivering bread for the Tip Top Bread Company; the Top Hat Inn was one of his customers. When the bread delivery company went out of business, Top Hat's owner, Arilla Simmons, offered Wilbur a chance to buy the place. Along with the business, he had to purchase Mrs. Simmons's barbecue sauce recipe. Oddly, Simmons had purchased the recipe from a chef at the Waldorf-Astoria Hotel in New York. Despite its Manhattan fine-dining pedigree, it is a ketchup-based sauce with the same sweet, sour, and hot flavors as most other Alabama barbecue sauces.

When Wilbur took over Top Hat in 1967, he knew very little about barbecue. He split the wood and did the heavy lifting, but he relied on two employees who came with the place, Betty Dooley and Cathy Hooper, for the cooking. The two women worked at Top Hat for more than thirty years each. The original pit held sixteen pork shoulders. Wilbur's wife, Ruth, helped with the cooking in the beginning, but when more pits were added, she turned the pitmaster duties over to Wilbur.

Dale Pettit got out of the U.S. Navy in 1971. His first morning home, his father woke him up at five a.m. and told him it was time to get to work. His father set him

to cooking meat, returning every now and then to point out what the rookie was doing wrong. After a year, Wilbur retired and left his son in charge. Dale has been the pitmaster now for more than forty years.

As Top Hat became recognized as one of the last pit-fired barbecue restaurants in the area, business increased. Pettit was cooking seven days a week and doing a double shift on Thursday to try to keep up with the demand. Finally, he had the new pit house built while he cooked in the old one. He now uses a cord of hickory wood a week and barbecues eighty-four shoulders at a time.

The quaintly rustic dining room of the original restaurant seated forty people. It had a distinctive ceiling of round log rafters held up by cedar posts. At the top of the posts, the stubs of a few branches were left to serve as hat hooks. As the Pettit family expanded the business, they used the same rafter-and-cedar-column, hat-rack design to maintain the cozy tavern feeling of the original Top Hat Inn. The distinctive wooden counter at the cash register once had five stools. It's now used as a display area for candy, old-fashioned packaged snacks, and vintage advertising signs. One of the Pettit daughters runs an antique store in the adjoining building.

Rufus and I got a barbecue salad and a barbecue sandwich on Texas toast for lunch. The chopped pork was excellent; the distinguishing feature of the sandwich

was the shape of the bread and the shocking color contrast of red sauce, green dill pickles, and the bright green plate. But the barbecue salad was something new. I asked the waitress whether people generally got the salad with barbecue sauce or salad dressing. She said most people got both. What kind of salad dressing was most popular? I asked. "Ranch," she replied.

The salad turned out to be a blend of iceberg, dill pickle chips, cherry tomatoes, croutons, red onion slices, and cheddar cheese with a pile of pulled pork in the middle, served on an oversize blue plate. The combination of chopped pork, barbecue sauce, and salad with ranch dressing was weirdly similar to the mix of flavors you get on a chopped pork sandwich when a ketchup-based barbecue sauce mixes with the mayo in the coleslaw.

As it happened, Dale's wife, Vickie Pettit, was in the kitchen frying up half-moon peach pies that day. She flipped the fried pies in an electric skillet until they were golden brown on each side. They looked so good that we waited around until they were done, and Rufus and I ate a piping hot peach fried pie with big scoop of vanilla ice cream. I may never be able to explain why fried pies and barbecue are so inseparable, but I will continue eating the dessert in hopes that someday I will become enlightened.

Top Hat also sells pork ribs and fried catfish. The ribs are cooked until the meat falls off the bones. All the catfish—500–600 pounds a week—is farm raised in Alabama and fried in the restaurant's unique batter. But the vast majority of what Top Hat sells is barbecued pork shoulder served in sandwiches, baked potatoes, and salads.

Dale Pettit's secret to great barbecue is to let it cook until it's tender. He says it gets done an hour or an hour and a half before it gets really tender—giving it a little more time until it falls apart is the difference between good and great.

Warnes's *Savage Barbecue* was published in 2008, the same year that the documentary filmmaker Max Shores featured Top Hat Barbecue in his film *Holy Smoke over Birmingham*. Top Hat subsequently gained a national following. Rufus and I met a couple of barbecue bloggers there—they came by and introduced themselves when they saw Rufus taking photos.

With its historic location, well-preserved dining room, and massive Alabama chimney pit, Top Hat has a "barbecue museum" feeling about it that attracts food writers from all over the country, along with others interested in documenting Southern barbecue culture. Maybe Andrew Warnes will work on his next book there.

In a section of *Savage Barbecue* devoted to modern "pit barbecue," Warnes writes that the "custodians of American cuisine" (I think he means restaurant critics) ignore pit barbecue because of its "unforgivable appearance among ketchup and soda, plastic cutlery and tabletops, and other paraphernalia alien to the idea of culinary excellence." Pit barbecue is a rebel cuisine that delights in its "barbaric associations"; it is "wallowing in grease, reveling in plastic, and generally holding the conventions of Western Civilization in a steadfast and almost punk-like contempt."

That's a funny idea to consider at Top Hat Barbecue. Dale Pettit doesn't exactly thumb his nose at Western civilization. He is a deacon in the Baptist Church and describes Top Hat Barbecue as a "Christian business."

It is true that a lot of barbecue joints serve their food in Styrofoam containers with plastic forks. At Luling City Market in Central Texas, you aren't given any utensils at all, just some butcher paper. But punk-like contempt is hardly the reason why. As noted earlier, some of the best barbecue joints in the South started out as meat markets, convenience stores, or gas stations that served migrant farmworkers.

The lack of china, cutlery, and tablecloths wasn't a sign of rebellion; it was part of an effort to avoid being classified as an eatery and thereby get around laws requiring segregated eating areas. That was just good business: it allowed the establishments to sell barbecue to the armies of migrant cotton pickers who roamed the South during the harvest. The custom of selling barbecue on a sheet of butcher paper or in a take-out container is part of the convenience-store barbecue tradition. It wasn't about rebellious contempt; it was an effort to fly under the radar of Jim Crow laws.

Warnes missed the mark in many of his generalizations, but he offered an excellent metaphor for the spread of barbecue culture. Rather than using the standard analogy of the roots and branches of a tree to describe the way a culture spreads, he suggests that the roots of American barbecue are more like a rhizome. The culinary cousin of invasive bamboo, it spreads under walls and impediments, popping up in unexpected places. Even when broken off from the source, the tenacious root creates a new plant.

Maybe that explains the diversity of Alabama barbecue; from the pig pickin' parties of tailgaters at college football games, to the home-cooked take-out food offered by tiny operations like Brook's and Liz's, to the very successful sit-down restaurants like Big Bob Gibson's and Top Hat Barbecue.

Southern culture in general was defined for much of its history by class and race distinctions. But Southern barbecue culture knows no bounds—it pokes up through the pavement in all kinds of neighborhoods.

Northport Sliced Pork

Archibald's barbecue pit is fueled with hardwood logs, just like the barbecue pits in Texas. If you have a Texas-style offset smoker, this recipe is easy to follow.

- 1 Boston butt, 4–5 pounds
- 6 tablespoons Stubb's Spicy Pork Rub (p. 50)
- 2 onions, peeled
- 1 quart Hog Mop (p. 53)

Season the pork roast with dry rub, pressing the spice mix into the meat, and refrigerate it overnight.

Cut the onions in half and put them in a water pan to flavor the steam. Add water to fill the pan.

Set up your pit for indirect heat with a water pan. Use wood chunks or logs and keep up a good level of smoke. Maintain a temperature between 275°F and 325°F. Place the roast in the smoker.

Replenish the water pan as needed. Mop with the Hog Mop every half hour or so. The meat is done when the Y-shaped bone protrudes from the meat, but don't worry about overcooking it—it will just keep getting better. When it reaches an internal temperature of around 175°F, which might take 4 or 5 hours, remove it from the pit.

Place the meat in a brown paper bag. Seal the bag and hold it in a pan on a cool part of the grill or in a warm oven for at least half an hour. Slice the meat just before serving. Pile pork slices on sandwich rolls and top with barbecue sauce and slaw. Or serve on a plate drizzled with barbecue sauce, with coleslaw and potato salad on the side. *Serves 8–10.*

Barbecue Salad

Here's Top Hat's version of barbecue salad. I like to make mine with peppery garden lettuces like arugula, curly mustard, and mizuna. I leave out the cheddar because I don't think cheese and barbecue go well together, but I am in the minority on this.

- 2 cups chopped lettuce
- ½ cup chopped celery
- ½ cup chopped red onion
- 1 small tomato, sliced
- ¼ cup pitted, sliced black olives
- ¼ cup shredded cheddar cheese (optional)
- ¼ cup chopped green onions
- ½ cup Ranch Dressing
- 6 ounces chopped barbecued pork, heated
- ½ cup Red Barbecue Sauce (p. 55)

Toss the lettuce, celery, and red onion together in a mixing bowl, then transfer to a serving bowl and top with tomato slices. Sprinkle with black olives, cheddar cheese, and green onions. Pour the ranch dressing over the salad and then top with chopped barbecued pork. Drizzle with barbecue sauce and serve. *Serves 1.*

Ranch Dressing

Homemade ranch dressing tastes a lot better than store bought, and it's really easy.

- ½ cup mayonnaise
- 1 cup sour cream
- ¾ cup buttermilk
- 2 tablespoons minced green onion
- ½ teaspoon fresh ground pepper
- 3 tablespoons minced red bell pepper
- ½ teaspoon salt

Combine the mayonnaise, sour cream, and buttermilk in a mixing bowl and stir until smooth. Add the remaining ingredients and mix well. Will keep for 1 week in a sealed container in the refrigerator. *Yields approximately 2¼ cups.*

Peach Fried Pies

- -

Don't forget the vanilla ice cream—hopefully, Blue Bell or homemade.

- 1 doubled recipe for Pie Pastry (p. 37),
 or 4 premade, unformed pie crusts
- 1 recipe Peach Filling

Prepare pastry dough and refrigerate. Or take premade, unformed pastry dough out of the refrigerator. Prepare filling.

Heat an inch of oil or lard in a cast-iron or other heavy-bottomed skillet. On a floured surface, roll pastry dough out to ¼ inch thick. Cut out circles 4–5 inches in diameter using a bowl, jar lid, or whatever else you've got.

To assemble pies: Lightly moisten the edges of a circle of dough. Drop 1 tablespoon of filling into the center. Fold the top of the circle over the filling and line it up with the bottom half. If any filling or juices seep out as you fold, push the filling back a bit and try again. Wipe the edges of the dough clean; any exposed filling will burn in the hot fat.

Press the seam closed all around the edges with your fingers, pushing in toward the center to plump the pie as you go. Use a fork to crimp.

Use a thermometer to test the oil; once it reaches between 350°F and 375°F, carefully drop pies in one at a time. Fry until the edges begin to turn golden brown (about 30 seconds), and then flip and fry another 20 seconds or so. Remove hot pies to a paper-towel-lined plate to drain.

Serve hot with a scoop of vanilla ice cream. *Makes 20–30 pies.*

Baked Variation

- -

Rather than frying, bake half-moon pies on an ungreased baking sheet at 350° for 15 minutes.

PEACH FILLING

- 6 ounces dried peaches
- ¼ cup brown sugar
- 1 teaspoon lemon zest
- ½ teaspoon ginger
- Dash ground cloves

Cover fruit with water in a small saucepan. Bring to a boil, cover, and simmer until peaches are rehydrated, plump, and soft, about 30 minutes.

Mash well with a potato masher and stir in sugar, zest, and spices. Continue simmering, uncovered, until thick and stewy, another 15–20 minutes. The cooked peaches will retain some liquid.

Use immediately or make ahead and store in the refrigerator up to 1 week.

Makes enough to fill about 30 rectangular or half-moon pies.

8

THE

HIGH LIFE

THE SMELL OF BEER and the sound of laughter greeted us at the front door of Leo and Susie's Famous Green Top Bar-B-Que on U.S. 78 in Dora, Alabama. We sat down at a worn red vinyl booth and took in the scene. Five men were seated at the bar; three of them wore gimme caps, and they all were drinking beer out of long-neck bottles. On every tabletop there was an impressive array of hot sauces, including Texas Pete, Louisiana, Frank's RedHot, and Tabasco. The waitress asked Rufus, "What'll it be, hon?" He ordered a Miller High Life and I asked for one of the same. There weren't any microbrews or imports.

Cold beer has long been the beverage of choice for barbecue connoisseurs. At early American barbecue feasts and community gatherings, drinking was part of the festivities. In Andrew Jackson's era, politicians went to barbecues and drank with their supporters. Today no Southern politician would dare to drink at a public barbecue for fear of losing Christian voters. Barbecue won't lose you any votes, though. Equally at home at church picnics and beer joints, barbecue is a neutral party in the Southern battle between virtue and vice.

Drinking in the South has been a matter of controversy for more than a hundred years. Like most drinkers, I once found the antialcohol stance of my Southern Christian friends laughably hypocritical, given their other vices. But as I learned more, I realized that the issue was complex. Southern Baptists weren't always prohibitionists; it was a Baptist preacher, Elijah Craig, who invented the process for making bourbon. Drinking was an accepted part of life in the South before the Civil War. A revival movement in the late nineteenth century brought about a change in religious attitudes toward alcohol that culminated in Prohibition.

What brought that on? I once knew a hard-drinking former Southern Baptist minister who opposed drinking, despite the fact that he drank every day. He explained this contradiction over a couple of martinis in an upscale Fort Worth watering hole. The Baptist teaching of abstinence goes back to frontier times, he said. Drinking was the plague of the Old West. In the late 1800s, drunkenness was standing in the way of progress.

In Fort Worth, the Baptists who opposed drinking, gambling, and dancing were really trying to close down the saloons, brothels, dance halls, and casinos in Hell's Half Acre, the part of town next to the stockyards where cowboys were fleeced of their paychecks. More than half of all the crimes committed in the city occurred in Hell's Half Acre, which grew to something closer to two and a half acres in its heyday, around 1900. Many of the illegal businesses were owned by prominent citizens, and the authorities were loath to crack down on them. So it was up to the preachers to try to clean up the city. The preachers didn't care about drinking among good Christians who had a few beers with dinner or a civilized cocktail now and then. They were at war against corrupt forces that were ruining people's lives, the former minister said.

Prohibition was the triumph of the Baptist opposition to the sale of alcohol. Of course, Prohibition created another set of vices, notably official corruption. But the repeal of Prohibition didn't end the legal influence of those opposed to alcohol sales. Many Southern states enacted laws that required counties to hold elections to determine whether they would allow the sale of alcohol. Hundreds of "dry" counties still exist in the South, and a bizarre coalition of existing liquor store owners and Southern Baptist churches lobby to keep it that way.

Leo and Susie's Famous Green Top Bar-B-Que owes its existence to this enduring legacy of wet and dry counties. "This used to be the last place you could get a beer between here and Mississippi," Richard Headrick, the owner, bartender, and pitmaster, told us when he sat down and joined us at our table. Tall and heavyset with a cleanly shaven head, Headrick looked like James Beard—or Uncle Fester.

As we sipped our beers and listened, Headrick told the tale of his parents, Leo and Susie, and their Famous Green Top Bar-B-Que. The story began in 1951, the year of Richard Headrick's birth and the year that U.S. Highway 78 was completed.

U.S. 78 is known as the Elvis Aaron Presley Memorial Highway at its western end, in Memphis. The highway runs through Mississippi, Alabama, and Georgia, ending in Charleston, South Carolina. The Alabama section of the road is hilly and verdant with many small towns and farms along the way.

Some of the Alabama counties along the highway allow the sale of alcohol, and some don't. For many years, the area between Jasper and the Mississippi state line was entirely dry. Numerous beer joints clustered at the county line, where the long stretch of dry counties ended in Jefferson County, which was wet. Drinkers from all over western Alabama came to the area to buy alcohol.

In 1951, when the new stretch of U.S. 78 was completed, Alton and Kenneth Cook opened the Green Top, the first beer joint on the new route. They were quickly followed by others. Around twenty establishments sold alcohol along the road in the 1960s. "My daddy used to stop at all of them," said Richard Headrick, laughing.

From the beginning, the Green Top served barbecue, and a handful of other joints eventually started serving food too. Edith Carey bought the Green Top in 1959. She served hamburgers along with the barbecue. "We used to stop in here when I was a kid," Headrick remembered. "The Green Top was one of the nicest of those beer joints, so Dad didn't mind taking me along in here when I was little. They always had the best barbecue."

Richard Headrick worked as a coal miner from the time he was in high school. His dad, Leo Headrick, and his grandfather and great-grandfather were all coal miners. Leo was in his fifties when he bought the Green Top from Edith Carey, over the strenuous objections of his wife, Susie. She thought it was a dumb idea at the time. She had worked at the same drugstore for nineteen years, and now her husband insisted that she had to start running the beer joint.

Leo agreed to pay Edith Carey six hundred dollars a month, and he continued working in the mines for another four years to make ends meet. Richard continued to work in the coal mines as well. Leo worked the owl shift at the mine and the day

Pitmaster and former coal miner Richard Headrick, of Leo and Susie's Famous Green Top Barb-B-Que, with photos of his mother and father

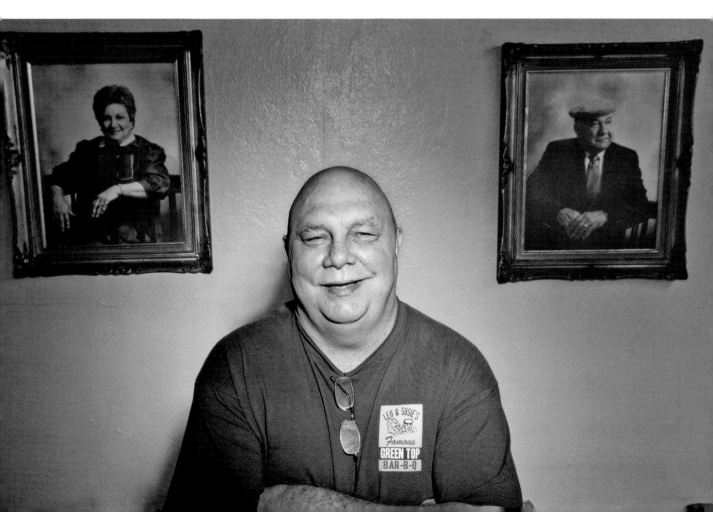

Susie Headrick, founder of Leo and Susie's Famous Green Top Bar-B-Que

shift at the restaurant; Richard worked the opposite shifts. Susie worked at the restaurant all the time. And nobody got a paycheck until Edith Carey was paid the entire thirty-thousand-dollar purchase price.

The Anglo version of the barbecue bar came from the tradition of offering free or inexpensive food in taverns to attract drinkers. When the Greek American restaurateur Charlie Vergos opened the Rendezvous in a Memphis basement under his family's restaurant, he was trying to create a bar that served snacks. An elevator shaft was turned into a smoker to make ham for ham sandwiches.

When the ham sandwiches didn't become popular, Vergos switched to pork spareribs. Using a recipe he got from an African American who cooked on a barrel smoker, he rubbed the rack with a spice mixture and grilled the ribs for an hour and fifteen minutes. His Memphis dry ribs were a hit with his bar patrons.

The African American barbecue and booze tradition traces its origin to juke joints, which combined food and drink with music and dancing. Juke joints began appearing in the South soon after emancipation. Located at rural crossroads, they offered African American laborers, who were banned from white establishments, a place to hang out after work. The word "juke," sometimes spelled "jook," probably came from a Gullah word meaning "unrestrained." Dreamland Barbecue in Tuscaloosa is a barbecue beer joint. The first time I stopped in there, I had my mother in tow. She loved the ribs, but she was quite upset to find out that the only sides available were potato chips and beer.

Urban juke joints first popped up in cities like Memphis and Chicago in the early 1900s as part of the Great Migration. Juke joints, where booze flowed and the blues and jazz were played, were condemned by churchgoing people. Barbecue establishments that served alcohol had an air of the illicit in the Bible Belt, since Southern Baptists are so famously opposed to drinking.

African American juke joints and Anglo beer and barbecue joints in the South had a lot in common. They were hangouts for laborers, and along with beer and barbecue, gambling was common. The Green Top was a coal miners' bar. There was no indoor toilet, just an outhouse. Things got rough sometimes. When poker

games were outlawed, the men started wagering on the bowling machine in the game room, an automatic shuffleboard game with a metal puck. Fights broke out regularly. Richard served as the bouncer, and he made a show of banning some of the more obnoxious patrons in an effort to create a more peaceful atmosphere.

Green Top's original pit was built into the counter behind the bar. It held fourteen pork shoulders, which cooked over burned-down coals, but Richard remembers that the fire was a little too close to the meat. There was a bucket of water with a dipper in it next to the pit. If the fire reached the meat, the bartender, who was also the pitmaster, doused the flames a little with some water. The shoulders were turned once an hour.

In 1977, some itinerant barbecue-pit builders from Arkansas constructed a new pit for the Green Top. It used indirect heat with a firebox outside and access to the meat on the inside from the kitchen. The pit had an ingenious damper system that allowed the pitmaster to divert the smoke away from the kitchen before opening the indoor side of the pit. That pit was a lot easier to cook with than the original one, Richard said.

In 1984, Leo tore down the Arkansans' pit and built two more just like it, only bigger. Richard also built a pit at his house so that he could cook extra shoulders without running back and forth to the restaurant every hour. The total capacity of all the pits combined is more than a hundred shoulders a day.

Shoulders cooking on the wood-fired pit at Leo and Susie's Famous Green Top Bar-B-Que

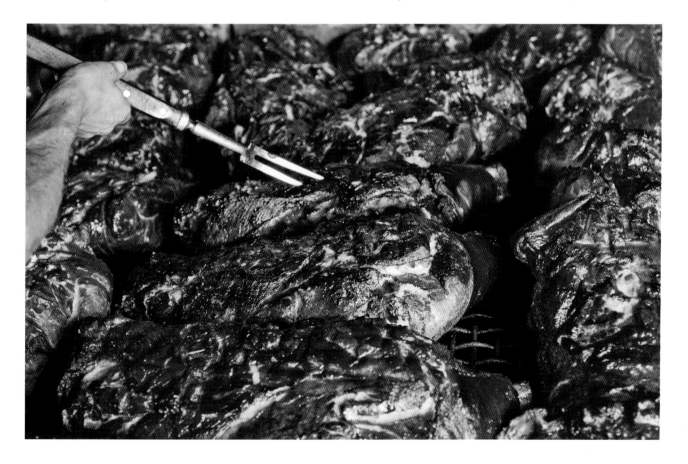

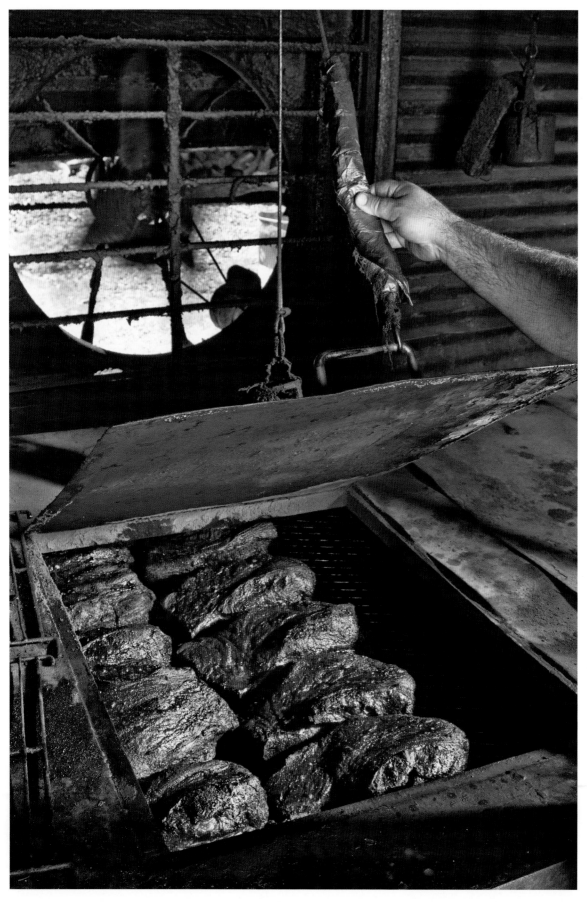

*Briskets on the pit
at Taylor Café*

The heyday of Taylor Café came to an end in the 1960s when cotton picking was mechanized. Tractor-size mechanical cotton pickers took over the hard work, and the number of migrant farm-workers dwindled. Taylor changed over the years as its younger residents moved off to Austin and other big cities instead of taking up farming. But the Taylor Café never changed.

Vencil is most famous for his "bohunk sausage." "Bohunk" is slang for Bohemian Czech, a common ancestry in Central Texas. Along with brisket, sausage, and ribs, the Taylor Café offers sides such as potato salad and beans, and home-made desserts such as banana pudding.

The Taylor Café isn't air conditioned, so the place gets very hot in the summer. There are lots of fans, but they don't do much good in July and August, when the temperature is close to a hundred. Vencil Mares spends all day, every day at his seat behind the bar, regardless of the weather. He says hello and good-bye to everybody who walks through the door—except when he's napping. He nods off in his chair a lot in the hot weather.

I like to sit at the bar and talk with Vencil. You don't really have to keep up your end of the conversation, because he can't hear you very well anyway. You can just sit there and experience what it was like in a small-town Texas barbecue beer joint a half a century ago. The brisket is decent and the sausage is great, but that's not the reason people stop by. One Tejano guy drinking beer at the bar told me he started coming here with his grandfather, and now he brings his son. He hopes to bring his grandson someday.

A chopped brisket sandwich and a cold beer in a koozie at Taylor Café

THE CULTURE OF THE FRONTIER SALOON persists in the South to a greater degree than in the rest of the country, but times are changing. As the *Anniston* [AL] *Star* observed in a 2009 story titled "The Gospel of Abstinence: Southern Baptists May Be Adjusting Their Stance on Alcohol Consumption," young Baptists are far more likely to approve of and engage in social drinking than their elders. While the Southern Baptist Convention will probably remain institutionally opposed to alcohol-related commerce for the foreseeable future, attitudes are evolving. Those who support a new attitude among Baptists concerning social drinking point out that the Bible does not forbid alcohol, or why did Jesus turn water into wine?

The *Star* article quotes Bill Leonard, a Baptist historian, dean of the Wake Forest University Divinity School, and author of *Baptists in America*, who said: "You can't have it both ways. You can't have a social prohibition on what the Bible itself allows while still arguing for the inerrancy of the Bible."

Ironically, my lunch at the Alabama beer joint was probably the healthiest meal I ate on the whole trip. I got the barbecue chicken salad. It was very close to a chef's salad, except the chopped barbecued chicken was tastier than the usual boneless, skinless chicken breast. Rufus got a delicious-looking chopped pork sandwich. We washed our meal down with another round of Miller High Lifes and toasted the portraits of Leo and Susie.

Leo and Susie's Famous Green Top Barbecue, the Taylor Café, the Kilgore Tavern, and Angelo's all have something in common: they all cook barbecue in wood-fired pits. Only a handful of these old Southern barbecue saloons still exist, but they are being imitated by a slew of new "concept restaurants."

Re-creations of Delta juke joints are a popular theme for bars on Beale Street. In Las Vegas, a new restaurant concept called Lynyrd Skynyrd BBQ & Beer opened in December 2011 in the Excalibur Hotel and Casino. The walls are salvaged wood planks with distressed paint. The bartenders, all women, are clad in very short "Daisy Duke" cutoffs and sleeveless black Lynyrd Skynyrd T-shirts. They dance while they work, incorporating cocktail shaking and long-distance pouring into the choreography of their routines.

The Southern rock band Lynyrd Skynyrd (or its current facsimile) made an appearance at the grand-opening celebration and played its anthem "Sweet Home Alabama." The restaurant has already announced its intention to franchise the Southern-rock-and-rib concept across the country. And I don't doubt that the franchises will soon outnumber the few remaining examples of the real thing.

Barbecue Chicken Salad

Here is the recipe for Leo and Susie's barbecue salad. It's just like the pulled pork salad I had at Top Hat Inn, but with different meat.

- 2 cups chopped lettuce
- ½ cup chopped celery
- ½ cup chopped red onion
- 1 small tomato, sliced
- ¼ cup pitted, sliced black olives
- ¼ cup shredded cheddar cheese (optional)
- ¼ cup chopped green onions
- ½ cup Ranch Dressing (p. 127)
- 6 ounces Barbecued Yardbird (p. 217) or Barbecued Brined Chicken (p. 218), cut in ½-inch dice

Toss the lettuce, celery, and red onion together in a mixing bowl, then transfer to a serving bowl and top with tomato slices. Sprinkle with black olives, cheddar cheese, and green onions. Pour the ranch dressing over the salad and then top with barbecued chicken dice. Serve with Miller High Life. *Serves 1.*

Vencil's Pinto Beans

If you cook beans slowly, they come out creamy on the inside, but each bean is still intact. Vencil cooks his beans in a 30-quart electric turkey-roasting oven, but a slow cooker works perfectly for cooking pintos at home.

- 2 cups dried pinto beans
- ½ onion, finely chopped
- 1 tablespoon chili powder
- 1 teaspoon ground black pepper
- 1 cup finely chopped bacon
- 1 teaspoon salt, or more to taste

Sort the beans to remove any stones or grit. Rinse in a colander and place the beans in a large pan with 6 cups of water. Add the onion, chili powder, pepper, bacon, and salt.

Put the beans in a slow cooker and cook on high for 2 hours. Turn to low and allow to simmer for 8 hours or overnight. Add more water as needed. *Makes about 6 cups.*

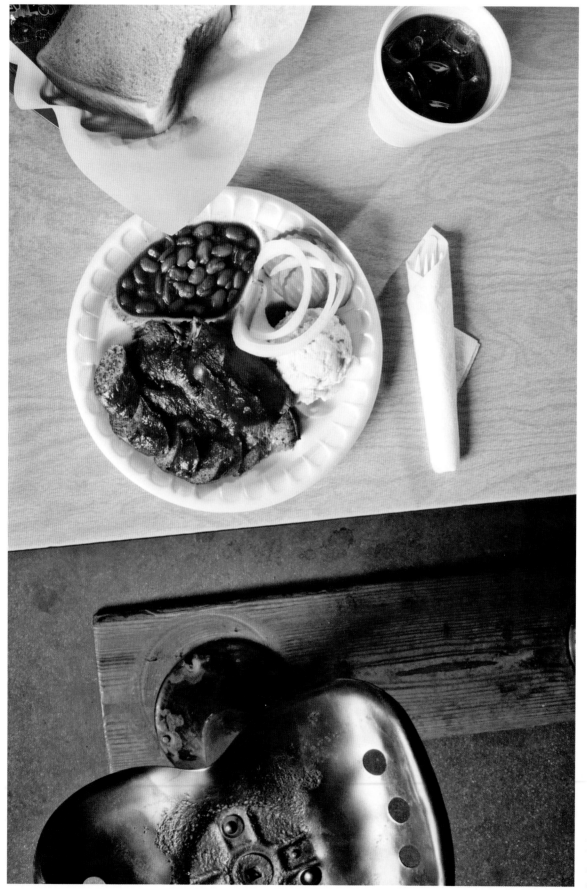

Vencil Mares's bohunk sausage with beans served at the bar at Taylor Café

Beer Joint Sausage

Vencil Mares of the Taylor Café learned how to make sausage at Southside Market in Elgin. This is a Bohemian Czech sausage recipe from Central Texas.

If you cook sausage too quickly, you render the fat out of the "batter" of meat and fat inside the casing. This causes the sausage to squirt out all its fat. For best results, set the batter by cooking the sausage very slowly at first. Once the batter is set, you can cook the sausage over high heat.

- 6 pounds beef rump roast or beef trimmings
- 4 pounds fatty Boston butt pork roast
- ¼ cup salt
- 5 cloves garlic, minced
- 3 tablespoons coarsely ground black pepper
- 1 teaspoon cayenne
- Medium hog casings (available at butcher shops)

Coarsely grind the beef rump and pork butt together through the ¼-inch plate of a meat grinder. In a large bowl, mix the ground meat with the salt, garlic, pepper, and cayenne. Knead the mixture with your hands until everything is well blended. Don't rush the mixing—it takes a long time.

In a small skillet, heat a little oil. Form a meatball-size piece of the mixture into a small patty and fry it. Taste for seasonings, and adjust to your taste.

Soak the hog casings in lukewarm water. Stuff the meat mixture into the hog casings with a sausage stuffer or a pastry bag, and tie into 4- to 6-inch links. The sausage will keep for 3–4 days refrigerated, and up to 2 months frozen.

When you're ready to cook the sausages, place them in a pan of warm water on the stove and slowly bring the heat up to 140°F to set the "batter." Set up your smoker for indirect heat with a water pan. Sear the links over hot coals for 3 minutes on each side, or until nicely brown. Move them to indirect heat over a drip pan and smoke for 30 minutes, or until cooked through. *Makes 10 pounds.*

VARIATION: VENCIL'S TURKEY SAUSAGE

Grind 8 pounds of boneless turkey and 2 pounds of fatty pork, and proceed with the recipe for Beer Joint Sausage.

9

FRESH AIR AND
PARCHED PEANUTS

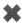

FRESH AIR BARBECUE in Jackson, Georgia, resides in a low-slung building that looks like a log cabin. The pillars that hold up the patio ceiling are pine tree logs, and the side of the building is sheathed in unfinished wood planks. Next door, a smaller building of the same general description serves as a warehouse and pantry. The smaller building housed the entire restaurant when Fresh Air first opened, in 1929. Originally, the fare was a "meat and three" plate lunch.

The restaurant's name and appearance were inspired by one of the most famous open-air revival groves in the South, the Indian Springs Holiness Campground, located three miles away in Indian Springs State Park. Considered the flagship of Georgia camp-meeting grounds, Indian Springs was established in 1890 and includes some 120 cottages.

The outdoor revival movement sought to bring celebrants into communion with nature, and so the architecture was intentionally rustic. Set in the middle of the forest, the cottages and worship centers were log cabins built of hand-hewn logs and raw wood. In their heyday, in the mid-1800s, camp meetings drew tens of thousands of pilgrims. The Indian Springs meeting ground has been hosting an annual revival for more than a hundred years.

In the 1930s, Fresh Air added the larger building with its unique stone barbecue pit. Plate lunches were still served on weekdays in the small building—barbecue was served on Friday, Saturday, and Sunday in the new building. Fresh Air's pit is at the center of the building rather than on one of the sides. The fireplace, which faces the back of the building, is fed with whole logs of ten feet or more that are shoved farther into the fire as they burn. The meat compartment faces the front counter.

In the 1940s, George "Toots" Caston, a fifth-generation Jackson native, bought the restaurant. The current proprietors, George and Charles Barber, are his descendants. Toots got rid of the plate lunches and turned Fresh Air into a strictly barbecue business. At the time, barbecue was one of the most popular restaurant items in the country.

The only meat cooked is uncured hams—not shoulders, not Boston butts, and not picnics. The meat is chopped very fine in a Hobart electric chopper. "Why hams?" I asked Charles Barber. He told me that hams were a lot more popular years ago than they are now. The ham has less fat, and since modern pork is leaner than pork used to be, Fresh Air's chopped pork is drier than most barbecue. "We tried mixing two hams to one shoulder, but our customers like the ham," Barber said. The barbecue benefits from a liberal dousing with the house-made ketchup-inflected vinegar-and-sugar-blend barbecue sauce.

The interior of Fresh Air Barbecue is a remarkable throwback to the 1940s. Many of the counter and kitchen implements, including the old-fashioned scale that the meat is weighed on, look like well-preserved antiques. Until 1955, the floor was covered with fresh sawdust every morning and swept up at the end of the evening. The health department declared the practice unsanitary and put that tradition to an end.

Long hardwood logs are fed into the fireplace at Fresh Air Barbecue in Jackson, Georgia.

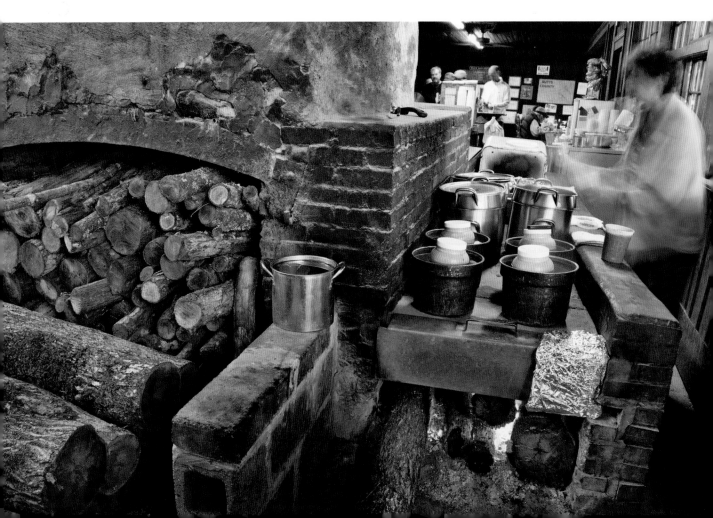

The people I met in line while waiting to order had been coming there for more than thirty years. I took their suggestion and ordered the Deluxe Plate, which included chopped pork with crackers, bread, pickles, white slaw, and a cup of Fresh Air's famous Brunswick stew. The stew is a concoction that has long been associated with barbecue, particularly in Georgia.

In one historical account I read about preparing a barbecue, the participants purchased a small pig called a shoat and started a pot on the fire before killing it. They threw the head, organ meats, and other hog parts that they weren't going to barbecue into the pot to start the stew. Available vegetables, liquids, and wild game were added. Historical recipes call for the stew to be cooked for many hours, until the ingredients dissolve into an unrecognizable mush.

Charles Barber laughed when I asked him whether Fresh Air used squirrels and pig heads in its famous Brunswick stew. "In the old days, barbecue men used hog heads and organ meat in Brunswick stew," he said. "Squirrels were always a popular addition. I used to hunt squirrels, but I haven't tasted one in forty years."

Over time, Brunswick stew became a catchall for barbecue restaurants. There was no recipe—it was a pot on the back of the stove where you threw the scraps so that you didn't waste anything. "I hear there's a barbecue man in Atlanta who still uses chicken and rib scraps," Barber said. "Our Brunswick stew isn't made out of scraps anymore. It's made from beef eye of round that we grind up here in the kitchen."

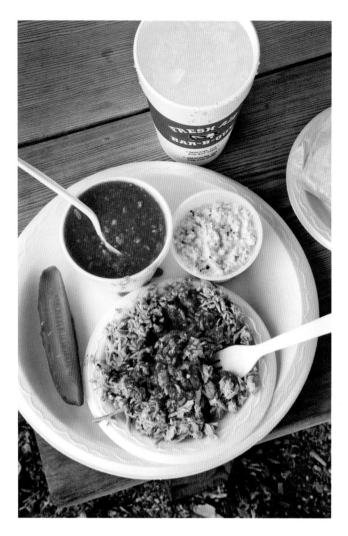

At Fresh Air, uncured hams are barbecued, finely chopped, mixed with sauce, and served on sandwiches and trays like this one with coleslaw and Brunswick stew.

The Brunswick stew at Fresh Air tastes like hamburger and vegetable soup. There was little to recommend it other than its connection to an old tradition. I look forward to finding some of the legendary Brunswick stew I keep hearing about—the stuff that's made with wild game and lots of pepper pods.

Before we found the original Fresh Air in Jackson, we made the mistake of visiting another Fresh Air run by a member of the family. That restaurant didn't have a wood-fired pit; it didn't even have an electric or gas stainless-steel barbecue oven. In fact, no cooking took place there at all; reheated barbecue was shipped in from another location.

The single most aggravating experience on the entire road trip was a visit to Purvis Barbecue in Louisville, Georgia. A woman I met who grew up in Georgia talked in glowing terms about this hole-in-the-wall barbecue and insisted I try it. I called the place from the interstate and asked whether the meat was cooked with wood or gas. The lady who answered the phone said neither. I proceeded through the litany of possibilities—charcoal, electric, etc.—but she insisted it was none of the above. I would just have to see for myself, she said. It was a long drive, past Waynesboro on tiny country roads.

When I finally got there, the guy behind the counter wanted to know what he was going to get in return for talking to me. He was of the opinion that journalists should pay the people they interview. His barbecue was obviously cooked in the shiny metal oven that stood right behind him in plain sight. I assume it was a pellet smoker, which would explain the silly guessing game. Pellets are compressed wood shavings that are dropped onto hot grill elements to emit smoke. Finally, I said being mentioned in a book might increase his business. He got angry, turned red, and barked that he didn't need any more business.

I am not trying to insult the food in Georgia. Atlanta is one of the premier food cities of the South. From the hamburger at the Buckhead Diner to the charcuterie at Holeman & Finch, to Scott Peacock's fried chicken, I have eaten my way around the city and loved every bit of it. Maybe it was bad luck or poor research, but we struck out when it came to Georgia barbecue. No doubt there are many great barbecue establishments in the state, but sadly, we failed to uncover them.

Our Georgia base was a house on Lake Lanier. In return for use of his generous guest rooms, we supplied my brother, Rick Walsh, with chopped pork, barbecued chicken, and other treats we picked up along the way. On various visits, I brought him barbecue from Fresh Air as well as from joints in Alabama, North Carolina, and South Carolina, all tucked away carefully in the cooler.

When you are on a barbecue road trip, you want to order a representative sampling of the fare at every establishment you visit. There is no way to eat it all. And after interviewing the owner or manager of the restaurant, it is very insulting to dump most of your meal in the trash while they are watching you.

Jeffrey Steingarten was the first food writer to articulate the etiquette of the doggy bag for me. When we visited three Houston restaurants in a few hours, he asked for the leftovers to be carefully packed everywhere we went. He carried the plastic bags containing the polystyrene containers carefully to my car and placed them on the back seat. Later, when we would come near a garbage can or a Dumpster, he would ask me to pull over while he threw the containers away.

He didn't want to insult the cooks who had so lovingly prepared his plates, he explained. But since he was traveling, he didn't have anywhere to keep the food. So he asked to have it packed up in a show of appreciation, and later threw it away. I took Steingarten's advice on always getting the leftovers packed up to go, but I

have trouble throwing food away. I always travel with a cooler. The leftovers came in handy from time to time when I woke up in the middle of the night with a craving for more barbecue. And Rufus and I were happy to unload our leftovers into the refrigerators of friends and family. Along with the barbecue, we made folks a lot of parched peanuts.

The road food of Georgia is boiled peanuts. We saw billboards advertising places that sold boiled peanuts everywhere we went. Boiled peanuts, or "goober peas," as they were once called, are made with young green peanuts that haven't hardened. They are a popular street food in Ghana and were probably introduced to Southern cuisine by African slaves. As a social gathering, the peanut boil is Georgia's answer to the Cajun crawfish boil.

Boiled peanuts, or "goober peas," as they were once called, are made with young green peanuts that haven't hardened.

Rufus confessed that he wasn't too fond of boiled peanuts, but he dearly loved the "parched peanuts" his mom used to make in the oven. I had never heard of parched peanuts. I was intrigued to hear of a Southern food specialty that I hadn't tried yet. Rufus said they were just raw peanuts roasted in the oven until they were a little crunchy. He said they acquired an intense, dry-roasted flavor that was so good you didn't even want to salt them.

I looked up "parched peanuts" on my iPhone. The article said that parching peanuts in the oven was very tricky, since they could go from underdone to burnt in a minute or two. The author said the modern way to parch peanuts is to put them in a brown paper lunch bag and microwave them. So I bought some green peanuts the next time we stopped into a grocery store to restock our cooler with water and beer. I also procured a stack of brown paper lunch bags.

My brother invited a bunch of his friends over one night when we had a lot of barbecue to share. Before dinner, I made parched peanuts in his microwave as a cocktail snack. The peanuts were as popular as the barbecue, and I ended up making batch after batch as the assembled guests gobbled them up as fast as I could parch them.

Georgia Barbecued Ham

- -

We are talking about an uncured ham here, not the bright red ham you serve at Easter or buy sliced for sandwiches in the deli department. You will find uncured hams alongside the Boston butts and picnics in the pork section of the grocery store meat case.

Barbecued ham is darker in color and lower in fat than Boston butt or pork picnic. At Fresh Air in Georgia they grind the barbecued ham up in a meat grinder and mix it generously with barbecue sauce. At Neely's in Marshall, Texas, they grind barbecued Boston butts in the same way to make Brown Pig sandwiches.

Grinding the barbecued pork in a meat grinder creates a mush that is more readily seasoned with sauces so it never tastes dry. If you have a meat grinder, you may want to give this technique a try.

- 1 uncured ham, about 8 pounds
- Salt and pepper to taste
- 1 quart Hog Mop (p. 53)

Season the meat with salt and pepper, pressing the seasoning into the meat, and refrigerate it overnight. Fill a water pan with water and place it in the pit.

Set up your pit for indirect heat with a water pan. Use hardwood lump charcoal or charcoal briquettes. Maintain a temperature between 225° and 275°F. Place the ham in the smoker with the largest area of skin down. The skin will shrink and harden, serving as a bowl to contain the fat and juice. You might rotate the ham to achieve more even cooking, but don't turn it over.

Replenish the charcoal and the water in the water pan as needed. Mop the meat whenever you open the lid. Expect a cooking time of eight hours—more if you raise the lid often or the fire goes out. Cook to an internal temperature of at least 195°F.

When the meat is done, allow it to rest for at least fifteen minutes. Then remove the skin and bones. Cut the meat into chunks, and then push it through a meat grinder. Season the ground barbecue mixture with salt and pepper and barbecue sauce.

Serve the minced meat on sandwich rolls topped with your favorite slaw. *Serves 8 to 12.*

Parched Peanuts

It may take a batch or two to get the timing down. Fresh out of the oven, these taste so good you may not want to bother with salt. They are called roasted peanuts in other parts of the country.

- 1–2 pounds raw peanuts in the shell
- Salt to taste

Preheat oven to 350°F. Spread the peanuts in their shells in a baking pan.

Depending on their size, bake peanuts 15–30 minutes, or until they are roasted, stirring around once or twice. If the peanuts begin to scorch, take them out right away. The peanuts may seem a little underdone when you remove them from the oven, but they will continue to cook. Be careful to let them cool before eating.

VARIATION

Motel microwave method: Put a couple of handfuls of raw peanuts in a brown paper lunch sack and fold the sack to seal. Microwave on high for 2–5 minutes, or until the peanuts give off a roasted aroma. You may need to adjust the cooking time, depending on the strength of the microwave. Repeat, reusing the sack until you have enough peanuts.

Old-Fashioned Brunswick Stew

I have no interest in making the modern version of Brunswick stew, but the old version sounds pretty interesting—if you have some squirrels on hand. Legend has it that Brunswick stew was invented in Brunswick County, Virginia in 1828 by "Uncle" Jimmy Matthews on a hunting trip hosted by his employer, a General Assembly member named Dr. Creed Haskins. That stew contained only squirrels, butter, onions, bread crumbs and seasonings. A succotash of lima beans and corn was added later when Matthews made the stew for his employer's political rallies. From those beginnings, the stew evolved into a more elaborate dish.

There are three recipes for Brunswick Stew in the 1878 cookbook, Housekeeping in Old Virginia by Marion Cabell Tyree. One is made with beef and the other two with chicken or squirrel. Here's my favorite of the three:

About four hours before dinner, put on two or three slices of bacon, two squirrels or chickens, one onion sliced, in one-gallon water. Stew some time, then add one quart peeled tomatoes, two ears of grated corn, three Irish potatoes sliced, and one-handful butter beans, and part pod of red pepper. Stew altogether about one hour till you can take out the bones. When done, put in one teaspoonful bread crumbs and one large spoonful butter.

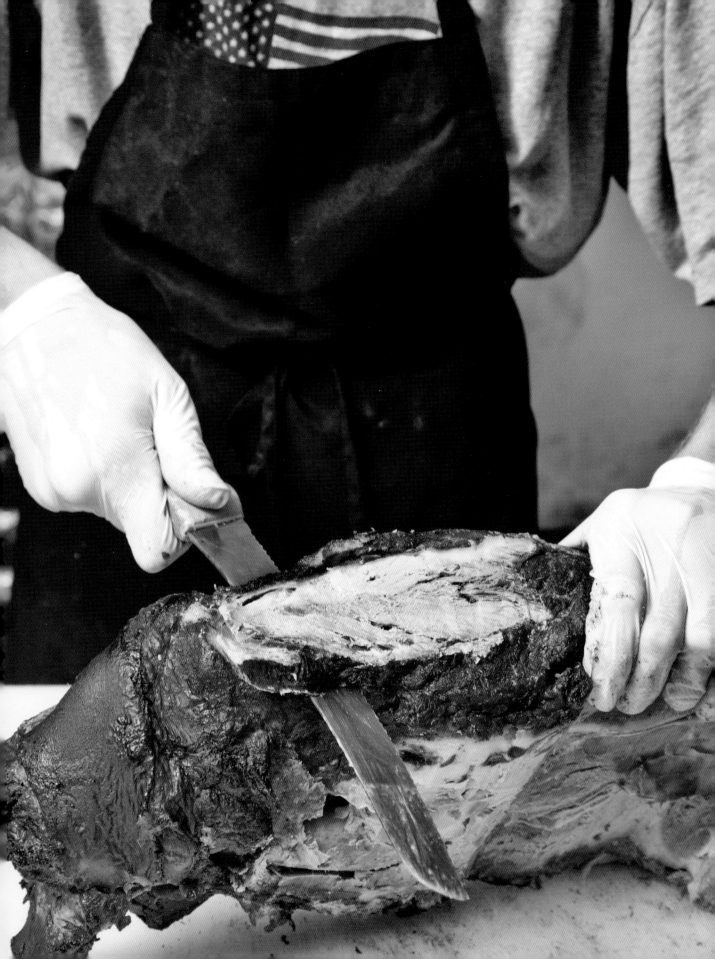

10

SHOULDERS AND RED DIP

FROM GEORGIA, I-85 enters northwest South Carolina, cutting the corner of that state before entering North Carolina. At Gaffney, South Carolina, near the North Carolina border, we paused to appreciate one of the nation's most famous public art projects—a water tower that looks like a giant peach rising high above the interstate. The steel was cast with the fruit's characteristic crease running from top to bottom. An artist named Peter Freudenberg painted the steel to match the color of the fruit at the peak of ripeness. A long green leaf of painted steel is attached to the top.

The giant peach is supposed to remind us that South Carolina is the leading producer of peaches in the South—not Georgia. But from the right angle, it also reminds motorists of an enormous booty.

The scenery along our route hadn't changed for days. We saw the same wooded hills, lakes, and pastures from Jacksonville, Alabama, and Lake Lanier in northern Georgia through Greenville, South Carolina, and on into Charlotte and Lexington, North Carolina. We were driving along the gently curving apostrophe of the Piedmont plateau, which runs all the way from central Alabama to New Jersey in between the coastal plains and the rugged Appalachian Mountains. "Piedmont" means "foothill" in French. The plateau is narrowest at its northern limit and widens out to around three hundred miles in North Carolina.

One thing we noticed when we passed the peach and entered North Carolina was the frequency of highway signs advertising barbecue. Barbecue stands, barbecue restaurants, and old-fashioned pit barbecues were touted at almost every exit.

Next page: Sunset in the North Carolina Piedmont

The first thing that you learn about North Carolina barbecue is that there is a regional rivalry. In Eastern North Carolina, pitmasters barbecue whole hogs and make the barbecue sauce out of vinegar and a little pepper. In the Piedmont, they barbecue pork shoulders and make barbecue sauce with a touch of ketchup. Out of this difference in cooking styles, a feud worthy of the Hatfields and McCoys seems to have evolved. At first, I thought it was all in good fun. But after learning more about the hundreds of years of animosity between the English planters of the coastal plains and the Germans of the Piedmont, I realized it was serious.

Rufus and I pulled into a gas station along the highway to fill the tank. There was a barbecue fast-food restaurant with a drive-through lane next to the station. Eating barbecue in your car is not only an old tradition around here, but is also a key to understanding barbecue culture. As Robert Moss explains in his book *Barbecue: The History of an American Institution*, it was the automobile that led to the "Golden Age of Barbecue." And nowhere is that easier to see than in the well-documented story of barbecue in Lexington, North Carolina.

Eating barbecue in your car is not only an old tradition around here, but is also a key to understanding barbecue culture.

In the railroad era, restaurants were located near train stations and in busy city centers. It was during this period that Lexington's first barbecue stand opened in 1919. It was a tent across the street from the Davidson County courthouse. The stand was set up by a barbecue man named Sid Weaver, and it was open when court was is session.

In 1923, Jesse Swicegood set up a stand near Weaver's. In a photo belonging to the Davidson County Historical Museum, Jesse Swicegood is shown holding a shovel next to a low, open barbecue pit made of cinder blocks and iron grates. Around thirty pork shoulders are cooking on the pit, and a half-dozen picnic tables are set up nearby. Swicegood is wearing a long white apron over his coat and tie. I wonder whether he got dressed up for the photo or whether he wore formal clothing to his outdoor barbecue business every day. I have seen that photo, or drawings done from it, hanging on the walls of several North Carolina barbecue joints. It is the enduring image of Lexington barbecue in the good old days.

A young man named Warner Stamey went to work for Swicegood in 1927 and eventually bought him out. Stamey would go on to hire Sid Weaver and become the father of Lexington barbecue. It was Stamey who came up with the idea of serving hush puppies with barbecue. A friend of his ran a successful catfish restaurant, and Stamey borrowed the recipe from him. Stamey is also credited with inventing Lexington red slaw, but his grandson Chip says the credit for that recipe should really go to an employee named Dell Yarborough, who was Sid Weaver's sister-in-law. But Warner Stamey's innovations went far beyond the menu. It was Stamey who invented the Lexington brick barbecue pit. His last restaurant in Greensboro was called Stamey's Drive-In. It was a barbecue restaurant for people in their cars.

Rufus and I had been on the road since the crack of dawn, and we were ready for lunch when we got to Lexington. Our first stop was the Barbecue Center, the best preserved example of a barbecue drive-in either one of us had ever seen. Just for fun, we stayed in the car and ordered from the carhop. The Barbecue Center is one of four barbecue restaurants that Rufus and I visited in Lexington that still have curb service, but it was the only one that still had the *Happy Days*-era metal-awning-covered parking curb stretching out from the building.

The barbecue was cooked in a wood-fired pit built into a brick chimney on the side of the building. The woodpile was in the parking lot. The chopped pork shoulder was extremely moist and mixed with a thin red sauce. The barbecue sauce, or dip, tasted like a simple vinegar and pepper sauce with a touch of ketchup. After eating our barbecue sandwiches in the car, we went inside to sample some of the Barbecue Center's other specialties.

"Barbecue soup" is one of the best things on the menu here. Cecil Conrad, the owner, was careful to point out that this was a soup of their own creation and was not intended to be Brunswick stew. He sounded so defensive that we could tell he had been abused about this before. The barbecue soup combined chopped pork barbecue with chunks of barbecued chicken in a broth with onions, carrots, celery,

Bar-B-Q Center in Lexington, North Carolina, is a barbecue drive-in complete with an awning and curb service.

The four-pound banana split at Bar-B-Q Center is a carryover from the restaurant's early days as a dairy bar.

and peas. Too bad Brunswick stew purists will not allow any actual barbecue to be used—this tangy barbecue soup was a lot better than any Brunswick stew I have ever tasted.

Before becoming the Barbecue Center, the establishment had opened as a dairy bar co-owned by the nearby Coble Dairy. It specialized in ice cream sundaes. In 1955, it was purchased by Doug Gosnell, who had learned to barbecue under Warner Stamey. Gosnell expanded the menu to include chopped pork shoulder sandwiches. Gosnell took his brother-in-law Sonny Conrad into the business and showed him how to cook barbecue. When Gosnell passed away in 1967, Sonny ran the restaurant for Gosnell's mother and eventually took it over. Today his two sons, Cecil and Michael, work at the restaurant as well.

The barbecue was excellent, and so was the barbecue soup, but one of the most famous things to eat at the Barbecue Center is a leftover from its days as a dairy bar—a banana split. But this is no ordinary banana split—it's the Great Wall of Ice Cream. Between two half bananas a long, cliff-like expanse of ice cream scoops is topped with whipped cream and lots of chocolate sauce. The enormous, four-pound dessert can feed a whole family.

But this is no ordinary banana split—it's the Great Wall of Ice Cream.

The walls at the Barbecue Center were decorated with posters advertising the Lexington Barbecue Festival. The festival, which was started in 1984 by the local daily newspaper, is one of the most successful civic festivals in the country. You would think that competition would be fierce among twenty barbecue restaurants in a city as small as Lexington, but the barbecue men of Lexington understood the wisdom of getting together and promoting Lexington barbecue to the world. By 1994, more than 100,000 people were attending the one-day event. But the new awareness of Lexington barbecue attracted barbecue enthusiasts year-round. The city used its barbecue history to promote tourism with maps, brochures, and websites. In 2004, the block near the courthouse where Sid Weaver and Jesse Swicegood ran their stands in the 1920s was renamed "Barbecue Alley."

IN THE 1920S and throughout the early days of the automobile, adventurous car owners who wanted to tour the countryside had to take picnics and camping gear wherever they went. Among the first businesses that opened on well-traveled motorways were gas stations that also sold food. Barbecue was a popular offering at these travel centers because it didn't have to be cooked to order. Such famous barbecue institutions as Owen's Bar-B-Q in Lake City, South Carolina; Golden Rule Barbecue in Irondale, Alabama; and Sprayberry's Barbecue in Newnan, Georgia, started out as gas stations.

Motorists didn't want to sit down and eat in a restaurant with a tablecloth; they wanted to grab something to eat in the car. Roadside barbecue joints fit the need perfectly. Cooking barbecue required little in the way of equipment. And the

takeaway meal was easy to package. Barbecue sandwiches were served on white bread with a few condiments, wrapped in paper, and carried away in a brown paper bag. That meant no plates or utensils and no dishwashers.

Some barbecue men have called barbecue the original fast food because although it cooks slowly, it doesn't take long to prepare a barbecue sandwich once the meat is cooked. A barbecue pit emitting smoke and the aroma of cooked pork also proved to be a successful form of advertising.

Urban barbecue joints catered to teenagers who spent their evenings "driving around town." In, 1921, the Pig Stand opened in Dallas. It was among the first drive-ins in America. In 1938, the Houston outpost of the Pig Stand chain was the first to use the term "drive-in" to describe its mode of service. As a car slowed down in the parking lot, an energetic youngster called a carhop would climb on the running board of the still-moving vehicle to greet the driver and start describing the menu. As the name would suggest, the Pig Stand specialized in barbecued pork sandwiches.

Drive-ins quickly turned into hangouts for kids in cars. When Rufus was a teen-ager, he hung out at the Rocket Drive-In in Jacksonville, Alabama. The Rocket was opened by the Marbut family in 1957. It used to have drive-in awnings like the ones at the Barbecue Center, and a blinking neon sign in the shape of a rocket out front.

Gary Marbut, owner of the Rocket Drive-In in Jacksonville, Alabama

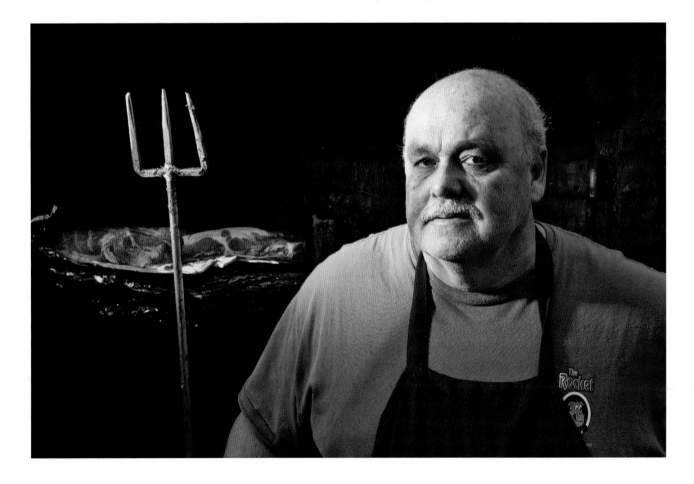

You pulled in and placed your order on the telephone that hung beside each parking spot. Barbecue sandwiches and hamburgers were equally popular at the Rocket, Rufus remembers. The excellent fried catfish sandwich came in third.

The pit at the Rocket Drive-In

The Rocket's barbecue pit is built into a chimney in the rear of the building. There's no access to the pit from the kitchen. Pork butts are slow cooked over hickory coals and then carried around from the back parking lot to the kitchen. Gary Marbut and his wife, Patsy, took the place over from Gary's parents and got rid of the drive-in awnings. But Gary still cooks a load of pork butts several times a week.

Rufus said that the barbecued pork sandwich at the Rocket is nearly identical to the "Brown Pig" sandwiches he gets at Neely's Sandwich Shop on East Grand Avenue in Marshall, Texas, not far from his home in Longview. The chopped barbecued pork sandwich at Neely's has become so iconic that most people mistakenly call the restaurant "Neely's Brown Pig." Many Southerners are incredulous when they hear that barbecued pork sandwiches have long been eaten in Texas. The common wisdom is that Texans eat only barbecued beef brisket, and only with a thick sweet barbecue sauce.

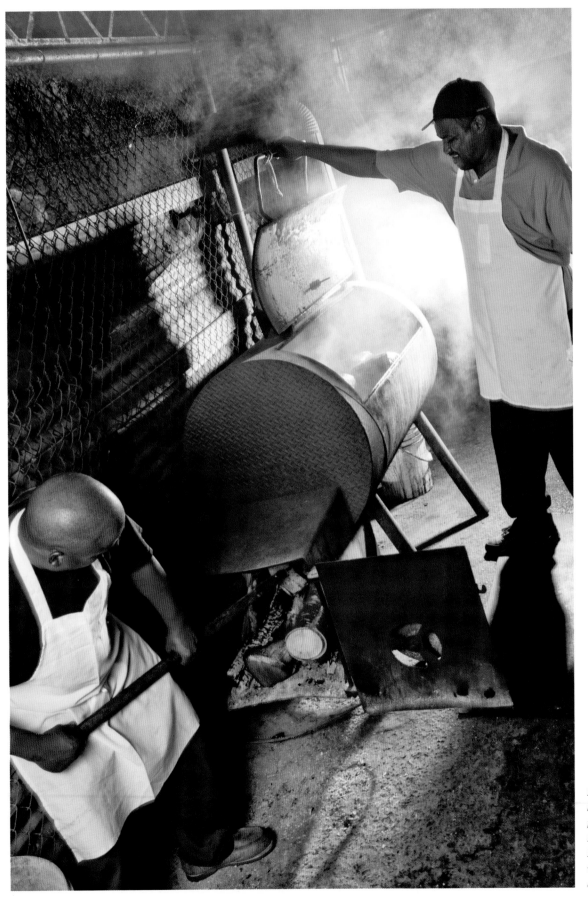

Barbecued pork butts for the famous Brown Pig sandwiches at Neely's are cooked with wood in an offset smoker.

East Texas is thoroughly Southern, but it's still Texas. Neely's barbecue pit, a steel-cylinder type, burns hickory wood—the pork butts, briskets, and hams are all wood-smoked with indirect heat in the Texas style, not barbecued directly over burned-down coals in the Southern style. The "Brown Pig" is made by mincing the smoked pork butts in a Hobart chopper and then seasoning the ground meat with a ketchup-and-vinegar barbecue sauce. It is served on a small hamburger bun, spread with mayo, and topped with lettuce. Bill Moyers, a Marshall native and lifelong Neely's fan, called it "the best sandwich between here and China."

When the restaurant was founded in 1927 as Neely and Sons, the chopped pork sandwiches sold for fifteen cents each. The name was changed to Neely and Brothers when James Neely took over from his deceased father. Later it became Neely's Sandwich shop. Neely's was inspired by the Pig Stand, and its current location was originally a drive-in. You can still order from a take-out window on the front of the place, the last vestige of the old method of operation. Two Neely sisters own the building, but the business was sold to an employee, Sally Cobb, a few years ago. Sally still works as a waitress at the restaurant she owns, darting from table to table taking orders and delivering Brown Pigs.

First opened in 1927, Neely's in Marshall, Texas, competed with the popular Dallas drive-in chain called the Pig Stand; both specialized in chopped pork sandwiches.

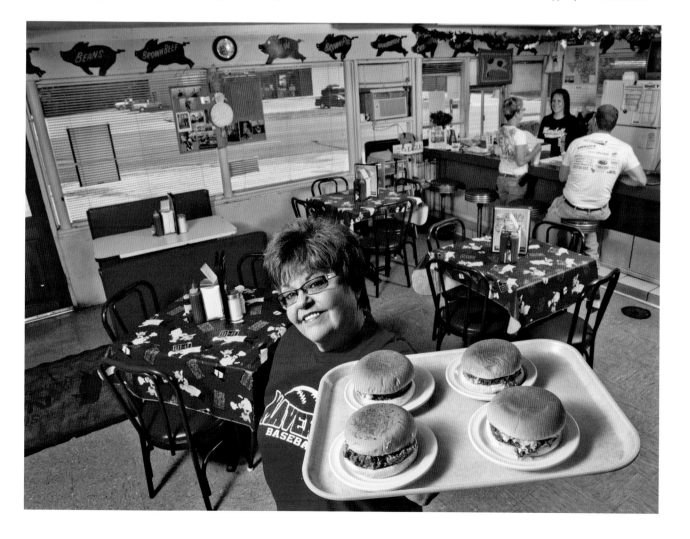

WHILE THE BARBECUE DRIVE-IN may have started in Texas, it is best appreciated today in Lexington, North Carolina, where it is still a tradition. After dark, Rufus and I pulled into a parking space along the side of Smiley's Pit Cooked Barbecue—right under a window with a neon light that spelled out "Curb Service." We ordered a couple of sandwiches from the curbhop. After sampling the perfectly crafted chopped pork, red dip, and red slaw sandwiches, we went inside to meet the owner, an intense man with a bushy mustache named Steve Yountz. Yountz turned out to be a devoted barbecue man who was eager to show us his well-worn brick pits and huge woodpile. Yountz is a member of the North Carolina Barbecue Association, an organization that admits only barbecue purists who cook with real wood into its ranks.

A few blocks north of Smiley's on Winston Road, we stopped at the oldest barbecue drive-in restaurant in Lexington. Speedy's opened in 1948 as Tussey's Drive-In. In the obligatory Lexington "begats," it must be noted that Tussey learned to barbecue from Warner Stamey. As the first drive-in in town, Tussey's became a teen

A curbhop at Speedy's BBQ in Lexington, North Carolina

hangout. Tussey sold the restaurant in 1963, and it was renamed Speedy's Drive-In. Today, it's just called Speedy's BBQ. The restaurant has a long history, but sadly the pork is now cooked on an electric rotisserie and tastes more like overcooked pork roast than barbecue. But the "Sound Horn for Service" sign on the side of the building is classic.

Late in the afternoon, before we did our evening survey of Lexington barbecue drive-ins, Rufus and I had checked into a motel across Cotton Grove Road. The next morning, when we asked for directions to the city's most legendary barbecue pit, Lexington Barbecue, our hotel clerk referred to it as "Honeymonk's." He handed us a visitor's map of Lexington; on the bottom were the addresses of fourteen barbecue restaurants, each with a corresponding flag on the map. I have never seen a chamber of commerce with such zeal about barbecue.

We knocked on the front door of Lexington Barbecue several hours before it opened, and got a chance to interview its founder, Wayne Monk. "Honeymonk Drive-In was the original name of the place," he told me when I asked about the nickname.

Smiley's
Pit Cooked
Barbecue

"Drive-ins were a big deal when we started out. 'Honeymonk' was a name that my original investor came up with. I couldn't get the bank to loan me any money, so I took on an investor named Sonny Honeycutt. We talked about naming the place for a few minutes one morning, and the next thing I knew, he had a sign installed out front that said 'Honeymonk Drive-In.' We were really a teenagers' hangout for the first two years. I bought Honeycutt out, and he was gone ninety days after we opened. I changed the name to Lexington Barbecue, but some of the locals still call us Honeymonk."

Monk switched the emphasis from hamburgers to barbecue. "I learned to barbecue from Holland Tussey. I started out as a curbhop at Tussey's Drive-In, which is now called Speedy's Drive-In. It was five years before I got to cook any meat. It was hard work. Tussey learned to barbecue from Warner Stamey. Of course, I have my own way of doing things now. We use oak wood here. Hickory is too expensive and it burns too hot. I like oak mixed with a little pecan."

The first thing you notice when you pull into the parking lot is the remarkable brick pit structure at Lexington Barbecue—one side of the kitchen is a brick wall with five chimneys sticking out of the top, each ending in a tapered metal flue. It

Wayne Monk, founder of Lexington Barbecue

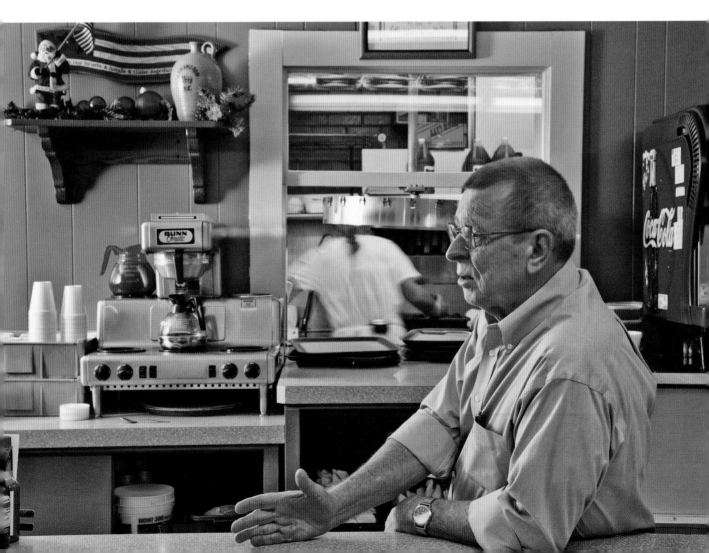

was easy to understand how barbecue had evolved from a hole in the ground to the waist-high pits we had seen in Tennessee. The giant, monolithic chimneys in Alabama were elaborate in construction, but had a fairly simple function. But the series of joined fireplaces and pits built into a brick wall that we saw in North Carolina had an industrial look. I asked Wayne Monk if he knew where that construction style came from.

"It was either Sid Weaver or Warner Stamey who started building the brick pits," Monk said. The problem with high-volume barbecue restaurants is that the constant heat burns out the pits. Regular bricks or cinder blocks are fine for a backyard barbecue pit that gets used now and then. But when the pit is running around the clock, a sturdier firebox is needed. Stamey came up with the idea of using steam-train furnaces with brick chimneys built around them. "The last time I had to rebuild a firebox, it cost me $28,000," Monk told me. "It was relined with firebrick and PPG fireproof mortar, and I had to beg somebody to do the work."

"You need one firebox for every two pits," Monk said. The firebox has a door on either end; wood is fed in from the outside; and coals are shoveled out the kitchen side. The hot coals are shoveled under racks full of pork shoulders, and the meat is then covered with cardboard to retain some of the heat and to keep the meat from getting covered with ashes.

Honeymonk's Drive-In opened in 1962 at the height of the drive-in craze. Barbecue restaurants of all kinds were multiplying across the country, but especially in the South. Even steak houses and fancy restaurants added barbecue to their menus. According to the historian Robert Moss, more than half the restaurants on North Carolina's "Historic Barbecue Trail" opened between 1945 and 1965.

Lexington Barbecue does a lot of business. Monk showed me a chart on a yellow legal pad that tracked the number of pork shoulders sold during Christmas week, the busiest week of the year for the last ten years. The totals ranged from 700 to around 950. The pork shoulders that Lexington Barbecue cooks average around 18 pounds each, so we are talking about roughly 18,000 pounds, or nine tons, of raw pork in one week. The restaurant sells an estimated 13,000 shoulders each year.

PORK SHOULDERS HAVE MORE MARBLING than hams or loins, and at eighteen to twenty pounds, they are easy to handle. The skin on the outside of the shoulder encases the meat, so the fat isn't lost, which makes shoulder meat much juicier than the meat from a skinless Boston butt. After the barbecue is "pulled," the skin can be fried into crispy chunks that are enjoyed by themselves or on "skin sandwiches." All this makes shoulder meat ideal for barbecue.

Whole shoulders are not available in most of the country—the joint is usually divided by meatpackers into two cuts: the picnic, which has some skin and a large bone, and the boneless roast called the Boston butt. Whole shoulder has long been a specialty at the meat market called Conrad & Hinkle in Lexington. Gary R. Freeze,

breakfast after circling the parking lot and admiring the impressive brick pit in the back. It was a homey sort of diner atmosphere with lots of regulars hanging around drinking coffee. I ordered barbecue and eggs for breakfast. When I asked our waitress what kind of wood they burned in the old brick pits, she winced.

"Those old pits aren't used anymore. They cook everything on an electric cooker now," she confessed. If we wanted great pit-cooked barbecue in Lexington, we needed to visit Cook's, she recommended. She was one of several people to mention that establishment. John Shelton Reed wrote that of the twenty or so famous barbecue establishments in Lexington, only three or four still cooked with wood: "Wayne Monk's Lexington Barbecue, Sonny Conrad's Barbecue Center, Steve Yountz at Smiley's, and (possibly) the Copes at Smokey Joe's (although some have hinted that the woodpile is mostly for show)."

In *Holy Smoke*, Reed reported a statistic from Dave Lineback, a North Carolina barbecue blogger who surveyed 500 North Carolina barbecue joints and found that only about one in twelve used wood in their cooking. Of the few that use any wood at all, most rely on a Southern Pride or Nunnery Freeman cooker that uses a combination of wood and other fuels. There are maybe two dozen artisan barbecue joints left in the state that use nothing but wood.

Chopped pork, biscuit, and eggs at Jimmy's in Lexington, North Carolina

Purists, including the barbecue authors John Shelton Reed and Bob Garner, lament that North Carolina barbecue has become merely a dish of shredded roast pork served with some kind of tangy sauce. Real pit barbecue was replaced by gas- and electric-cooked meat years ago, and few people in North Carolina even remember the difference.

Among the couple of dozen pitmasters still carrying on the artisan barbecue tradition, Reed recommended Brandon Cook at Cook's Barbecue, just outside Lexington—the same place our waitress mentioned. So we left our breakfasts at Jimmy's half-eaten, overtipped the waitress, and drove down Cotton Grove Road to visit Brandon Cook.

COOK'S BARBECUE is located in the countryside outside Lexington off Rockcrusher Road near High Rock Lake. It's owned by the Payne family, who are friends of the founder, Doug Cook. Doug moved on to another barbecue venture, but the Paynes hired his son, Brandon Cook, to do the barbecuing. At 8:30 a.m. we found Brandon Cook hustling to get his pork shoulders ready. He had been cooking them all night.

"My dad, Doug Cook, learned how to cook barbecue from Wayne Monk. Dad started cooking barbecue for folks in a hole in the ground on the side of our house to make a little extra money," Brandon said. "We lived right across the street. The health department came out and told him he couldn't sell barbecue without a sanitary kitchen. So he built a little pit right here." Brandon pointed to the utilitarian-looking rectangle of concrete we were standing on and the near vicinity. "There was the pit, a sink, a fryer, and that was it. He only did to-go orders. Later, he added the dining room with the fireplace in front."

The original dining room at Cook's looks like a log cabin with a stone hearth. It's one of the most charming barbecue restaurants I've ever seen. Brandon Cook grew up in this space. He and his friends built forts out of empty cardboard boxes in the old dining room. He has a lot of fond memories.

"We sold barbecue trays, slaw and hot dogs, and hamburgers with chili—that was it. Business was really good in the summer because of all the people going out to the lake," Brandon remembered. "But the winter wasn't so good. Dad decided to move on and open a new restaurant. He wasn't cooking with wood anymore. His friends the Paynes bought this place. I was working construction at the time, but things were slow. They hired me to come back and take over in 2002. I went back to cooking with wood. And I started cooking beef brisket several days a week along with the pork, chicken, and ribs. The beef is real popular. Sorry we don't have any today."

While Brandon was busy shoveling coals into his pits, Rufus and I wandered around for a while. Out back, we watched a husband and wife team of seventy-somethings unload a huge pile of wood. Then, in the kitchen, we learned how to make red barbecue-joint slaw from Susan Gibson. She ground fifty pounds of cabbage in a Hobart chopper until it resembled confetti. Then she added very little salt,

Brandon Cook, "The Boy Who Went Back to Wood"

a lot of sugar, ketchup, and vinegar. I sometimes sweat the cabbage when I make slaw in order to remove some of the water. "Barbecue slaw has to be wet. Sometimes I add more water," Gibson said. She probably has gotten the hang of it by now. The restaurant goes through 200 pounds of red slaw a week. They also make white, mayonnaise-based slaw.

A framed newspaper article hanging on the wall of the kitchen bore the headline "The Boy Who Went Back to Wood." Brandon Cook's decision to return to the older way of cooking barbecue was apparently a "man bites dog" story in the eyes of the reporter.

Rufus and I sat down in the dining room when the restaurant opened, and ordered barbecue sandwiches with white slaw. Brandon Cook was still chopping the pork shoulders when we sat down to eat the steaming barbecue sandwiches. The meat was moist and creamy with lots of crunchy bits. It was one of the moistest barbecue sandwiches we had on the trip, but it's probably cheating to have the pitmaster make your sandwich from freshly chopped pork when you are the only customers in the restaurant. We split a slice of red velvet cake for dessert.

But no matter who makes your sandwich, this is the kind of place that barbecue lovers dream about. The rustic lake-lodge atmosphere, the earnest second-generation pitmaster who revived the artisan cooking style, the location across the street from his boyhood home—Cook's serves up a whole lot of warm and fuzzy feelings along with the handmade food.

"The food is great, but it's the places and the people that really interest me," Rufus said as we got back on the highway leaving Lexington. "Remember that picnic table made out of stumps and logs behind Morris Grocery outside Memphis—and the mailbox covered in kudzu—that speaks worlds to me. And the people—they love the hell out of what they do. They take a lot of pride in their work. It's not just their livelihood, it's their life. When you do something that well, it becomes an art. And that's the way I see some of these pitmasters."

Chopped pork sandwiches at Cook's Barbecue

WARNER STAMEY TAUGHT Holland Tussey, who taught Wayne Monk, who taught Doug Cook, who taught Brandon Cook. After tracing all the begats that always led back to Stamey, I was eager to visit a restaurant founded by Warner Stamey himself.

In 1953, Warner Stamey relocated to Greensboro and opened the last of his barbecue restaurants, Stamey's Drive-In on High Point Road. Charles and Keith, part of the second generation of the Stamey clan, expanded the operation and built the existing family-style restaurant on the drive-in location. There is a second Stamey's location in Greensboro on Battleground Road.

Before I set foot in the restaurant, I found the enormous pit building, far to the rear of the High Point Road parking lot. It was the largest and most impressive chimney pit complex I have ever seen. Three furnaces and six barbecue pits were housed in the huge brick structure. The door was open and there was someone inside. "*Hola*," I said, trying to strike up a conversation with the short dark-haired man who was tending the fire. "*¿Qué tal?*"

He looked up from what he was doing, pointed to himself, and said: "Cambodian." I had to laugh. *Qué tal*, indeed. After my self-directed tour of the Stamey-designed pits, I headed for the front door of the restaurant.

Except for some black-and-white photos of old barbecue pits, it didn't look like a barbecue place. The wallpaper was a loud Pennsylvania Dutch hex pattern, and the furniture looked Colonial. Except for the "Old-fashioned barbecue" slogan on the top of the menu, Stamey's looked as if it were trying to be an Applebee's. I got a booth and asked the waitress to help me pick out a representative sampling of Stamey's famous barbecue. She recommended a mixed plate of sliced barbecued pork and chicken with the customary hush puppies and slaw. The pork was dry and lackluster, and the chicken was drenched in barbecue sauce.

When he asked me what I thought about the food, I wish I had been diplomatic, but I couldn't stop myself.

When the waitress asked how everything was, I told her the chicken didn't taste like barbecue. She said, "It's not barbecue. It's roasted in the oven in the kitchen." The best barbecue was the "outside brown" sandwich she said. It wasn't listed on the menu. I was a little irritated that she had saved this news for now. I asked for a little of the brown to sample, but the waitress said it was available only in a sandwich. I almost did a Jack Nicholson and asked her for a brown sandwich, hold the bun.

About that time, Chip Stamey, Warner Stamey's grandson, came and sat in the booth with me for a while. Chip graduated from Wake Forest University with a degree in psychology and worked for Apple Inc. for six years before he came back to run the family business. While I was wide-eyed to be sitting in an establishment associated with the famous Warner Stamey, his grandson was obviously very jaded by the whole barbecue-history thing. He didn't hang any newspaper or magazine stories on the wall, because the locals already knew all that stuff.

When he asked me what I thought about the food, I wish I had been diplomatic, but I couldn't stop myself. I told him I didn't think much of the overroasted chicken and thought that it was deceptive to call it "Chicken-Q." I suggested he cater to barbecue tourists with a "Barbecue Lovers Plate" that would include the outside brown, since the specialty wasn't on the menu. I suggested he charge ten or twelve dollars for it instead of the five to six dollars he currently charged for a plate. Then I handed him my iPhone and showed him negative comments about Stamey's from food bloggers, most of whom agreed the restaurant has slumped.

Chip Stamey was insulted. He countered that the locals liked his restaurant just fine and that he didn't care about barbecue lovers. "Foodies want to go to dumps, and this isn't a dump," he said.

I was still a little hungry when I stopped at Allen & Son Pit Cooked Bar-B-Q an hour east of Greensboro, in rural Chapel Hill. I took a walk around to stretch my legs. The big built-in pit was located in its own building out back. There were lots of barbecue trailers parked nearby and piles of split hardwood all over the place. A charming picnic grove sat under some shade trees on top of a hill.

The dining room was located in a low-ceilinged cinder-block cabin. The tables were covered with green-checked tablecloths, and the chairs were wooden. There were bottles of house-made Allen & Son barbecue sauce for sale at the register. The sauce had separated inside the bottles, leaving a layer of fat on top. When I asked the cashier about it, she told me the sauce was made with vinegar, ketchup, salt and pepper, sugar, and lots of butter. You have to shake it or heat it to get the butter to mix back into the sauce.

I got a barbecue tray with pulled pork, slaw, hush puppies, and Brunswick stew. The pork on my lunch tray was moistened with the buttery sauce and mixed with crunchy bits of skin. It looked like part of the meat was chopped and part of it was pulled. The white slaw was excellent, and the big round hush puppies were crunchy on the outside and fluffy inside. The Brunswick stew was as good as any I'd had. (Which isn't saying much.) I ended my meal with a big wedge of sweet potato pie.

I didn't get to interview anyone, because the owners and pitmasters were gone the afternoon I visited. And Rufus had the day off, so there weren't any photos. Nevertheless, Allen & Son was one of the most remarkable barbecue joints I encountered in North Carolina. The barbecue was outstanding, but much of the charm of the place can be attributed to the woodsy backyard, the picnic grove, and the homespun feeling of the dining room.

I had to give Chip Stamey some credit. He's right: like most barbecue lovers, I prefer to eat in the rustic atmosphere he calls a "dump."

Barbecued Pork Shoulder

--

If you live in North Carolina, it's easy to find a whole pork shoulder. The rest of us have to special order them. Ask your butcher for a whole shoulder of between 15 and 20 pounds that is still covered with skin. Inevitably, the butcher will suggest you cook two pork roasts cut from the shoulder that are already available in the meat case.

A whole shoulder is made up of the Boston butt and the picnic. Cooking these two cuts side by side isn't a bad idea. But it's not the same thing as cooking a whole shoulder. The skin surrounding the shoulder keeps the meat much juicer. After giving up on getting a pork shoulder at the grocery store, I found two sources for whole shoulders in my hometown of Houston.

J & J Packing Company in Brookshire buys small pigs and processes them for Asian markets where they are used to make Chinese roast pork and other specialties. I bought an 18-pound shoulder there for about $40. I injected the shoulder with a sweet and spicy Dr Pepper brine (p. 230) and served it pulled pork style. The barbecue was very good.

The upscale grocery Revival Market sells pork from pigs raised on their own farm. I bought the first shoulder that market had ever sold. It came from an experimental cross between the imported Mangdalista pig and the heritage Red Wattle. The whole shoulder had a few ribs still attached, and it cost me around $125. I rubbed it with a little salt and pepper and then pulled it and chopped it. The high fat content produced a very juicy barbecued pork that tasted like confit. It was sensational.

Finding a pork processor or upscale meat market that will sell you a pork shoulder isn't as easy as going to the grocery store. But it's worth it.

- 1 whole pork shoulder, 15 to 20 pounds
- 6 tablespoons Hog Rub (p. 69)
- Dr Pepper Injection (p. 230), optional
- 1 quart Pork Mop (p. 53)
- Red Dip (p. 179)

Season the pork roast with the dry rub, pressing the spice mix into the exposed meat. Inject the meat with the Dr Pepper solution if desired. Fill the water pan. (If your barbecue didn't come with a water pan, use a fireproof steel bowl.)

Set up your smoker for indirect heat with a water pan. Use hardwood lump charcoal or charcoal briquettes. Maintain a temperature between 225° and 275°F. Place the shoulder in the smoker with the largest area of skin down. The skin will shrink and harden, serving as a bowl to contain the fat and juice. You might rotate the shoulder to achieve more even cooking, but don't turn it over.

Replenish the charcoal and the water in the water pan as needed. Mop the meat whenever you open the lid. The shoulder is done at 195° to 200°F. Expect a cooking time of approximately an hour per pound, but you have to add time if the temperature goes too low or you open the lid too often. To be safe, start the shoulder around 24 hours before you plan to serve it. A little extra cooking won't hurt anything.

After letting the shoulder rest for at least half an hour, remove the skin and reserve. Remove the bones, ligament, and undesirable pieces of fat. Put the meat, the crusty outer bark, and the melting bits of fat and any pieces of crispy skin you can find on a chopping block and mince together with a pair of meat cleavers. Season the mixture with salt and pepper and enough Red Dip to moisten. Serve the chopped meat on sandwich rolls with Red Dip or your favorite barbecue sauce and slaw.

Fry the pork skin following the directions on p. 260. *Serves 15 to 20.*

NOTE: Shoulders vs. forequarters: If you are going to the trouble of buying a custom cut, you might want to consider ordering something slightly larger (see Barbecued Hog Forequarter, p. 199).

Hush Puppies

In Texas, hush puppies are usually the size and shape of golf balls. In North Carolina, hush puppies are closer to the size and shape of your little finger. You shape them by rolling them between your palms. Or you can just drop the batter from a spoon into the hot oil and make them free-form shapes.

- Peanut oil for deep-frying
- 2½ cups yellow corn meal
- 1 teaspoon soda
- 1 teaspoon salt
- 2 tablespoons sugar
- 2 tablespoons flour
- 1 tablespoon baking powder
- 1 egg, beaten
- 2 cups buttermilk
- 3 tablespoons chopped onion

Mix the dry ingredients in a bowl. Beat the milk and egg together and combine with the dry ingredients. Add the chopped onion. The batter should be stiff enough to hold its shape. If the batter is too soft, add more cornmeal until it is firm.

Gather a heaping tablespoon of batter and roll into a ball or a finger shape as desired and drop into 350°F oil and fry 3–4 minutes or until golden brown. Maintain the temperature and fry in batches of 4 or 5. *Makes about 20 hush puppies.*

Lexington Red Dip

Barbecue Center and Lexington Barbecue have both given out their "red dip" recipes to the world. Here's an adaptation that is a combination of the two.

- 4 cups cider vinegar
- 4 cups water
- 6 cups ketchup
- 3 tablespoons sugar
- 1 tablespoon crushed red pepper
- 1 tablespoon cayenne
- 1 tablespoon black pepper
- 3 tablespoons salt

Combine the ingredients in a saucepan, bring to a boil, then simmer for 10 minutes. Allow to cool. Use immediately, or store in bottles in the refrigerator for up to a month. *Makes 3½ quarts.*

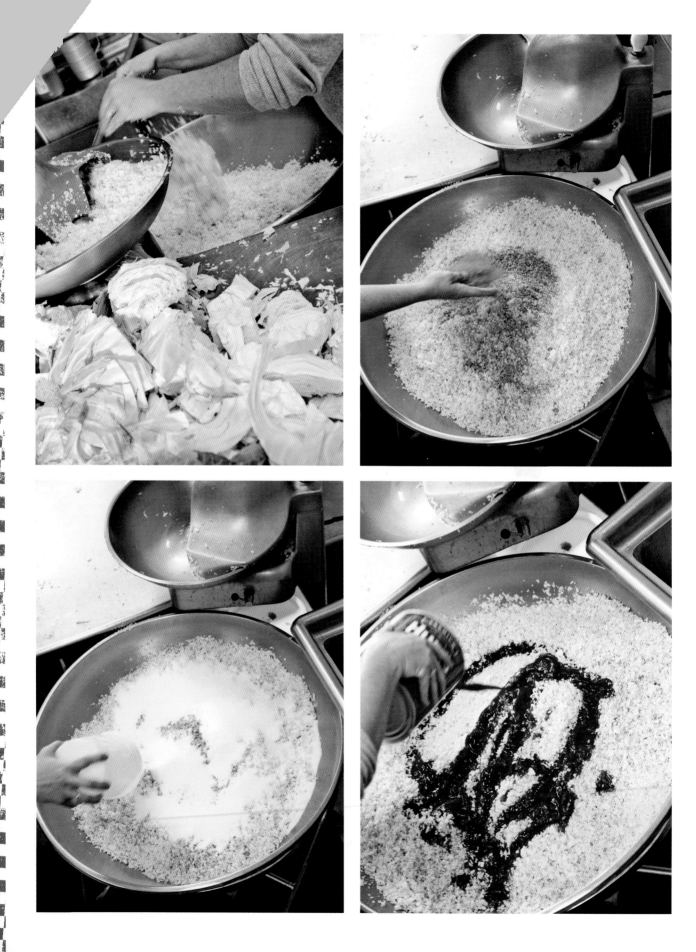

Cook's Red Slaw

- -

- 8 cups finely chopped green cabbage
- 1 cup ketchup
- ½ cup sugar
- ⅓ cup cider vinegar
- 2 teaspoons salt
- 2 teaspoons ground black pepper

You can chop the cabbage by hand if you like, but it's much easier to chop it in batches in the food processor, pulsing 8 or 10 times until the shreds are the size of confetti. Then combine all the ingredients in a medium mixing bowl and mix well with a wooden spoon or your hands. Refrigerate before serving to meld the flavors. Slaw wilts and loses volume, so the yield will be less than the amount of raw ingredients. Will keep in the refrigerator in a sealed container for up to 1 week. *Yields 8 cups.*

Cook's White Slaw

- -

- 6 cups finely chopped green cabbage
- ¼ cup white vinegar
- ¾ cup mayonnaise
- 2 teaspoons salt
- 3 tablespoons sugar
- 1 teaspoon ground black pepper

You can chop the cabbage by hand if you like, but it's much easier to chop it in batches in the food processor, pulsing 8 or 10 times until the shreds are the size of confetti. Then combine all the ingredients in a medium mixing bowl and mix well with a wooden spoon or your hands. Refrigerate before serving to meld the flavors. Slaw wilts and loses volume, so the yield will be less than the amount of raw ingredients. Will keep in the refrigerator in a sealed container for up to 1 week. *Yields 6 cups.*

At Cook's Barbecue, the cabbage for slaw is chopped very fine in a Hobart chopper. Salt and pepper are added first, then sugar. Finally, ketchup and vinegar (for red slaw) or mayonnaise and vinegar (for white slaw) are mixed in.

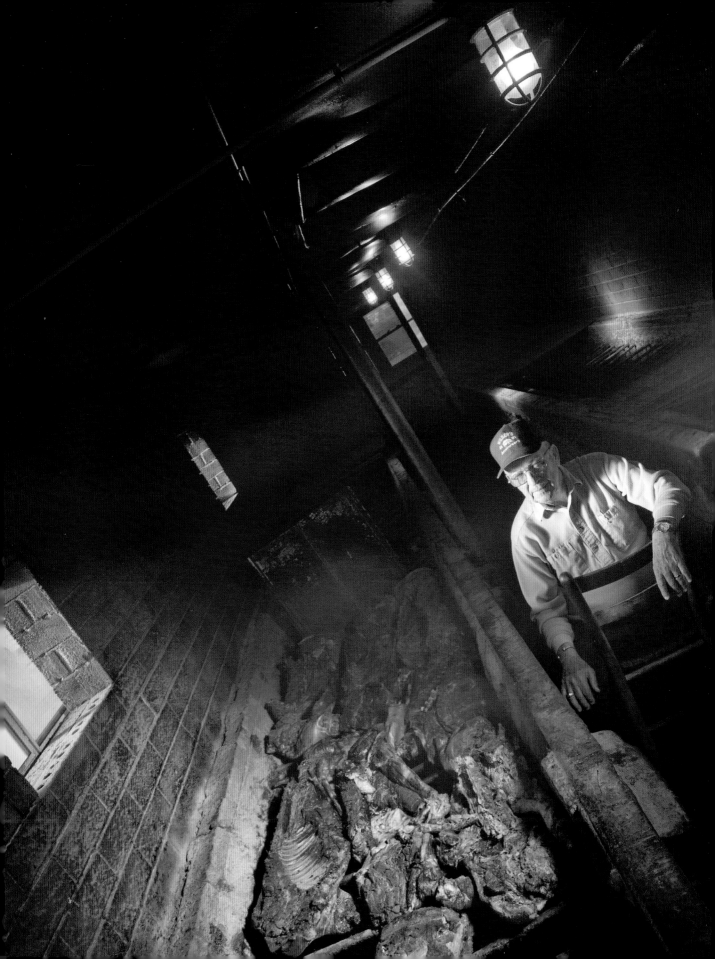

11

WHOLE HOG AND OLD HICKORY

IT TOOK A FEW HOURS to drive from the Piedmont to the flat farmlands of the coastal plains. Twenty miles north of Goldsboro, we passed a billboard for the Nahunta Pork Center, the largest pork retailer in the nation. The pig store started out as the Nahunta Hog Market and Slaughter House in 1955. It was a hog-buying station and custom cutter.

In 1975, Nahunta opened a retail outlet next to the slaughterhouse and discovered there was a ready market for a variety of pork cuts. Finding a whole hog, or even a whole pork shoulder, is something of a project in Texas. In North Carolina, it's pretty easy. Nahunta also has an outlet at the Raleigh Farmers Market.

Eastern North Carolina was first settled by plantation owners and their black slaves. Barbecue there goes back hundreds of years to early colonial times. The region's barbecue fans claim that the older style is more "Carolinian" than the barbecue of the Piedmont. Goldsboro is frequently singled out as the capital of the eastern Carolina style because of Wilber's Barbecue and another famous barbecue joint called Griffin's, which closed in the 1980s.

At Wilber's Barbecue in Goldsboro, I got a chopped beef sandwich, which was a bizarre introduction to East Carolina barbecue. The meat was mixed up with a ketchup-based barbecue sauce. "Way back when, we tried cooking a whole side of beef on a big pit," Wilber Shirley, the owner, said with a chuckle. "That didn't work. It got burnt on the outside and it was still raw on the inside. We've been cooking beef briskets one day a week on Thursday for a while. The beef barbecue is pretty popular."

Wilber Shirley checks a pit full of whole hogs at
Wilber's in Goldsboro, North Carolina.

"I thought ya'll didn't put ketchup in the barbecue sauce," I said.

"Well, we don't as a rule. But we had to come up with a different kind of barbecue sauce for the beef brisket because the vinegar sauce we use on the pork over here in East Carolina just didn't work. 'Never put vinegar on beef, and never put ketchup on pork'—that's what I've always heard," Shirley said. "We only cook beef briskets one day a week, so we don't use ketchup sauce very much."

Shirley told me that he learned to barbecue at family gatherings before buying the restaurant. It was called Hill's Barbecue when it opened in 1962. "Fred Hill was an older man when he built the place. It was going to be his retirement hobby, but then he had a heart attack before it opened, and he never got a chance to run it. I bought it from him with a partner," he remembered. Shirley and his partner called it the Hwy. 70 Barbecue. Within the year, the partner sold out and the name was changed to Wilber's Barbecue.

Wilber, Rufus, three pitmen, and I were standing beside the pit house, which is located in a building out behind the restaurant. A huge fire was burning in a hole in the ground about twenty feet away. Although the pit house has a built-in fireplace, it is no longer used. "It feels like 400 degrees in there with all the pits cooking and the fireplace burning," Wilber Shirley told me. "So we just started burning the wood outside."

When I noticed that some of the wood on the fire was hissing, I realized it was green wood. Using green wood is a major mistake in Texas barbecue—it imparts a nasty flavor to the meat. Some Texas barbecue men say it will make people sick. I asked the pitman who was tending the fire about it. "Green wood, seasoned wood, it doesn't matter when you are burning it down to coals before you cook with it. In fact, some folks think green wood coals burn better," Eddie Lee Ward said. Shirley took us inside the smoky pit room and lifted one of the lids to reveal the whole hogs stretched out on the grate. The pit workers were getting ready to turn the hogs over.

"We used to get hundred-pound pigs, but those are getting hard to find," Shirley said. "These are between a hundred and fifteen and a hundred and twenty. We buy our hogs at Nahunta Pork Center."

Pitmaster Eddie Lee Ward at Wilber's

After Shirley left, Rufus and I went to check out the restaurant. Like a lot of other successful barbecue joints, Wilber's interior was a series of interconnected dining rooms. In the big room, just inside the front door, the walls were covered with knotty pine paneling and the floors with brown linoleum. Wilber Shirley's U.S. Marine uniform hung in a display case on the wall, a souvenir of a two-year stint in the military in 1952 during the Korean War. College pennants covered the rest of the walls.

Along with the barbecue trays and sandwiches, Wilber's menu included Brunswick stew, barbecued and fried chicken, fried livers, fried pork chops, fried oysters, shrimp, fish, hamburgers, cheeseburgers, hot dogs, country ham, and various combinations of the aforementioned. A combination plate included slaw, potato salad, and your choice of rolls or hush puppies. Having learned my lesson at Stamey's, I asked the waitress whether the barbecued chicken was cooked on a pit or in an oven in the kitchen. She said half chickens were cooked in the oven and coated with barbecue sauce.

> *Wilber's prides itself on mixing all the pork cuts together in its barbecue sandwiches. "That's what makes whole-hog barbecue unique."*

In Texas, a chopped beef sandwich is usually made from scraps left over from carving a brisket. (A brisket is made up of two parts, the lean flat and the fatty point.) Some Texas barbecue joints serve the neat slices of the flat on plates and grind up the messy-looking parts of the fatty point to use in sandwiches. The beef sandwich at Wilber's was made from the entire brisket. Both the flat and the point were chopped up together with meat cleavers on a chopping block, just like chopped pork. The result was a lot of uniform chunks. The brisket was a tad underdone, so the chunks were chewy. It was like no chopped brisket sandwich I've ever had.

Wilber's whole hog sandwich was tasty, a blend of dark and white meat with skin and juicy middlins. Wilber's prides itself on mixing all the pork cuts together in its barbecue sandwiches. "That's what makes whole-hog barbecue unique," Shirley said. The famous East Carolina barbecue sauce is an innocuous mixture of vinegar, water, salt, black pepper, and red pepper. After eating a few bites of barbecue with the vinegar sauce, I added some Texas Pete to liven it up a little.

LAYERS OF BLUE SMOKE shone in the slanted rays of dawn drifting through the silhouettes of pine trees across Arrington Bridge Road. The blue smoke rose from the cookhouse behind Grady's Barbecue, a restaurant at a rural crossroads in the farmlands of Wayne County, North Carolina, a few miles from the hamlet of Dudley. Stephan Grady, a seventy-something farmer and retired sawmill worker, was burning down some wood in the fireplace as he prepared to finish barbecuing a hog that had been cooking all night.

Stephan starts the long and low redbrick pit with charcoal briquettes, goes home and sleeps for four hours, then comes back and starts burning down the wood. He

fires the hogs at around two in the morning, lets them cook for six hours, and then burns down more wood at dawn. The pig on the pit had been divided into halves. "It makes it easier to handle," Stephan Grady told me when I asked about the cut. "Sometimes Gerri has to take care of the place by herself."

Stephan's wife, Gerri, is the reason the restaurant exists. The two of them bought the tiny restaurant when Gerri lost her job. "She loved to cook, and she needed something to do. While I was working at the sawmill, I got all the wood for free."

"My brother, H. B. Grady, built the cookhouse. Only he built it too low," Stephan said. Not long after the restaurant first opened, a pig on the pit caught fire and set the roof ablaze. "When I rebuilt the roof, I added four courses of cinder block to raise it up higher. It still catches fire sometimes. In twenty-five years of doing this, I learned never to turn your back. When a pig catches fire, you close the pit up real tight. It will go out. Unless it's already set the cookhouse on fire. After a few years, you don't burn so many. But it still happens. Last time I had to rebuild the roof, I moved the vent," he said pointing at the crisscrossed wooden rafters above our heads. The center part of the roof was lifted by the rafters to create an open space, just below the peak on one side, where the smoke could escape. The space was screened to keep the flies out.

Stephan Grady cooks a whole hog cut into halves at Grady's Barbecue in the North Carolina countryside, a few miles from Dudley.

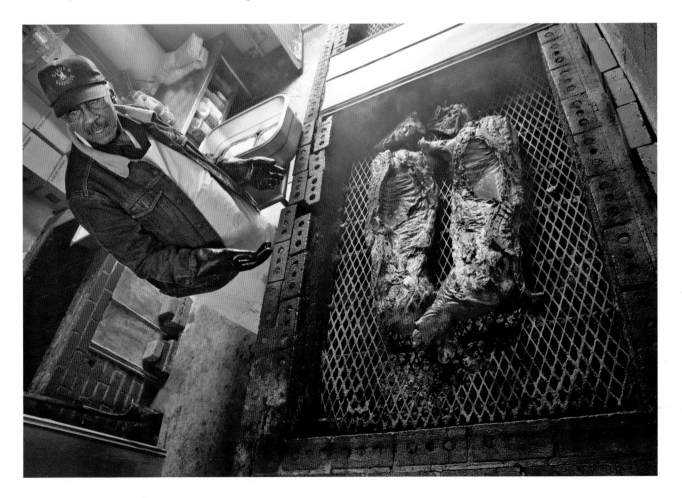

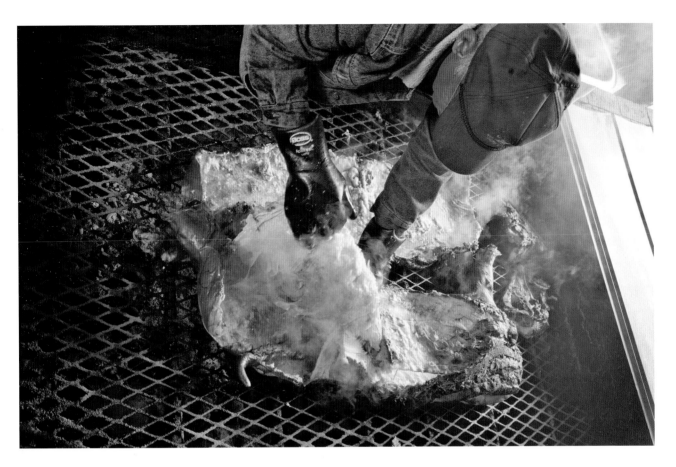

When the hot coals were ready, Stephan went to the kitchen and came back with several rectangular stainless-steel "hotel" pans. Instead of trying to carry the hog to the kitchen, the pitmaster donned a pair of heatproof gloves and pulled the pork while it was still on the pit. He started by pulling the ribs off one half hog and methodically removed every bit of steaming meat. When the hotel pan started to get heavy, he carried it into the kitchen, came back, and started filling another one.

When all the meat had been removed from both of the half pigs, Stephan began shoveling hot coals under the skins, which were all that remained on the pit. He would cook the skins with hot coals until they sizzled and got crispy. Then he would cut the skin into pieces and take it inside in steel trays so he could chop it and mix it with the rest of the pork. By cutting a small pig into halves and then pulling the pork while the pig was still on the pit, Stephan and Gerri Grady had developed a system of cooking whole hogs that one retired person could handle without any help.

In the kitchen, Gerri was cooking greens and black-eyed peas on the stove. Stephan put on an apron and started chopping the pork on a white plastic cutting board with a meat cleaver. When he was finished chopping, he put the meat into a clean pan and seasoned it with vinegar, salt, and pepper. He didn't measure anything; he just tasted it as he went. When he was finished, the meat was pleasantly

Stephan Grady pulls the pork while the hog is still on the pit.

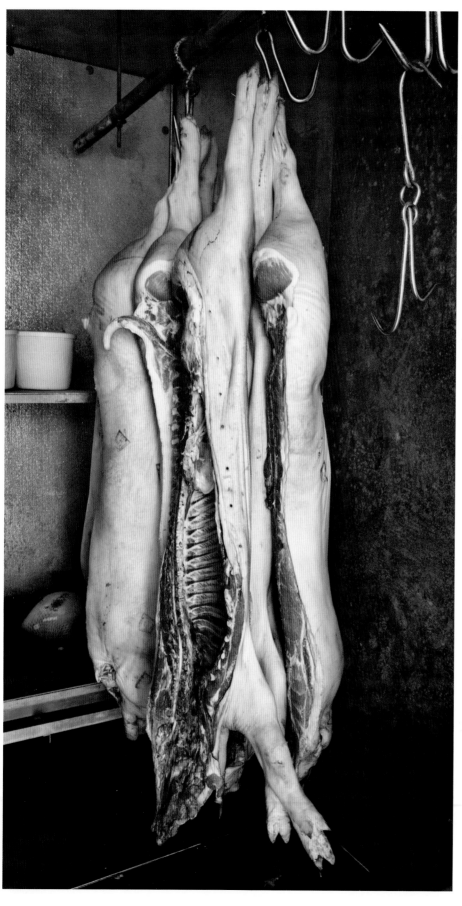

*Whole hogs hanging
in the meat locker at
Grady's Barbecue*

accented with the salt and pepper and moistened with a little vinegar, but the dominant flavor was slow-cooked pork with textural variations provided by the crispy skin and outside crunchy pieces.

Stephan and Gerri Grady cooked nineteen pigs for Christmas that year. "That was a lot of work," Stephan said when he sat down to take a break. "Usually, we just cook one pig a day, maybe two on the weekend. You can't make any money cooking one or two pigs a day. It makes the Social Security check go farther. But mainly we just do it because we love it."

Stephan learned how to barbecue at gatherings held on his family's farm. "My grandfather Walter Grady was the neighborhood barbecue king in Lenoir County. He would start a fire in our barbecue pit, which was a hole in the ground. He laid some hog-wire fencing across it. Then he laid pipes down to stretch out the hog wire. Granddaddy cooked fifty- to sixty-pound shoats. Back then, people didn't think you could cook big hogs—they were too tough. Now the pigs weigh up to two hundred pounds. We barbecued for the Fourth of July, for Granddaddy's birthday in September, and during hog-killing time when it got cold around Thanksgiving, and for Christmas. We always ate barbecue at Christmastime."

I asked Stephan Grady why barbecue restaurants in North Carolina could still get whole hogs in the 120-pound range when they were so hard to find in Tennessee. "Demand," he said. "No one around here wants to eat shoulders. That's not barbecue. They look for that whole-hog taste. We cook four hundred or so a year. Wilber's in Goldsboro does thousands and thousands."

I asked him whether he bought his hogs at the Nahunta Pork Center. He said he bought live hogs from farmers. "In the late 1940s, every farm around here had a few hogs. If you went to the store to get chicken, it was a live chicken. Up until the 1960s, people were still dressing their own pigs. Then the price of pork went down, and there wasn't any reason to raise pigs anymore."

Commercial pig farms put the small pig farmers out of business. "A friend of mine raises pigs down in Duplin County. Now that corn is up to seven or eight dollars a bushel, he can barely make it."

We walked outside to the meat locker, and Stephan showed us the half hogs he had hanging up inside. He said these were 125-pound hogs. "I paid eighty cents a pound for them. But I only buy pigs on the hoof. I'll tell you why. These small hogs they are selling are cull hogs. That's usually okay, but if it's a sickly hog, that's bad. I'd rather buy a hog on the hoof. He's going to look good, or I'm not going to buy him. The hog-processing plant kills them for me one day a week, on Mondays."

Back inside the restaurant, I sat down with Gerri in the dining room, and we talked about cooking and recipes. "Our families both cooked pigs in a hole in the ground over hog wire," she said. "We both learned how to barbecue at an early age. I grew up on a farm in Wayne County. We grew tobacco, cotton, cucumbers, and corn to sell. And then we had a garden for our own food. There were turnips and other greens, potatoes, cabbage, onions, string beans, and Dixie Lee peas.

Next page: Head chef Gerri Grady and pitmaster Stephan Grady in the dining room of their restaurant

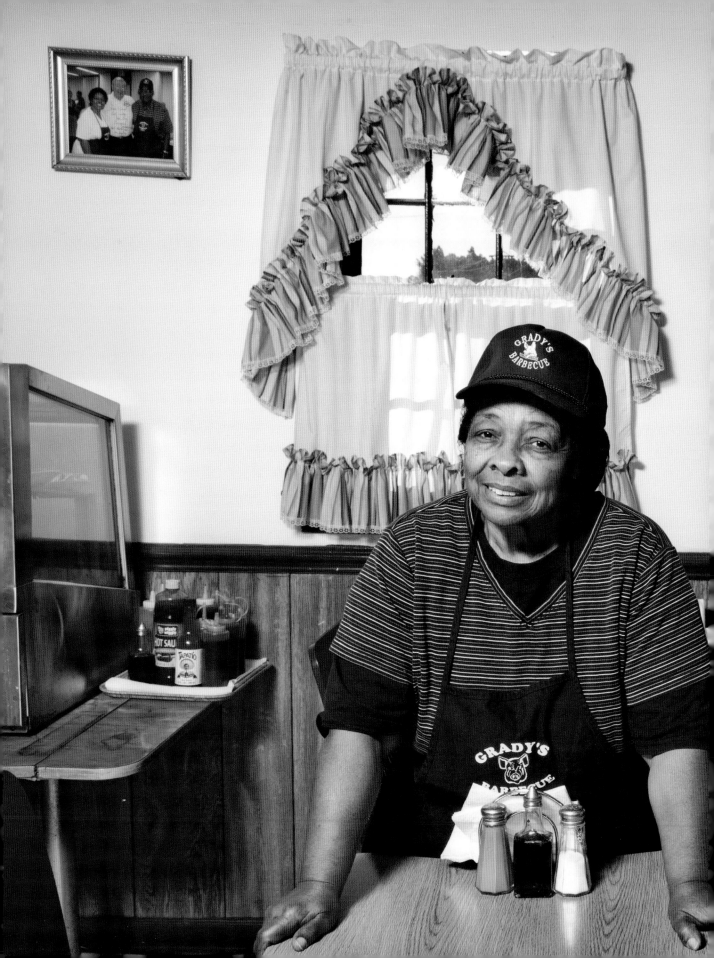

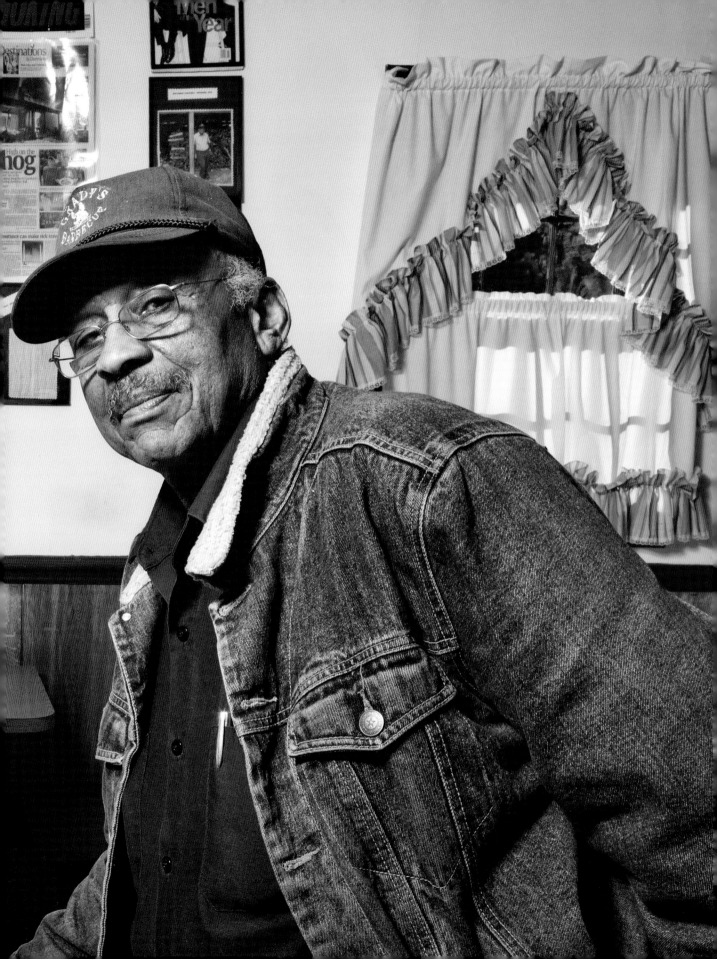

Gerri makes her distinctive green slaw with cabbage, mayonnaise, sugar, salt, and hand-chopped sweet pickles. Her potato salad is made with mayonnaise, mustard, and sweet pickles. She also cooks plain steamed cabbage, black-eyed peas, collard greens, and butter beans. The food is served on polystyrene plates with plastic utensils.

I asked Gerri how she and Stephan met. "Our families were acquainted," she said as she started to giggle. "Stephan was nine years older than me, but he always had his eye on me. Then, when I got ripe, he plucked me."

A sign on the wall behind her proclaims "Stephan and Gerri Grady and the Highly Seasoned Foods Staff, Specializing in Pig Pickings." The restaurant had a portable pit for cooking whole hogs, she explained. The price was $200 plus the cost of the pig; it usually came out to $300 to $400. And what did "highly seasoned foods" mean, I asked.

"When we first opened, we didn't season the food very much," Gerri said. "Our customers encouraged us to go ahead and spice it up." I had noticed a large collection of hot sauces and unlabeled bottles on a tray beside the dessert case. There was some of the house barbecue sauce, a mixture of vinegar, black pepper, and a little

Home-style barbecue spread at Grady's, including coleslaw, black-eyed peas, butter beans, greens, and chopped pork

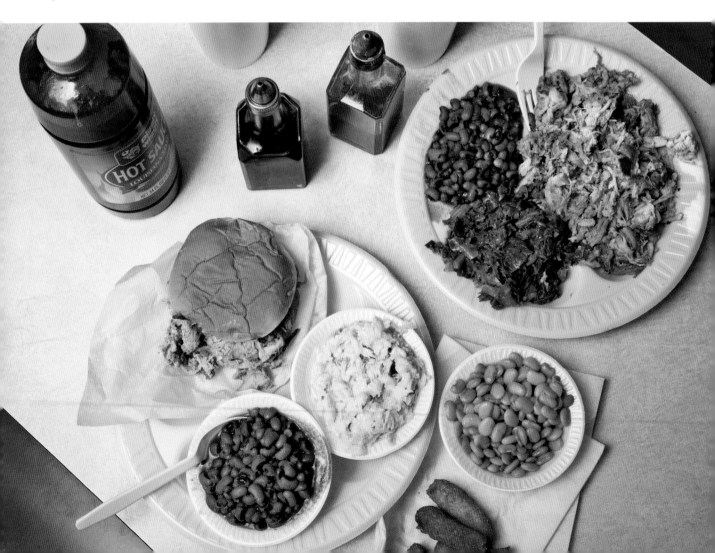

fresh chile pepper. There was Texas Pete, of course, and there was also a large plastic bottle of Piggly Wiggly Louisiana Hot Sauce. "We have lots of hot pepper sauces for the Mexicans—you just can't get it hot enough for them." There was also a bottle of red barbecue sauce.

I asked Gerri whether many people asked for the Lexington-style barbecue sauce. "Yes, she said. "Some people turn up their noses at our barbecue." She went on to tell the story of a well-dressed woman from the western part of the state who made snide comments about the food. "But most people have been very kind to us. We are so grateful for the response we have gotten."

At ten a.m., Gerri turned on the lights in the dining room, parted the curtains, and did the rest of her opening ritual. Rufus and I had skipped breakfast, so we ordered just about everything on the menu except for the hamburger steak. He got a barbecue sandwich piled high with pork and a side order of black-eyed peas and Gerri's sweet green slaw. I got a barbecue plate with at least a half a pound of Stephan's just-pulled pork with collard greens and black-eyed peas, and we split an order of creamy butter beans and hot, crunchy hush puppies.

It was the kind of soul food and barbecue spread that makes you fall in love again with old-fashioned Southern cooking.

It was the kind of soul food and barbecue spread that makes you fall in love again with old-fashioned Southern cooking. We were looking for the wellsprings of barbecue culture, and at Grady's Barbecue we felt connected to the living tradition. On the farms around here, whole hogs were still being cooked every holiday season. There was a sign on the wall that advertised smoked hog jowls. "People want hog jowls to cook with their black-eyed peas for New Year's," Stephan said.

Gerri wouldn't let us leave without eating dessert. Stephan came over to our table with a piece of pie on a polystyrene plate. He had heated the pie in the microwave. Usually sweet potato pie is brown and seasoned with cinnamon, nutmeg, and cloves so that it tastes like pumpkin pie. But this pie was bright orange, with big chunks of fresh sweet potato in it. "A family who lives on a farm down the street wanted to trade their sweet potatoes for barbecue," Stephan said. "So we took their sweet potatoes and fed them. Then we made this sweet potato pie."

IN 1588, AN ENGLISH ARTIST named John White painted a watercolor of Native Americans barbecuing fish in present-day North Carolina. The artwork was copied for an engraving in a German book about the discovery of Virginia. Several other drawings showing similar scenes survive as well. Accounts of Native American barbecues, as well as the artworks, make it clear that the technique of cooking whole fish, iguanas, birds, and small game on a grate suspended above glowing coals was borrowed from Native Americans.

It was the European introduction of pigs, sheep, and cattle that set colonial barbecue apart from the Native American tradition. Ox roasts were common even

before pig roasts. But pigs proliferated in the Americas at such an incredible rate that they quickly became the focus of community barbecues. The feral hog problem currently plaguing much of the American South began in 1539 when Hernando de Soto first turned hogs loose in North America. Virginia colonists taking a census of livestock in the 1700s recorded precise numbers of cattle and sheep, but listed pigs as "too many to count."

In *Barbecue: The History of an American Institution*, Robert F. Moss describes the earliest barbecues as community pig roasts like the one English colonists held in Peckham, Jamaica, around 1706. Whole pigs were basted with a pepper sauce made of Madeira wine and green chiles. It was described as a wild event fueled by rum.

Barbecues weren't just a Southern phenomenon in colonial times. Hog Island, near Falmouth, Maine, was named after a "festal barbecue" held there to celebrate the fall of Quebec City in 1759 during the French and Indian War. Community barbecues were the primary form of public gathering in Massachusetts and the rest of the American colonies.

"From its earliest days, barbecue was not just a type of food or a cooking technique but also a social event," wrote Moss. Holding a barbecue was a way to get people together, and watching the meat cook was as much a part of the event as eating it.

In the early 1800s, sermons were heard at church barbecues and patriotic speeches were delivered at Fourth of July barbecues. Out of this tradition, the camp meeting barbecue and the political barbecue were born. When Davy Crockett hosted a squirrel roast in 1821, he was among the first to hold a barbecue for the sole purpose of campaigning for office. The symbolism of the outdoor cooking style fit the folksy image of the candidate. There were few experienced lawmakers running for office on the frontier, and so military service, quality of character, and the ability to give a good speech became qualifications for public service.

For the elite in Washington during the early 1800s, political barbecues represented backwoods ignorance and drunken revelry. For Southerners and pioneers, on the other hand, political barbecues were part of a new populism that would change the way the nation was governed.

Public barbecues were linked to the rough-and-ready pioneer culture of southern and western voters in the presidential campaign between Andrew Jackson and John Quincy Adams in 1828. Adams was the incumbent president and the son of former president John Adams. A distinguished diplomat who had spent much of his early life in Europe, Adams was educated at Harvard and practiced law in Boston. He had a reputation for elitism and a general disdain for the uneducated rabble. His supporters warned that Jackson's political barbecues were a prelude to mob rule.

Jackson, nicknamed "Old Hickory," was a wealthy slave owner of Scots-Irish ancestry who had never been abroad and spoke no foreign languages. He was a military hero of the War of 1812, having defeated the Creek at the Battle of Horseshoe

BARBECUE CLUBS

IN CONTRAST TO community barbecues, a tradition of private "barbecue clubs" also arose long ago in the South. In his book, Robert Moss describes these as "gentleman's organizations that consisted of the leading citizens of the community." Such clubs were organized around other activities; there were "farmers' clubs," "hunting clubs," and so forth. Members gathered for feasts in "barbecue houses" outside town. We know about the Beaufort Hunting Club's barbecue house because its destruction by a hurricane in 1804 was described in a poem titled "On the Fall of the Barbacue-House at Beaufort, S. C. during the Late Tremendous Storm," published by the *Charleston Courier* in that year.

Several of the South Carolina barbecue clubs still exist. John Shelton Reed told me that he was recently invited to attend a barbecue at the Beech Island Agricultural Club, which was organized by James Henry Hammond and other local planters in 1855 and still serves barbecue monthly.

In Virginia, the Richmond Barbacue (or Quoit) Club, founded in 1788, was one of the most famous barbecue clubs because Chief Justice John Marshall of the U.S. Supreme Court was a member. The club met every other week from May to October for quoits (a ring-toss game), mint juleps, and barbecued shoat.

At an Alabama Foodways Gathering held in Montgomery in 2009, attendees heard a presentation about a project initiated by the Center for the Study of the Black Belt at the University of West Alabama. It sent Pam McAlpine and Dustin Prine to interview members of the barbecue clubs of rural Sumter County, Alabama.

The barbecue-club tradition of Sumter County goes back some 175 years. Settlers from the Carolinas brought their barbecue styles with them and sought to preserve them by meeting for barbecues. In the absence of other social organizations, the barbecue clubs became community centers. The oldest of the remaining clubs, the Timilichee BBQ Club, in Geiger, was formed in 1927. Membership is restricted to residents of the area, but members can bring guests to the whole-hog barbecue dinners the club holds regularly in the summer.

The Boyd BBQ Club started in 1951 and holds monthly barbecue suppers from April to July. It started out cooking whole hogs at a time when most members raised hogs on their own farms. Today, the club cooks pork butts or shoulders. Attendance is declining, but when the club started out, it was a vital part of local social life. "We didn't have televisions or telephones," one charter club member pointed out to the researchers. The barbecue club isn't dying out though; a new generation is reshaping the tradition. The Sumterville BBQ Club was formed in 2001. Instead of cooking barbecue, it gets takeout.

The Panola BBQ Club started in 1946 to raise money for the local Methodist church, which was building new Sunday-school rooms. The club cooked two hogs for its first fund-raiser and now cooks six hogs a year on open pits over hickory coals on the grounds of a 1940 schoolhouse. It's one of many barbecue events that's connected to a church.

Bend and the British at the Battle of New Orleans. "J. Q. Adams can write, but Andy Jackson can fight" was one slogan heard around the barbecue pit during Jackson's campaign.

The campaign of 1828 was the first in which a candidate appealed directly to the people. At rallies, parades, and barbecues held all over the country, Jackson's organizers spread the theme that Washington was run by an undemocratic aristocracy. The tactic worked: twice as many people voted in the 1828 election as had voted in 1824, when Jackson lost to Adams, and the barbecue lovers outnumbered the aristocrats. Jackson won easily.

"WHERE IS THE BIRTHPLACE of American barbecue?" I asked Robert F. Moss. I had never met the food historian before, but I was using his book as a reference. I wanted to get the details right, so I called him at his home in South Carolina. I suspected that maybe settlers from Barbados who established a colony in South Carolina might be the earliest. But Moss threw me a curve.

"Virginia was really the birthplace of American barbecue," Moss replied. For some reason, the colonial barbecue tradition died out in Virginia, so there is no place to go to learn about it now. The whole-hog barbecue of Eastern North Carolina, just a few miles south of the early Virginia colony, was the closest thing you could find to the barbecue of the early settlers, Moss told me.

As it happened, I was calling Moss from the parking lot of Parker's Barbecue in Greenville, North Carolina. It wasn't exactly a beach on the Atlantic Ocean, but the Neuse River empties into Pamlico Sound at Greenville, so technically I had reached the Atlantic coast. There wasn't a woodpile at Parker's Barbecue, just a lot of commercial stainless steel. Maybe Parker's wasn't it, but the place I was looking for wasn't far away.

Ayden, North Carolina, and the famous Skylight Inn were eleven miles south of the Greenville Day's Inn where I spent the night. The Skylight Inn opens at ten in the morning; I got there at eight. (Sadly, Rufus had to take the day off, so we didn't get any photos.)

The restaurant, which has a bizarre-looking dome on top, resembles a miniature of the Capitol in Washington, D.C. The billboard in the parking lot featured a portrait of "Pete Jones, Bar-B-Q King" over an outline of the North Carolina map with a star indicating the location of "Bar-B-Q Capital of the World, Ayden, N.C." There was also a slogan: "If it's not cooked with wood, it's not barbecue." The bottom of the sign read: "Upholding a family tradition of wood-cooked barbecue since 1830."

In an enormous woodpile behind the parking lots, James Henry Howell, a sixty-six-year-old African American man, was loading a wheelbarrow with firewood. The wood was mostly oak, although there was some pecan and hickory mixed in, he said. Howell took the wood inside the pit house and shoved it into a roaring fire on a grate suspended a few feet off the floor of the brick fireplace.

When he was finished bringing in wood, Howell lifted the two enormous steel lids on the waist-high brick barbecue pit to reveal four beautifully browned whole hogs laid end to end. They had been cooking all night. At the Skylight Inn, the hogs are cooked with their heads still attached, a custom I hadn't seen before. Howell picked up a shovel and began "firing the hogs."

As the hot coals fell down to the bottom of the fireplace, Howell loaded his shovel and began pouring hot coals into the smoker on either side of the hogs. The cooking was actually done by indirect heat, since the coals were spread close to the brick wall of the pit while the pigs were stretched out in the middle. This last burst of high heat was the final step in the cooking process. The pigs would be done when the skin was hard and crisp, the pitmaster said.

"If it's not cooked with wood, it's not barbecue. . . . Upholding a family tradition of wood-cooked barbecue since 1830."

One of the Skylight Inn's owners, Jeff Jones, joined us around eight thirty. I asked him about the hogs being cooked. He said the pigs on the pit were 180-pound hogs.

"Back in the day, my ancestors cooked eighty-pound hogs. We used to raise pigs on the farm where I grew up. Dirt-raised pigs took longer to grow. Now the pigs are raised on concrete floors. They can't root for natural food; they give them controlled feed and stuff to make them grow faster. They are bigger and leaner. But the flavor is in the fat. You used to have to wait twenty minutes after you took a pig off the pit so that all the grease could drain off. Not anymore."

I followed Jones into the kitchen, and we talked while he made cornbread. He mixed white cornmeal, salt, and water with his hands in a big steel bowl. I kept waiting for him to add milk, eggs, baking powder, or other ingredients, but he never did. Some people call this flat, unleavened style of cornbread "cornpone."

The dome above the restaurant was a trophy from a barbecue cook-off held in the mid-1980s, Jones explained. "All of these congressmen in Washington, D.C., were arguing about who had the best barbecue, so they had a contest." In a competition between North Carolina and South Carolina barbecue men, Pete Jones and the Skylight Inn took the honors—hence the dome and the "capital of barbecue" claim.

Pete Jones died in 2006. His son Bruce Jones, grandson Samuel Jones, and nephew Jeff Jones run the business now. Pete claimed to be a fifth-generation barbecue man; his great-great-grandfather, Skilton Dennis, cooked pigs in earthen pits for community events. Legend has it that the barbecued pork that Dennis sold from his wagon in the 1830s was the first barbecue sold to the public in the state. Pete Jones worked with his uncle Emmit Dennis in his barbecue business before he and his brother Robert opened the Skylight Inn in 1947.

When I mentioned I was a member of the Southern Foodways Alliance and a friend of John T. Edge, Jeff told me I should meet his nephew Samuel, who also worked at the restaurant. He called him on his cell phone and told him to come and join us. Samuel Jones and John T. Edge were part of a traditionalist barbecue cook-off team called the Fatback Collective. (More on that subject in Chapter 12.)

I asked Samuel why there were two pit buildings in the back of the restaurant. He chuckled. "That's our insurance," he said. When the roof of the other structure caught fire a few years ago, the operation was moved from one pit building to the other. "To insure a cook house, the insurance company wants you to install a fire suppression system. But it's so expensive that we decided it was cheaper to just build a new roof every thirty years or so when it burns off. Since we have two cook-houses, we only lost one day of business the last time the roof caught fire."

It was around nine thirty when James Howell started loudly chopping hog meat with two meat cleavers, one in each hand. Jeff grabbed me a few tidbits and brought them to the table. The steaming meat was incredibly juicy and full of intense pork flavor.

Howell would add the vinegar sauce, Texas Pete, and other seasonings a little later, but Jeff insisted I try the meat without any sauce first. I was amazed that bar-becued pork could taste so good without any seasonings. It made me wonder about all the brines, injections, rubs, mops, dips, and sauces we put so much faith in. I ate some of the succulent pork by itself, then I ate bites of pork mixed with chunks of cornbread and slaw.

When the cash register opened at ten, I was first in line. There are only barbecue trays and sandwiches on the menu. I got a tray. It came with the flat cornbread that Jones had just baked and a simple coleslaw. The meat included middlins, loin, ham, and shoulder all blended together, with large pieces of crispy skin mixed through. I mopped my chin with napkins a lot as I ate, much to the amusement of seventh-generation barbecue man Samuel Jones.

The Jones family of Ayden, North Carolina, had the most extensive family his-tory in barbecue I had ever heard of. Samuel Jones, along with his wife and family, live in the house he built next door to his parent's farm. Most of the family lives in a complex of houses and farm buildings across the street from the restaurant. None of them live more than a few miles away. It's a multigenerational family-farming and barbecue dynasty.

THIS JOURNEY TO TRACE the evolution of American barbecue culture by traveling back to its beginnings turned out to be a bumpy ride. The road was washed out here and there, and we had to take some detours. But finally, at Grady's Barbecue and here on the North Carolina shore, we encountered barbecue at its most elemen-tal—whole hogs cooked over wood coals without seasonings—and that became a touchstone.

Now it was time to turn around and head west—and to see whether we could figure out where barbecue was going.

Barbecued Hog Forequarter

- -

The whole hog blend of juicy pork belly, tender loin, white shoulder meat, dark ham, and crispy skin all chopped up together is considered by many to be the quintessential flavor of American barbecue. But cooking a whole hog in your backyard is a major undertaking (see Whole Hog recipe, p. 258).

Stephan Grady's technique of cutting the hog into two halves and pulling the meat while it's still on the pit simplifies the process and turns it into a one-man operation. Of course it's not actually a whole hog anymore. And once the hog is cut in half, you can further simplify the process by cooking half a hog at a time. Cutting the whole hog into manageable pieces suggests other possibilities.

The first time I attempted to buy a pork shoulder at the upscale Revival Market in Houston, the butcher cut the hog in half and then in half again. The cut he gave me is known as a hog forequarter and in some parts of the world it's a common primal. Technically, it consists of the shoulder plus half of the rib cage, cut between the third and fourth rib.

Getting a forequarter instead of a shoulder was a fortuitous accident. When you barbecue a forequarter, you are cooking all of the shoulder meat, plus half of the loin and pork belly. This blend of pork cuts comes very close to the flavor of whole hog. And a quarter of a small pig fits easily on the Texas-style offset smoker I already have in my backyard.

Barbecue cook-offs award trophies for whole hog and pork shoulder. Hog forequarter is not a competition category. Which means this superb pork cut is unknown to most barbecuers—what a shame! If you are custom ordering a pork shoulder to cook on an offset smoker, consider asking your butcher to cut a forequarter instead. You will be amazed how closely the texture and flavor resembles whole hog.

- 1 hog forequarter, 25 to 30 pounds
- 6 tablespoons Hog Rub (p. 69)
- 1 quart Pork Mop (p. 53)

Season the pork roast with the dry rub, pressing the spice mix into the exposed meat. Set up your smoker for indirect heat. Use hardwood lump charcoal or charcoal briquettes. Maintain a temperature between 225˚ and 275˚F. Place the forequarter in the smoker with the largest area of skin down. You can put a square of foil under the skin to keep it from getting too burnt if you plan on friyng it. The skin will shrink and harden, serving as a vessel to contain the fat and juice. You might rotate the cut to achieve more even cooking, but don't turn it over.

Replenish the charcoal as needed. Mop the meat whenever you open the lid. The meat is done at 195˚ to 200˚F. Expect a cooking time of approximately an hour per pound, but you have to add time if the temperature goes too low or you open the lid too often. To be safe, start the forequarter around 30 hours before you plan to serve it. A little extra cooking won't hurt anything.

After letting the meat rest for at least half an hour, remove the skin and reserve. Remove the bones, ligament, and undesirable pieces of fat. Remove the ribs and pull away the stringy belly meat (middlins), and loin meat (catfish), and set aside. Put the white shoulder meat, the crusty outer bark, and the melting bits of fat on a chopping block in separate piles.

Combine a little of each meat on the chopping block and mince together with a pair of meat cleavers. Repeat until all of the meat is chopped. Place the meat mixture in a hotel pan or large aluminum foil roasting pan. Season the mixture with salt and pepper and enough Red Dip to moisten. Serve the chopped meat on a tray with sandwich fixin's and sides, or on sandwich rolls with Carolina Barbecue Sauce (p. 202, 205) and slaw.

Fry the pork skin following the directions on p. 260. *Serves 20 to 25.*

Grady's Green Slaw

Gerri Grady chops pickles for her slaw, but you can use pickle relish if you are in a hurry.

- 6 cups finely chopped green cabbage
- ½ cup finely chopped white onion
- ¼ cup finely chopped green bell pepper
- ¼ cup finely chopped celery
- ¼ cup cider vinegar
- ½ teaspoon salt
- 1 teaspoon ground black pepper
- ½ teaspoon celery salt
- ½ teaspoon celery seed
- 2 tablespoons sugar
- 1 teaspoon yellow mustard
- 2½ tablespoons chopped dill pickles or pickle relish

You can chop the vegetables by hand if you like, but it's much easier to chop them in batches in a food processor, pulsing 8 or 10 times until the vegetables are the size of confetti. Then combine all the ingredients in a medium mixing bowl and mix well with a wooden spoon or your hands. Refrigerate before serving to meld the flavors. Slaw wilts and loses volume, so the yield will be less than the amount of raw ingredients. Will keep in the refrigerator in a sealed container for up to 1 week. *Yields 4 cups.*

Pepper Sauce

This is the oldest kind of pepper sauce. In Jamaica, it's often made with small Scotch bonnets. In Louisiana, it's made with small cayenne chiles called "sport peppers." In Texas, it's made with wild-harvested chile pequins. The oldest recipes for pepper sauce used cane vinegar made from cane syrup. You can buy cane vinegar by mail order from Steen's or look for a Filipino brand in an Asian grocery store.

- ½ cup small hot chiles
- ½ cup cane vinegar (such as Steen's)
- Pinch of salt

Clean a previously used pepper shaker bottle with boiling water. (Or use a pancake-syrup dispenser.) Pack the bottle with chiles. Heat the vinegar in a small saucepan over low heat until it steams slightly. Pour the vinegar over the chiles to the top of the jar and add salt. Seal the jar and allow the mixture to sit for a day before using. You can use the vinegar as a pepper sauce, or open the bottle to take out a few chiles. The bottle can be refilled with vinegar and salt several times. Keeps refrigerated for 6 months or more. *Makes 1 jar of sauce.*

East Carolina Barbecue Sauce

The amounts are a little daunting, but you need a lot of barbecue sauce for a whole hog.

- 1 gallon cider vinegar (diluted with water to 40 grain)
- 1 cup crushed red pepper
- 3 tablespoons freshly ground black pepper
- ¼ cup kosher salt

Combine all ingredients in a large soup pot over low heat and stir until the salt dissolves. This will keep indefinitely at room temperature in a gallon bottle. *Yields 1 gallon.*

ABOUT VINEGAR

✖ THE BARBECUE JOINTS I visited used either cider vinegar, white vinegar, or colored white vinegar (white vinegar with a little caramel color) for their mops, barbecue sauces, and slaws. If you want to be authentic to the current practice, you will find these vinegars are readily available and quite cheap.

Cane vinegar was used for barbecue sauces in the Caribbean during the era of sugar cane plantations. It has a pleasant trace of residual sugar. Apple cider vinegar, with its tart apple aroma, became the favorite for barbecue sauces in the United States during colonial times. Cider vinegar was an important product on early American farms because it kept indefinitely at room temperature and sold for three times the price of hard cider. White vinegar is a modern industrial product made in huge batches. It has little or no taste or aroma, but is often infused with other flavors and colors. Rice wine vinegar is a slightly more flavorful substitute for white vinegar.

If you are interested in experimenting, there are many options. Vinegar is an ancient condiment that can be made from anything that will ferment, including wine, fruit juice, coconuts, rice, and countless other bases. To make vinegar, a solution is fermented until alcohol is produced, and then the alcoholic solution is oxidized to produce acetic acid. The natural process takes several months.

Vinegar is sold by strength. In the United States it must contain a minimum of 4 percent acetic acid (40-grain vinegar—grain strength is ten times the acetic acid percentage). Pickling vinegar should be between 40 and 50 grains. On the other end of the spectrum, 200-grain white vinegar is popular with pickle manufacturers, who save on transportation and storage by diluting the strong vinegar with water before using it.

Homemade vinegar is often below the 40-grain strength required for safe pickling, but it makes a wonderful barbecue sauce. I used Revival Market's house-made sorghum vinegar and wild chile pequins for a Carolina-style barbecue sauce while testing recipes for this book. I also used 70-grain sherry vinegar for a barbecue sauce, but I had to add 2 cups of water to 2½ cups of 70-grain vinegar to make 4½ cups of approximately 40-grain vinegar.

If the vinegar you are using is stronger than 40 grain, it should be diluted until the acetic acid level equals 4 percent.

ob's Carolina Barbecue Sauce

I spent most of my life in Texas, but since I was born in Jacksonville, North Carolina, I figure I can get away with this.

- 1 cup Pepper Vinegar (p. 200)
- 4 cups sherry vinegar (diluted with water to 40 grain)
- 2 tablespoons kosher salt
- ¼ cup cane syrup or molasses
- 2 tablespoons ground black pepper
- 1 teaspoon red pepper flakes

Combine the ingredients in a saucepan over medium heat and stir until the salt and syrup are dissolved. Allow to cool and then transfer to a large glass jar. Store in the refrigerator for up to 1 month. *Yields 5 cups.*

Corn Pone Bread (Unleavened Cornbread)

- ¼ cup bacon grease
- 1½ cups yellow cornmeal
- 1½ teaspoons salt
- 1 tablespoon sugar
- 1⅓ cups buttermilk
- 2 eggs

Preheat the oven to 425°F. Put the bacon grease in a 9-inch skillet and put the skillet in the oven. Combine the other ingredients in a mixing bowl, stir well, and allow to sit for 10 minutes. With a rubber spatula, scrape the batter out into the hot skillet. (Some of the grease should flow over the top of the batter.) Bake 20–25 minutes or until a toothpick comes out clean. Cut in pie-shaped wedges and serve hot. *Serves 6 to 8.*

Sweet Potato Pie

For a lighter-colored sweet potato pie, you can use boiled sweet potatoes instead of baked ones.

- 1 recipe for Pie Pastry (p. 37)
- 3 cups baked, peeled, and mashed sweet potatoes
- 1 stick butter (½ cup), softened
- 1 cup brown sugar, firmly packed
- 3 eggs
- ¼ teaspoon salt
- ½ teaspoon vanilla extract
- ½ teaspoon cinnamon
- ⅛ teaspoon ground cloves
- ¼ teaspoon ground ginger
- ⅛ teaspoon ground nutmeg
- ¼ teaspoon allspice
- 1 cup evaporated milk

Preheat oven to 350°F.

Line a 9-inch pie pan with an uncooked piecrust (premade or using the recipe on p. 35). Cream butter and brown sugar, then beat eggs and add to the mixture. Stir in salt, vanilla, and spices. Add sweet potatoes and evaporated milk and beat with an electric mixer until smooth. Pour into the pie shell and bake about 1 hour, until the center is firm.

Sweet potato pie from a bushel of bartered sweet potatoes

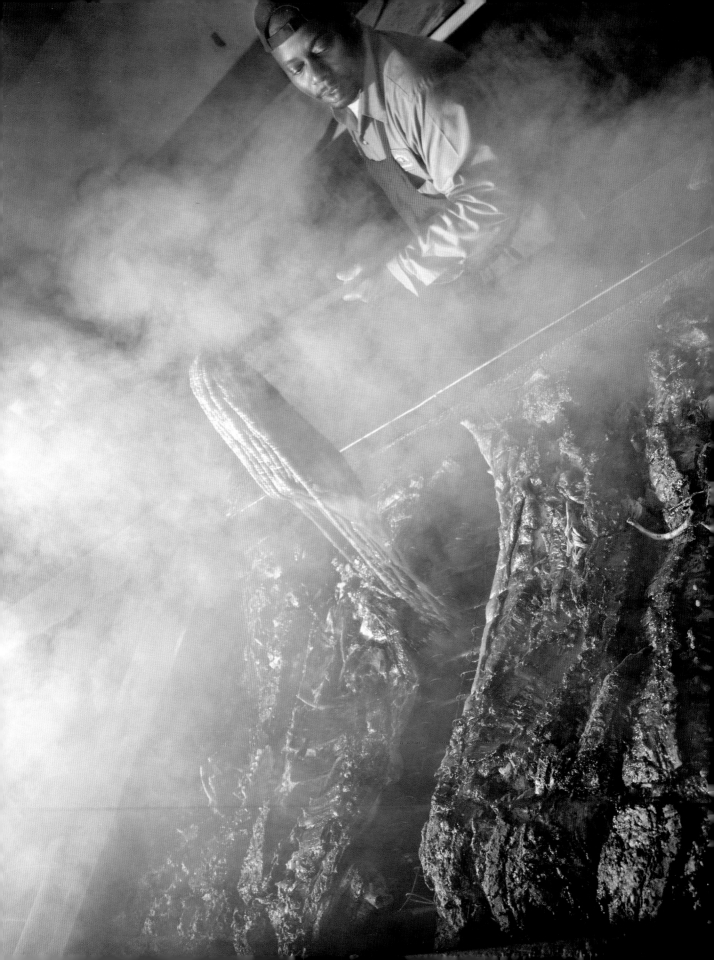

12

YOUNG BLOOD

AT AROUND FIVE IN THE AFTERNOON, Rufus and I pulled up to Scott's Variety in Hemingway, South Carolina, a rural convenience store that sells barbecue. On the front porch were containers of okra and rows of watermelons. A sign advertised fresh field peas by the pint or quart—the peas were kept in the cooler inside, along with the Pepsi. In the winter, bushels of sweet potatoes and huge heads of freshly harvested cabbage are available.

Rufus and I wanted to look around and buy some barbecue for dinner and then come back before dawn to watch the whole hogs being cooked. The shelves were stocked with Sunbeam King Thin White Bread and staples like Dixie Crystals sugar. According to the hand-lettered sign over Scott's kitchen window, the store will cook your hog for $110. You can buy a medium-sized barbecued whole hog for $400—half a medium hog is $200. That's quite a bargain—depending on the size of the hog, it comes out to somewhere between $2.65 and $3 a pound. Barbecue sauce is $22 a gallon.

"Who buys a whole hog?" I asked the young pitmaster, Rodney Scott, when he came inside the store.

"Tailgaters buy them on Saturday mornings during football season," he told me. "They pull up and load a pig on the back of their pickup truck on the way to the game so they can say to their buddies, 'Look what I've been doing all night!'"

Luckily, you can also buy barbecue by the pound at Scott's Variety. We ordered a pound with some coleslaw and beans on the side. It was an easy choice—those are the only sides available. The barbecue sauce is red, but you taste peppers and vinegar more than ketchup; it was one of the spiciest I sampled on the whole trip. We also got several slices of white bread so we could make our own sandwiches. The bill was ten dollars.

Rodney Scott, pitmaster at Scott's Variety

A few years ago, the old-fashioned country store in Hemingway and its handsome thirty-nine-year-old pitmaster started to attract national attention. "John T. Edge wrote about us in *Garden & Gun* magazine in 2008, and then in the *New York Times* in 2009," Rodney Scott remembered. "After that, the local news station here won an Emmy for a broadcast about us."

Scott was invited to cook whole hogs at the annual New York barbecue event called the Big Apple Barbecue Block Party, along with Samuel Jones from the Skylight Inn, Chris Lily from Big Bob Gibson's, and several other famous Southern pitmasters. A documentary about Scott titled *cut/chop/cook* by Joe York, a Southern Foodways Alliance filmmaker, debuted at the event. Scott was overwhelmed by the experience of cooking barbecue in Manhattan.

"When I saw how those folks reacted to a whole hog, I was amazed. It changed my life."

"There were 100,000 people there. Some of them had never eaten barbecue before," Scott said. "When I saw how those folks reacted to a whole hog, I was amazed. It changed my life. It made me realize what I was doing was something I had to keep up." After the publicity and the New York event, people from all over the country started showing up at Scott's Variety. More media attention followed. Scott became the model of a new breed of hip, food-scene-savvy pitmasters. He forever changed the image of South Carolina barbecue.

He made a welcome contrast to the previous flag bearer. Shortly after the Confederate Stars and Bars was removed from the South Carolina statehouse in 2000, Maurice Bessinger, the owner of the Piggie Park chain, lowered the giant American flags he used to fly over his nine Piggie Park barbecue restaurants, and raised the Confederate flag at all nine locations. It wasn't the first time Bessinger had taken a rebel stand. In the early 1960s, Bessinger refused to integrate his barbecue joints until, as a result of the oft-cited case of *Newman v. Piggie Park Enterprises* (1968), he was forced to by the courts.

Bessinger was the head of the National Association for the Preservation of White People in the 1960s. He was a strong and vocal opponent of desegregation, spoke out loudly against racial mixing, and refused to let blacks into the main dining room of his restaurant. He complains today that people have treated him unfairly. "What the blacks didn't realize," he said in an interview, "was that they got the best food, because their dining room was in the kitchen."

Given that history of discrimination, and the fact that Bessinger sold religious tracts in his restaurants claiming slavery was justified by the Bible, the usual "regional pride" defense of the Confederate flag didn't wash. And so blacks started protesting Bessinger's racism. As a result, national chain stores, including Wal-Mart, removed his popular barbecue sauce from their shelves, wiping out his business. Bessinger sued, claiming his right to free speech had been violated.

"The Bessinger controversy has given barbecue a starkly political dimension," wrote the *New York Times* reporter Brent Staples in September 2002. "The pulled

pork sandwich you eat is now taken as an index of where you stand, on the flag, the Civil War and on Maurice Bessinger."

A few months after the Bessinger flap in the fall of 2000, *The West Wing*'s season opener began with a story about an assassination attempt by a white supremacist. The shooter, a skinhead with a swastika tattooed on his hand, is shown in silhouette, sitting in a restaurant. The camera pans to a neon sign: "Bar B Q." *The West Wing* writer Aaron Sorkin was well known for borrowing plotlines and characters from current events.

In *Savage Barbecue*, the English writer Andrew Warnes saw these few seconds of television as a glimpse into America's psyche. Rather than a clever reference to the Maurice Bessinger affair, Warnes saw a statement about American barbecue culture. He wrote that the image of barbecue calls to mind "the white bigot filled to the brim with pork, beer and racist bile," and a vision of "the unreconstructed South" so powerful that "this food contains a suggestion of savagery appropriate to the Ku Klux Klan."

The fact that Rodney Scott has replaced Maurice Bessinger as the most famous barbecue man in South Carolina doesn't mean racism has been carved out of barbecue, anymore than the election of Barack Obama means that racism has disappeared from politics. But both are potent symbols.

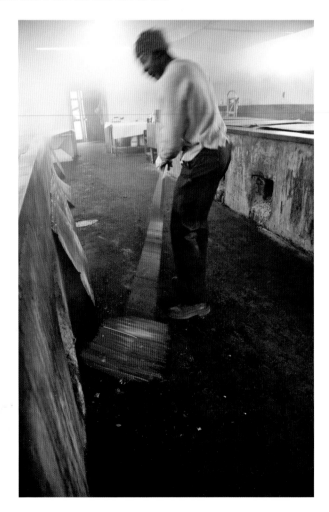

IT WAS DARK WHEN Rufus and I arrived at Scott's Variety the next morning at five. We followed the sound of an electric guitar to the "cook house," where Rodney Scott was finishing the hogs. A cardboard sign on the screen door of the old garage read: "Barbecue 9:30 am *No* Sooner Respect that!!" After we knocked for a while, someone let us in. Inside, Rodney was mixing some spices together. Out the back door of the garage, a huge fire roared in a giant metal fireplace. Rodney's assistants carried shovelfuls of glowing coals in and emptied them into the pit under the hogs. There were three compartments side by side in the long pit structure. Each compartment had an opening in the bottom front where coals were shoveled in, and each had two pigs cooking on the grate above the coals.

There was a wooden chair beside the pit. "You got to sit with the baby," Rodney said. The hogs had been on all night, and someone had been sitting there watching them at all times. The babysitting is

required because whole hogs cooking over hot coals will sometimes catch fire. If you catch a fire fast enough, you can get the pit shut down before it does much damage, Rodney said. Unchecked, a fire in the pit will set the roof on fire.

"Always got music on when I'm cooking," Rodney said over the loud blues tune. "It keeps me in a good mood. You can't cook good food in a bad mood. You get the red pepper in your hand when you're pissed off and who knows where you're going to take it. While the hogs are cooking through the night, we listen to blues, R&B, country, but we leave the hip-hop alone. I love hip-hop, but not while you're cooking. That comes later, when you're chopping."

It was time to turn the pigs, Rodney told us. He pulled back the steel lid on top of the pit to reveal two whole pigs, skin side up. Each pig was stretched out on a rectangle of hog wire, the heavy-gauge steel-mesh fencing used to confine hogs. Rodney and an assistant laid another rectangle of hog wire on top of the pig and then lifted the hog and turned it over so the skin side was down.

"We cook around six hogs a day, but Christmas week, we have done as many as 125," Rodney said. Rodney broke into each hog in several places with tongs, exposing the meat and allowing steam to escape. This would allow the spices to penetrate all the way to the bone, Rodney explained. Dipping a cotton mop in a stockpot full

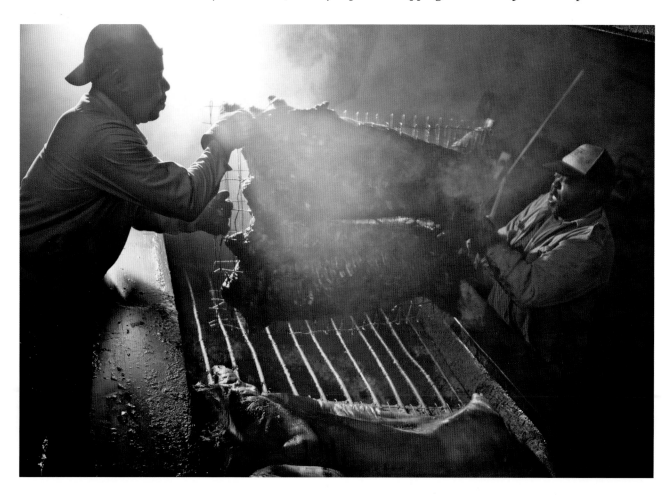

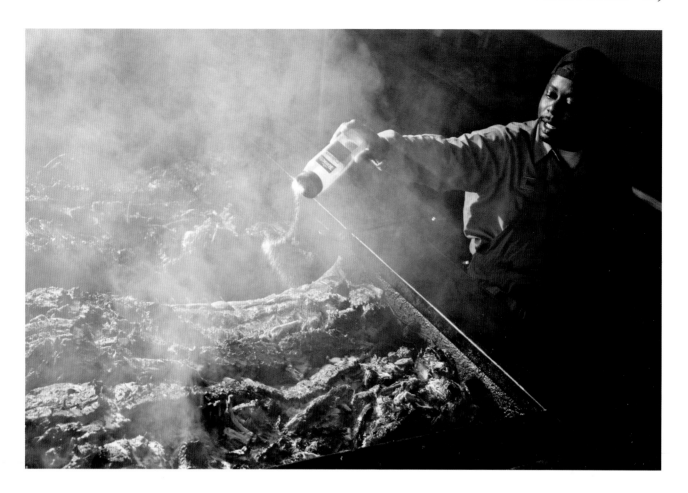

of liquid, he mopped the barbecue with a mixture of water, lemon, vinegar, red pepper, sugar, and other ingredients. "I like it saucy, all the way down to the bottom, with lots of bark on the outside," he said.

He sprinkled salt from a large plastic bottle across each hog. It looked like a lot of salt, but he was seasoning nearly a hundred pounds of pork. After the salt, he sprinkled the meat with a secret spice mix. I could taste pepper, garlic powder, and MSG. Rodney pulled some meat out of the middle of the hog and let Rufus and me sample some. There is nothing like the taste of steaming barbecued pork right off the pit—add salt, red pepper, vinegar, and MSG, and you get a wild flavor ride.

When Rodney pulled some pork off one of the pigs to sample it, a crowd appeared. His father, Roosevelt Scott, grabbed some ribs, and a number of assistants and store employees got samples, too. While we savored our hot barbecue, someone started banging on the screen door. Rodney had promised a friend some barbecue before business hours. The man was on his way to Maryland, and he wanted to take some barbecue with him. With a polystyrene to-go container in one hand and tongs in the other, Rodney packed up several pounds.

I asked Roosevelt whether the store had ever cooked any other barbecue meats. In the 1970s, when Roosevelt took over the store, he said whole hogs were selling for twenty-five to thirty cents a pound. "I know a lot of pig farmers. I always bought hogs on the hoof," he explained, adding, "This is hog country. When people around here barbecue, they put a whole hog on the pit."

Roosevelt learned to barbecue from his uncle Thomas Scott, but in the beginning, a local barbecue man named Shirley Cooper supplied the store. "He used to cook hogs behind a service station or at his home before the health department made him stop," Roosevelt said. "Lots of people around here used to cook hogs and sell barbecue. The health department cracked down in the mid-1980s." Roosevelt built his first pit in the garage next to the store and hired Shirley Cooper to cook hogs there. They started cooking one hog a week, every Thursday. They knew they had something big when a line formed outside the door before they opened on Thursdays.

"The health inspector shut us down a couple of times. I just paid the $200 fine and kept cooking. Every time they came out here, I would ask them what we needed to do." At the direction of the health department, Roosevelt installed hoods, screens, and ventilation fans; finished the walls and painted them; and made countless other improvements.

Rodney Scott and his dad, Roosevelt Scott

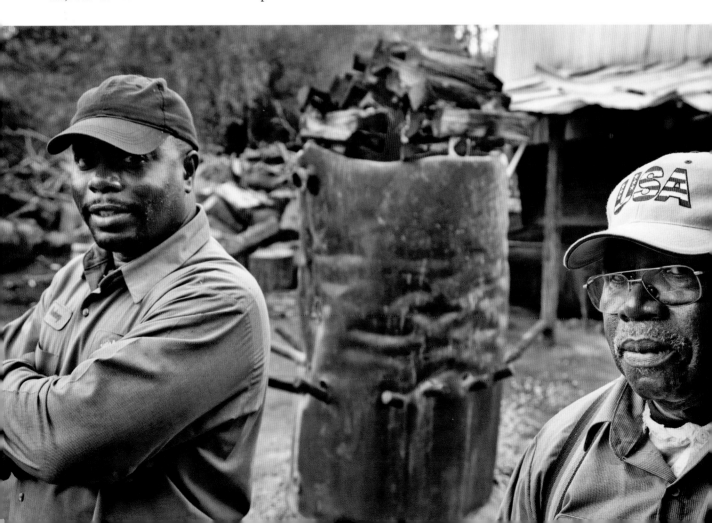

"Why did we need any of this? What good is it doing? I have no idea," Roosevelt said. "I asked them, 'Who is complaining?' Nobody was complaining. They were just harassing us. Sometimes an official would come and park across the street and sit there in his car for hours, watching us. It appeared to me they just wanted to shut me down."

Rodney shoveled coals into a smaller barbecue pit outside the cookhouse and loaded the grate with two dozen orange chickens. The chickens had been butterflied so that the whole chicken would lie flat on the grate. I guessed they were seasoned with red pepper, paprika, garlic powder, and other spices. Rodney drizzled the same mop sauce that he used on the pork over the chickens from time to time, being careful not to let the mop come in contact with the chicken.

I asked Rodney whether he loves what he does.

"I didn't when I was in high school, but I do now," he said with a smile. Rodney took over pitmaster duties in 2000 when Roosevelt had a stroke. Ella Scott, Rodney's mother, runs the store, does the books, and chops and sells the barbecue. Rodney runs the barbecue pit. Roosevelt still comes to work every day. I asked him how it feels to see his store in national magazines and on television. "It's a pleasure to have people coming here from all over. It was a hard fight—most people would have given up," Roosevelt said. "But we kept at it."

Bureaucrats who use petty complaints to harass barbecue joints are partly responsible for the near disappearance of artisan wood-fired barbecue.

Bureaucrats who use petty complaints to harass barbecue joints are partly responsible for the near disappearance of artisan wood-fired barbecue. But their enforcement efforts generally reflect prevailing public attitudes. Motives for getting rid of barbecue stands include environmental and sanitary concerns, neighborhood beautification, racial prejudice, and protecting the interests of competing restaurant owners.

But as the example of Scott's Variety illustrates, things are changing. The culture of barbecue has endeared itself to a significant portion of the general public. The rise of the locavore and farmers-market movements and the success of organizations such as the Southern Foodways Alliance and Foodways Texas have started to inform public opinion about the danger of losing our food history and heritage.

In 2000, Alan Richman, a food writer for *GQ* magazine, took a barbecue tour of North Carolina. After hearing so many stories of harassment, Richman called the state's environmental health services department and asked point-blank whether they were trying to put barbecue men out of business. The backpedaling supervisor Richman interviewed suggested that the state was only trying to remedy gross violations like grease-soaked cinder blocks and soot-covered walls. (How do you cook whole hogs in a cinder block pit over wood coals without getting grease on the cinder blocks and soot on the walls?)

At around eight in the morning, Ella opened up the store. Rodney and an assistant carried a hog on its hog-wire holder across the backyard and into the back door

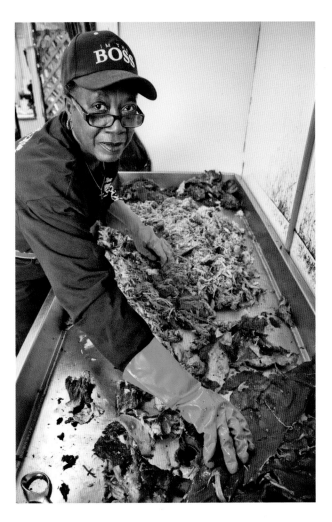

Ella Scott chopping pork

of the store. There, on a table, Ella pulled the pork and chopped it with a meat cleaver. The meat had already been seasoned; she mixed it all together and checked to see that seasoning was evenly distributed. Some of the skin was mixed in, but most of it was sold separately.

Rodney's friends came and went all morning as he worked, and he found time to joke with all of them. One guy named Michael Williams dropped off some food. Rodney said it was wild game stew and offered me some for breakfast. "You get tired of barbecue after smelling it all night," he said. He got two lidded polystyrene containers in the kitchen and ladled grits into the bottom of each from a Crock Pot. "This is rabbit and squirrel stew," he said as he spooned some over the grits. The peppery gravy and grits were terrific together. The squirrel was a little dry, but the rabbit was tender and delicate. It was sort of like Brunswick stew, only a lot better.

"We have been in *Saveur* and *Time* magazine and all kinds of blogs," Rodney said. "I am going to food festivals and meeting chefs all over the country." For people who are interested in artisan techniques and authentic American foodways, this African American grocery store in rural South Carolina might as well be a national monument.

"We get foodies showing up here who found us on the Internet and day-trippers from all over the place," Rodney Scott said. "This lady showed up the other day with maps and newspaper clippings in her hands, she drove all the way from New Jersey. Private planes land at Stuckey so people can run over here to get some barbecue to take with them on the plane."

I asked whether the attitude of the health department had changed with all the publicity. "Big difference," Rodney said. "They are cool now. The inspector came by one day, and there was a television crew shooting here. The state tourism people were here too, so there was a vehicle with a state seal parked out front. Inspector just turned around and left. The harassment has stopped. No more demands or fines. I ask them more questions than they ask me now."

"Whole-hog barbecue was nearly gone in this part of the state," Rodney said. "We revived it. But we had no clue it would ever be this big.

SCOTT'S VARIETY IS ON THE CUTTING EDGE—by virtue of being so old-fashioned. It is a destination for barbecue zealots looking for the last of the endangered species that wood-fired pit barbecue has become, for heritage-livestock folk studying alternatives to factory pig farming, and to the new generation of chefs and food enthusiasts who are rediscovering pork.

Rodney Scott is not only helping save a barbecue tradition, he is working with top chefs on new innovations. Scott, along with Samuel Jones of the Skylight Inn and John T. Edge from the Southern Foodways Alliance, is a member of a barbecue cook-off team sponsored by a group called the Fatback Collective. The team also includes four James Beard Award–winning chefs.

In 2011, the team entered a Mangalitsa pig in the whole-hog competition at the Memphis in May barbecue cook-off. Imported from Europe, the Mangalitsa is a heritage breed that is much fattier and more flavorful than the lean commercial pigs raised in factory farms today. The idea was to return to an older barbecue tradition with a smaller, pasture-raised pig.

The cook-off team came in a respectable third. But the competition was a small part of a larger scheme. The Fatback Collective was sponsored by Nick Phakis, the owner of Jim 'N Nick's Barbecue, a chain of twenty-eight barbecue restaurants across the country. Along with barbecue restaurant owners such as Danny Meyer at Blue Smoke in Manhattan, Phakis is working on finding alternatives to commercial pork.

Barbecue men everywhere would love to be able to buy the small pigs on the hoof that Stephen Grady and Roosevelt Scott get from local farmers in the eastern area of the Carolinas. Across the country, small pig farms are producing heritage breeds, but the supply is limited. Blue Smoke cooks Niman Ranch pork from California. But while big-city chefs will gladly pay top dollar for the tastier pork, the prices are far beyond what traditional barbecue restaurants are willing to pay. As more small pig farms start producing, the price may come down some. But the real question is whether barbecue lovers will be willing to pay more for a higher-quality product.

The definition of barbecue as "cheap meat made delicious" by slow cooking may have to be sacrificed. There is no cheap meat anymore. The small pigs Rodney Scott and Stephan Grady buy on the hoof are much more expensive than commercial pork. In a meat market, small spareribs of three pounds or less sell at a steep premium. A long drought has driven up the price of cattle just when the demand for brisket has never been higher. There are traditional precedents for premium barbecue meats. Kreuz Market in Lockhart, Texas, has always barbecued a limited amount of prime rib, and it has always sold out quickly. Cooper's Old Time Pit Bar-B-Que in Llano, Texas, sells a lot of barbecued sirloin.

In Austin, Aaron Franklin has gone one step further. He has experimented with Wagyu beef and USDA Prime briskets. Franklin is also tweaking the Texas barbecue

tradition with little touches such as his espresso barbecue sauce, conceived during his years as a barista at Little City Coffee House in Austin. Franklin slices everything he cooks in a few hours from 11 a.m. to 2 p.m. and then hangs up the Sold Out sign and goes home. Every morning in front of his door there is a line of people waiting to buy every morsel.

Thirty-five-year-old Aaron Franklin grew up in the barbecue restaurant his parents owned in Bryan. His grandfather was a steel-guitar player who toured with Bob Wills. Franklin moved to Austin, where he got a gig as a rock 'n' roll drummer, but the job didn't pay very well. He supplemented his income by holding barbecues at his home and charging his guests for dinner. He worked for John Mueller at a barbecue restaurant on Manor Road in Austin and bought Mueller's cylindrical steel smoker, made out of an old propane tank, when Mueller went out of business.

Inspired by the food trucks and trailers that dominated the city's street-food scene, he opened a barbecue trailer in December 2009 and quickly succeeded beyond his wildest dreams. On the Sunday morning I stopped by, there were twenty-four patrons waiting when the chain-link gate opened at eleven. By 1:30 p.m. the meat was all sold out. Franklin slipped the padlock on the gate and closed his shade-tree barbecue operation two and a half hours after he opened it, with a full cash register and no leftovers.

Aaron Franklin, founder of Franklin Barbecue

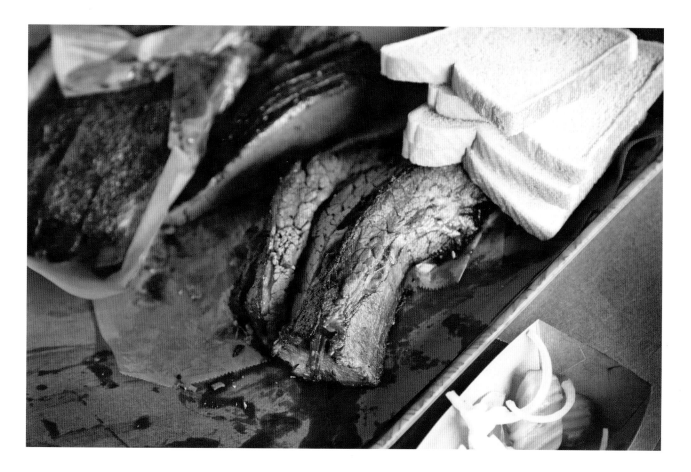

Franklin's brisket

Franklin Barbecue is now located in a space that was once the home of Ben's Long Branch Barbecue in the historic African American East Eleventh Street neighborhood. Franklin has added more smokers, but he still sells out in a matter of hours every day. And he has no plans to add gas-fired stainless-steel barbecue ovens to meet demand. "It's not about how much money I can make," he said. "It's about the tradition."

While expanding the definition of American barbecue culture, a new generation of chefs has started to recast traditional barbecue as part of a white-tablecloth cuisine. Zakary Pelaccio at Fatty 'Cue, in Brooklyn, serves smoked brisket points with chile jam and steamed Chinese bao buns. Tim Byres at Smoke, in Dallas, serves "North Carolina–style whole hog" with blue cheese slaw and rustic toast. His smoked Berkshire pork chop comes with apricot preserves, potato dumplings, wilted greens, and unfiltered olive oil. The beef barbecue is coffee cured, and the dry-rubbed ribs come with mac 'n' cheese and pickled green beans.

Smoke has a full-size A. N. Bewley barbecue smoker built into its kitchen, and there is always something cooking in it. The restaurant is attached to a boutique hotel, so it's open for three meals a day. I had an amazing breakfast of brisket hash with poached eggs and some smoked rabbit sausage on the side.

Tim Love's Woodshed Smokehouse in Forth Worth has a similar gourmet-barbecue menu. He offers a whole smoked cauliflower head with olive oil, lemon, and chile de arbol, and smoked artichokes with parmesan. There are bulgogi tacos, pulled pork sandwiches, and wood-grilled game birds, along with barbecued ribs and smoked beef tenderloin.

Barbecue purists may not easily accept such newfangled dishes—until they taste them. In an article in *Garden & Gun*, John T. Edge recanted his previous testimony on the subject after eating at Smoke. "It would be easy to dismiss such work as blasphemy," Edge wrote. "Five years back, confronted with comparable riffs on culinary tradition, I keened and hollered about how, while much of the South was being strip-malled, barbecue could and should be appreciated as a cultural bulwark, an intransigent expression of the past in the present. But I was wrong. Small-minded even."

It would be comforting to believe that a new generation of young purists such as Brandon Cook, Samuel Jones, Rodney Scott, and Aaron Franklin was going to save the American barbecue tradition. And that chefs like Tim Byres, Tim Love, and Zakary Pelaccio were going to take it to new heights. But the sad fact is that the purists are losing ground and the innovators can be counted on the fingers of one hand.

Barbecue is hot—restaurant chains are building barbecue outlets all across America. But for the most part, barbecue artisans have been replaced by mass-production stainless-steel ovens and a fast-food version of barbecue. Burger King added several barbecue items in the summer of 2012, including a "Memphis Pulled Pork Sandwich." Expect McDonald's to go beyond the McRib and get back to its barbecue roots.

Barbecued Yardbird

Watching Rodney Scott barbecue chicken made me eager to go home and do it myself. It sure is a lot easier than cooking whole hogs. Rodney started the chickens early in the morning and cooked them by the direct-heat method in a regular barbecue rig over hot coals shoveled from the big metal furnace in the middle of the yard. The distance between the chicken and the coals was around 8 inches.

- 1 whole free-range fryer, 3–5 pounds
- ¼ cup Rooster Rub (p. 218)
- 6 cups Yardbird Marinade (p. 218)

Remove the giblets and, with a sharp knife or poultry shears, cut the chicken along each side of the backbone. Butterfly the chicken by removing the backbone and flattening the rest of the chicken open. Rinse the insides. Place the chicken in a freezer bag with 3 cups of the marinade and place in the refrigerator overnight.

The next day, remove the chicken from the refrigerator and discard the marinade. Season the chicken inside and out with Rooster Rub, pressing it onto the skin, and allow to sit for at least 1 hour.

Set up your barbecue for direct heat. Burn down a large pile of charcoal or wood, then spread the hot coals out and place the chickens, bone side down, on a grate 8 inches or more above the coals. Keep a spray bottle of water handy in case of flare-ups. Cook for about 1½ hours, using the remaining 3 cups of Yardbird Marinade as a mop sauce. You may need to burn down more coals in a chimney starter or another charcoal grill in order to have coals to add during cooking. Test for doneness by wiggling the leg bone. When it moves easily, the chicken is done to medium. Turn the chicken over and cook on the skin side for 15 minutes, or until nicely colored. (The USDA recommends cooking chicken to 165°F.) *Serves 2–4.*

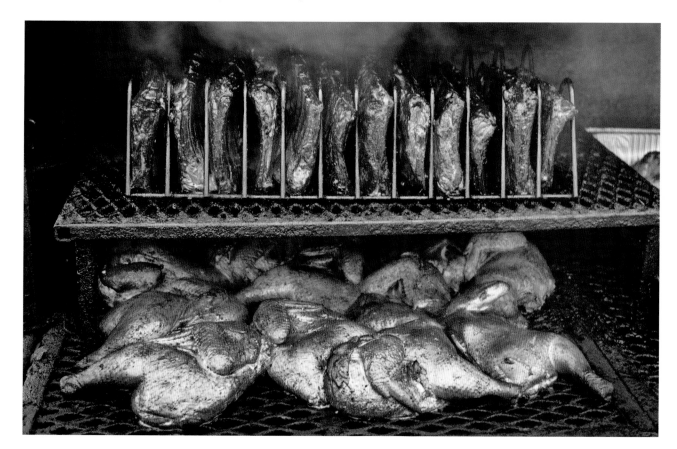

Rooster Rub

- -

The paprika in this rub adds an appealing red color to the chicken skin.

- ½ cup Arkie Rub (see p. 50)
- 2 tablespoons poultry seasoning
- ¼ cup pimenton (smoked paprika), or substitute paprika

Mix everything together in a shaker bottle and use as a rub on chicken. This rub will keep for a couple of months in an airtight bottle. *Makes almost 1 cup.*

Yardbird Marinade

- -

Cook-off competitors swear by Wish-Bone Italian dressing as a chicken marinade, and I have never found anything that works much better. Doctor it up with your own additions. I like to zip mine up with red pepper and hot sauce.

- 2 cups bottled Italian dressing such as Wish-Bone
- ¼ cup crushed red pepper
- 1 tablespoon Texas Pete or other pepper sauce

Combine all ingredients in a bowl and refrigerate until ready to use. *Makes 2 cups.*

Barbecued Brined Chicken

- -

Brining keeps chicken juicy and adds flavor. But don't bother trying to brine an "enhanced" grocery-store chicken—it's already pumped so full of saltwater that it won't absorb any more. (Check the ingredients list on the package to see whether the chicken has been "enhanced.")

- 8 cups boiling water
- ½ cup sea salt
- 2 tablespoons hot-pepper sauce
- 1 tablespoon freshly ground black pepper
- 1 can beer
- 1 whole free-range fryer, 3–5 pounds
- ¼ cup Rooster Rub (p. 218)
- 3 cups Italian dressing

In a soup pot that will fit in your refrigerator, bring the water to a boil and add the salt, hot-pepper sauce, and pepper, making sure the salt is dissolved. Add the beer. Cool the mixture down in the refrigerator.

Remove the giblets and, with a sharp knife or poultry shears, cut the chicken along the backbone and flatten it open to butterfly it. Rinse the insides. Submerge the chicken in the brine, placing a weight on top of it to keep it submerged. Keep it in the refrigerator for 24 hours to cure.

Set up your smoker for indirect heat with a water pan. Use wood chips, chunks, or logs, and keep up a good level of smoke. Maintain a temperature between 225°F and 275°F.

Remove the chicken from the brine; pat dry. When the chicken is dry, rub it with dry rub. Spread the butterflied chicken on the grill, bone side down, and cook with indirect heat for 3 hours, mopping with Italian dressing every 30 minutes.

When it reaches an internal temperature of 165°F, test for doneness by inserting a knife tip into the thickest part of the thigh. If the juices run clear, the chicken is done to medium. (The USDA recommends cooking chicken to 165°F.) *Serves 2–4.*

Smoky Tender Beef Ribs

- -

Cooking beef ribs in a pan is a great way to get them tender. Tim Byres's Beef Rub is the perfect spice blend for them.

- 12 beef short ribs (square cut)
- 1½ cups Tim Byres's Beef Rub
- 1 tablespoon vegetable oil
- ½ onion, chopped
- 3 garlic cloves
- 12-ounce bottle cane-sugar-sweetened Dr Pepper
- 1 cup cane syrup (such as Steen's)

Rinse the ribs and remove the membrane. Season the ribs with the rub and allow to marinate for a few hours or in the refrigerator overnight. Allow the ribs to come to room temperature before cooking.

When ready to cook, light about 25 charcoal briquettes in a chimney and prepare the grill with the coals on one side only. Add a chunk of hardwood now and then for smoke. Place the ribs in a roasting pan. Start the pan directly over medium-hot coals and turn the ribs when they start to sizzle. Continue cooking in the pan for an hour, turning to caramelize on all sides. Move the pan to the cool side if the meat begins to burn or stick.

Heat the oil in a skillet and add the onion. Cook until softened, about 5 minutes. Add the garlic and cook another minute. Add the Dr Pepper, bring to a boil, then simmer.

Add more wood to the grill if needed. When the ribs are well browned, pour the cane syrup over each rib, turning to coat. Then add the hot Dr Pepper mixture to the roasting pan. Place the pan over hot coals until it simmers. Then move it over to the cool side of the grill and allow the ribs to smoke and simmer for another hour, turning often until the meat begins to loosen from the bone.

Cover the pan tightly with aluminum foil and allow to steam for half an hour. Remove from the grill and put the ribs in a serving dish. Stir the braising liquid and molasses left over in the pan together, heating the liquid in a pan on the stove if necessary, and then pour it over the ribs. Serve immediately. *Makes about 3 pounds of meat.*

Tim Byres's Beef Rub

- -

Tim Byres combines traditional barbecue recipes with a fine-dining sensibility at Smoke, his famous restaurant in Dallas. Byres won *Food & Wine*'s Best New Chef Award in 2012.

- ⅔ cup dark brown sugar, packed
- ⅓ cup dark-roasted coffee, finely ground
- 5 tablespoons salt
- 3 tablespoons granulated dry garlic
- 2 tablespoons paprika
- 1 tablespoon dried oregano leaves
- 1 bottle (5 ounces) Tabasco Chipotle Pepper Sauce

Combine dark brown sugar, ground coffee, salt, garlic, paprika, and oregano in a medium bowl. Add the Tabasco Chipotle Pepper Sauce; stir until well mixed. Use as a rub on beef ribs, roasts, and steaks. *Makes 1½ cups.*

13

THE COOK-OFF
CIRCUS

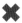

MY BARBECUE HORIZONS were vastly expanded by watching the masters of Southern barbecue at work. When I got back from our trip, I went into a pork frenzy. The guys in the meat department of the grocery store convinced me that cooking a Boston butt and a picnic side by side was the same as cooking a whole pork shoulder. Once you chopped up the pork, who would know the difference? So I put the two pork roasts on my sawed-off-barrel barbecue pit and tried to cook them over a direct fire of burned-down coals, Southern style. Luckily, I had moved the barbecue pit away from the garage, and I was able to extinguish the roaring fire with a garden hose. It would have been so embarrassing to call the fire department on my first attempt to barbecue a pork shoulder.

It took two more attempts to turn out a decent pork shoulder. I learned that a Boston butt and a picnic side by side are not the same thing as a whole shoulder. And I accepted the fact that indirect heat was the only method that was going to work. Now I use heritage pork that costs a lot of money, but has a lot more flavor. I have custom pork cuts to work with and a whole new way of cooking them.

Poking at the charcoal in my barrel pit, I wondered whether the true gauge of American barbecue culture isn't right here in our backyards. Would this democratic view mean that hot dogs and hamburgers are just as much a part of American barbecue as the whole pork shoulder on my pit? The Piedmont pitmaster Chip Stamey doesn't think so. He says "barbecue" is a noun and not a verb, by which he means that you can't "barbecue" weenies on a gas grill. But the many definitions of "barbecue" in the dictionary are determined by common use, not by the opinions of experts.

Of course, the changes in common use that turned hamburgers and hot dogs into barbecue weren't spontaneous; they were the result of commercial forces that

sought to expand the definition of "barbecue" in order to increase profits. The home-barbecue business began in the 1940s when Heinz introduced its barbecue sauce and Ford dealerships began selling cheap charcoal braziers and paper sacks full of briquettes. It was part of a campaign at the Ford Motor Company to make money from waste products; automobile frames were then made out of wood, so a Ford relative named E. G. Kingsford came up with the idea of making charcoal briquettes out of wood scraps. Motorists took the braziers and charcoal along on trips and then barbecued by the side of the road. In 1951, the company, which was renamed Kingsford, began selling charcoal to supermarkets.

In 1952, George Stephen invented the Weber kettle grill by refashioning the steel spheres used to make buoys. In the 1960s, the gas grill was invented by employees of the ARKLA natural gas company in Little Rock as part of a marketing effort to increase sales of natural gas. In the mid-1960s, major food companies bought into the backyard-barbecue business by advertising sauces and related products in national magazines. Bottled barbecue sauces came with recipes that turned any food into "barbecue" when it was doused in the sauce. Grills and bags of charcoal came with instructions on "barbecuing" everything from fish to vegetables. While Southern purists may hold that grilling chicken wings and salmon steaks isn't really barbecue, it is interesting to recall that Native Americans cooked poultry and fish at the barbecues early European explorers witnessed in the 1500s.

The backyard barbecue, marketed as a new leisure activity, spawned a corresponding array of equipment, cookbooks, accessories, outdoor furniture, and fashions. Sales of barbecue grills and accessories went from nearly zero in 1940 to around $4 billion a year today.

The spread of the backyard barbecue may have created confusion about what was and wasn't "real barbecue," but the trend also sparked a revival of interest in American barbecue traditions. While barbecue restaurants were being replaced by fast-food outlets on the American highways, the most ambitious backyard enthusiasts were reviving artisan techniques. Certainly, the vast majority of Americans were perfectly happy "barbecuing" hamburgers and hot dogs; but the minority who worked to perfect their pork shoulders and beef briskets represented a substantial subculture. The first barbecue cook-offs supplied an outlet for the enthusiasm of these new amateur artisans and became the meeting ground for serious backyard barbecuers.

The first Memphis in May competition was held in 1978 in a parking lot near the Orpheus Theater. Twenty-five contestants paid the $12 entry fee. The $500 first prize was won by an African American woman named Bessie Louise Cathey. A born performer, she wore a chef's toque and big round glasses while she cooked on a portable grill, joking with the crowd the whole time. Barbecue contests became extremely popular all across the country. In the beginning, they were a lot of fun for contestants and onlookers. But when entry fees increased and liability insurance was required, the atmosphere began to change.

Thirty-some years later, it is difficult to recognize what the barbecue cook-off has become. Prize money has skyrocketed, enticing a new breed of pros to move in and take over. Minorities and talented amateurs without corporate connections are being pushed out.

"It costs around $100,000 to do this booth every year," Richard Flores told us as he led Rufus and me around the Cold River Cattle Company Barbeque Team's tented enclosure at the Houston Livestock Show and Rodeo's 2012 World's Championship Bar-B-Que Contest. Around 350 teams entered the event, which drew 260,000 attendees. We arrived on Saturday morning, just before the judging started. Richard had worked with the crew that cooked for the big party on Friday night.

A very intense young cowboy named Heath Ray was in charge of the competition crew at Cold River. He was moving from pit to pit, checking his briskets and pork roasts before getting ready to send his meat to the judges. Each team is given numbered polystyrene boxes by the judging committee. They are filled with the specified meat and turned in to the judging booth at the scheduled time.

We walked around the Houston cook-off as Richard pointed out some interesting barbecue smokers. One team was cooking a whole hog on a rotisserie made out of a pair of fireplace grates sandwiched together. It rotated on a rod turned by an electric motor, and there was a waterwheel at the other end. The water poured into a

moat, and the whole thing was surrounded by an elaborate re-creation of snow-covered Alps that towered twenty feet above the ground. "I don't even want to know how much that booth cost," Richard said.

To cover the costs of entering, barbecue teams acquire corporate sponsors. The sponsors sell wristbands that allow invited guests to attend a barbecue party in the booth—which is why the booths became ever more elaborate. Famous country-music groups play inside the tents, and those lucky enough to get a wristband get all the food and drinks they want. The money usually goes to a worthy cause, but the result is an exclusionary atmosphere.

The first time I bought a general admission ticket to the Houston Rodeo's barbecue cookoff was in 2002. Walking around the Reliant Stadium parking lot, I said howdy to a lot of good old boys in cowboy hats. The sign in front of one booth had the words "Confederated Cooks" emblazoned across a stylized Confederate flag. The Stars and Bars had been banned at the cook-off in 2001 after the South Carolina statehouse controversy, but this group found a way around the rule.

Ten years later I discovered that the Confederated Cooks were still competing. Their booth was in the exact same spot near the entrance. Right in front of the Stars and Bars booth was a long row of chairs on stands manned by African American shoeshine men. It is something of a tradition to wear your best cowboy boots to the rodeo—and where better to get them cleaned and shined?

In 2002, right around the corner from the Confederated Cooks, I first met the Skinner Lane Gang. The team had won the overall championship trophy in 1994, even though it had one of the smallest booths at the competition and no big sponsors. It was also the first all black barbecue-cook-off team I'd ever seen. I interviewed the team leader, Louis Archendaux, Jr., about the racial divide in barbecue.

In 2012, the team was in the same spot, but it had changed its name to The Next Generation Skinner Lane Gang. The team was now being run by Louis Archendaux's son Louis III and by his son-in-law, Reginald Wilson. The younger generation had been up all night cooking, but Louis Jr. was there in the tent when I came by Saturday morning. I asked him whether things had changed much in the last ten years.

In 2002, there were 2 or 3 African American teams entered in the cook-off out of a little more than 300 total. In 2012, Louis estimated there were 5 or 6 out of 350. The main reason blacks don't enter barbecue cook-offs is money, Archendaux told me ten years ago. The team barely made ends meet with a budget of $6,000 back then. Ten years later, it had found a little sponsorship money.

The other problem is the difference between the African American barbecue aesthetic and the judging criteria of the cook-offs. The brisket I ate at the booth ten years ago was falling apart tender and served in irregular chunks. Archendaux told me the brisket they enter for judging is completely different.

"If you get it really tender, you can't slice it perfectly," said Archendaux. "And appearance is very important to the judges."

"Are any of the judges black?" I wondered.

"Probably not very many," he said.

When I visited the judging booth in 2002, all the judges I saw were white. In 2012, I counted one black judge out of forty-five as the first round of judges were seated. There were several more rounds of judging, but I am guessing the ratio stayed about the same.

Texas isn't the only place where barbecue cook-offs are divided along racial lines. Jim Auchmutey of the *Atlanta Journal-Constitution* attended a Georgia cook-off

called the Big Pig Jig in 1994. "Only a few black teams registered, an imbalance that's typical of the cook-off circuit," he wrote. Although organizers would like to see more black teams, the "Caucasian block party" atmosphere drives them away, Auchmutey reported. One sign he saw read: "Redneck Mardi Gras." And that sums up the cook-off atmosphere pretty well, he told me on the telephone. Confederate flags were much in evidence at the Georgia event. "The flag is a big issue at these things," he says. "If you fly even one, that puts out a signal to black people that this isn't our scene."

The Skinner Lane Gang was proud to be the shock troops of black barbecue cook-offs; the team broke the color barrier at Texas barbecue cook-offs for decades. "We were the first black team at the Fort Bend County cook-off in 1984," Archendaux said. "They had Confederate flags flying all over the place."

"Did anybody give you trouble?" I asked him.

"There's always a few," said Archendaux. "But we are kind of rowdy. If you want to take it there, we can help you out. We never minded a little scrape."

AS MENTIONED IN THE LAST CHAPTER, when the Fatback Collective entered a Mangalitsa pig in the whole-hog competition in the Memphis in May cook-off, it hoped that two legendary pitmasters and four James Beard Award–winning chefs cooking a heritage hog would be enough to win. But the team came in third. The win-at-all-costs chicanery of the modern barbecue cook-off had gone far beyond the time-honored artisan techniques the Fatback Collective was using.

Injecting the meat with sodium phosphate to increase flavor and water retention, packing the loins of a whole hog with ice packs to keep that cut at a lower temperature, and pouring a garlic-butter-and-MSG solution over the meat just before giving it to the judges are all cheap tricks regularly employed by a new breed of cutthroat professional barbecue competitors.

In the early 1990s, I served as a judge at the Taylor Barbecue Cook-off, a regional qualifier for a larger event. In those days, barbecue cook-offs were still fairly low-key affairs, especially small cook-offs like the one in Taylor. It was held in a park under some shade trees, and the competitors were all glad to shoot the breeze with the public. The atmosphere hasn't changed much at local competitions. But at the big-money events there is a new attitude, as evidenced in the hit show on the TLC network, BBQ Pitmasters. Myron Mixon is one of the stars of the show.

"I am Myron Mixon, from Unadilla, Georgia, and I am the baddest barbecuing bastard there has ever been," begins his best-selling barbecue cookbook, Smokin'. The son of a Georgia barbecue man and whiskey runner named Jack Mixon, Myron spent his childhood tending the pit and stoking the fire barrels at his dad's barbecue joint. "I learned about the whys and wherefores of barbecue the way the sons of farmers learn to grow crops," Mixon writes.

Mixon won two categories in the first cook-off he ever entered. After his father died and Mixon got divorced, he found himself short on money. When he looked at

the barbecue cook-off circuit, he saw folks "getting in their little circles and drinking their little cocktails." Those people were "hobbyists who were there for the fun and camaraderie," he wrote. Mixon understood that, but understood also "that there was some serious money to be made."

For somebody who grew up cooking whole hogs for a demanding father in the hot Georgia sun, winning barbecue cook-offs was a breeze. "People ask me about what motivates me to win the contests. It's easy. You ever not know where your next truck payment is coming from? That's some powerful motivation." Mixon recommends that if you want to get drunk and hang out with your friends, stay home and drink in your backyard.

Mixon injects his whole hogs with a brine that contains MSG, and he packs extra Boston butt roasts under the loin to keep it from overcooking. When the hog is nearly done, he throws the overcooked Boston butt roasts away. "I'm all about doing whatever it takes to get the desired result to win," he writes. To the many people who feel that injecting meat with flavoring solutions isn't "authentic" barbecue, he explains that this is the latest stage in the evolution of barbecue cookery.

For somebody who grew up cooking whole hogs for a demanding father in the hot Georgia sun, winning barbecue cook-offs was a breeze.

Mixon also occasionally teaches a class in open-pit barbecue for purists, using a replica of the pits he cooked on at his dad's house. He sees it as a reenactment of a "method of cooking that's almost forgotten." His classes for barbecue competitors are much more popular than his open-pit class. He has one bit of advice for both groups: "Staying up all night over an open pit is just completely impractical, whether you're at a competition or in your own backyard."

Thanks to the television show, Myron Mixon is well on his way to becoming the most famous barbecue man in America. *BBQ Pitmasters* fits the formula of manufactured drama that makes reality TV so popular. With his all-black wardrobe and cigars, Mixon is the barbecue version of a World Wrestling Federation character. No doubt the producers added Aaron Franklin as a judge in hopes that he would lend the show some integrity, but the scripted comments they gave the easygoing Austin musician-pitmaster made him sound as melodramatic as Mixon.

There are still a lot of folks on the barbecue cook-off circuit who enter contests for fun and camaraderie. I know quite a few of them. They rely on their jobs to make a living. Barbecue is a passion they pursue on their days off. And they resent having their hobby belittled on television because of the rude behavior of the self-proclaimed "winningest son-of-a-bitch in barbecue." Of course, they aren't above borrowing his recipes.

I read Mixon's whole-hog instructions very closely before I attempted to cook my first. There is no doubt this guy knows how to barbecue. I am not really opposed to injecting either, although many of my friends are. Ever since I bought my first Cajun Injector while I was learning to deep-fry turkeys, I have become a junkie—I love to stick a needle full of butter or apple juice into turkeys and pork roasts.

Stuffing a whole hog with extra pork roasts and then throwing the meat away as Mixon advocates is something that I could never bring myself to do. "Wasting food is a sin," "Think of the starving children in India," and a host of other platitudes endured over a lifetime have left their mark.

Everybody has a vision of barbecue purity. Few backyard barbecuers want to inject the food they are feeding friends and family with phosphates, nitrates, nitrites, or pink salt. But Rodney Scott, one of the most traditional pitmasters in the South, has no problem at all sprinkling MSG on his whole hog, so there are no clear sides to this argument.

Anyway, most of the pork and chicken you buy in the grocery store is "enhanced," which means that it has been injected with salt, phosphates, antioxidants, water, or flavoring. This adds about 15 percent to the weight of the meat, making the product more profitable for the meatpacker. The chemicals also make the cooked meat taste juicier. Barbecue competition rules require that contestants start with meat that has not been "enhanced" or preseasoned. Discount clubs like Sam's and Costco are among the few places where you can find unenhanced meats, as well as pork ribs in the difficult-to-find smaller sizes.

But in the end, the problem with using barbecue cook-offs as a benchmark of barbecue culture isn't the injections or the chemicals—it's the perversion of the original purpose of holding a barbecue. In early America, barbecues brought people together. Whether held at a church or in someone's backyard, that's what a barbecue has always been about. That intent was still there when barbecue competitions were friendly affairs where competitors got together "in their little circles with their little cocktails."

But that spirit has been run over by a monster truck. "What I do best is beat everybody else's ass," writes Myron Mixon. You can't begrudge the winningest son of a bitch in barbecue his millions or his mansion with the extra rooms to hold all his barbecue trophies. But what does it say about American barbecue culture when the top cook-off winner is trying to make a virtue out of beating up the other kids for money?

Bourbon-Glazed 3-2-1 Ribs

- -

I rarely bothered with the big 5- to 6-pound pork ribs found in grocery stores until I came across this technique developed by barbecue competitors. The numbers refer to the suggested cooking times: 3 hours of smoking, 2 hours of braising on the grill, and 1 hour of glazing. While the numbers make the recipe easy to remember, they are a little off. Two hours is way too much braising time. The bones will fall out of the meat if you go that long—1 hour is more like it. You don't need 1 hour to glaze the ribs either; 30 minutes will suffice. Of course, if the recipe were called 3-1-½ Ribs, nobody would remember it.

- 1 5- to 6-pound rack of pork spareribs
- 1 cup cider or cane vinegar
- 3 tablespoons Arkie Rub (p. 50)
- 1 cup Hog Mop, plus more for basting (p. 53)
- Shot of bourbon
- Shot of cider vinegar
- ½ cup honey
- 1 teaspoon prepared Dijon mustard
- 1 teaspoon butter

Trim the ribs as desired. Remove the membrane from the bone side of the ribs. In a roasting pan, rinse both sides of the ribs with the vinegar and allow them to soak for fifteen minutes. Discard the vinegar. Shake off the excess vinegar, then season both sides of the ribs with the rub. Allow to marinate for several hours or cover in plastic wrap and refrigerate overnight.

Set up your barbecue for indirect heat. Start a fire with charcoal briquettes and add hardwood lump charcoal or hardwood logs or chunks. Maintain a temperature between 250°F and 300°F. Smoke the ribs, bone side down, for 3 hours, turning so they cook evenly. Place the ribs in a roasting pan bone side down with 1 cup of the Rib Mop and cover the pan tightly with aluminum foil. Cook for 1 hour, mopping with Rib Mop once after 30 minutes. Do not turn the ribs over. After 1 hour, check to see whether the tip of a knife or a toothpick passes easily between the ribs. If not, cook covered for another 10 minutes or until the ribs are very tender.

Combine the whiskey, vinegar, honey, mustard, and butter in a small pan and cook over medium heat until the butter melts. Mix the glaze well. When the ribs are tender, transfer to a clean pan and apply the glaze with a spoon or brush. Shake a little extra rub over the top of the sticky glaze. Return to the smoker for 30 minutes to 1 hour as the coals die down or until the glaze begins to bubble. The glaze burns easily over a hot fire, so be careful not to burn it.

Allow to rest at least 15 minutes before carving into individual ribs. *Serves 3–4.*

Mustard BBQ Sauce

- -

A Texas cook-off competitor entered the mutton category of a cook-off in Tennessee. His entry was shunned by the judges because it didn't include mustard barbecue sauce—the traditional accompaniment to mutton.

On our drive across South Carolina, we sampled whole hog with the traditional mustard sauce at Jacky Hite's Barbecue in Leesville. The old-fashioned barbecue joint was originally a take-out-only operation, but it added a big lunchroom not long ago. With its fluorescent lights, Formica tables, and steam tables filled with canned vegetables, the lunchroom might remind you of a hospital cafeteria. If you go to Jacky Hite's, I recommend you get the excellent barbecued pork and tangy mustard sauce to go.

Mustard barbecue sauce is generally made with yellow mustard, but you can use any prepared mustard you like.

- 2 cups cider vinegar
- ½ cup juice from a jar of pickled jalapeños
- ½ cup dark brown sugar
- ½ cup light brown sugar
- 2 cups prepared yellow mustard
- 1 teaspoon kosher salt
- 1 teaspoon Worcestershire sauce
- ½ teaspoon ground black pepper
- ¼ teaspoon cayenne

Combine all ingredients in a saucepan over medium heat. Bring to a boil and reduce heat to a simmer. Cook for 3 or 4 minutes and mix well. Use immediately. *Makes 6 cups.*

Lamb Rub

- -

Lamb or mutton was once among the most popular barbecue meats in the South, ranking right behind pork.

- ¼ cup celery salt
- 1 tablespoon coarsely ground black pepper
- 1 tablespoon minced garlic
- 2 tablespoons chopped fresh rosemary

Combine all ingredients well, then rub on the meat and allow to marinate before cooking. *Makes around 8 tablespoons.*

Dr Pepper Pork Injection

- -

Apple juice is the usual main ingredient for pork injection recipes and you can use it if you like, but I prefer the complex flavor of Dr Pepper or Coke. I only use the cane-sweetened versions of the soft drinks for this purpose.

- ¾ cup cane sugar–sweetened Dr Pepper (or substitute Mexican Coke)
- ½ cup water
- ½ cup sugar
- ⅓ cup salt
- ¼ cup soy sauce
- 3 cloves garlic, crushed

Combine all ingredients in a saucepan over low heat and stir until the sugar and salt dissolve completely. Strain to remove the garlic. Allow the mixture to cool.

*Inject the shoulder all over with the liquid. Use very light pressure while injecting or the liquid will squirt back out of the hole.

Barbecued Mutton

- -

A square-cut lamb shoulder roast works perfectly for this and is fairly inexpensive, but unfortunately the cut is hard to find. Leg of lamb works too, but it ain't cheap.

- 1 square-cut lamb shoulder roast, 7–8 pounds
- 2 tablespoons Lamb Rub (p. 230)

FOR THE CHILE PUREE
- 2 ancho chiles, stemmed and seeded
- 2 guajillo chiles, stemmed and seeded
- 2 chipotle chiles, stemmed and seeded
- (or substitute available dried chiles)

FOR THE BROTH
- 2 tablespoons olive oil
- 2 celery stalks, cleaned and chopped
- 1 onion, chopped
- 4 cloves garlic, minced
- 14.5-ounce can stewed tomatoes
- 2 carrots, peeled and chopped
- Leaves from 3 sprigs fresh rosemary, cleaned and chopped
- Leaves from 3 sprigs fresh thyme, cleaned and chopped
- Salt and pepper to taste

FOR SERVING
- Mustard BBQ Sauce (p. 230)

Rub the meat with Lamb Rub and allow to marinate for a few hours. Light about 25 charcoal briquettes in a chimney and prepare a grill with the coals on one side only. Brown the lamb roast over the hot fire for 10–15 minutes, turning often, until well browned. Move it to the cool side of the grill or to the smoking chamber of an offset barbecue smoker. Put some hardwood chips or chunks on the coals and close the lid. Allow the roast to smoke for 3 hours at around 250°F, turning to cook evenly.

Meanwhile, in a saucepan over low heat, simmer the chiles in water to cover. Allow them to sit in the hot water for 10–20 minutes until soft. Puree the chiles in a blender, adding the soaking water a little at a time until the puree is smooth.

In a soup pot, heat the oil over medium heat and add the onions and celery. Stir and cook for 5 minutes or until softened. Add the garlic and cook another few minutes. Add the remaining vegetables and herbs and 8 cups of water and bring the mixture to a boil. Turn down the heat and allow to simmer while the lamb smokes.

Add more charcoal and wood to the fire. Place a metal roasting pan on the grill directly over the coals. Carefully pour the chile broth into the roasting pan. Place the meat and the broth in the roasting pan. Allow the meat to simmer and smoke for 1–1½ hours, replenishing the liquid level if needed.

With the aid of fire gloves or pot holders, remove the pan from the fire and cover the roast and the roasting pan with aluminum foil and seal tightly. Return to the fire. Simmer over the coals or in a 300°F oven for another hour until the meat is tender. You want the shape to be intact, but the meat to be very soft.

Reserve the broth. Clean the meat away from the bones and chop lightly. Serve the cleaned meat with Mustard BBQ Sauce and the broth on the side. You can also serve some of the broth in a cup as a first course. *Yields around 4 pounds of meat.*

14

COMMUNITY BARBECUES

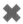

SOMETHING LIKE FORTY PEOPLE showed up at our community barbecue over the course of a Saturday afternoon. The whole hog we cooked weighed a hundred pounds. It was a new hybrid that is being produced for the Revival Market in Houston. Morgan Weber, a pig farmer and store owner, crossed a traditional East Texas breed called a Red Wattle with the extremely fatty Austrian Mangalitsa to produce a pig that reached a high fat content at an early age and small size.

Using photos of the pits I saw on our trip as a guide, Richard Flores and I designed a cinder-block barbecue pit big enough to hold a splayed-out whole hog with room to add coals on either side. We built the pit in Richard's carport on Houston's East Side. It took a while to get the hang of barbecuing Southern style, but after watching a few large pieces of pork go up in flames at my house, I learned to cook with less fuel, a twenty-four-inch separation between the coals and the grate, and a lot of patience. Sitting beside the barbecue pit, "watching the baby" as Rodney Scott would say, gave me a lot of time to think about the trip.

When Rufus and I set out, I expected to trace "American barbecue culture" back to its roots in some rural Southern barbecue restaurants. We did come across a few old-timers, such as George Archibald and Stephan Grady, who offered a glimpse into the past, and a few young pitmasters, such as Rodney Scott and Samuel Jones, who held out the promise that the old traditions might continue. But the larger lesson was that for the most part, barbecue restaurants are not places to go looking for American barbecue culture anymore.

A restaurant is a business, and the purpose of a business is to make money. It may be disappointing to find that such legendary barbecue restaurants as Big Bob Gibson's in Decatur, Alabama, have added stainless-steel barbecue ovens to their traditional pits, but it is pointless to tell them how to run their businesses.

Shayne Carter offers a sample

Profitability—not artisan barbecue traditions—is the concern of all those barbecue chains that are building franchise outlets beside the highway.

But our journey led me to stumble upon the wellspring of American barbecue culture anyway. Artisan barbecue is becoming rare in restaurants, but restaurants aren't where American barbecue came from. The oldest barbecue tradition in America is the community barbecue, and it continues all over the South, largely unnoticed. The pits are ancient, the cooking methods are traditional, and the barbecue is sometimes excellent.

Some of the most knowledgeable pitmasters I met on our trip, including Grady Stephens, Wilbur Shirley, the Jones family, and Roosevelt Scott, told me that they or their ancestors learned to cook at community barbecues. From tailgating at college football games, NASCAR events, and Jimmy Buffet concerts; to the Fourth of July barbecue at the local VFW hall or community center; to church suppers, block parties, and company picnics, community barbecue is everywhere.

Some years ago, I gave a talk titled "Wurst Barbecue in Texas" at a symposium held by the Texas Dance Hall Preservation group. Every German, Czech, and Polish dancehall has a barbecue pit of some description out back, and I was pointing out

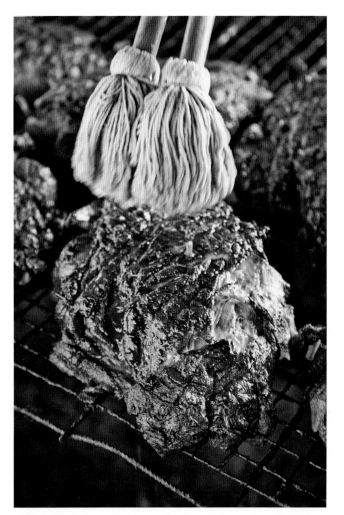

the differences among the sausage styles. I described as well the open pits once used at Southern barbecues in the 1800s and early 1900s. A white-haired gentleman raised his hand during the question-and-answer period and told me there was still an open pit like the ones I was describing at the dance hall in Millheim, Texas, and he encouraged me to attend the annual barbecue there. I gave the man my card and asked him to call me and remind me—and he did.

Early in the morning on Father's Day, Rufus and I found Mark Bolten, the president of the German singing society that owns Millheim Hall, sitting in a folding chair at one end of a seventy-five-foot-long barbecue pit watching the twenty-man crew tending the meat and dousing flames. A handsome man in his fifties, Bolten was wearing jeans, a dress shirt, and a cowboy hat. He wasn't sure how long the old German dance hall near Sealy had been holding this Father's Day barbecue, but he knew it started before he was born. As we talked, the crew began basting the joints of meat with a vinegar sop applied with cotton mops.

The trinity of Texas barbecue—brisket, pork ribs, and sausage—wasn't on the menu. They had been replaced by the barbecue meats of an earlier era: mutton, beef clod, and pork shoulder. The pit didn't have any of the usual metal doors or chimneys.

It was an open pit, a long low trench recessed several feet into the ground and lined on either side with a single course of bricks. There were no coverings to retain the smoke or heat. The void in the middle had been filled with oak and pecan wood the night before, and the wood had burned down until nothing remained but glowing wood coals. The biggest cuts of meat went on the pit late last night. The crew tended the pit throughout the night, extinguishing flare-ups with a squirt of water or a shovel full of sand.

I was amazed by what I saw. It was as if I had entered a barbecue time machine. This is almost exactly what barbecue pits across the Old South looked like in the late 1800s and early 1900s, according to the black-and-white archival photos I had seen. But while I was marveling at how much of the tradition had been preserved, the guy next to me was grousing about how much of it had been lost.

"Times have changed," said Bolten glumly.

"Why, what's different?" I asked.

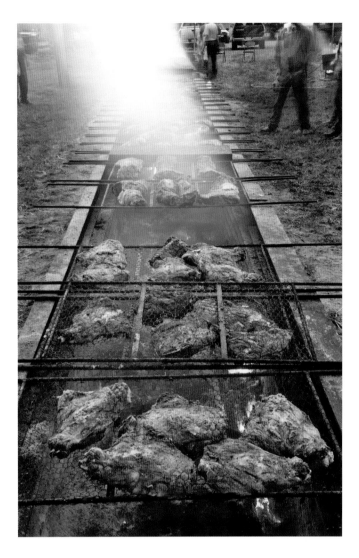

"Those ice chests," he said. "We never put the cooked meat in an ice chest in the old days." I'm not sure when the practice of wrapping barbecued briskets and pork butts in butcher paper and putting them in coolers to finish cooking came in. I suspect it's an innovation introduced by barbecue cook-off competitors. But it's a great way to keep the meat warm and give it a little extra slow-cooking time without burning it. I didn't even notice the coolers until Bolten mentioned them.

"And those baskets, we didn't have those either," he said pointing to the portable grates of welded bars and expanded metal that stretched from one side of the pit to the other, holding the meat above the coals. When the men wanted to turn the meat, they would place an empty basket over the top of one on the pit, turn them both over, and take the top one off. "We always used these," Bolten said pointing to a thick and rusty eight-foot-long metal rod.

"I'll show you," he said as we walked over to the hall and went in the back door. On the wall in the kitchen, Bolten pointed to a collection of fading snapshots taken at the barbecues of the 1960s and 1970s. It was the same pit, but the pieces of meat in the photos were a lot bigger. They were skewered with the giant metal rods and rotated over the coals as they cooked. "The sheep and the shoats [small pigs] were killed and butchered here and cooked whole," Bolten said. "The cattle were cut into four quarters and each one was turned on a pair of metal rods."

According to old documents on the wall inside the hall, the German singing society called the Millheim Harmonie Verein was established in 1872. The hamlet of Cat Spring, about fifteen miles down the road from Millheim, was settled by German immigrants from Westphalia starting in 1831. Some settlers moved to Millheim (originally Muelheim) to build a mill on the Clear Creek in 1845. From those German towns, it was only fifteen miles to San Felipe de Austin, the capital of Stephen F. Austin's Mexican land grant, one of the state's largest urban areas at the time.

"We used to build wood fires under the pots. But your pants got so hot standing next to the fire that nobody wanted to do the stirring."

There were several cotton plantations in the Austin colony, some not far from San Felipe, which was a cotton shipping center and riverboat port. Some of the settlers of Austin's colony were Southerners who brought their slaves along. By 1825, the 300 families of Austin's colony owned 443 slaves. By 1834, one-third of the population was African American. No doubt the German settlers learned the open-pit barbecue technique, along with the basics of cotton planting, from their Southern neighbors and their slaves.

BACK OUTSIDE, WE JOINED the group that was cooking the beans and barbecue sauce in cast-iron wash pots over propane burners. When I asked about the barbecue sauce recipe, I was quickly corrected. "We don't call it 'barbecue sauce.' We call it 'gravy,'" said James Grawunder, the head of the barbecue crew, who kept the recipe in his head.

Watching the process, I would guess that a twenty-pound sack of onions was chopped and cooked in something like twenty pounds of butter, to which five pounds of ancho peppers and a lot of tomato sauce were added. The men took turns stirring the pots with wooden boat oars. Propane was another newfangled innovation that was grudgingly accepted by Bolten and the traditionalists.

"We used to build wood fires under the pots," said Grawunder. "But your pants got so hot standing next to the fire that nobody wanted to do the stirring." Grawunder wasn't sure how long the barbecue had been going on, but he had been part of the crew since 1958. "My father did it before me, and he died in 1955," he said. His sons, James, Jr., and Ray, and their cousin Tom Grawunder were helping make the gravy.

I asked James Grawunder whether I could volunteer to come and peel onions next year. "Sure you can—but you better not show up in those 'city pants,'" he said

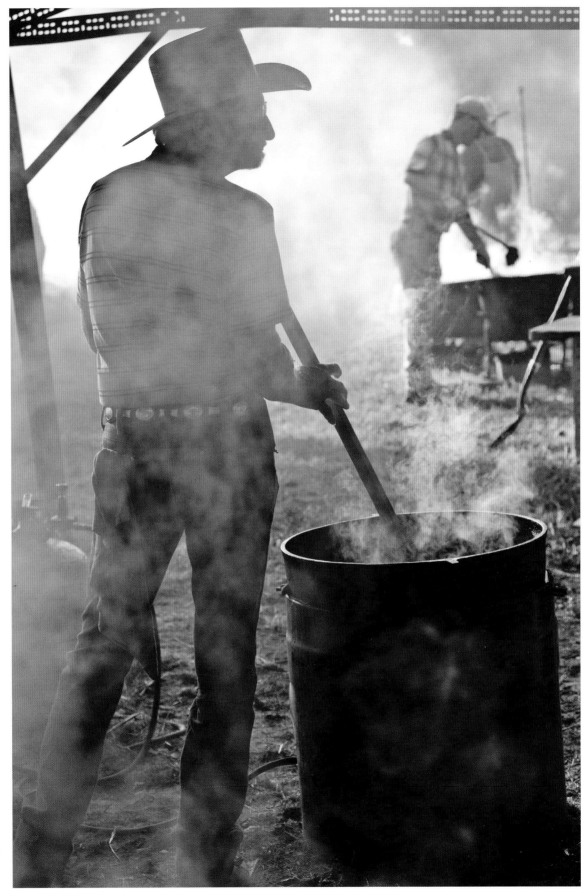

Stirring the beans in 50-gallon cast-iron wash pot

loudly while he pointed at my shorts. The crew members, who were attired in blue jeans and boots to protect themselves from the hot coals, got a laugh out of that. They were mostly local guys who knew each other from the volunteer fire stations and the county highway department, but there were black and Hispanic volunteers and a couple of younger guys in the group.

"We are always looking for new volunteers," Joseph Jez told me. The bearded Jez is the head of the volunteer crew at the annual Mother's Day barbecue in Peters. He also helps out at the barbecue for the annual Frydek Grotto celebration at St. Mary's, the Czech Catholic church in Sealy. Community barbecues used to be common in Austin County, but many of the old halls and lodges and fraternal organizations are closed now, Jez told me. "If we don't get more young people involved, the tradition is going to die out."

For more information about how things were done in the old days, Bolten and Grawunder told me to talk to Allan "Cap" Hilboldt, the oldest active member of the society and its unofficial historian. I found Cap at the long wooden table with the crew that was carving the barbecue. Some of the meat was hand-sliced and some was cut on a Hobart electric slicer. Cap sharpened an old butcher's knife on a whetstone he carried in his pocket before the veteran barbecue man started slicing mutton. In the booklet published for the Millheim society's centennial celebration, I noticed that the schedule of events included "dinner consisting of Veal and Mutton Barbecue with all the trimmings." I asked Cap why pork, mutton, and "veal" were the Texas barbecue meats back then.

Allan "Cap" Hilboldt at Millheim Hall

Up until the 1950s when refrigeration became common, whole sheep and small pigs were brought to the barbecue pit and slaughtered on the spot, Cap told me. It was difficult to kill and butcher an 800-pound steer, so beef barbecue was rare; calves were easier to handle. The barbecue committee would drive around to neighboring farms and look at calves before buying a few and sending them to the butcher shop. "The calves were around 300 pounds live weight. They dressed out to somewhere around 175 pounds," Cap recalled. When the meat market delivered the veal quarters, they weighed a little more than forty pounds each.

Beef shoulder clods, which weigh around twenty-five pounds apiece, have replaced the veal quarters. Whole sheep are still butchered, though

they are cut into parts these days. Mutton hindquarters and mutton prime rib sections are among the largest cuts on the pit. Mutton ribs are the last items to be added. The whole shoats have been replaced by pork shoulders.

The original Millheim hall was built in 1874. When it was demolished, the lumber was used to build the new hall, which was erected in 1938. In its current form, the Millheim Father's Day barbecue had been going on for over seventy years, Cap said.

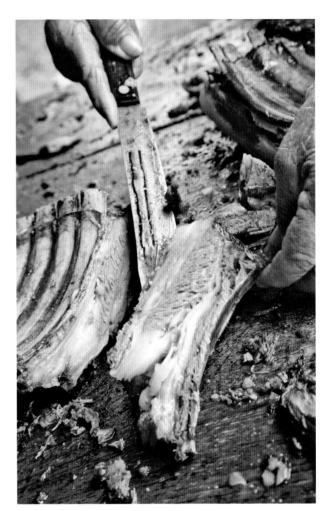

My wife and our two toddlers met Rufus and me at the Millheim dance hall shortly after eleven o'clock, when the serving line opened. Three huge hotel pans full of sliced meat were constantly being replenished. "Beef" was printed on the paper tablecloth beside the first pan, beside it was "Pork," and next to that "Mutton." The beef shoulder was pretty good if you found a pinkish slice. The pork butt was a little dry for my taste, but I was picky since I'd been eating a lot of whole hog lately. But the mutton was spectacular. Having watched the meat being carved, I knew to skip the hindquarters and look for the juicy slices from the lamb's prime rib. The buttery barbecue sauce was terrific, as were the pinto beans. Beer and soda were sold from two concession stands.

Adult plates were nine dollars and kids plates were half that. We carried our food to a table inside the air-conditioned dance hall and sat down to eat while a guitar-and-accordion duo serenaded us. A band called the Lazy Farmers played polkas and waltzes in a pavilion outside while we waited in line for our food. Later on, a German singing society called the Houston Saengerbund was scheduled to perform.

Dessert was a selection of homemade cakes, pies, cobblers, brownies, and the like for fifty cents a slice. My five-year-old put a dollar on the cake wheel and won a strawberry cake with cream cheese icing on her first try. Of course she immediately wanted to do it again. (Try explaining the evils of gambling to a five-year-old with a strawberry cake in her hands.) The kids wanted to hang around for the auction so that we could bid on the exotic chickens up for sale, but we went home shortly after lunch. Rufus hung around to take photos of the musicians and the dancers.

The Millheim Father's Day barbecue is a fund-raiser for the preservation of the dance hall. There are similar community barbecue fund-raisers at the other old German dance halls in Austin County, as well as at a few volunteer fire departments

and churches. But the barbecue crews are so short on volunteers that they have combined forces. The crew that cooked the barbecue at Millheim includes volunteers from the Peters, Cat Springs, and Kenney barbecues. The same crew would rotate through six community barbecues that year.

A few weeks later, I met up with Rufus at Kenney Hall, in tiny Kenney, Texas, just north of Bellville, for the annual Kenney 4th of July Barbecue. While Rufus and I watched, a crew that included many of the same guys we met in Millheim prepared 700 pounds of beef shoulder clods, 650 pounds of pork butt, and 400 pounds of mutton for somewhere around 800 attendees.

Jerry Stein, the president of the Kenney Agricultural Society, claims that the 4th of July Barbecue at Kenney Hall has been held every year since 1902, except for one year in the 1950s when a hurricane caused it to be cancelled. More than 1,000 people attended the Kenney Centennial barbecue in 2002.

TEXAS DANCE HALLS were built by German *verein* societies—secular organizations dedicated to choral singing, marksmanship, or some other activity. The Germans and, later, some Czech groups built more than 1,000 dance halls in Texas—some 500 still exist. I wonder how many of them have old-fashioned open pits?

Walter Jetton, the barbecue impresario who catered Lyndon Johnson's barbecues at the LBJ Ranch, also cooked on an open pit. The idea of enclosing the pit to capture the smoke was crazy, in Jetton's opinion.

Those of us who value tradition have been mourning the disappearance of wood-fired pits from barbecue restaurants and complaining about the extremes of the cook-off circuit, but we have mostly overlooked the events where American barbecue culture has been best preserved.

RUFUS AND I MET UP at another community barbecue in the Brazos Valley, at the Sons of Hermann lodge in Washington, Texas. I got there at seven in the morning, but Rufus and the Honda Element were already there. There were lots of other vehicles parked in the grassy lot, mostly Jeeps, pickup trucks, and Suburbans. The Sons of Hermann barbecue crew had been there all night.

A big guy in a camouflage hunting cap introduced himself as Lance Jahnke and passed me a Mason jar full of sweet homemade wine. "Communion wine," he said solemnly. I could tell by the look on Rufus's face that he had already had a swig. While I would have preferred coffee at that hour, I took a chug to prove that I was one of the faithful.

Drinking the communion wine with the Sons of Hermann

Jeff Wright, Larry Kopecky, James Stolz, Roger Finke, Don Roese, Tucker Roese, Gary Grebe, Larry Jensen, and Patrick Busa were among the dozen men milling around the barbecue shed. There were a whole lot of empty beer bottles in the trash bucket. Sitting up all night making sure the barbecue doesn't catch fire isn't a very difficult job. One person could handle it. But it has become a tradition for a crew to gather around the fire and spend the night telling tales and drinking while tending the barbecue.

The barbecue pit was covered with cardboard. It was three courses of cinder block above ground level and ten cinder blocks long, which would make it two feet high and fifteen feet long. The opening looked to be around four feet across. On top of the cinder-block chamber, a grate made of metal rods with stout wire mesh attached spanned the opening. The mesh area was only three feet across so that there was a gap between the edge of the cinderblock and the cooking area. This allowed the fire underneath to be refueled. When the cardboard was pulled back to reveal the meat, I counted fourteen briskets and around thirty Boston butts.

At the far end of the pit, I saw a couple of rabbits and a few coils of sausage. I confessed that I had never seen barbecued rabbit before. "That's not for the barbecue lunch. That's just our breakfast," one guy told me while the rest of the gang laughed. While the cardboard was pulled back, three men mopped the meats with small cotton dish mops dunked in a big pot of mop sauce. Lumps of B&B hardwood charcoal were added to the fire.

An elderly gentleman sporting a long white beard and wearing overalls and a MoorMan's Feed gimme cap sat in a lawn chair nearby, drinking beer. His name was Bubba Roese, and he was the guy who told me about the Sons of Hermann barbecue to begin with. I first met Bubba at the 105 Grocery & Deli in Washington, a country store with an awesome homemade hamburger. I sat down with Roese and his companions at a table in the rear of the store, where they were drinking beer. His friends introduced Bubba as the "mayor of Graball." Evidently, the Roese family once had a country store a few miles down Highway 105 in the town of Graball. Bubba said the burger at the Graball store was even better than the 105's. But the store, along with the town itself, was long gone.

When I told him I was a food writer, Roese started talking about the sad state of Texas barbecue. In his opinion, the German meat markets in Central Texas weren't cooking barbecue—they were smoking meat and sausage, just as they did in the old country. "Barbecue isn't supposed to taste like smoke," Bubba said. "Real barbecue is cooked in a traditional open pit, not in a smoker." When I asked him where I could find that kind of old-fashioned barbecue, he had told me to come to the Sons of Hermann lodge in Washington on the third Sunday in October. It took me several years, but I finally made it.

The Washington lodge was founded in 1898. The Sons of Hermann is a German mutual-aid society that was founded in New York in 1840. The San Antonio chapter

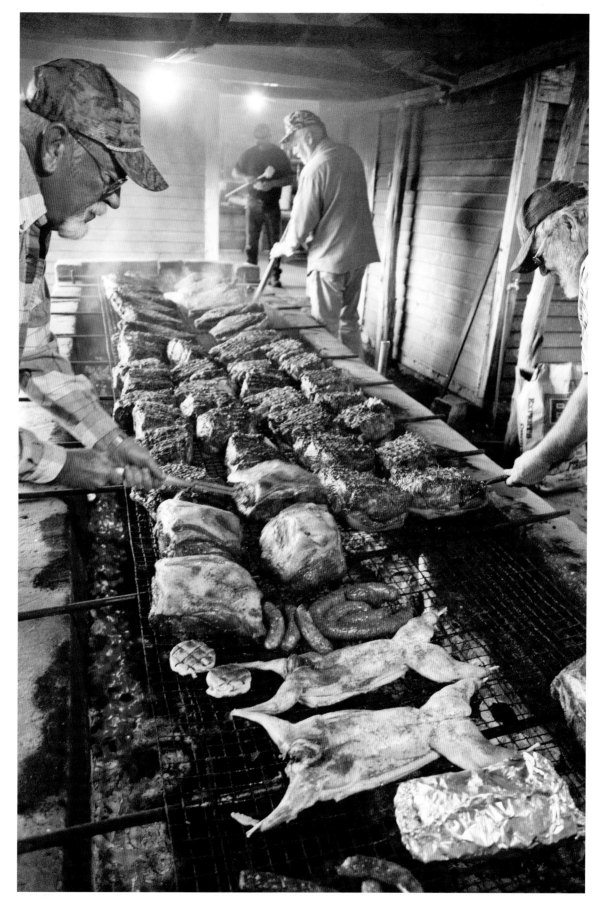

Briskets and pork bulls were cooked for the community barbecue; the rabbits and sausage were treats for the pitmasters.

came up with the idea of offering not-for-profit life insurance for all members. The society never had an initiation fee, but all members are required to buy a life insurance policy. The wooden hall at the Washington lodge was built in 1955 after the original hall burned down. The barbecue shed, with its distinctive construction of natural cedar posts and a tin roof, was built in 1948, along with the cinder-block pit.

The barbecue tradition in Washington goes back a long way, probably all the way to the founding of the lodge, Bubba Roese told me. "But the tradition lapsed for a few years because the old guys didn't want any kids around." When they were all gone, there was nobody to carry it on. After World War II, young people started moving to the city to get jobs, and the lodge started to decline. A lot of community groups and lodges in the area went under. As Bubba recalled: "We started cooking Boston butts and briskets in the 1960s. It's a lot easier, and I don't know where we could find a

Carving the barbecue at the Sons of Hermann Hall in Washington, Texas.

shoat anymore anyway. We don't burn the wood down and shovel the coals anymore, either. We use B&B charcoal. It's a charcoal company in Weimar [Texas] that makes oak lump charcoal. The flavor is just like oak coals. Charcoal doesn't put out a lot of smoke, so this is real barbecue, not smoked meat like over there in Central Texas. In the old days, the barbecue pit was open on top, but now we cover it with cardboard. That retains the heat, so the meat cooks faster with less fuel."

Every community hall represents an ethnic group, Bubba told me. "The Sons of Hermann lodge in Washington was beer-drinking German Lutherans. The Knights of Columbus hall in Chappell Hill was Polish Catholic, the SPJST [Slovanská Podporující Jednota Statu Texas; Slavonic Benevolent Order of Texas] hall in Snook was Czech Catholic." Each ethnicity had its own language and its own cooking traditions. The Germans seasoned their sausage with mustard seed, the Polish used marjoram, the Czechs liked garlic. The groups eventually intermarried, and so did their sausage seasonings.

The Germans seasoned their sausage with mustard seed, the Polish used marjoram, the Czechs liked garlic. The groups eventually intermarried, and so did their sausage seasonings.

At around ten thirty, the meat began to be transferred, a few briskets and Boston butts at a time, to a long wooden table in an open shed formed by cedar poles and a tin roof. The beams that held up the roof were so low that I smacked the top of my head every time I attempted to move, much to the amusement of the firemen. The carvers wore rubber gloves on the hands that held the meat and gripped plastic-handled slicing knives in their other hands.

As the steaming meat was sliced for serving, I stole a few chunks to sample. The pork had been cooked to around 190°F, so it fell in very tender slices. The meat was very juicy, with a big pork flavor and just a hint of smoky charcoal. There was a nice bark on the edges. The big chunks of the fatty end of the brisket glistened in the morning sunlight. It was hard to get used to the idea that brisket didn't have to be smoky to taste good, but it was true. The flavor of the beef dominated, with just a little accent from the oak charcoal; it reminded me of the taste of steak cooked on a charcoal grill.

The men began carrying steel trays of sliced meat from the barbecue shed over to the lodge building. The women of the lodge were already there assembling the feast. It was a wooden-floored dance hall with a stage at one end and a kitchen at the other. Tables were set up in long rows near the stage end of the building. There was seating for a little more than one hundred.

The sides were average. The beans came out of a can and had been doctored up with spices and heated in the kitchen. Someone brought German potatoes cooked with onions. The hot items were held in the big white enameled electric ovens most Texans call turkey roasters. There were lots of pickles, plenty of white bread, and a huge bowl of onion slices.

Next page: Slicing brisket at the Sons of Hermann community barbecue

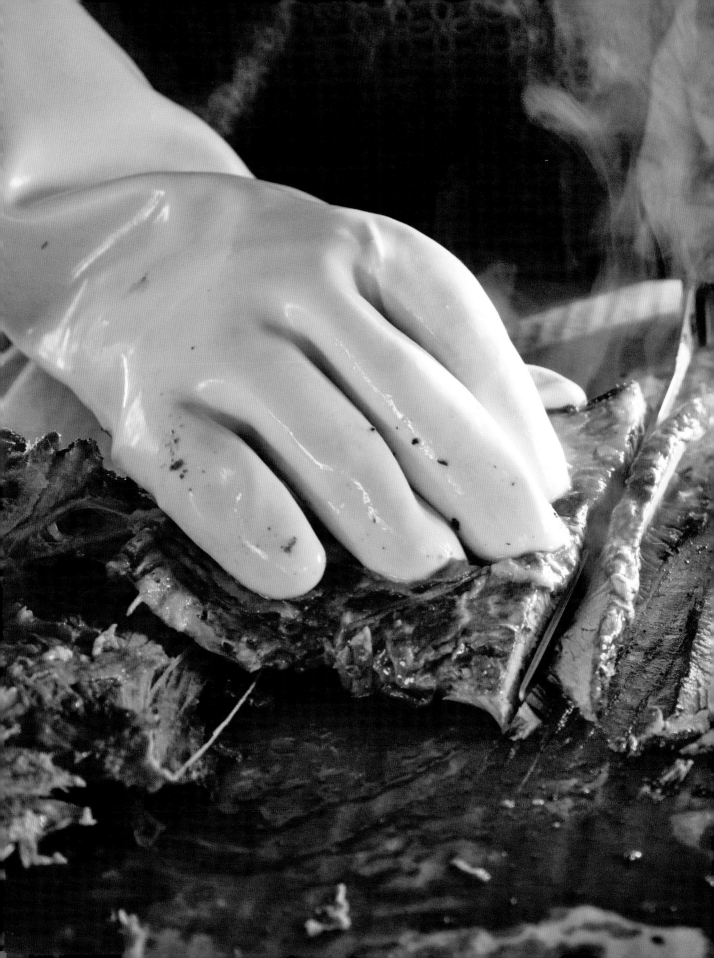

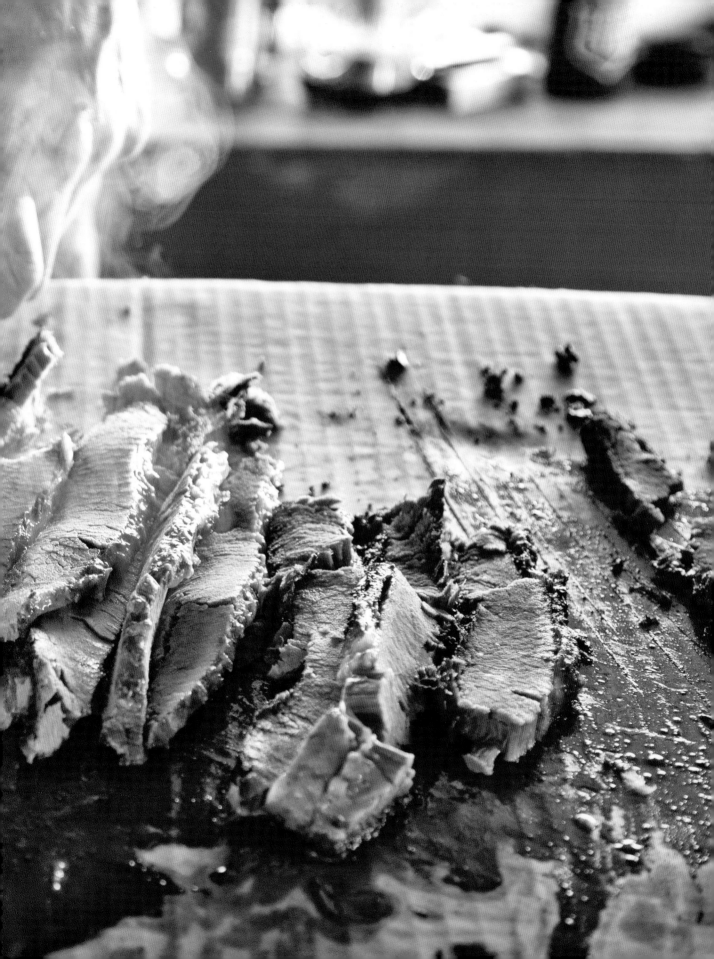

When the doors opened promptly at eleven, there were already twenty people waiting outside the door. It took awhile for them to get inside because quite a few of them were using walkers. I'd estimate the average age at seventy. One of the women serving food told me with a smile that younger people tend to eat lunch a little later. These were the early birds.

A big round wire-mesh cylinder with a crank handle on one end was sitting on a table near the entrance, and it was already filling up with tickets. At the far end of the hall, there was a table displaying elaborately decorated cakes wrapped in cellophane gift packages with ribbons. I guessed that they were either auction items or raffle prizes.

The dessert table was covered with homemade sweets. Pecan pie, coconut pie, chocolate cake, lemon pound cake, red velvet cake, and decorated cupcakes were among the choices, but there were still more plastic cake and pie carriers that hadn't been opened yet. The bragging-rights competition among the women who baked

the cakes and pies was much more intense than any barbecue cook-off. These white-haired Texas ladies would eat Myron Mixon alive.

When things calmed down, I talked to Bubba about the barbecue tradition in this part of East Texas. "Before World War II, they put whole lambs and shoats on the barbecue," Bubba said. "The lambs were not all that small. We called it mutton. The shoats were between seventy-five and ninety pounds, but they weighed a lot less once you cut the head off and removed the guts. There was no beef at all on the barbecue. It was too hard to handle a yearling, and refrigeration was not all that common in those days.

"The last time we cooked whole hogs was in 1975 or so, for Marion Busa's wedding. I think we cooked six.

"Back in the 1950s, there was a big black guy named Abe Johnson who cooked the barbecue for us. He burned down wood coals in a fire pit and shoveled them under the hogs and lambs. This was mostly an African American cotton farming area. Lots of black folks barbecue around here. They used to hire Abe to do the hard work, and everybody else just hung around drinking beer. Abe made the mop sauce too."

Kasey Whidden of Bellville, Texas. His dad, Lucas is in the background at right.

Photos of Southern community barbecues usually show black men turning the meat, shoveling the coals, and doing the work. Their white supervisors are mentioned by name, but in the photo captions the pitmen are listed simply as Negroes. When enjoying modern community barbecues, it's easy to forget that blacks are part of this tradition, too. It was barbecue men like Abe Johnson who did the cooking for the white barbecues as well as the African American ones.

"When we revived the barbecue, we took over the cooking instead of hiring someone," Bubba said. "But we learned how to do it from watching Abe Johnson. We still use his recipe. We always called the mop sauce the 'big n——' sauce. But I'm not sure you need to write that in your book."

IN FEBRUARY 2012, an African American U.S. district judge, Vanessa Gilmore, requested that a large painting be removed from the federal courthouse in Houston. The painting depicts a steamship docking in the Houston Ship Channel just after the Civil War. The scene includes a shirtless black man hauling logs on his shoulder, and a white sheriff with his hand on his pistol.

The painting is by Alexandre Hogue, a famous Texas artist whose works hang in the Smithsonian Institution and in the Musée National d'Art Moderne in Paris. It was commissioned by the General Services Administration as part of a public art project during the Depression. But the judge wrote that the painting is "offensive to persons who would rather not be reminded about that period in history or their part as either overseers or 'workers.'"

Like the building of the Houston Ship Channel, the history of African American barbecue in Texas involves the stories of slaves and former slaves. It would have been easier to avoid that sensitive topic on our road trip and stick with the smoked-meat eating and whiskey drinking. But when two white guys go driving around the South looking for the roots of barbecue culture, race is at the heart of the matter.

Race was also a topic at the 2002 symposium titled "Barbecue: Smoke, Sauce, and History" held by the Southern Foodways Alliance. The meals at the symposium were catered by some of the most famous names in Southern barbecue—black and white. The alliance brings together a diverse group of scholars, journalists, and restaurant folk. Founding members include Jessica B. Harris, an authority on African American food, and Nathalie Dupree, a doyenne of Southern cooking.

Racial reconciliation is at the core of the alliance's mission. In the 1970s, as desegregation changed the way Southerners thought about themselves, revisionist historians began the long process of correcting the historical record in order to give credit to African Americans for their contributions to Southern culture. As that revised history emerged, it demanded a rewriting of Southern food history as well.

The consensus of the community eating lunch under the shade trees in the quadrangle at Ole Miss was that barbecue is an icon of the American South held equally dear by blacks and whites. And as several symposium speakers explained, barbecue in the Deep South is sometimes the common ground that brings the races together, and sometimes the battleground on which they clash.

When I started writing my first barbecue book, *Legends of Texas Barbecue Cookbook*, I believed that Texas barbecue was invented by German butchers in meat markets like Kreuz Market, Smitty's, and City Market in Luling. But there were a few problems with the genesis story. For one thing "barbecue" isn't a German word or a German concept. I wondered how wurst suddenly turned into Texas barbecue.

Several old-time pit bosses explained that it was the hoards of black and Hispanic cotton pickers who started calling German smoked meat "barbecue." So I combed through archives in Texas libraries and museums looking for material about cotton pickers and barbecue. What I found instead were accounts of barbecue on Texas cotton plantations before the Civil War, and photos of blacks cooking barbecue in earthen pits.

The Slave Narrative Collection, a series of interviews with more than 2,300 former slaves conducted in the late 1930s by writers working for the Works Progress Administration (WPA), contains several descriptions of barbecues on plantations

by former Texas slaves. Given the evidence that the American barbecue tradition was introduced into East Texas by Southerners two hundred years ago, why do so many people insist that Texas barbecue was invented by Germans in Central Texas? Maybe it's because whites didn't eat black barbecue. A *Texas Monthly* article from 1973 put it this way:

> The heavily-sauced, chopped East Texas barbecue is a reflection of the fact that it was originally a Negro phenomenon, an ingenious method for rendering palatable the poorer, less-desirable cuts of meat which often were the only ones available to the poor black. Hence most of the attention was lavished on the hot sauce, whose purpose was to smother the dubious flavor of the meat which the barbecuing process had at least made tender.
>
> In Central Texas, by contrast, the Saturday barbecue at the town meat market was developed by the dominant social class, who could pick and choose from among the best cuts of meat and cook them to emphasize their flavor. Piquant sauces had little appeal in that situation, and it is therefore not surprising that Central Texas sauces are often a rather bland incident to the large well-flavored chunks of beef enjoyed for their own sake.

I gave a talk at the 2002 Southern Foodways symposium that explored the reasons for the exclusion of black barbecue from Texas food history. I asked Neil Foley, a historian at the University of Texas for help. Foley is the author of *The White Scourge: Mexicans, Blacks, and Poor Whites in Texas Cotton Culture*. "If blacks were cooking barbecue on cotton plantations in Texas in the early 1800s, why do so many Texans think that German butchers invented barbecue?" I asked. "And how did it happen that we forget blacks used to cook barbecue in Texas in the first place?" According to Foley, Texas rewrote its history to

"And how did it happen that we forget blacks used to cook barbecue in Texas in the first place?"

downplay slavery and its role in the Confederacy and emphasize instead its cowboy tradition beginning in 1936 with the Texas Centennial celebration, a world's-fair-size event. The cowboys beating the Mexicans at the Alamo became the central tableau of Texas mythology. "But there weren't any blacks in the Alamo scene. African Americans have been completely erased from the meta-narrative of Texas history," Foley told me. It was part of a grand marketing and rebranding scheme to change the image of Texas from a Confederate state to a western state. And the plan worked. In a survey conducted in the 1990s, more than 30 percent of Texans said they didn't think of themselves as Southerners.

A FEW YEARS AGO, Rufus and I attended a Juneteenth barbecue at the 5 Bar S Ranch, a sixty-seven-acre horse farm in Fresno, about a forty-minute drive south of Houston. The party was held by the Sugar Shack Trailblazers Riding Rodeo Club

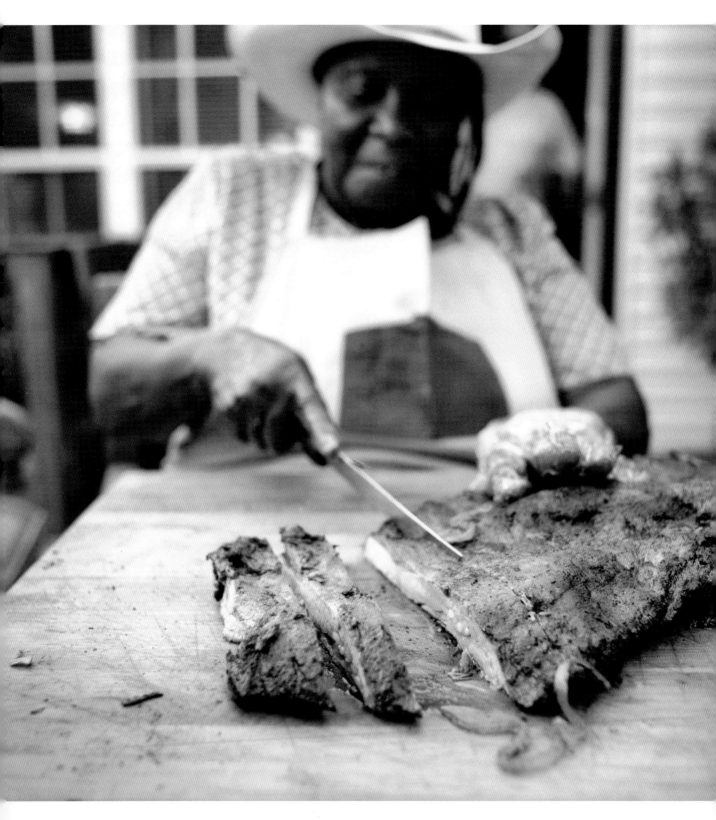

Mama Sugar carves a rack of ribs.

of Arcola/Fresno. The African American equestrian club rides in the annual Houston Livestock Show and Rodeo trail ride, among other events. The club has around fifty members, and most of them made it to the barbecue. The Texas state holiday known as Juneteenth (short for June 19) commemorates the anniversary of June 19, 1865, when the Union general Gordon Granger arrived in Galveston and announced the freeing of the slaves.

The barbecue was prepared by LaDraun Campbell, who manned two barbecue trailers parked under a carport, in case of rain. "We always celebrated Juneteenth with a barbecue in my family," Campbell told me as he raised the lid so I could check out the meats in the barbecue smoker.

Campbell grew up in Lane City, Texas, a small farming community near Wharton about half an hour southwest of Houston. "My daddy took us to the beach in Freeport for Juneteenth every year," he said. He remembered the vanilla ice cream, made on the spot with an old-fashioned ice-cream crank. He also remembered the barbecued brisket. His parents' barbecue pit was a fifty-five-gallon oil drum with a grill welded inside, and it was carried to the beach in the back of a pickup truck.

LaDraun has been barbecuing since the age of eleven or twelve. He used to run a company called L&D BBQ and Catering in Missouri City, Texas. He learned how to cook brisket from his mother. The rub was only salt and pepper, but that wasn't the only seasoning. "My mom poked holes and stuck garlic in it. Basted it with a mop of vinegar, lemons, and onion. Mama made me watch the meat. She seasoned it, I flipped it."

Domino players at Mama Sugar's Juneteenth barbecue

In the big barbecue trailer, there were a whole lot of briskets—I couldn't count them for all the thick smoke. LaDraun rubbed the briskets with a commercial seasoning called Fiesta Brand Brisket Rub, and he planned to smoke them for five hours, fat side up at around 300 degrees. The wood was mostly oak, with some pecan added for its sweeter flavor, he said. After five hours of smoking, the briskets were wrapped in aluminum foil to hold them.

Mama Sugar, owner of the ranch and the head cook and spiritual leader of the Sugar Shack Trailblazers, throws the party every year. Everybody said grace, and then Mama carved the brisket and ribs. After the meal, there was a domino match for devotees of that game. The trail riders' kids spent the afternoon on horseback. After the big kids galloped around the pasture, they took the little kids for horseback rides.

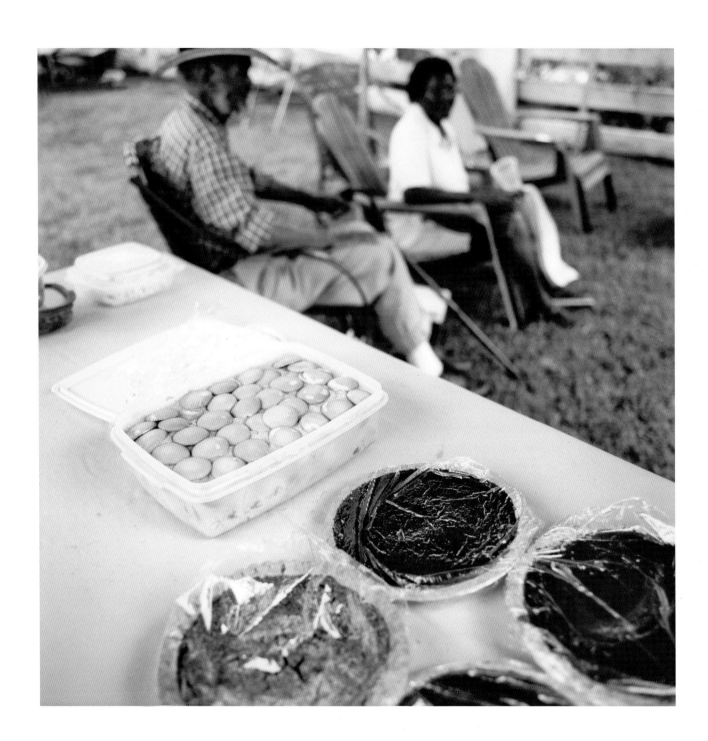

Juneteenth has been a state holiday in Texas since 1980 thanks to the efforts of black legislators like Al Edwards, a state representative from Houston. It has since spread from Texas to other parts of the country. Remembering the role of African Americans in Southern barbecue means confronting some uncomfortable truths. But if we avoid the subject, the contributions of African Americans will never be fully recognized.

AT OUR COMMUNITY BARBECUE, Richard Flores and I cooked the pig to an internal temperature of 206°F at the shoulder and then pulled the meat away while the hog was still on the grill. The rich, creamy pulled pork was chopped and seasoned with a light vinegar-and-pepper sauce and served on toasted rolls. It was the best pulled pork sandwich most of our guests had ever tasted. We used the meal to raise money for Foodways Texas, an organization dedicated to preserving, promoting, and celebrating the diverse food cultures of Texas. By which I mean we passed the hat and raised a couple of hundred dollars.

If you are really interested in reconnecting with the roots of American barbecue culture, you might consider lending your talents to a community barbecue in your hometown. It's also easy to hold your own community barbecue by renting one of the many lodges or other historic venues with old-fashioned barbecue pits that can be found all over the country. The halls are usually eager for the extra income, and they make a wonderful place to hold a party or fund-raiser.

After visiting the Sons of Hermann lodge in Washington, I wondered how many community barbecues there must have been in the 1950s, when organizations like the Kiwanis, Lions, Elks, Rotary, and Optimists were at their peak and churches were still holding camp meetings regularly. Once upon a time, before television and the Internet, those groups were our "social network."

Although community organizations are shrinking, many of the old barbecues are still going on. They aren't conveniently located in restaurants, and they aren't open seven days a week. The service is terrible—you have to stand in line. But give one of these events a try. Pretty soon, you'll find yourself slowing down and getting caught up in a conversation. When you sit at a common table and share your enthusiasm for great smoked meat, tangy sauce, or juicy sausage with the people you meet, you become a part of a community of barbecue lovers.

And that's what American barbecue culture is really all about.

COMMUNITY BARBECUE

POST A LISTING about your event on the
Community Barbecue Section at ZenBBQ.com.

✖ BEFORE RURAL ELECTRIFICATION came to the Texas Hill Country and the rural South in the 1950s, if you wanted to barbecue a whole hog, you took a live hundred-pound shoat to the barbecue pit and killed it just before you were ready to start cooking.

Today we go to the meat market for our pork. Finding a small hog for a barbecue is easy in North Carolina, difficult in other parts of the country, and impossible in some places. If you live near a pig farm in the country, you may be in luck. You may also get lucky if you live in a big city with a large Asian population. But have a plan in mind when you buy a whole hog—it won't fit in the refrigerator very well. You had better arrange to pick up the pig just before you are ready to cook it. Otherwise, you might end up with a pig covered with ice in your bathtub.

A processing plant outside my hometown of Houston specializes in small pigs. Their main customers are Asian grocery stores. The processor will gladly sell a hundred-pound whole hog butchered the way you want it for a barbecue. It sells shoulders and hog forequarters also.

The pigs it sells include rejects from commercial hog-raising operations, mainly runts that didn't grow to a sufficient size to meet industry specifications. These undersized pigs are generally lean, and they can come out dry when barbecued. When we cook these sorts of pigs as whole hogs at the Foodways Texas Barbecue Summer Camp, the meat experts at Texas A&M's Meat Science Center inject a generous amount of brine into the meat to improve moisture retention.

It is extremely difficult to barbecue a hundred-pound whole hog by yourself, because you can't lift it alone. And so every whole-hog barbecue becomes a collaborative effort. While I can't say that I barbecued the hogs at the Foodways Texas Barbecue Summer Camp, I did stand around the pit and nod and take photos while graduate students from the meat science program did the work. I ate quite a bit also.

The pigs were cooked standing up and were served whole and upright on a tabletop in the classic style of barbecue feast known as a "pig-picking." The skin is stripped away, and the exposed meat is torn off by the participants and made into sandwiches with provided fixings.

I have cooked a whole hog splayed in the Tennessee-Carolina style and pulled the meat. Inspired by the efforts of Samuel Jones, Rodney Scott, and the Fatback Collective crew that entered the Mangalitsa hog in the Memphis in May cook-off, I decided to try cooking one of Morgan Weber's Red Wattle–Mangalitsa hybrids for the community barbecue that Richard Flores and I put on. The cost was obscene. We spent more than four hundred dollars on a hundred-pound hog. (Twice what we raised in donations for Foodways Texas.) Of course, the real purpose of that community barbecue was to generate a terrific whole-hog recipe for this book.

I seasoned the pulled pork lightly with a Carolina vinegar barbecue sauce and supplied three other styles of barbecue sauces for guests to choose from. The meat was wonderfully flavorful, so juicy it was literally dripping with rich lard, and the creaminess of the texture was absolutely sublime. I heard several veterans comment that it was the best whole hog they had ever eaten.

So which is the right pig to buy if you want to barbecue an authentic Southern-style whole hog? Are you better off getting a heritage hog from an expensive gourmet butcher shop—or an inexpensive hundred-pound pig from the processing plant? The Fatback Collective would argue that the heritage pig tastes how whole hog used to taste back in the day, before factory farming and the market for lean meat ruined American pork. Another group of purists would say that American barbecue is about using slow cooking to make cheap meat delicious and that when foodies barbecue designer pork, they are introducing a class system into barbecue.

Isn't it great to have choices?

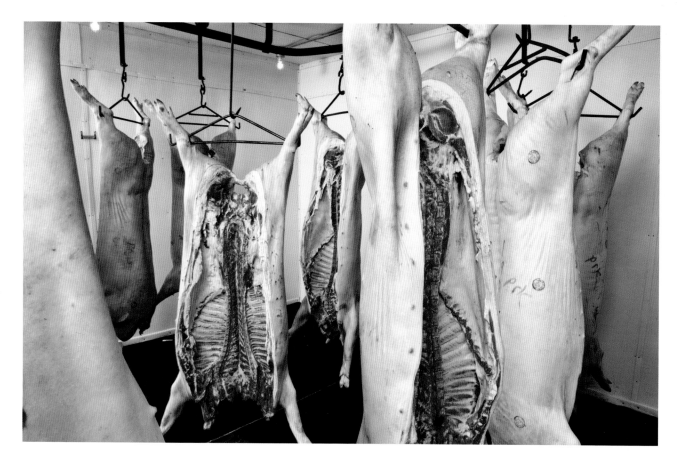

BUILDING A CINDER-BLOCK PIT

✖ OUR PIT WAS four cinder blocks wide, seven blocks long, and four blocks high, with a hole that could be opened and closed at either end to regulate airflow. The pit floor was black iron to prevent the concrete underneath from buckling. Inside the structure, we built up columns of three half cinder blocks to keep the grates for the pig two feet above the pit floor. The fuel went into the spaces between the columns. The grates were welded with a gap on either side to allow easy refueling. You can use cardboard or corrugated tin as a cover, but a friend of Richard's fabricates stainless steel for a living, so he got a fancy cover.

Big Abe Johnson's Mop Sauce

- 4 cups vinegar, plus 8 cups water
- 1 cup of butter
- ½ cup Worcestershire sauce
- ¼ cup Louisiana hot sauce
- 2 bottles of beer

Combine all ingredients in a large pot and cook over medium heat until the butter melts (or set over hot coals on the pit). Using a cotton dish mop, use the mop sauce to baste meat as it cooks. *Yields approximately 3½ quarts.*

Whole-Hog Barbecue

- -

Start the pig about 24 hours before you plan to serve it. You will need a pit large enough to accommodate the splayed pig, with openings in the grate to allow fuel to be added from above along the sides of the pit, or through openings on the bottom where the coals can be shoveled in. While the method is known as direct-heat barbecue, in practice most pitmasters keep the coals to the sides of the pit and the pig in the middle to avoid flare-ups. If the grease dripping off the pig reaches the hot coals, a fire will likely result. To control the heat and prevent fires, it is best to use a pit that can be completely sealed, with ventilation openings that can be closed or opened incrementally. If a flare-up occurs, close the pit up tight to put the fire out. If that doesn't work, douse it with water.

Ask the butcher for a hundred-pound pig, gutted and cleaned, with the head and feet removed. You can take the head and feet home in a plastic bag. The pig's feet can be pickled, or used to cook a sauce or soup. The head can be smoked, and the jowls used to flavor a pot of greens or beans. Or you can use the head to make headcheese.

The remaining carcass will weigh about eighty pounds. Traditionally, the carcass is split at the top of the spine starting just below the neck—but the skin is not cut through—so the whole hog lies flat. You can depart from tradition and make life easier by having the pig split into two forty-pound halves, the way Stephan Grady does it in North Carolina. This makes moving the pig around a lot easier. One man can carry half a pig over one shoulder.

In this recipe, the whole hog is cooked skin-side down the entire time. The skin forms a container that keeps the moisture, fat, and seasonings from running off, so the meat simmers slowly in its own juices. Instead of attempting to move the cooked pig, you pull the pork while the whole hog is still on the grate.

- 1 100-pound whole hog, cleaned and split, feet and head removed
- 2 cups peanut oil
- Kosher salt
- Black pepper
- Big Abe Johnson's Mop Sauce (p. 257)
- Robb's Carolina Barbecue Sauce (p. 202)

ALSO REQUIRED
- 2 bags (20 pounds each) best-quality charcoal briquettes
- 2 bags (20 pounds each) hardwood lump charcoal
- 2 starter chimneys
- Heavy-duty aluminum foil
- 6 disposable 18" × 26" full-size aluminum sheet pans
- 6 disposable 12" × 20" hotel pans or disposable aluminum hotel pans
- 2 digital meat thermometers with long heatproof wire leads

Lay the pig out, skin side up, and rub the skin with the peanut oil. Place several large sheets of aluminum foil on the grate and put the pig on top. The foil will protect the skin from burning for the first part of the cooking process so that you can fry it later. Fold the edges of the foil up to tent the pig loosely.

Using a sharp knife, remove any large pieces of excess fat from the inside of the carcass. If desired, place them in a large pan in a slow oven to render excellent cooking lard for another use. Season the inside of the carcass with salt and pepper.

Set up the pit for cooking by isolating the areas where the charcoal will burn. To do this, arrange the aluminum sheet pans on the floor of the pit directly under the pig. They will catch the grease as it drips, keeping it away from the coals. Load the two starter chimneys with briquettes and fire them up. Distribute

the hot coals evenly in the spaces you have created for the fuel. Put a few pieces of lump hardwood charcoal on top of the hot coals along the sides of the pit. You want a very low fire, so don't overdo it.

Put one thermometer lead in the shoulder of the pig and another in the ham so that you won't have to open the pit to monitor the internal temperature. Cook the pig for 12 hours at 180°F–200°F, adding a few chunks of charcoal as needed and adjusting the vents to control the heat. Be patient. Unlike a backyard grill, a big cinder-block pit responds very slowly when you add fuel or open and close the vents. It's like the difference between driving a motorcycle and a cement mixer.

After 12 hours, remove the foil and increase the heat in the pit to 250°F. Baste the meat with the mop sauce and repeat every 20 minutes or so. Cook the pig for another 6 hours or until the internal temperature reaches about 190°F. About 2 hours before you are ready to serve, add some fuel to the pit, fill the starter chimneys with coals, and light them. Spread the hot coals evenly across the fuel area. You can add a few chunks of hardwood for some smoke flavor. Close the lid and bring the temperature up to 300°F inside the pit. After 1½ hours or so, the internal temperature of the shoulder should reach the ideal temperature of 200°F to 205°F. When the desired temperature is reached, open the pit, extinguish the coals with water, and allow the pig to rest for 30 minutes.

To pull the meat: put on insulated gloves, remove the ribs from one side of the hog, and reserve if desired. Pull out the loin meat (known as the catfish) and the long, stringy belly meat (known as the middlins), and place all the meat in a hotel pan or an aluminum pan. Continue removing the shoulder (white meat) and then the ham (brown meat). Repeat the process on the other side. You should end up with around 20 pounds of meat from each side, or 40 pounds of meat total. Put the skin in a separate hotel pan and reserve for frying.

Put the meat on a chopping block. With a pair of meat cleavers, lightly chop a few pounds of loin and middlins together with 5 pounds of white meat, dark meat, and crispy fat (if desired) to make a mixture that contains a little of each variety of meat. Season the mixture with salt and pepper and a cup or so of Robb's Carolina Barbecue Sauce to taste. Don't overseason the mixture, since more barbecue sauce will be added later. Put the seasoned mixture in a pan for serving. Repeat the chopping and mixing process until all the meat has been seasoned. Serve immediately. For sandwiches, provide your guests with toasted rolls, several varieties of slaw, and several barbecue sauces. Mustard BBQ Sauce (p. 230) and Robb's Carolina Barbecue Sauce were the most popular at our barbecue.

Store any extra barbecue in vacuum-sealed 1-pound packages in the freezer. *Yields 40 pounds of meat and 8 pounds of skin.*

Fried Pork Skins

- -

Fried pork skins, known as *chicharrones* in Spanish, make a great cocktail snack when zipped up with a sprinkling of hot sauce. They are a popular ingredient on taco-truck tacos too. In North Carolina, the skins are sometimes fried in squares and served on a bun with barbecue sauce as "skin sandwiches."

- 5 pounds pig skin from a barbecued whole hog
- 1 pound lard
- Salt to taste
- Barbecue sauce

Cut the skin and attached meat and fat into strips or pieces. You can cut 1" squares for cocktail snacks, 1" × 3" strips for tacos, or 3" × 3" squares for skin sandwiches.

Set a cast-iron Dutch oven over a propane burner in the backyard. Add the lard and heat to about 350°F, or until a piece of skin dropped into the hot lard bubbles. Control the heat to keep a constant temperature. Fry all the skin, turning it with a Chinese strainer until it gets very crispy, which may take 5–10 minutes, depending on the thickness of the skin. Salt the cracklings lightly and serve with barbecue sauce or pepper sauce on the side as cocktail snacks, with eggs on breakfast tacos, or on skin sandwiches.

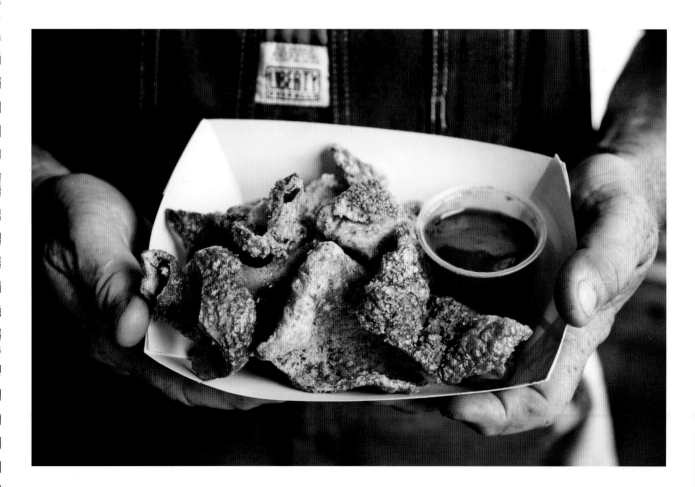

Fried pork skins and dipping sauce.

ACKNOWLEDGMENTS

WE WOULD LIKE TO THANK all those who participated in the making of this book. We especially appreciate the barbecue professionals who shared their time and knowledge with us, especially Ricky Parker, Wayne Monk, Brandon Cook, George Archibald, Samuel Jones, Rodney Scott, Aaron Franklin, and Tim Byres.

Our gratitude to Dave Hamrick, Casey Kittrell, and all the University of Texas Press folks who helped make this book complete.

Special thanks to our wives, Frances Lovett and Kelly Klaasmeyer, for putting up with all the time and travel this project has taken.

Thanks to the Southern Foodways Alliance Southern BBQ Trail Documentary Project for the oral histories. Thanks especially to oral historians Rien T. Fertel and Amy Evans for their tireless research. Thanks to John T. Edge for the barbecue lore recorded in his book *Southern Belly*. We also wish to thank John Egerton, Calvin Trillin, Lolis Eric Elie, John Shelton Reed, Robert Moss, Daniel Vaughn, Marvin Bendele, Elizabeth Englehardt, Chris Lily, Myron Mixon, John Morthland, Jim Shahin, and all the other barbecue writers whose passion for the subject has informed and inspired us over the years.

O. Rufus Lovett wishes to thank Wyatt McSpadden, to whom he paid homage as he photographed a subject Wyatt knows and loves so well. Rufus is also grateful to Richard and Martha Rorschach whose friendship and help with his photographic endeavors are sincerely treasured.

Next page: Ghost of a chopped pork sandwich

BIBLIOGRAPHY

Barker, Ben, and Karen Barker. *Not Afraid of Flavor.* Chapel Hill: Univ. of North Carolina Press, 2000.

Bass, S. Jonathan. "How 'bout a Hand for the Hog: The Enduring Nature of the Swine as a Cultural Symbol of the South." *Southern Cultures* 1, no. 3 (Spring 1995): 301–320.

Baylor County Historical Society. *Salt Pork to Sirloin: The History of Baylor County, Texas, from 1879 to 1930.* Quanah, Tex.: Nortex Offset, 1972.

Brantley, Max. "The Ribs Hit the Fan: The Politics of Barbecue." *Arkansas Gazette,* June 21, 1977.

Carriere, J. M. "Indian and Creole Barboka, American Barbecue." *Language* 13, no. 2 (April 1937): 148–150.

Cecelski, David, and Mary Lee Kerr. "Hog Wild." *Southern Exposure* 20, no. 3 (Fall 1992): 8–15.

Clark, Kathleen Ann. *Defining Moments: African American Commemoration and Political Culture in the South, 1863–1913.* Chapel Hill: Univ. of North Carolina Press, 2005.

Crosby, Alfred W. *The Columbian Exchange: Biological and Cultural Consequences of 1492.* Westport, Conn.: Greenwood, 1972.

Davis, Ardie. *The Great Barbecue Sauce Book: A Guide with Recipes.* Berkeley: Ten Speed, 1999.

Douglas, Mary, ed. *Food in the Social Order.* New York: Sage, 1984.

Dupre, Daniel. "Barbecues and Pledges: Electioneering and the Rise of Democratic Politics in Antebellum Alabama." *Journal of Southern History* 60, no. 3 (August 1994): 479–512.

Edge, John T. "Redesigning the Pig." *Gourmet,* July 2005.

———. *Southern Belly.* Chapel Hill: Algonquin Books, 2007.

Egerton, John. *The Americanization of Dixie: The Southernization of America.* New York: Harper and Row, 1974.

———. *Southern Food: At Home, on the Road, in History.* New York: Knopf, 1987.

Elie, Lolis Eric, ed. *Cornbread Nation: The United States of Barbecue.* Chapel Hill: Univ. of North Carolina Press, 2004.

———. *Smokestack Lightning: Adventures in the Heart of Barbecue Country.* New York: Farrar, Straus and Giroux, 1996.

Essman, Elliot. "Barbecue." *Life in the USA.* Accessed December 11, 2006. http://www.lifeintheusa.com/food/barbecue.htm.

Ferris, Marcie Cohen. *Matzoh Ball Gumbo: Culinary Tales of the Jewish South.* Chapel Hill: Univ. of North Carolina Press, 2005.

Foley, Neil. *The White Scourge: Mexicans, Blacks, and Poor Whites in Texas Cotton Culture*. Berkeley and Los Angeles: Univ. of California Press, 1997.

Garner, Bob. *North Carolina Barbecue: Flavored by Time*. Winston-Salem, N.C.: Blair, 1996.

Gold, Jonathan. "Smoke Gets in Your Eyes." *Travel and Leisure*, April 2000.

Hale, Smoky. *The Great American Barbecue and Grilling Manual*. McComb, Miss.: Abacus, 2002.

Hedgepeth, William. *The Hog Book*. Athens: Univ. of Georgia Press, 1998.

Henderson, Fergus. *The Whole Beast: Nose to Tail Eating*. New York: Ecco, 2004.

Hilliard, Sam Bowers. *Hog Meat to Hoecake: Food Supply in the Old South, 1840–1860*. Carbondale: Southern Illinois Univ. Press, 1972.

Hirsch, George. *Know Your Fire*. New York: HP Books, 1999.

Hitt, Jack. "A Confederacy of Sauces." *New York Times Magazine*, August 26, 2001, 28–31.

Hughes, Dorothy B. *The Big Barbecue*. New York: Random House, 1949.

Jamison, Cheryl Alters, and Bill Jamison. *Smoke and Spice: Cooking with Smoke, the Real Way to Barbecue*. Rev. ed. Boston: Harvard Common Press, 2003.

Jarman, Rufus. "Dixie's Most Disputed Dish." *Saturday Evening Post*, March 7, 1954: 36–91.

Johnson, Greg, and Vince Staten. *Real Barbecue*. New York: HarperCollins, 1988.

Jordan, Terry G. *Trails to Texas: Southern Roots of Western Cattle Ranching*. Lincoln: Univ. of Nebraska Press, 1981.

Kaminsky, Peter. *Pig Perfect: Encounters with Remarkable Swine and Some Great Ways to Cook Them*. New York: Hyperion, 2005.

Karmel, Elizabeth. *Taming the Flame: Secrets for Hot-and-Quick Grilling and Low-and-Slow BBQ*. New York: Wiley, 2005.

Kirton, John William, ed. *One Thousand Temperance Anecdotes*. London: Smart and Allen, 1867.

Lily, Chris. *Big Bob Gibson's BBQ Book: Recipes and Secrets from a Legendary Barbecue Joint*. New York: Clarkson Potter, 2009.

Lovegren, Sylvia. "Barbecue." *American Heritage*, June 2003, 36–44.

MacClancy, Jeremy. *Consuming Culture: Why You Eat What You Eat*. New York: Holt, 1992.

Marianski, Stanley, Adam Marianski, and Robert Marianski. *Meat Smoking and Smokehouse Design*. Parker, Colo.: Outskirts Press, 2006.

May, Mark. *Mark May's Hog Cookbook*. Silver Spring, Md.: Rosedale, 1983.

Moss, Robert F. *Barbecue: The History of an American Institution*. Tuscaloosa: Univ. of Alabama Press, 2010.

Perl, Lila. *Red-Flannel Hash and Shoo-Fly Pie: American Regional Foods and Festivals*. Cleveland: World, 1965.

Raichlen, Steven. *The Barbecue! Bible*. New York: Workman, 1998.

Reed, John Shelton. *Holy Smoke: The Big Book of North Carolina Barbecue*. Chapel Hill: Univ. of North Carolina Press, 2008.

Root, Waverley, and Richard de Rochemont. *Eating in America: A History*. New York: Morrow, 1976.

Rountree, Moses. *The Success Story of Adam Scott, the "Barbecue King."* Goldsboro, N.C.: Nash, 1977.

Sauceman, Fred. *Home and Away: A University Brings Food to the Table*. Johnson City: East Tennessee State Univ., 2000.

Schlesinger, Chris, and John Willoughby. *Let the Flames Begin: Tips, Techniques, and Recipes for Real Live Fire Cooking*. New York: Norton, 2002.

Smith, Griffin, Jr. "The World's Best Barbecue Is in Taylor Texas. Or Is It Lockhart?" *Texas Monthly*, April 1973.

Sokolov, Raymond. *Why We Eat What We Eat: How the Encounter between the New and Old World Changed the Way Everyone on the Planet Eats*. New York: Summit, 1991.

Southern Foodways Alliance. Oral History Project. http://southernfoodways.org/documentary/oh/index.html.

Staples, Brent. "South Carolina: The Politics of Barbecue and the Battle of Piggie Park." *New York Times*, September 16, 2002.

Stogner, Johnny. *Barbecue: Lexington Style*. Lexington, N.C.: Stogner, 1996.

Tannahill, Reay. *Food in History*. New York: Crown, 1988.

Taylor, Joe Gray. *Eating, Drinking, and Visiting in the Old*

South. Baton Rouge: Louisiana State Univ. Press, 1982.

Thompson, Michael. "'Everything but the Squeal': Pork as Culture in Eastern North Carolina." *North Carolina Historical Review* 82, no. 4 (October 2005): 464–498.

Trillin, Calvin. *Feeding a Yen: Savoring Local Specialties from Kansas City to Cuzco*. New York: Random House, 2003.

———. *The Tummy Trilogy: "American Fried," "Alice, Let's Eat," and "Third Helpings."* New York: Farrar, Straus and Giroux, 1994.

Viola, Herman J., and Carolyn Margolis, eds. *Seeds of Change: Five Hundred Years since Columbus*. Washington, D.C.: Smithsonian Institution Press, 1991.

Voltz, Jeanne. *Barbecued Ribs, Smoked Butts, and Other Great Feeds*. New York: Knopf, 1990.

Wall, Allie Patricia. *Hog Heaven: A Guide to South Carolina Barbecue*. Lexington, S.C.: Sandlapper, 1979.

Walsh, Robb. *Legends of Texas Barbecue Cookbook: Recipes and Recollections from the Pit Bosses*. San Francisco: Chronicle Books, 2002.

———. "Summer and Smoke." *Natural History*, August 1996, 68–72.

Warnes, Andrew. *Savage Barbecue: Race, Culture, and the Invention of America's First Food*. Athens: Univ. of Georgia Press, 2008.

Watson, Lyall. *The Whole Hog: Exploring the Extraordinary Potential of Pigs*. Washington, D.C.: Smithsonian Books, 2004.

York, Jake Adam. "The Marrow of the Bone of Contention: A Barbecue Journal." *Story South*, Winter 2003. http://www.storysouth.com/winter2003/bbqframe.html.

INDEX OF RECIPES AND FOOD PREPARATION

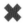

GENERAL INDEX

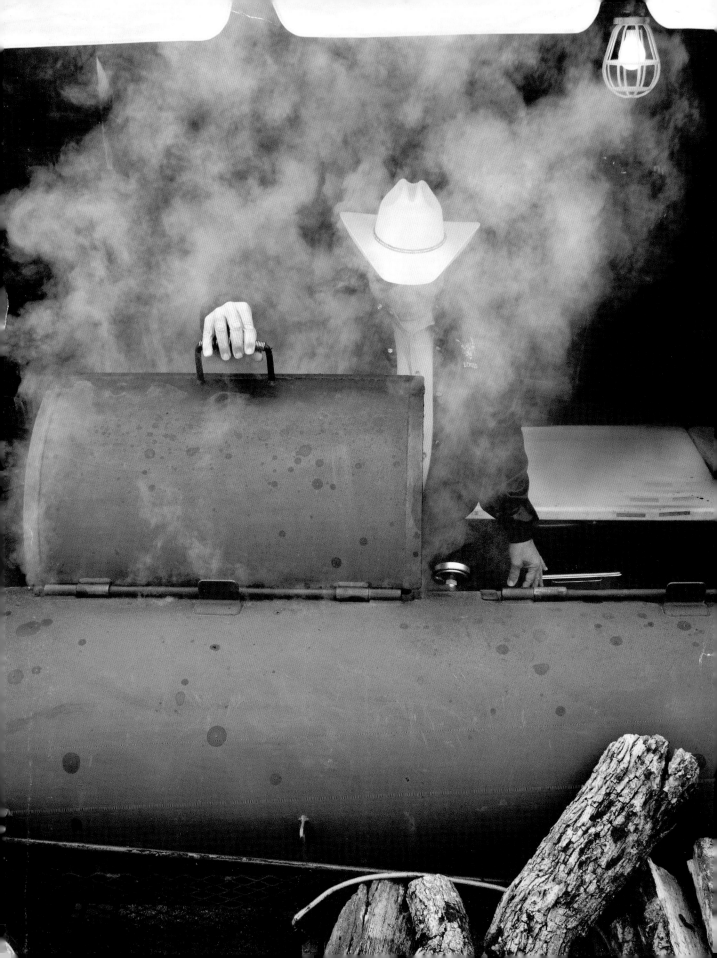